Art and Politics in China
1949–1984

Art and Politics in China
1949–1984

Maria Galikowski

The Chinese University Press

ISBN 962-201-649-9

THE CHINESE UNIVERSITY PRESS
The Chinese University of Hong Kong
Sha Tin, N.T., Hong Kong
Fax: +852 2603 6692
 +852 2603 7355
E-mail: cup@cuhk.edu.hk
Web-site: http://www.cuhk.edu.hk/cupress/w1.htm

ACKNOWLEDGEMENT
Reprint permission for the illustrations is arranged through The Copyright Agency
of China.

Printed in Hong Kong

Contents

Preface

This book started out in 1986 as a doctoral thesis at Leeds University. The original aim of the thesis, completed in 1991, was to look at the extent to which art in the first three decades of the People's Republic of China mirrored official discourse. The Mao era (1949–1976) was characterized by a high level of social and ideological control. I was interested in the organizational and ideological means by which this control was imposed on artists and what effects it had on the art work produced. As someone from the West, brought up to believe that the creative impulse wells up from the very soul of the artist, I was fascinated to know how artists in China dealt with the problem of having to produce art that reflected a particular official line, and the means they might utilize to try and subvert official directives.

Subsequently, the scope of the project was enlarged to encompass the early years of the Deng era, which were marked by a level of liberalization unprecedented in the People's Republic. The authorities began to relax their grip on artists, and in response, artists began to demand greater creative autonomy. The first seeds of the New Art Movement that gathered momentum in China in the second half of the 1980s were quietly (and in one or two instances, not so quietly) being sown in those initial heady years of the reform era. Today, artists in China enjoy considerable creative freedom, for which they owe at least a partial debt to the courage, tenacity and enterprising spirit of the artists who formed the first unofficial

art groups, the editors of art journals who dared to publish ground-breaking articles, and the artists and art theoreticians who wrote those articles. The final chapter of this book is a small tribute to them.

Many people have made invaluable contributions to the shaping of this book. Amongst them, I would like to thank Professor Don Rimmington and Professor Bill Jenner for supervising my doctoral research at Leeds University; Professor Glen Dudbridge at Oxford University for his insightful comments on certain sections of the book; Dr. John Clark for his encouragement, and for providing me with useful materials; Li Xianting, who gave me so much of his time and introduced me to useful contacts at the Central Academy of Fine Art in Beijing; and Shui Tianzhong, Chen Dehong, Yan Li, Luo Zhongli and Li Shan, who allowed me to conduct interviews with them. I would also like to say a special thank you to the academic and administrative staff in the Department of East Asian Studies, Waikato University and what was formerly The Oriental Institute, Oxford University, who offered me so much help in so many ways. I am also indebted to The British Academy for providing a scholarship that enabled me to carry out research on the project in both Britain and China between 1986 and 1989. I would like to express my appreciation, too, to The Chinese University Press, and in particular, the Project Editor, Olivia Wong, for making this book possible. The journey from initial submission of the manuscript to final publication has been a long one, more than five years, involving a number of editors and other staff, to whom I would now like to extend my thanks.

Most of all, I would like to thank Lin Min for his unstinting support.

Illustrations

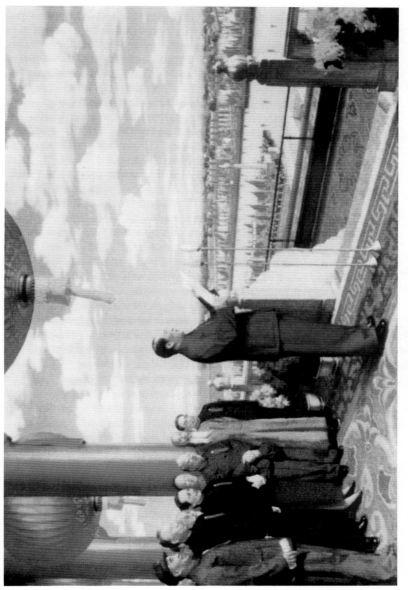

Fig. 1 *Founding Ceremony*—Dong Xiwen (oil, 1953)

Fig. 2 *We Are Together with Chairman Mao*—anonymous (New Year picture, c. 1950)

Fig. 3 *Child and Pigeons*—Jiang Zhaohe (traditional Chinese painting, 1954)

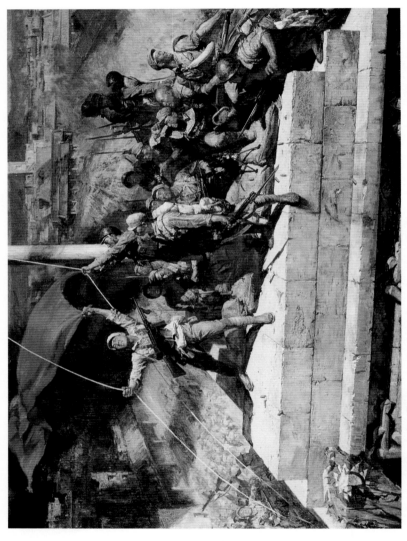

Fig. 4 *Destruction of the KMT* —Chen Yifei (oil, 1970s)

Fig. 5 Carp Jumping over the Dragon Gate—Shi Banghua (New Year picture, 1959)

Fig. 6 A *Pumpkin As Big As a Boat*—anonymous (traditional Chinese painting, c. 1958)

Fig. 7 *Our Fertilizer Incinerator Is Like a Flaming Mountain*—anonymous (mural, c. 1958)

Fig. 8 *Bathed in Dew*—Pan Tianshou (traditional Chinese painting, 1959)

Fig. 9 *Battling against the Drought* — Ya Ming and Song Wenzhi
(traditional Chinese painting, 1959)

Fig. 10 *The Rent Collection Courtyard* (section) —collective work (clay sculptures, 1965)

Fig. 11　A *True Portrayal of the People of Yiqiao Township, Shandun District, Hang County, Eagerly Presenting Their Agricultural Taxes to the Authorities*—Pan Tianshou (traditional Chinese painting, 1950)

Fig. 12 *Shepherd's Song in the Tian Mountains*—Guan Shanyue (traditional Chinese painting, 1974)

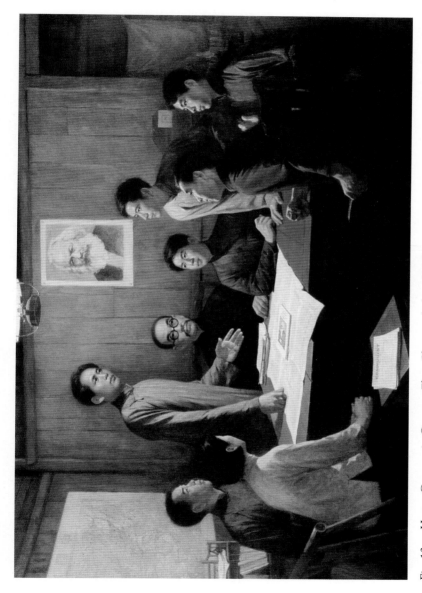

Fig. 13 *Hunan Communist Group*—Zhou Shuqiao (oil, c. 1970)

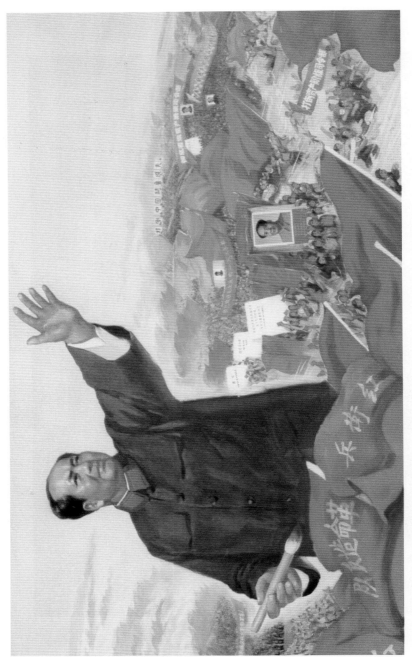

Fig. 14 *Follow Closely Chairman Mao's Great Strategic Plan*—anonymous (gouache, 1968)

Fig. 15 *Chairman Mao Goes to Anyuan*—Liu Chunhua (oil, 1967)

Fig. 16 *Liu Shaoqi and the Anyuan Miners*—Hou Yimin (oil, 1961)

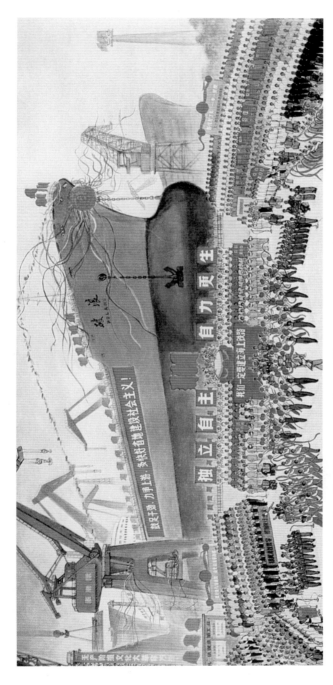

Fig. 17 *Advance Triumphantly* — Shi Meicheng (traditional Chinese painting, c. 1974)

Fig. 18 *Old Party Secretary*—Liu Zhide (gouache, c. 1974)

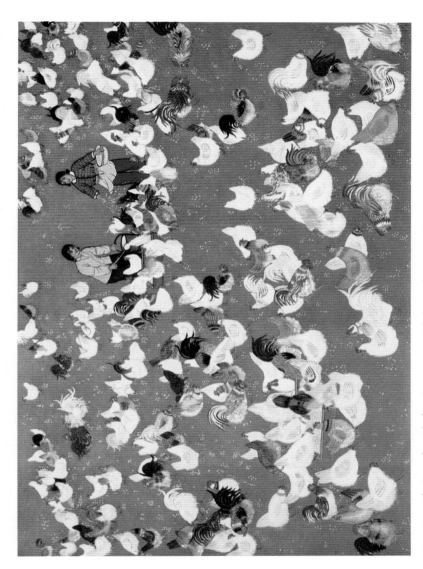

Fig. 19 *The Brigade's Chicken Farm*—Ma Yali (gouache, c. 1974)

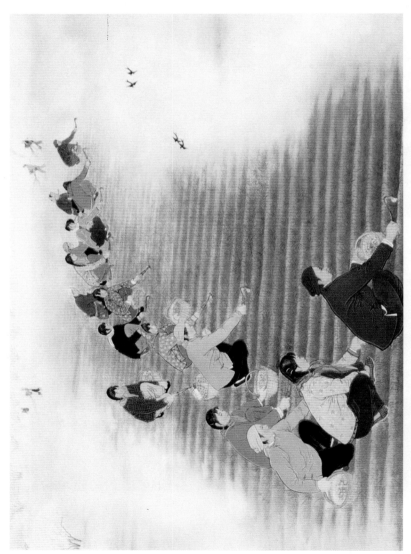

Fig. 20 *Spring Hoeing* — Li Fenglan (gouache, c. 1974)

Fig. 21 *Commune Fish Pond*—Huang Zhengyi (gouache, c. 1974)

Fig. 22 *Welcome Spring*—Chen Dayu (traditional Chinese painting, 1973)

Fig. 23 *The Winking Owl*—Huang Yongyu (traditional Chinese painting, 1978, based on original completed *c.* 1972)

Fig. 24 *I Am "Seagull"* —Pan Jianjun (oil, *c.* 1972)

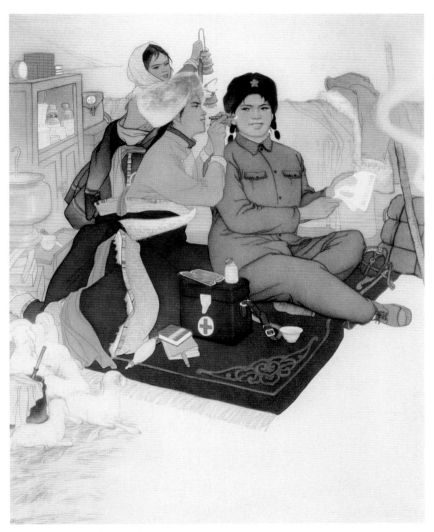

Fig. 25 *Practising Acupuncture*—Shao Hua (traditional Chinese painting, 1972)

Fig. 26 *Guerrilla War*—Luo Gongliu (oil, 1950)

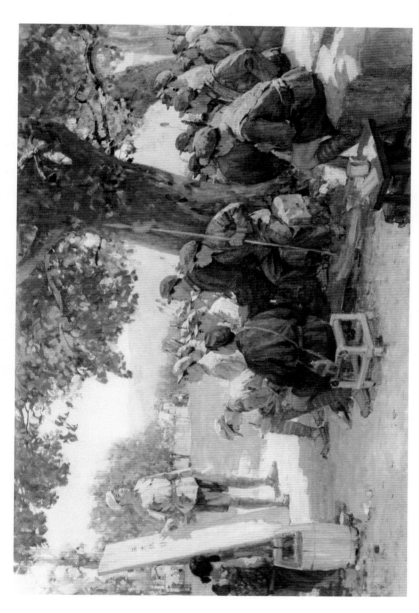

Fig. 27 *The Red Army Attending a Political Class* — Zheng Hongliu (oil, c. 1972)

Fig. 28 *Fire Trees, Silver Flowers, the Sky Never Darkens*—Cheng Shifa, Xie Zhiguang, Xu Zhiwen, Yan Guoli and Zhang Guiming (traditional Chinese painting, c. 1972)

Fig. 29 *With You in Charge, I'm at Ease* — Peng Bin and Jin Shangyi (oil, 1977)

Fig. 30 *1968 x Month x Day Snow*—Cheng Conglin (oil, 1979)

Fig. 31 *Father*—Luo Zhongli (oil, 1980)

Fig. 32 A *Girl and Her Younger Brother*—Cheng Conglin (oil, 1984)

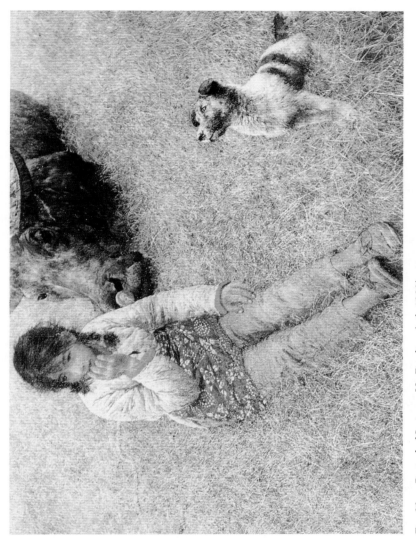

Fig. 33 *Revival of Spring*—He Duoling (oil, 1982)

Fig. 34 *Going to Town*—Chen Danqing (oil, 1980)

Fig. 35 *Six Square Metres*—Ma Desheng (wood block print, 1980)

Fig. 38 *People at Ease* — Feng Guodong (oil, 1980)

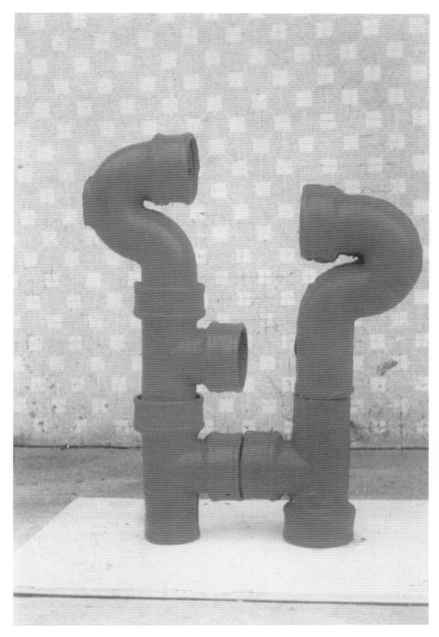

Fig. 39 *Conversation* — Xing Shenghua (sculpture, 1985)

Fig. 40 *In the New Era—The Enlightenment of Adam and Eve*—Meng Luding and
Zhang Qun (oil, 1985)

Fig. 41　*Spring of Science* — Xiao Huixiang (mural, 1979)

Fig. 42 *The Water Sprinkling Festival—Song of Praise for Life*—Yuan Yunsheng (mural, 1979)

Introduction

This study looks at art and politics in China between 1949 and 1984, and examines the effects of Communist policies on artists and their work in the People's Republic. Its main objective is to discuss the organizational structures and ideological framework governing Chinese art over the period in order to assess how art has been used since 1949 for propaganda purposes, and to elucidate in what ways and to what extent aesthetic discourse has mirrored its political counterpart. It explores three important dimensions of the relationship between art and politics, namely the art institutions, the ideological scheme and the political movements by means of which political dominance was asserted over artists. During some periods, organizational and ideological control was regarded by the authorities as sufficient to keep artists in line. At other times, political movements to thwart the re-emergence of "bourgeois" or "feudal" thinking were considered necessary. Each chapter thus lays different emphasis on the three areas to reflect the fluid nature of the relationship between art and politics.

In my analysis I have attempted to examine the subject from social, historical and comparative perspectives in order to look at the main theoretical premises underpinning the cultural policies of the People's Republic, and the way in which these theoretical premises were practically applied to the creative work of artists. The study provides an overview of

general developments in art after 1949, as well as individual case studies. It also looks at both the continuing influence of traditional Chinese painting and folk art forms, as well as the impact of foreign ideas and styles. The relationship between art and politics in the People's Republic has not been static, but characterized by continual changes. These changes have been contingent mainly on social-political considerations, but also on the response of artists to the political constraints imposed upon them.

The book is divided into chapters representing four major historical-political stages. During the first stage, the Chinese Communist Party took steps to consolidate its political position on a national level and extend its authority in the cultural sphere. In order to secure a high degree of ideological uniformity among the artist community, and among intellectuals in general, it established institutional structures to mediate the Communists' ideological scheme and initiated political campaigns on three occasions.

Once the Party had attained its initial goals of gaining political and ideological legitimacy and of winning the general cooperation of artists, during the second stage it mobilized artists *en masse* to participate in socialist construction through a series of large scale social-political movements, including the Great Leap Forward in 1958 and the Socialist Education Movement in the early 1960s. To ensure the active participation of artists in these movements, their ranks were periodically purged, most notably during the Anti-Rightist Movement in 1957 and, to a lesser extent, the Anti-Rightist Deviation Movement in 1959. This second period is marked by significant fluctuations in the relationship between the authorities and artists, as policies vacillated between liberalization and radicalization. It was also during this time that the Party's authority began to come into question because of the disastrous failure of a series of political and economic initiatives.

The third stage, that of the Cultural Revolution, represented a major attempt by the radicals in the leadership to re-affirm their supremacy over the political and cultural spheres. Cultural policies were taken to radical extremes, with the result that a uniformity in art of a degree unprecedented since 1949 was established as political and artistic discourses merged.

However, this degree of ideological control proved unsustainable and collapsed following the death of Mao Zedong in 1976. The period after his death, representing the fourth and final stage discussed in this book, was

symbolized by the forging of a new relationship between art and politics, and between artists and the state. It saw the emergence of concepts relating to the individual subjectivity of the artist and the search for a new mode of artistic expression within a limited framework of social reform. In a considerably more tolerant political atmosphere, the Party attempted to forge a new ideological consensus, whilst artists sought to establish a new interface with the Party and society by re-defining their functions within the new system.

Historical background

The organizational and ideological systems established by the Communist Party after 1949 to govern art activities were natural developments resulting from policies formulated and applied during the Communists' struggle for power through the 1930s and 1940s.[1] From the 1930s, several leading figures in the Communist Party, such as Qu Qiubai and Mao Zedong, began to develop their ideas on the social function of art according to Marxist theories as interpreted by Russian and Soviet political and cultural theorists. Mao shaped these ideas further in his 1942 Yan'an Talks in the form of a synthesis which delineated the social and ideological functions of writers and artists and included the use of popular art forms as political propaganda.[2]

At an organizational level, the Communists had already set up a department of propaganda by the late 1920s to direct all cultural activities within their own geographical sphere of influence. In the urban areas, the Party sought to extend its influence by organizing leftist sympathizers into cultural associations, such as The League of Left-Wing Writers and The League of Left-Wing Artists,[3] whose activities were directed towards propaganda work.[4] Artists with no previous experience of producing wood block prints, for example, were now trained in woodcutting techniques to be used for the purposes of political propaganda. Wood block prints were a cheap and easy form of art to produce, they had a long tradition in China going back as far as the Tang dynasty,[5] and they had become popular in the early 1930s following Lu Xun's introduction of the work of European woodcut artists to Chinese art circles.[6] Many members of The League of Left-Wing Artists, such as Jiang Feng and Cai Ruohong, later travelled to

the Communist base in Yan'an, where they became established as leading art cadres.[7]

It was here in Yan'an, at the Lu Xun Academy of Art (Lu Xun Yishu Xueyuan), set up in the winter of 1937 by the Communists, that the Party's ideas on the appropriate institutional structures and ideological framework for cultural activities were crystallized. The Academy had departments of literature, drama, music, and art, and courses were designed to train the mainly urban youth in cultural propaganda work. For the artists, this meant training initially in woodcuts and, after 1942, increasingly in New Year pictures (simple coloured woodblock prints changed at each Chinese New Year), which were especially popular with the peasants. After a short spell at the Academy, graduates were often sent to local villages to collect folk songs and to paint New Year pictures with political messages. During the War against Japan their main task was to mobilize resistance against the Japanese and to raise morale generally both in the villages and at the war-front.[8]

The Academy became an important experiment centre for the implementation of Communist cultural policy. It not only produced a core group of Party cultural cadres to help oversee propaganda work, but it also in all respects became a "model" for later cultural institutions and activities. Mao even talked about preparing writers and artists to go from the "Small Lu Yi" or "Small Lu Xun Academy of Art" to the "Big Lu Yi", i.e., from the Academy and its environs to the country as a whole, the implication being that there would be a continuation in general cultural policy once the Communists had moved from their base areas to take over the whole of China. The importance of the ideas and practices developed in the Academy can be seen in the fact that after 1949, the Communist leadership attempted constantly to remind writers and artists of the "spirit of Lu Yi" as an ideal that should be worked towards. As late as the 1980s, sixteen volumes of works produced in the Academy were collected and published, ranging from woodcuts to short stories and New Year pictures to poetry.[9]

During the 1930s and 1940s, the pattern of organizational and ideological control of the Party over left-wing cultural activities that was to be established throughout China after 1949 was gradually evolved, and it involved three main aspects. First, the Party attempted to assert its

leading role in the cultural field through maintaining control over various organizations, including The League of Left-Wing Artists and the Lu Xun Academy of Art, over publications such as the *Literary and Art Supplement* (*Wenyi fukan*) in the *Liberation Daily* (*Jiefang ribao*), and over a series of woodcut, cartoon and New Year picture exhibitions held in Yan'an.[10] Second, the Party made efforts to impose its own ideas as to the style and content of artistic work in order to establish its dominance in the ideological sphere. Whenever new conditions arose and political imperatives changed, the Party required writers and artists to adjust their work to suit the new situation. Therefore, during the War against Japan, art was required to raise the people's patriotic fervour and inculcate feelings of hatred against the Japanese invaders. When the target of attack became the rival Guomindang, or Nationalists, artists were encouraged to portray the ills of Chinese society under Guomindang rule. Similarly, when the peasants expressed a dislike of many of the woodcuts produced by artists at Yan'an, because of western-influenced features such as heavy shading, artists were compelled to adhere to more acceptable Chinese methods or to switch completely to producing coloured New Year pictures and picture story books.[11] The prominent woodcut artist, Hu Yichuan, made a major statement on New Year pictures in January 1942 in which he set forth the following guidelines:

> In terms of lines and colours, make every effort to achieve simplicity, clarity, vigour and brightness … the theme must be clear and obvious, so that the people can understand it at once…. If possible, avoid using symbolism and exaggerated dimensions…. Don't over-emphasize shading on faces.[12]

Third, the Party attempted to reform the thinking of writers and artists, discouraging them from elitism and encouraging them to participate directly in the lives of the workers, peasants and soldiers. One of the main purposes of Mao's Yan'an Talks was to set out systematically ideological guidelines for writers and artists by defining the social function of the arts and delineating the role of the artist within the ideological framework. Ominously, the Party also began to carry out small-scale purges against non-conformists within its ranks, the most extreme example being the criticism and execution of the writer, Wang Shiwei, for his heterodox views and independent thinking.[13]

Though only at a formative stage in the 1930s and 1940s, these three features were to play a crucial role in the comprehensive system of control established by the Party after the founding of the People's Republic.

Prior to 1949, the vast majority of artists throughout China were not subject to Communist control either organizationally or ideologically. Many remained completely aloof from political affairs and maintained their own artistic independence, especially a large number of traditional Chinese painters who continued to produce their highly stylized landscape or flower-and-bird ink paintings. Some, however, disturbed by the chaos caused by conflicts between warlords vying for power, the level of corruption under the Guomindang, and China's poor reputation on the international stage, had sympathy for the left-wing cause. As part of its strategy to forge a united front with as many Chinese social sectors as possible, the Communist Party deliberately tried, through those who openly sympathized with it, such as Guo Moruo and Mao Dun, and through its underground networks,[14] to win the support of artists and writers working in Chongqing, the temporary Guomindang capital in China's interior. Zhou Enlai, for example, at that time a Party Politburo member, maintained close links with the prominent painter, Xu Beihong, who was based in Chongqing.[15] Many artists who were courted by the Party were well-known and respected in their particular fields. Several, such as Xu, had studied academic oil painting abroad in prestigious European art academies, and, after 1949, many of them were to take up important positions in new art institutions as a reward for their previous support, and as a means to give added credence to the Party's expressed aim at maintaining a united front of all artists.[16]

Before 1949, although the Party had begun to assert its control and influence over artists and intellectuals in general, its dominance was far from complete. It was still vulnerable to Guomindang attacks in the civil war and in order to unite as broad a range of artists as possible, it was forced to rely mainly on persuasion, rather than coercion. After 1949, however, the situation was to alter dramatically as the Party now had at its disposal the political power and organizational means to impose its will on all artists in China.

Notes

1. Cai Danye, *Zhonggong wenyi wenti lunji*; Wang Jicong, *Zhonggong wenyi xilun*.
2. Chen Tiejian *et al.* (eds.), *Qu Qiubai yanjiu wenji*; Mao Zedong, *Mao Zedong lun wenxue he yishu*.
3. Established in 1930 in Shanghai.
4. Wang Jicong, *Zhonggong wenyi xilun*, pp. 71–96.
5. Lu Di, *Zhongguo xiandai banhuashi*, p. 3.
6. Ibid., pp. 44–47.
7. Jiang Feng, *Jiang Feng meishu lunji*; Cai Ruohong, *Cai Ruohong meishu lunji*.
8. Ai Ke'en (ed.), *Yan'an wenyi yundong jisheng: 1937–1948*; Gu Yuan (ed.), *Yan'an wenyi congshu (meishujuan)* (Introduction).
9. For details on the gathering of the materials used for these sixteen volumes, see Zhong Jinzhi and Jin Ziguang (eds.), *Yan'an wenyi congshu (wenyi shiliaojuan)* pp. 1092–1095.
10. Ai Ke'en (ed.), *Yan'an wenyi yundong jisheng: 1937–1948*; Zhong Jinzhi and Jin Ziguang (eds.), *Yan'an wenyi congshu (wenyi shiliaojuan)*.
11. Zhong Jingwen, *Yan'an Lu Yi — wo dang suo chuangbande yisuo yishu xueyuan*, p. 42.
12. Lu Di, *Zhongguo xiandai banhuashi*, pp. 193–194.
13. Dai Qing, *Liang Shuming, Wang Shiwei he Chu Anping*, pp. 41–110. This illuminating account not only of what happened to Wang Shiwei, but also of the treatment meted out after 1949 to two others, Liang Shuming and Chu Anping, provides some interesting insights into the relationship between the Chinese Communist Party and intellectuals. For further information on the organizational methods adopted to instil Party unity at Yan'an, see F. C. Teiwes, "The Origins of Rectification: Inner-Party Purges and Education before Liberation", *China Quarterly*, 1976, No. 65, pp. 15–32.
14. Wen Tianxing (ed.), *Guotongqu kangzhan wenyi yundong dashiji*, pp. 22–28.
15. Hou Yimin, "Youhuajia jian bihuajia", *Fine Art*, 1983, No. 3.
16. Liao Jingwen, *Xu Beihong — Life of a Master Painter*, pp. 306–325.

From "Small Lu Yi" to "Big Lu Yi":
The Formative Stage, 1949–1956

The period 1949 to 1956 constituted a new stage in the complex relationship between politics and art in China. After 1949, the Chinese Communist Party became the exclusive arbiter of cultural policy throughout the country. Its aim was to ensure that the ideological and cultural principles and organizational guidelines which had formed the basis of the Lu Xun Academy of Art, and which had been systematically set out in Mao's Yan'an Talks,[1] were effectively implemented among all "cultural workers", as those involved in cultural activities were to be called. However, the task facing the new Communist government was considerably more problematic than had been the case at Yan'an, and the general situation more difficult to control.

With regard specifically to art, the Party had to incorporate into its cultural/ideological framework a greater diversity of artistic forms. Furthermore, many artists from the newly liberated areas, unlike those at Yan'an who had on the whole been prepared to accept and support party directives, were ambivalent towards, even suspicious of, the new regime. For this reason, although there was a basic continuity of policy after 1949, with most principles and guidelines remaining essentially the same as they had been at Yan'an, the Party felt it necessary to take into consideration the more complex nature of its newly-established relationship with artists throughout China and to allow initially a certain degree of flexibility in its approach.

Of primary importance to the Party in its dealings with artists was the achievement of two fundamental objectives, namely, to establish and maintain an ideological monopoly as a means to legitimize its power and consolidate its political supremacy, and to enlist the direct participation of artists in the continuing process of social revolution and socialist construction and in all political movements. The highly politicized nature of the role assigned to artists forced them to re-evaluate their function in society, and to re-assess the form and content of their work.

In order to understand developments in art after 1949, it is necessary to look first at the paradoxical nature of the relationship between the authorities and intellectuals as a group, of which artists comprise an integral part. The paradox has been an underlying factor in all policies affecting intellectuals,[2] and it is based on two main considerations. The Communists were fully aware upon taking power that intellectuals, by virtue of their capacity for independent thought and their creative talents, constituted a potential threat to the political supremacy of the Party, to ideological unity and to stable political order. To minimize this threat, the new Communist government needed to maintain rigid ideological control and bring intellectuals periodically to heel through fear of persecution. At the same time, aware of the crucial role that intellectuals could play in legitimizing the regime's position of power and promoting its policies, it aimed to mould these intellectuals ideologically into a malleable group that would help implement policy. Those involved in the arts, for example, possessed the cultural means to propagate ideas amongst vast numbers of people. (In this respect, art had a particularly important role to play. Since the main target for the Party's political message was China's millions of illiterate peasants, art naturally had an advantage over the written word as a vehicle for propaganda; it was also a much speedier way of reaching a large audience than say, a drama troupe, which, by necessity, must perform to limited numbers of people.) Therefore, while stressing the need for a strong political dimension in the arts, the Party also saw the wisdom in allowing some degree of debate on aesthetic standards, in order to ensure the maximum effectiveness of the arts as a means of spreading its political message.

The paradoxical nature of the relationship between the authorities and artists was manifested in several major debates on art, in the

organizational structure of art institutions, and in the involvement of artists in a series of political movements. The basic pattern of this relationship can be revealed by analysing the methods employed to exercise control over artists and the way in which the artists in turn responded. To do this, we need to look at three major areas, these being the organizational structures through which the authorities institutionalized their control; the ideological scheme imposed on artists, as manifested in debates on art and in the resulting creative work that was produced; and key political and ideological movements, periodically engineered to bring artists into line through criticism and self-criticism, demotions, denunciations and purges.

The creation of organizational structures as a means of institutionalizing political control

Once they had extended their control from the "old liberated areas" mainly in the north to all other areas of China, the Communists began to establish organizational structures through which cultural policy could be disseminated over the entire country. It was necessary to set up associations on a national scale which would encompass all cultural endeavours, including art, literature, drama and so on, to "facilitate the carrying out of work, the training of talented people, popularization and reform".[3] The fundamental principles which formed the basis of these associations were initially set down at the First National Congress of Literary and Art Workers (July 1949), and reiterated at the Second (September 1953).[4]

The Congress held in 1949 was particularly important in that it brought together for the first time all those working in the cultural field from both the old Communist-held areas and the regions which had only recently come under Communist control. The significance the authorities attached to creating a unified cultural force out of these disparate groups was apparent from the large number of leading political figures, including Mao Zedong, Zhou Enlai, Zhu De and Lu Dingyi, who attended the Congress and delivered speeches. Mao's address clearly aimed at bringing the different groups together by stressing the shared purpose and common ground of all Congress participants as "progressive cultural workers of the people". He stated: "You are all needed by the people. You are the people's

writers, the people's artists or the people's organizers of literary and art work. You are useful to the revolution and to the people."[5]

Zhu De, the Commander-in-Chief of the People's Liberation Army, acknowledged that there was a high level of cultural diversity in China, but, in an attempt to minimize the very real differences that existed among Congress participants, he pointedly asserted that the main cultural current since the May Fourth period (1919) had always been in line with "the people's democratic revolutionary movement".[6] Later, Zhou Enlai, the new Premier, in his political report to the Congress, specifically emphasized the need to achieve unity between cultural workers from the old and the newly liberated areas, between those politically committed individuals who had a history of participation in left-wing cultural activities, and those who had previously exhibited no particular political orientation in their work but were now willing to "reform themselves".[7]

In addition to the speeches given by prominent political figures, the presentations of leading individuals in the various cultural fields also addressed the question of the division in the ranks of cultural workers. Jiang Feng, a wood-cut artist and long-standing Party activist who had worked in the Lu Xun Academy of Art at Yan'an, gave a report on behalf of artists from the old liberated areas. He outlined the close association between art and Communist policy in these areas, stating that, even though the situation had now changed and artists from the Communist base areas had moved from the countryside to the city, the essential characteristics of the revolutionary art practised in the base areas were to be maintained. In order to achieve this, practical measures were to be adopted, including the speedy re-education of an increasingly large pool of artists, particularly folk artists and traditional Chinese painters, and by making full use of modern printing facilities in the cities to print large quantities of art work for dissemination amongst the populace.[8]

The traditional Chinese painter, Ye Qianyu, who, unlike Jiang Feng, had never been directly involved in left-wing art activities, having spent most of his time before 1949 teaching at the Beiping College of Art, acted at the Congress as a representative of the areas recently brought under Communist control. Though opening his speech by acknowledging that some good work had been produced in these areas, he nevertheless went on to enumerate the many shortcomings of the "progressive" art[9] movement,

of which he himself had been a part. These shortcomings, including factionalism, a lack of strong leadership, an incorrect or superficial understanding of Party policy towards the arts, divisiveness, individualism, remoteness from the masses and social life, and excessive reliance on "western bourgeois artistic methods and aesthetic values", were to be used as the basis for artists to measure their past failings. To correct these failings, Ye stated, artists needed to study earnestly Mao Zedong Thought and Mao's policies on art, and unite with the workers, peasants and soldiers to struggle for a new China.[10]

These two speeches by Jiang and Ye revealed in part how the authorities intended to impose their own cultural values on artists from the newly-liberated areas in order to bring them into line with those from Yan'an, and thus effect a measure of ideological unity. From Ye Qianyu's implicit self-criticism, this was clearly to be achieved largely through a critical examination by each individual of his or her past mistakes, followed by a whole-hearted willingness to accept the guidance of the Party.

At the same time, incentives were used to induce artists to offer their support to the regime. These took the form of positions of importance, particularly in the newly-established Artists' Association, for better-known individuals who were thus assured of a prominent place in the new system and the chance to maintain, even enhance, their personal prestige. Ye Qianyu is a prime example of an artist rewarded in this way, first acting as Chairman and leading member of the artists who attended the Congress, and later becoming Deputy Chairman of the Artists' Association. The composition of the executive committee of the Artists' Association, the institution through which art policy was to be disseminated nationwide, revealed that, of the thirteen members, almost half were mainstream artists who had enjoyed a high reputation when living and working in the Guomindang-held areas. The presence of these artists, like Xu Beihong, Wu Zuoren and Liu Kaiqu, added stature to the new Association and went some way to allay the fears of artists suspicious of the Communist regime. These mainstream artists also possessed technical skills that were generally superior to their counterparts from the old liberated areas due to their rigorous artistic training both in China and abroad. Such skills could be an important asset in achieving Mao's demand at Yan'an that there should be a "raising of standards" in artistic levels, as well as the "popularization" of art.[11]

However, although the authorities, for the sake of unity, created the impression of a power balance within the executive committee between mainstream artists and the artists and art cadres from Yan'an, real power lay, in fact, with members of the second group. They comprised the majority within the committee, but, more significantly, all four sub-committees in which the major decisions were taken and specific art policy formulated were headed by veteran Party cadres. Cai Ruohong chaired the important editing and publishing committee, Wang Chaowen became head of the committee that dealt with political movements, Ye Fu was responsible for exhibitions, and Jiang Feng was in charge of the committee for "artistic welfare".[12] Xu Beihong, who became the first Chairman of the Artists' Association in 1949, was, in reality, only a figurehead. Suffering from ill-health throughout his time as Chairman, he died three years later.[13] Qi Baishi, the traditional Chinese painter who replaced Xu as Chairman, was already in his nineties when appointed[14] and to an even greater extent exerted only nominal authority. Ultimate power rested with Jiang Feng as head of the Party group within the executive committee of the Artists' Association,[15] and it was clear that in 1949 the dominant force within the Artists' Association was the old "Lu Yi" group, which comprised the long-term active supporters of Party policy. It was this group that was to be most influential in formulating specific art policy. It should be remembered, however, that the Artists' Association itself was not a body which could freely make decisions. It remained subordinate to the Ministry of Culture and ultimately to the Department of Propaganda which super-vised cultural affairs and mediated decisions between the Politburo and the cultural organs under its control.[16]

Following the closing session of the First National Congress of Literary and Art Workers, forty local congresses were held throughout China. Each of them set up a local branch of all the different cultural associations that had been established at the national level,[17] and organizational control by the Party of cultural activities was extended down to the grass roots level. This power structure remained virtually unchanged until the Cultural Revolution in 1966. The Second National Congress of Literary and Art Workers held in September and October 1953 saw little change in the composition of the executive committee of the Artists' Association. Qi Baishi had replaced Xu Beihong as Chairman, but the Vice-chairmen still

included Jiang Feng, Liu Kaiqu, Ye Qianyu, Wu Zuoren and Cai Ruohong. Jiang Feng and Cai Ruohong were the key figures, as head and deputy-head respectively of the Association's Party group.[18] The power wielded by individuals like Jiang and Cai derived from the Association's central role in determining the extent to which individual artists could bring their work before the public. If artists wished to exhibit their work or have it published in the official art periodicals, they needed to receive permission from one of the Artists' Association's committees. If they wished to exhibit or publish regularly, it was a virtual necessity for them to be members of the Association, particularly at the national level.[19]

The constitution of the Artists' Association promulgated in 1954 outlined the Association's main functions in guiding creative work,[20] and revealed its highly politicized nature. It opened with the contradictory statement that the Association was a voluntary organization (implying a high degree of autonomy), but one which must actively participate in the Chinese people's revolutionary struggle and socialist construction, support the Party's Marxist-Leninist art policies, accept that art should serve the people and be closely linked to them, and adopt the creative and critical method of Socialist Realism. A series of specific tasks were set down. The Association was to organize artists to participate in a variety of creative activities and produce artwork with a combination of a high level of ideological content and artistic quality; encourage enthusiasm and a healthy work ethic among artists and take a lead in the study of art theory and criticism; organize the study of art theory based on Marxism-Leninism and Socialist Realism; study the policies of the Party and government; observe what was happening in society and, using the method of criticism and self-criticism, reform and improve continuously the thinking of artists; organize the selection, introduction and exhibition of works of art; train young artists and help amateur artists and the masses in general in their artistic activities in order to promote the development of the people's cultural life; promote the study of, and research into China's cultural heritage; and strengthen the international exchange of culture and art, particularly between China on the one hand and the Soviet Union, Eastern Europe, and the "people's artists" from other countries on the other.

Funding of the Association was to come partly from members' subscription fees, but mainly from state subsidies, highlighting the

Association's financial dependence on the authorities. Finally, the constitution warned that any member who violated the interests of the state or the people (without actually defining what constituted a violation) or who was guilty of "reactionary" behaviour or speech would be expelled. This was no small threat, for an expulsion could bring permanent disgrace.

Two institutional channels of political control — Art publications and exhibitions

Art publications and exhibitions became the main channels for the Communist government to get its political message across in a visual form to the general public. They were also the two key channels by which artists were able to gain regular access to the public. If denied access to these channels, an artist would lose the most important means of sharing his or her work with the wider public, arguably the *raison d'être* for creative expression. The authorities thus ensured that strict control was maintained over these channels through the Ministry of Culture and the Artists' Association. Without the official approval of, or sponsorship by, one of these organizations, it was virtually impossible for artists to have their work published or exhibited at the national, or even local level. By exercising strict control, the Party was guaranteed authority over the aesthetic ideas and ideological principles to which art was required to conform.

During the latter half of 1949 more than forty different cultural magazines and journals were established, each new publication being sponsored and edited by official organizations or cultural institutions. They included such influential publications as the *Literary and Art Gazette* (*Wenyi bao*) (May 1949), and *Popular Arts* (*Qunzhong yishu*) (October 1949), edited by Zhou Erfu; *People's Literature* (*Renmin wenxue*), (October 1949), edited by Mao Dun and Ai Qing; *People's Drama* (*Renmin xiju*), (April 1950), edited by Tian Han; *Mass Film* (*Dazhong dianying*) (June 1950) and *New Traditional Drama* (*Xinxiqu*) (September 1950).[21]

In February 1950 the first official national publication on art, *People's Art* (*Renmin meishu*), was published, with the Yan'an veterans Wang Chaowen and Li Hua as editors. It was established, sponsored and controlled by the Artists' Association, as was the publication that superseded it in 1954, *Fine Art* (*Meishu*). In addition, in December 1955 the Artists'

Association and the People's Art Publishing House co-sponsored and co-edited *Artists' News* (*Meishujia tongxun*). The publication of art magazines and journals was facilitated by the establishment of art publishing houses at the national and local level, all of which came under the direct control of official art organizations and, ultimately, the State.[22] By maintaining a strict monopoly on access to publications, the authorities were able to promote their own policies on art, criticize heterodox views and artistic trends, and encourage the kind of creative work that suited current political needs.

As the second major channel by which Chinese artists gained access to a public audience, exhibitions also came under the strict control of official art organizations at the national and local level. These organizations included the Artists' Association and all its branches, the China Art Gallery and all its branches, and the various art colleges nationwide. The selection of works for any exhibition involved a lengthy process of assessment by a variety of officials, not all of whom were art experts. The process was particularly complicated and laborious for national art exhibitions. Works were first submitted, usually by art teachers and students, for approval at the county level; if they passed this initial test, they would then be scrutinized by officials at the provincial level and, if successful, they would receive final approval or rejection by a panel of judges, comprising leading members of the Artists' Association in consultation with the head of the Central Academy of Fine Art, the head of the College of Arts and Crafts in Beijing, the fine art editor of the *People's Daily* (*Renmin ribao*), the head of the People's Fine Art Publishing House, and a number of well-established artists.[23] Artists were themselves effectively precluded from organizing their own exhibitions due to the monopoly exercised by the Artists' Association and the Ministry of Culture over all suitable public display areas.

The first national exhibition held after the Communists had seized power was organized in 1949 by those artists who later went on to occupy leading positions in the Artists' Association. It was held concurrently with the First National Congress of Literary and Art Workers and it was dominated by works from the old liberated areas "reflecting the revolutionary struggle of the workers and peasants".[24] Only a small percentage of the work was contributed by "progressive" artists from the areas originally held by the Guomindang.

This exhibition was followed by the "First National Exhibition of Fine Art" (October 1950), also arranged by the Artists' Association. A third exhibition (October 1951) on the art of ancient China, was organized by the Ministry of Culture to raise patriotic sentiments at a time when China was fighting the Korean war. Other exhibitions arranged by either the Artists' Association or the Ministry of Culture or, in some cases, jointly by the two, included a "National Exhibition of Traditional Chinese Painting" (1953), a "National Exhibition of Folk Arts and Crafts" (1953), the "Second National Exhibition of Fine Art" (1955) and the "Second National Exhibition of Traditional Chinese Painting" (1956).

The re-structuring of art educational establishments

Art educational establishments were an integral part of the authorities' aim to achieve comprehensive ideological control in the art world since they were the places where principles and guidelines concerning creative work could be systematically conveyed to art students. At Yan'an, the Party had established the Lu Xun Academy of Art as an experimental institution to help train artists according to Party principles. Many of the veteran art cadres and teachers from the Academy had then moved on to occupy the top positions in the new official art organizations after 1949.[25]

In 1949, when the People's Liberation Army (PLA) swept into China's big cities, it was ordered by the Communist leadership to occupy all key factories, government offices and educational establishments, particularly the big universities. As a measure of the importance the Communists attached to gaining control over all art activities in China, upon entering Beijing and Hangzhou, PLA units were sent to occupy the Beiping College of Art and Hangzhou State College of Art, the two largest and most influential centres of art education and training in the country.[26] Later, both institutions were placed under the direct control of the Ministry of Culture, whilst other minor art colleges were run directly by provincial or city education committees.[27] Beiping College of Art was subsequently merged with the art department of North China University's Academy of Literature and Art. The latter was a Communist-dominated arts institution, formed from the original Lu Xun Academy of Art and other base area art organizations and schools which had joined together

prior to 1949. Beiping College of Art was re-named the Central Academy of Fine Art in November 1949.[28] Hangzhou State College of Art was also renamed the East China Campus of the Central Academy of Fine Art.[29]

Upon taking control of the two establishments, the authorities began to carry out a series of reforms. As a first step, Party groups were set up to work within them. Although Xu Beihong was appointed Principal of the Central Academy of Fine Art, administrative authority in reality lay with an inner circle of five Party members. The five, Hu Yichuan, Wang Chaowen, Luo Gongliu, Jiang Feng and Zhang Ding, were all old members of the original Lu Xun Academy of Art.[30] At Hangzhou, the nominal head was Liu Kaiqu but, again, decision-making was left largely to the two Vice-Principals, Ni Yide and Jiang Feng, both Party stalwarts. A Party group with Jiang Feng as head was also set up and this further ensured that control of the college would remain firmly in the hands of the authorities.[31]

Though most professors and teachers were retained in their posts, there were immediate attempts to alter the educational orientation of the two establishments. A statement issued by Jiang Feng indicated the new direction for art education. He made it clear that the basic guidelines to which all art educational establishments should adhere had been set out in Mao's Yan'an Talks, and that accordingly art was to "serve the workers, peasants and soldiers, and should be closely associated with revolutionary practice."[32] A set of regulations drawn up in 1951 by Jiang for the East China Campus of the Central Academy of Fine Art provided further details of the comprehensive range of principles to be applied to art education. The colleges were expected:

> *[to adopt] educational methods which combine theory and practice, to cultivate middle- and high-ranking artists of talent who have a revolutionary world outlook and a revolutionary artistic outlook, and who have attained a certain level of artistic skill to meet the needs of the new democratic construction, to carry out political and ideological education in accordance with Marxism-Leninism-Mao Zedong Thought, to eliminate feudal, compradore and fascist anti-revolutionary thinking, to establish a scientific outlook and scientific methods, to develop thinking that is patriotic and directed towards serving the people, and to carry out education in art theory and practical skills using realism and China's [own] national and revolutionary art.*[33]

The curriculum was re-arranged and teaching methods modified. Art practice was taken as the cornerstone, with realism as the main creative

style. Students and teachers were sent to factories, villages and army barracks to "observe and learn from real life" (*tiyan shenghuo*) and collect materials for their work. For both teaching and creative work, the guideline was to be "the political criterion first, the artistic criterion second". In addition, as art was now based on the "needs and likes of the people", students were to focus on more "popular" art forms, such as New Year pictures, picture-story books, propaganda posters and portraits of leaders. During practice sessions, attention was to be paid to sketching, a method popular in the old liberated areas, because it had a strong illustrative quality. It had the advantage of being mastered quickly and easily by students, and was well-suited to propaganda work.[34] Many aspects of the old curriculum came under attack. The teaching of traditional Chinese painting was criticized for allowing "self-expression", encouraging "ink play" and ignoring realistic themes. Several traditional Chinese painters found themselves inexplicably removed from their teaching duties. Pan Tianshou, one of China's most renowned flower-and-bird painters of modern times, was stripped of his title of Associate Professor and his salary lowered. He was relieved of his teaching duties at the East China Campus of the Central Academy of Fine Art, and was instead placed in charge of amongst other things the traditional Chinese paintings in the College's research room.[35] Western painting, regarded as being influenced by "western avant-garde artistic ideas", was also criticized for running counter to Party policy.[36]

Students from the ranks of workers, peasants and soldiers were actively encouraged to attend art colleges in order to change the composition of the student population, which traditionally had comprised predominantly those from a professional background. As a consequence, the percentage of students from lower socio-economic backgrounds increased every year from 1949 with the introduction of this policy of positive discrimination. The authorities' aim was to train art cadres from suitable social backgrounds to take charge later of the various art establishments. During 1950, fifty individuals attended the Central Academy of Fine Art for short courses specially organized for them.[37]

From these reforms it was clear that the authorities were determined to exert influence on all aspects of art education. They placed their most reliable and active supporters in key positions of authority and insisted that

only art designated as politically desirable should be taught whilst anything else should be criticized and rejected. Lastly, through the selection and training of art students, teachers and cadres from a politically acceptable class background, they aimed to ensure the continuation of left-wing policies in the art academies and colleges.

The setting up of these organizational structures gave the state unprecedented control over all areas of artistic endeavour, and radically altered the conditions under which Chinese artists had traditionally operated by providing an all-embracing framework within which they were forced to work. However, politicized organizational structures could not, in themselves, guarantee comprehensive control of the art world. In addition, an ideological scheme and an ideological mechanism were necessary for Party principles and policies to be re-interpreted in terms of art theory and applied to the process of artistic creation.

The ideological scheme as the theoretical framework for artistic creation

The ideological scheme formulated by the authorities constituted the basic theoretical framework for all aspects of cultural activity. At its centre was the concept of new socialist literature and art, which was propounded at Mao's Yan'an Talks, and which consisted of a definition of the social function of the arts. This idea did not, in fact, originate with Mao, but had its roots in Marxist theories of art as developed by the early Russian Marxists, such as Plekhanov and Lenin, and Chinese Marxists, in particular Qu Qiubai. During the late 1920s and early 1930s, questions on the essence or fundamental characteristics of art, as well as its class nature, were explored by Qu. He stated the Marxist view that art, as a form of social ideology, belonged to the superstructure and reflected and was influenced by social relationships based on economic production. In turn, art exerted an influence on social relationships.[38] He also confirmed the orthodox Marxist theory of "no art for art's sake", and asserted that art was an important tool in class struggle. In his view art should serve the masses, or more specifically, "craftsmen, the urban poor and peasants".[39] Later, at Yan'an, Mao was to replace these three categories with his own — the

workers, peasants and soldiers. Qu, like other left-wing writers, through his translations of Russian and Soviet theoretical works and his own essays, became a bridge between the Marxist theory of art as understood in the West and the Chinese version as ultimately formulated in Mao's Yan'an Talks. According to one Chinese scholar, Mao's ideas on art for the workers, peasants and soldiers was the logical development of the Chinese proletarian art movement pioneered by Qu Qiubai and other left-wing writers and artists.[40]

The practical consequence of the new policy meant that after 1949, most art tended to fall into one of three main categories according to political content. These categories were:

(1) Art that glorified Party leaders and Party history, with titles such as *Founding Ceremony* (oil painting by Dong Xiwen)[41] (Fig. 1), *A Portrait of Chairman Mao* (sculpture by Liu Kaiqu), *The Memorial to the People's Heroes* (sculpture by Liu Kaiqu *et al.*), *Fang Zhimin in Prison* (woodblock print by Zhang Huaijiang), *Crossing the (Yangtse) River* (woodcut by Gu Yuan) and *Railway Guerillas* (picture-story book by Han Heping).

(2) Art promoting specific Party policies. The editorial of the first issue of the official publication *People's Art* called upon artists to do their utmost to portray the new China, and promote the political programme formulated by the Chinese People's Political Consultative Conference in 1949.[42] The first edition of *Fine Art* in 1954 reported on a meeting held by the Artists' Association specifically to support the "general Party line during the transitional period",[43] which amounted to a call to artists to reflect current policies in their work. Almost every issue of *People's Art* and *Fine Art* between 1949 and 1956 included articles exhorting artists to study particular policies and then, by means of their work, help the authorities convey these policies to the general public. One of the numerous examples was a book entitled *Illustrations on the Suppression of Counter-Revolutionaries* produced in 1952 during the movements against the "three evils"[44] and "five evils".[45] The book, which depicted in pictorial form the regulations for the suppression of counter-revolutionaries, sold as many as ten million copies.[46]

(3) Works of a more general political nature or those depicting socialist heroes or the workers, peasants and soldiers. Even those with no obvious association with the workers, peasants and soldiers, or any overtly political

theme in their title, such as *The Adventures of San Mao*[47] by Zhang Leping, could still be considered of political value. The *San Mao* cartoon-story book was not originally conceived as a political work, yet it was considered by the authorities as acceptable because it condemned the old pre-1949 society and positively supported the new system.[48] Other examples of works in this category are Ye Qianyu's oil painting *The Uniting of All the Peoples (of China)*, Zhang Songhe's sculpture *Militiamen*, Deng Shu's New Year painting *Defending Peace* and Li Keran's New Year picture *A Labour Model Visits the Park*. We can see from these titles that the content of many works of art had been imbued with strong political overtones. However, although correct political content was the primary consideration for the authorities, they could not afford to ignore the aesthetic dimension if art was to be successful as propaganda. They therefore came up with a formula that was to became a central tenet of the new socialist art, namely, a "unification of revolutionary political content and the most perfect artistic form possible".[49] The question for artists and Party ideologues in charge of art was, how exactly was this aim to be achieved? What was the most appropriate way of unifying content and form in a highly politicized cultural context? The authorities' demand that art should primarily be a reflection of current policies inevitably limited the range of themes that artists could incorporate into their work. This did not, of itself, necessarily mean that such work would automatically be aesthetically disappointing. We only have to look at European religious painting and Chinese landscape painting to find that, even though the same themes were re-worked many times over hundreds of years, such painting was still able to engender in the viewer strong feelings of inspiration, spirituality or tranquillity. However, when artists, even very talented artists, attempted to portray the new socialist China in the "most perfect artistic form possible", the results were rarely successful, aesthetically. This must at least partly be due to the fact that whereas the individuals who produced the great religious and landscape paintings were steeped in the cultural traditions and values they were trying to convey; in other words, they believed in what they were trying to paint, in the early years of the People's Republic most artists had, at least initially, an extremely poor and superficial grasp of Marxism, a foreign system of thinking artificially grafted on to Chinese soil. How were they to express something they did not necessarily understand, did not

necessarily feel committed to? When these artists were forced to express something they did not wholly understand or believe in, they tended to fall back on standard, formulaic conventions, which rendered their work dull and lifeless, more political propaganda than art.

Although this problem was encountered by artists working with virtually all art media, I focus here on three areas of particular concern for the Chinese art world in the 1950s, these being popular or folk art, traditional Chinese painting and western art.

Popular or folk art

The issue surrounding popular or folk art was how to combine revolutionary or political content with highly stylized folk art forms[50] that were popular with and easily understood by the masses, including illiterate peasants. Here, we shall take the interesting example of the New Year picture (*nianhua*) to highlight the problems faced by folk artists.

The New Year picture was one of the most important Chinese folk art forms. Although originally intended for the urban gentry and merchant families,[51] since the setting up of the first print workshops more than three hundred years ago it had become a genuine art of the people, closely associated with the events of ordinary life, particularly in the countryside. The forms of the traditional New Year pictures and the techniques used to produce them had been developed and become highly stylised over several generations. The New Year picture images were usually taken from pattern books and reproduced using woodblock printing methods.[52] The pictures were generally characterized by large areas of unmodulated primary colours, diffuse perspective and standardized or formal compositions.

Their traditional content can be divided into five main categories.[53]

(1) Good luck messages:

> *All one's heart desires year after year*
> *Health, wealth, happiness and a long life*
> *An abundant harvest of all food crops*

(2) Popular stories concerning particular individuals:

> *The foolish son-in-law visits his father-in-law*
> *Yang Guifei after bathing*

(3) Popular stories based on mythical characters — deities, immortals, fictitious animals with amazing powers, and so on:

Journey to the West
Eight Immortals cross the sea

(4) Traditional Confucian values:

Twenty four exemplars of filial piety
The three obediences and the four virtues

(5) Traditional gods:

The door gods
The kitchen god
The earth god

From these five categories, we can see that, traditionally, New Year pictures consisted of symbolic pictorial representations of the aspirations, dreams, moral principles and religious beliefs of the Chinese people. They were an expression of a popular collective consciousness and value system developed over many years. In presenting Chinese social life and aspirations in artistic terms, they had strong associations with social behaviour and social relations, becoming, in one sense, an integral part of social ritual. They thus had deep roots in Chinese social consciousness, and were the only examples of art work to be found in many peasant homes.[54]

The Communists had been aware of the importance of New Year pictures at an early stage, and at Yan'an these pictures were used on a wide scale from 1942 for political purposes.[55] After 1949, of all the various art forms, they again attracted special attention, representing as they did one of the most popular and effective means of disseminating political messages. In November 1949, Mao personally authorized the issuing of a document called "Directive of the Cultural Ministry of the Central People's Government on Launching New Year Picture Work".[56] The document claimed that in pre-1949 Chinese society, New Year pictures had been used as a medium to convey "feudal ideas and concepts". Therefore, it was important to reform them and create a new type for the purpose of educating the people. The document defined the new themes that were to be used in New Year pictures for the following year as being "the birth of a new China", "the great victory of the people's war of liberation", and "the

life and struggle of the ordinary labouring people". It advised cultural and educational organizations to encourage artists to create New Year pictures, implicitly acknowledging that there was some reluctance on the part of many urban-based artists with a high level of cultural sophistication to engage in work involving an art form usually considered as little more than a rural craft.

The document also encouraged art organizations to cooperate on projects with older and well-established New Year picture painters and, in fact, all folk artists, who were to be given material assistance and help in adapting the traditional forms with which they were familiar to the new political requirements. Finally, it called for the expansion of retail outlets for New Year pictures and other folk art forms, such as small shops, bookstalls and street pedlars.[57] By these means the political message contained in the pictures could reach a wide audience. Certainly, the new government seemed to have had a degree of success in terms of the sheer numbers of pictures and other folk art forms produced in the years immediately following the founding of the new Republic. After 1949, initially only one of the firms producing New Year pictures that had been operational before liberation, Xiecheng, was able to resume production, with the help of the central authorities and the Tianjin branch of the Artists' Association. By 1950, it had produced 400,000 copies of 14 types of new New Year pictures.[58] Two years later, the circulation figure for New Year pictures, produced by Xiecheng and a network of newly-established firms, was 40 million copies.[59] By 1953, the total circulation nationwide of New Year pictures, picture-story books and propaganda posters had reached a staggering 180 million copies.[60]

Shortly after the issuing of Mao's document, the February 1950 edition of *People's Art* published four major articles on the question of creating modern New Year pictures by reforming their traditional content. In fact, throughout the early 1950s, discussions on New Year pictures and folk art forms in general held a prominent position in official arts magazines.[61] In 1950 and again in 1952 New Year picture competitions were sponsored and organized by the Ministry of Culture, and several exhibitions were held.[62] The increased emphasis on the pictures by the authorities resulted in many artists, such as the traditional Chinese painter, Li Keran, and the woodcut artist, Lin Gang, switching temporarily or permanently from their usual

work to the painting of new style New Year pictures. A report written in 1953 even asserted that the production of woodcuts fell significantly in the early 1950s because woodcut artists were diverted from their usual occupation to produce New Year pictures instead.[63]

During the War against Japan, in both the Communist base areas and the areas under Guomindang control, efforts had been made to utilize the New Year picture for propaganda purposes. Lai Shaoqi in the Guomindang-held areas, for example, had helped produce *War of Resistance against Japan Door Gods*.[64] At Yan'an, initial attempts to use the New Year picture as propaganda were hampered by a failure to reform its traditional conventions, which caused artists to become "prisoners of ready-made concepts, metaphors and social values."[65] Difficulties were increased by the attitude of the educated urban artists who often found the traditional New Year picture "backward and repulsive".[66]

After 1949, the authorities continued to be aware of the need to reform the New Year picture. As Wang Chaowen, art critic and influential member of the Artists' Association, stated in 1950:

> *We cannot and should not deny the advantages of old forms or old techniques, but we also should not tolerate the backwardness of the traditional New Year picture. We cannot equate people's customary sense of aesthetic appreciation with surrendering to old habits and feudal tastes … People's needs and habits have been formulated in the old society. We cannot just follow them and not try to improve them or create new forms. We must help people to form new aesthetic concepts. It is an important way to improve the New Year picture.[67]*

Of particular concern to the authorities was the traditional content of New Year pictures which they regarded as being based on fantasy, superstition and other reactionary elements. It had to be replaced by themes of more positive political significance. The political content with which the new pictures were imbued was clearly illustrated by the title of some of the most popular New Year pictures of the early 1950s, such as *Celebrate the Birth of the People's Republic of China*, *Chairman Mao Reviews the Troops*, *The Founding Ceremony of New China* and *The Peoples of China Unite!*[68]

The New Year picture's traditional form of representation, characterized by exaggerated proportions, simple patterns, vivid colour and dramatic composition, was also regarded as too outmoded for the new messages it was to convey. Its standardized mode of representation was in

direct conflict with the authorities' demand that artists should "paint from real life" and depict "the hot revolutionary struggle" and "socialist construction". Therefore, after 1949, attempts were made to infuse the new New Year pictures with more realistic techniques of representation. The traditional Chinese painter, Shi Lu, in his report summarizing the work being carried out in the Shaan Gan Ning[69] area in 1950, commented that the new form of New Year pictures was based on classical realism, influenced by western artistic methods, though he did not go on to specify which aspects of realism this involved.[70] The majority of New Year pictures were by 1950 produced with stone plates and offset lithography, rather than the wood-blocks traditionally used by the peasants and the Communists in the old liberated areas.[71] These methods produced a stronger and clearer definition of line and a more refined image, and may have been considered a more appropriate vehicle for a formal realistic style.

However, these reforms of the New Year picture still failed to resolve the difficulties artists had been experiencing since Yan'an over how to utilize this traditional art form to convey a political message convincingly. Before long, the authorities themselves began to notice that there was still much room for improvement. They complained that many New Year pictures were "neither fish nor fowl", and that artists had not succeeded in fundamentally altering the old content and form of the pictures. Vivid examples of this were cited: traditional pictures of the God of Fortune and the Four Heavenly Kings were now being used to depict People's Liberation Army heroes, with the result that the soldiers were beginning to look like the old God of Fortune; a political banner with the slogan "Support Chairman Mao" was simply added to the traditional representation of the "Three Gentlemen", Happiness, Wealth and Longevity; features of the traditional image of the door god were incorporated into the depictions of workers, peasants and soldiers.[72] Wang Chaowen criticized in particular a New Year picture of Mao, titled *We Are Together with Chairman Mao* (Fig. 2), which even appeared in Hong Kong in the Communist-supported newspaper *Dagong bao*. Not only did it portray the workers, peasants and soldiers surrounding Mao as caricatures but it also represented Mao himself with an inordinately large head and a small body. Wang complained that it had produced a cartoon-like effect, making Mao look foolish through its "distortion of the people's leader".[73] Shi Lu, in his report from the Shaan

Gan Ning area, also had to admit that despite efforts to incorporate a measure of realism into the New Year pictures, the images portrayed were far from "realistic", with the workers not looking like workers, and the same being true for peasants and soldiers.[74]

The failure to reform traditional New Year pictures successfully was in part acknowledged by Cai Ruohong at a meeting in 1954 held specifically to discuss them. In his speech, called "When Creating New Year Pictures, Artists Should Make Full Use of the Good Traditions of Popular New Year Pictures"[75], he pointed out that, according to the opinions of peasants and workers, most of them were dissatisfied with the new style of New Year pictures. When asked what they disliked and approved of in the pictures, the replies they gave revealed a continuing appreciation of those features most closely associated with traditional pictures. They did not want to look at anything considered unlucky, unintelligible or devoid of bright colours. (Shi Lu had acknowledged that because of printing difficulties and the need to keep costs down, only light washes of red, yellow or blue colour tended to be used in the new New Year pictures. This lack of bright colour and an insufficient variety of colours was deemed by him to have affected the general quality of the pictures.[76]) Amongst the opinions voiced, there was no word against any of the "feudal" or "superstitious" elements so disapproved of by the authorities.

The five themes positively welcomed by the workers and peasants comprised "the rivers and mountains of the motherland", a growing family, a happy marriage and family life, technical knowledge related to production, and scientific knowledge. Of these, only the last two could be regarded as having strong political overtones, whilst the other three were typically traditional subjects. After five years of Communist rule, it appeared that workers and, in particular, peasants were still clinging to their own cultural heritage. It seemed that the new style of New Year pictures had at this stage largely failed to win them over.

Traditional Chinese painting

Policies towards traditional Chinese painting gave rise to the same kind of contradiction as that facing the reform of the New Year pictures, and to some extent the problem was even more acute. Traditional Chinese

painting (*guohua*) was regarded by the authorities as being at the opposite end of the social spectrum to folk art, and it was looked upon as an elite art form far removed from the lives of ordinary people. Over the centuries it had been developed and refined exclusively by the literati or scholar-official class and was thus considered by the Communist authorities to be an expression of an elitist world view. It was produced by the brush and ink method, and consisted primarily of landscapes, flower-and-bird painting and figurative painting, none of which accorded with the authorities' requirements that art should reflect "the struggle of the workers, peasants and soldiers".[77] Flower-and-bird painting was particularly inappropriate for conveying political ideas. In addition, one of the most common styles of traditional Chinese painting, the *xieyi* style or freehand brushwork charac-terized by vivid expression and bold outlines, lacked many elements of classical realism, such as single-point perspective and dissection, which were being increasingly favoured by the authorities.

At Yan'an there appear to have been no major debates on the relative merits and defects of traditional Chinese painting. The Communist Party at that stage concentrated largely on utilising folk art forms which were simple and economical to produce and which held the greatest appeal for the local people. In addition, the vast majority of traditional Chinese painters remained within the Guomindang areas, far from the revolution-aries at Yan'an. After 1949, the authorities had to deal with a sizeable group of traditional Chinese painters and formulate some kind of policy towards them. Once again, it was Mao's pronouncements in 1942 that formed the basis for this policy.

At Yan'an, Mao had declared that "tradition was to serve the present", and he had called for a "pushing out of the old to bring out the new".[78] Both of these slogans advocated a critical assimilation of those aspects of traditional Chinese art which could be usefully adapted to the new politi-cal requirements. These observations of Mao's were taken as the basic guidelines for the reform of traditional Chinese painting, but they offered no real insights as to which aspects of traditional Chinese painting should be considered as "feudal dregs" and which as "fragrant flowers". This problem, which in many respects was the continuation of the contro-versy that had been going on since the turn of the century over how best to reform traditional Chinese painting,[79] thus became a major issue of

debate in the official organs of the Artists' Association, *People's Art* and *Fine Art*.

On the issue of the reform of traditional Chinese painting, artists and art critics could be divided into two main groups. The first group, which may be termed the "reformers", overwhelmingly comprised figures from the Yan'an days, who had been influenced by art practice in the Soviet Union, which was based on nineteenth century European realism. They tended to be advocates of the reform of both the content and techniques associated with traditional Chinese painting, arguing that a unity of technique and content was required to produce a complete and effective work of art. As the portrayal of a new socialist life in China required new themes, so would it need new forms.

Li Hua, a veteran woodcut artist who was then an executive committee member of the Artists' Association, asserted that a precondition for the reform of traditional Chinese painting was the expunging of the "literati ideas and concepts" that governed it. According to Li, this could only be achieved if there was a fundamental change in artists' thinking, causing them to reject many aspects of their cultural traditions and embrace a new system of values based on political criteria. He stated bluntly that landscape and flower-and-bird painting had no place in the new era and that traditional aesthetic principles like *qi yun* or "breath resonance",[80] which had formerly comprised integral components of traditional Chinese painting, should not be pursued as ends in themselves:

> Breath resonance, brush and ink and other manifestations of formalism … are no longer the directions pursued by artists. Painting should express collective life and the thoughts and feelings of "the people", so it must be realistic. Expressing the truthful, the ideological and the educational aspects of reality constitutes the highest realm of art. Thus, landscapes, flowers-and-birds and the "Four Gentlemen" have no scope for development.[81]

Li suggested that traditional Chinese painting should be reformed by painters incorporating "Socialist Realist content" into their work.[82]

In Cai Ruohong's view, if traditional Chinese painters used only traditional methods to depict socialist life, it would result in a weaker, less dramatic expression of the subject and thus reduce its impact. He advised that painters should develop new techniques to deal with themes previously untouched, suggesting, like most "reformers", the adoption of

"realistic" (i.e., scientific) methods to force traditional Chinese painting out of its impasse. His recommendation was greater focus on the training technique of *xiesheng* or painting or sketching quickly on the spot[83] (a technique often employed by western landscape artists).

Another "reformer", Hong Yiran, encouraged painters to do their utmost to create new forms, citing the artist Shi Lu as a good example of someone who, although a relative newcomer to traditional Chinese painting (he had originally been trained as a woodcut artist), had been experimenting with new painting techniques.[84] Shi Lu was regarded as a leading reformer of traditional Chinese painting in the early 1950s, together with Jiang Zhaohe.[85] Both had been attempting to infuse their work with techniques more commonly associated with academic oil painting, such as modelling and single-point perspective[86] (Fig. 3).

Of special significance were the views of one of the most powerful figures in the art world, Jiang Feng, who made it clear that he believed it was extremely difficult for traditional Chinese painting to portray socialist life without major changes in its content and modes of representation.[87]

The second group, the "conservatives", included several of the most prominent traditional Chinese painters, such as Fu Baoshi, as well as many lesser-known artists.[88] They organized a counter-attack against the "reformers" by accusing them of ignoring or rejecting China's cultural tradition and of blindly worshipping the West. They went to great lengths to stress the historical importance and aesthetic values of traditional Chinese painting, showing little inclination to alter its basic forms. Mo Pu, for example, argued that in depicting human figures and landscapes, traditional Chinese painting had its own unique qualities, because "with a few simple brushstrokes, one can at the same time depict the characteristics and spiritual state of the object."[89] The prawns of Qi Baishi and all of Shi Tao's work were cited as vivid illustrations of this point. Mo Pu then went on to refute the most serious charge laid against traditional Chinese painters by the "reformers" — that it could not portray "real life" because it was lacking in scientific method. He stated:

> In traditional Chinese landscape painting there is the use of heavy and light layers of ink to depict various kinds of scenery and to convey a sense of vast space. In figure painting, [we] use simple lines to depict different qualities of the human form,

something that can be clearly seen in the figures at Dunhuang. Therefore, the people who claim that in comparison with traditional Chinese painting, western painting is so much more rational and scientific, and say that the former has no perspective, no dissection and no genuine colour are actually basing their arguments on an ignorance of the true essence of traditional Chinese painting methods.[90]

Pan Tianshou echoed this view when he stated:

If we use western techniques such as the method of light and shade in traditional Chinese painting, it will obscure its unique beauty of line. Traditional Chinese painting methods encompass the unification of form and soul. Any compromise will weaken its unique nature and decrease its brightness.[91]

This polarization of views was eventually acknowledged by the art authorities, who admitted that the main contradiction in traditional Chinese painting was that of form and content. Zhang Ding, deputy head of the Central Academy of Fine Art, observed that traditional Chinese painting had a long history and a highly stylized and sophisticated form, but these facts had caused it to become remote from reality and the demands of the people. He claimed that the problem of how to overcome the limitations of this art form in portraying the new life in China had become so acute that most people had either maintained a conservative stance and opposed any kind of reform, or gone to the other extreme and denied tradition totally. Though Zhang criticized both tendencies, he was unable to provide any credible solution to help resolve the contradiction.[92] Similarly, Zhou Yang, the Party ideological chief in charge of cultural affairs, in a speech to the Artists' Association, also acknowledged the existence of two opposing attitudes, one conservative and one "nihilist", towards China's cultural heritage. Though he too criticized both as being harmful, he revealed his own uncertainty over how traditional Chinese painting should be practically reformed in his nebulous idea that artists should "inherit a realistic spirit" and "possess an affinity with the people".[93]

As pressure for its politicization continued, traditional Chinese painting began to be forced to accommodate such themes as "The Newly Constructed Office of the Red Star Collective Farm", "Striving to Sell Surplus Grain" and "Always Be on Your Guard". However, the contradiction that had been highlighted in the discussions on the reform of traditional Chinese painting was already becoming manifest in some of the work produced. Arnold Chang, in his assessment of a traditional Chinese

painting, *The Liberation of the Great Southwest Leads the Troops Onward* (1951),[94] described it thus:

> The landscape is painted in the conventional Chinese manner; the scene is divided into three parts, foreground, middleground and background. The brushwork and light colouring are reminiscent of Ming dynasty works; the handling of the buildings, rocks and clouds is sensitive and accomplished. But the treatment of the figures and horses and the bright red banners and flags is more like the type of outline and colour drawing employed in nien-hua (New Year pictures). These two types of representation seem totally incompatible in this work. In addition, the artist has made no effort (or if he has, he has not succeeded) to reconcile the traditional three distances of the Chinese landscape with the linear perspective required for accurate portrayal of the figure grouping. The result is a terribly unconvincing recession into depth and a confused distortion of scale. One feels that this artist is caught between two worlds, but is still a good deal more comfortable in the old one than in the new.[95]

Similar problems were also apparent from a major review of the First National Exhibition of Traditional Chinese Painting held in Beijing in 1953, in which it was pointed out that the task of trying to use the old form of traditional Chinese painting to express life "realistically" was causing difficulties. Attempts by traditional Chinese painters to utilize certain western painting methods were also deemed unsatisfactory. The review particularly mentioned landscapes which appeared to have figures grafted on to them. The background landscape was clearly traditional in style, but, it was claimed, the figures in the foreground had been produced using western painting techniques and thus gave the impression that they were figures cut out from elsewhere and simply affixed to the original landscape. The review commented that even the work of Jiang Zhaohe and Shi Lu needed improvement because the faces in their paintings looked dirty and unnatural due to the incorrect application of western painting techniques. It ended on the gloomy note that after four years of debate and artistic practice with no real results, the question of how best to develop a new style of traditional Chinese painting still remained.[96] Perhaps a solution could be found by altering the basic form, but if this were done, "Would that really be traditional Chinese painting or western water-colour painting?"[97]

As a final point, it should be noted that not all traditional Chinese painters were forced to compromise over their work by attempting to politicize it. Several of the more prominent painters in particular, like Qi

Baishi and Yu Fei'an, were relatively unaffected by the new political climate. Even the commemorative paintings they were on occasions asked to produce usually consisted of representations of traditional subjects such as flowers or birds. They were tolerated by the authorities because they were seen as the main upholders of China's "artistic heritage", about which the authorities were to remain ambivalent over the next few decades. On the one hand, traditional Chinese painting was regarded as an art of the Chinese social elite; but, on the other, it was also a symbol of the sophisticated brilliance of Chinese culture and, therefore, a matter of national pride. At a time when the new government was striving to establish its political legitimacy throughout the country, it could not afford to be seen adopting a nihilistic attitude towards traditional painting. For this reason, although some traditional Chinese painters were badly treated after 1949, and most were either passively discouraged from continuing their work by being denied public spaces to exhibit[98] or actively encouraged to adapt it to the new political requirements, a small group of renowned painters were left to continue to produce, exhibit and publish paintings in their own personal style.

Western art

Debates had taken place amongst Chinese artists on the relative merits of western art since the turn of the century and particularly after the May Fourth Movement. The question asked had been the same as that of traditional Chinese painting — which aspects of western art were worth adopting to revitalize Chinese art and which aspects should be disregarded. Many artists had travelled abroad to study art in Europe and had then returned to China to pass on their knowledge and expertise to students at home.[99]

At Yan'an the situation was complex. Many of the woodcut artists had been heavily influenced by Europeans like Kathe Kollwitz and Frans Masereel and a few had interests in modern western oil painting styles, particularly impressionism. At the same time, the Soviet Union's adaptation of European academic realism for its own political purposes in the form of Socialist Realism was an idea beginning to gain ground. In 1942, however, most experimentation in purely western art forms came to an

end, with Mao's push for the "sinification of Marxism" and a search for local solutions to local problems.[100] In art, as we have seen, this involved concentrating on folk art forms that appealed to the Chinese peasants, rather than imitating foreign styles which the peasants were said to have largely disliked.

Nevertheless, at Yan'an Mao had not totally rejected the possibility of utilizing aspects of western art as long as they could be shown to be useful to the Communist cause. His concept, "foreign things to serve China", dictated that all elements of foreign culture were to be analysed and divided into the "cream" or "best" and the "dross" or "dregs". The dross was to be rejected and the cream retained to serve the new situation.[101]

After 1949 the art authorities, on the basis of these rather vague guidelines, defined what was worth saving in western art and what had to be rejected, and in so doing formulated a set of basic policies. What they decided to adopt was essentially classical realism and, in particular, the form it had taken in the Soviet Union, Socialist Realism. In the first issue of *People's Art* in 1950, an article written by Jiang Feng on Italian Renaissance painting linked classical realism with the stage of capitalist ascendancy in the West and affirmed its progressive nature.[102] In fact, almost all articles on western art in official publications after 1949 were concerned with either classical realism or Soviet Socialist Realism. The only modern western art published tended to be work that embodied strong elements of realism, as exemplified by a feature on a selection of French, Italian and American modern woodcuts. As Jiang Feng pointed out, "Although the cutting method and style of these works are diverse, nevertheless they all take as their starting point the requirement to express a real or true image."[103]

Most modern western art was, however, criticized as decadent and reactionary and totally unsuited to portraying life in Socialist China. It was labelled as being associated with the declining stage of capitalism, and branded at the theoretical level as "formalism" (*xingshi zhuyi*).[104] Using Mao's analysis of acceptable and unacceptable western art, the authorities criticized Chinese artists whose work betrayed signs of supposedly undesirable tendencies from abroad. Lin Fengmian and Pang Xunqin, the most prominent representatives of the so-called "new-style painting" (*xinhuapai*), based on modern western art styles,[105] at the East China

Campus of the Central Academy of Fine Art in Hangzhou, were forced to make self-criticisms. Lin admitted: "The road I previously took was wrong and this has been a bad influence on my students,"[106] whilst Pang confessed: "I also advocated the new-style painting but today I must put into practice the new teaching principles. I hope I can redeem my errors."[107]

Impressionism was singled out for particular criticism because, of all the modern and contemporary western styles of art, it was, and had been since the 1920s, one of the most popular among Chinese artists, and its emphasis on light and colour to the exclusion of all else meant that form took precedence over content, something to which the authorities had always been directly opposed. It was, therefore, dismissed as being essentially a "formalistic method guided by subjectivism".[108]

Socialist Realism and its philosophical basis

In 1951 Zhou Yang stated that China "must learn from other countries and especially from the Soviet Union. Socialist Realist literature and art are the most beneficial spiritual food for the Chinese people and the broad ranks of intelligentsia and youth."[109] In the following years, there was a continuous stream of pronouncements on the importance of Socialist Realism, such as that made at a meeting called by the Ministry of Culture in July 1955, emphasizing the theoretical principles of Socialist Realism as they applied to art.[110]

The Marxist view of art is based on the theory of reflection (*fanyinglun*), consisting of two components.[111] These two components were originally part of two different philosophical approaches, both of which were major influences on Marx. The first is the material (mechanical) realist approach adopted by the eighteenth century French Encyclopaedia School and the empirical tradition in western philosophy, closely associated with mechanical science and mathematics, and, in art, with various scientific techniques such as perspective and shading. The aim of such art is to produce a scientific likeness of the material or external world, or to produce a mirror-image of objective existence or reality.[112] The second approach is objective idealism, based on Plato's Universal Form[113] or Hegel's Abstract Categories or Absolute Ideas.[114] This approach takes the ideal world as the essence or foundation of the world we live in.

Abstract ideas and concepts constitute the foundation of practical existence. They have a transcendent or independent existence external to the individual subjective faculties. One example of this which is relevant to the realm of art is the concept of Beauty. In objective idealism, Beauty is not "in the eye of the beholder", but exists as a set of absolute criteria that determine an object as being beautiful, regardless of subjective perceptions. Objective idealism is in one way similar to the materialist approach in that it aims to project a mirror-image of the world, but of the ideal and not the material world.

Socialist Realism is a synthesis of these two approaches. If we look at Socialist Realist art we find aspects of it that clearly indicate a reflection of the material world in its representations of peasants, workers, factories and farms, and in the predominance of work with a strong plot or story-line. But we also find that it embodies idealized elements, dramatic composition, the liberal use of bright colours (particularly red), and so on. Marx himself indicated that it is these two factors which constitute the foundation of Socialist Realism, the aim of which is, "to reflect life truthfully according to real social content and … evaluate life from the heights of Communist ideals."[115]

The theory of reflection obviously entails an over-emphasis on the cognitive dimension of art, since one must first and foremost have an understanding of the external world (as well as knowledge of a host of relevant abstract principles) if one is to depict it competently. A major consequence of this emphasis on the cognitive element is the overriding importance in artistic work of content, using standard forms according to fixed "scientific" criteria. This approach can be seen in the work of some Russian and Soviet theorists, most notably Belinsky, which led them to the conclusion that the difference between art, science and philosophy is only in their outward forms, their content being fundamentally the same, sharing as they do the same basic principles.[116]

Socialist Realist art in China

Chinese Socialist Realism had its antecedents in Soviet Socialist Realism, which was formally adopted by the Soviet Union in 1934 once Stalin had managed to bring cultural activities firmly under his control. Soviet

Socialist Realism as it applied to art was based on the late nineteenth century Social Realism of Ilya Repin and his colleagues, who were collectively known as the *Peredvizhniki* or "Wanderers".[117] They in turn had based their work on the formal realism of the European academies, infusing it with themes of human poverty and degradation, which reflected their own sense of social responsibility. Socialist Realism adopted the formal aspects of the "Wanderers" paintings, but its content was based on the Communist ideals of which Marx wrote.

Similarly in China, Socialist Realist works were to be used for "combining the reality of today with the ideals of tomorrow."[118] A good definition of what a work produced in the Socialist Realist style might look like was given by Ellen Johnston Laing in her seminal book *The Winking Owl*:

> For figural subjects, the principal individuals are placed at or near the center of the composition, they usually are highly colored and detailed, and they often are spotlighted with natural or artificial light.... Attention is focused on the main figures not only by their central location in the composition, by the color and lighting, but also by their placement at the apex of a triangular ground plane the diagonal sides of which are formed by lesser figures or by objects.... In landscapes a common feature ... is a serpentine or curving line of figures curling into the distance with the figures diminishing in scale as they recede.[119]

It should be remembered, however, that by no means all the art produced after 1949 was in the Socialist Realist mode. It tended to be reserved mainly for oil painting (Fig. 4) (which like Socialist Realism itself was a western import), and to a lesser extent for New Year pictures and other folk art forms, and infrequently for traditional Chinese painting.

The introduction of Socialist Realism into China after 1949 was facilitated by the initial contacts Chinese artists had with western art during the early twentieth century. Several artists influential in the newly-established Artists' Association and art academies, such as Xu Beihong and Liu Kaiqu, had studied the methods of academic realism in Europe in the 1920s and 1930s. As both academic realism and Socialist Realism are normative-based, it was relatively easy for these artists to switch from producing nude studies and paintings of still life to those depicting Party leaders, smiling peasants and workers.[120] In addition, Xu Beihong, as head of the Central Academy of Fine Art, played a crucial role in spreading the

influence of formal realism, which comprised the foundation of Socialist Realism, throughout China's art educational establishments.

The dominance of Soviet influence

The new Chinese government looked to the Soviet Union, its ideological mentor, for guidance and material help in achieving "socialist reconstruction". This resulted in a high degree of Soviet influence in Chinese political, cultural, industrial and agricultural affairs as the Soviet Union sent advisors and technical equipment to assist its Communist neighbour.

As a consequence, prominent Soviet artists and art theorists like Alexander Gerasimov, president of the Soviet Academy of Arts, were invited to China to deliver lectures, and their Chinese counterparts, including Jiang Feng, Luo Gongliu and Cai Ruohong, were sent on visits to the Soviet Union and Eastern Europe.[121] Exhibitions of Soviet and Eastern European art in the Socialist Realist style were regularly featured in official art publications, and vast numbers of translated publications on Soviet art and art theory appeared during the early 1950s. One educational establishment alone, the East China Campus of the Central Academy of Fine Art, over a period of just four years (1952 to 1956), translated and published a whole range of Soviet books on art, such as *Soviet Plastic Arts over the Last Thirty Years* and *The Global Significance of the Soviet Plastic Arts*, as well as other publications on Soviet historical paintings, landscapes, posters, political cartoons and illustrations, altogether totalling more than eighty titles.[122]

The theoretical principles of Soviet Socialist Realism were inculcated into groups of Chinese students who attended art courses in the Soviet Union. In China, these ideas were disseminated mainly by the Soviet oil painter Konstantin Maximov, who held a training class in Beijing from February 1955 to July 1957.[123] At this class, students were introduced to the ideas of the nineteenth century Russian art theorist, Pavel Chistiakov,[124] who dictated that artists must "depict an object in such a way that it looks as it exists in the natural world and as our eyes see it."[125] This was to be achieved through laying inordinate stress on fine drawing, which was regarded as being "scientific" and "objective", and at the same time dispensing largely with colour, which was branded as "subjective".[126]

The adoption of Socialist Realism in China and the rejection of all other western schools of art inevitably resulted in extreme limitations being placed on the work of artists. Most oil paintings, and many New Year pictures, woodblock prints, woodcuts and propaganda posters became expressions of political formulae, artistic manifestations of political concepts and reflectors of "socialist reality". This resulted in oil painting in particular becoming stultified and characterized by a great deal of repetition.

Gradually, the authorities recognized the limitations and disadvantages of their restrictive policies. At a conference on the teaching of oil painting held in 1956, the Deputy Cultural Minister, Liu Zhiming, admitted that "Our oil painting still has no style. In the future we will advocate a variety of schools and styles ... the oil painting profession itself ought to have many different schools. In the arts, what has to be avoided at all costs is 'sameness'. In the future there should be a diversity of styles."[127]

Liu's comments amounted to a virtual open acceptance of the failure of the authorities' art policies with regard to the modification of western art to suit Chinese requirements. His sentiments were to be echoed many times over during the liberal period of the Hundred Flowers (to be discussed in the next chapter). Only by severely limiting the range and scope of artistic expression to an extremely narrow domain had the authorities managed to cover up temporarily the contradictions caused by their own ideological scheme. However, narrowing the options open to artists resulted in a constant re-working of a small number of political themes in the same style, leading almost inevitably to a decrease in the effectiveness of artistic works as tools for educational or propaganda purposes. The question of how to sustain the effectiveness of a work of art or how to link content and form so that in depicting important political themes the aesthetic dimension need not be sacrificed still awaited a satisfactory answer.

The political movement as a means of control

The third important factor in the relationship between art and politics in

China was the use by the authorities of political movements as an effective means of control, to affirm their ideological line and to assert their monopoly of power in the cultural field. The political movement was considered by them as a necessary manoeuvre to bring intellectuals periodically into line and it formed part of their policy of alternating periods of relaxation with repression. Relaxation allowed breathing space for some development of intellectual and cultural work within the parameters set by the authorities; repression was seen as a means of circumventing scepticism, dissent or any intellectual challenge which might threaten the ideological monopoly of the Party.

Between 1949 and 1956 there were three major political campaigns that particularly affected the intellectuals. Though originally not aimed at the art world, they eventually developed into wider movements embracing all aspects of cultural endeavour, including art. The three were criticism of the film The Story of Wu Xun (Wu Xun Zhuan) in 1951; criticism of Yu Pingbo's research into Dream of the Red Chamber (Honglou Meng) in 1954, and the campaign against Hu Feng in 1955. These political movements shared certain common fetaures, which also characterized several later campaigns. They all began from one particular event which then caused reverberations throughout the intellectual-cultural world, becoming ultimately nationwide political movements. The academic discussion surrounding them was always finally turned into a political discussion, that is to say, the intellectual debate was always made the prelude to a political movement. The method of severe widespread criticism of intellectuals was then utilized to eradicate any signs of dissent and to force intellectuals into making self-criticisms.

The criticism of the film The Story of Wu Xun

In May 1951, the People's Daily published Mao's article, "We Should Pay Great Attention to the Film The Story of Wu Xun", which became the signal for the first political movement aimed at criticizing "feudal bourgeois ideology".[128] In fact, The Story of Wu Xun was, by most standards, an unremarkable film released in February 1951, depicting a historical figure, Wu Xun, who lived during the last years of the Qing Dynasty, and who devoted his life to the cause of providing free education. The real point of

the criticism was revealed in an article in the *Literary and Art Gazette* by Zhou Yang, the title of which, "Ideas Which Oppose the People and History, and Art That Opposes Realism", gave some indication of the basic theme of the campaign. Zhou claimed that the discussion of the film concerned not only the film itself, but also all cultural, educational and social science circles throughout China. He called it a "serious ideological debate relating to two different views of history", with *The Story of Wu Xun* supposedly representing the "anti-people's view of history". Its themes and characters were condemned by Zhou as "reactionary".[129] The crux of his argument focused on the characterization of the main figure in the film, Wu Xun, and the ideas he expressed. Zhou Yang summarized them thus: "Wu Xun is depicted as a lonely idealist. He walked a long, bitter road … but this image of the loner produced feelings of respect amongst petty bourgeois intellectuals in the audience." He continued by saying that when "petty bourgeois intellectuals" failed to associate themselves with the masses, they always ended up weak, hesitant and lonely. They were faced with two alternatives — either to give themselves up to the Party and the people, or to rely on individual philosophy and struggle. He concluded: "The film *The Story of Wu Xun* leans towards the latter tendency."[130]

Clearly Zhou's main purpose was not only to criticize this film, but also, through a particular interpretation of its characters and themes, to criticize independent and individualistic tendencies among Chinese intellectuals. A few months later, a rectification movement began in cultural circles which was linked to the controversy over *The Story of Wu Xun*. In this movement, Zhou Yang and Hu Qiaomu both repeatedly advised artists and other cultural figures to reform and divest themselves of their "petty-bourgeois outlook and artistic view".[131]

During the campaign to attack *The Story of Wu Xun* and the following rectification movement, with the exception of Jiang Qing's criticism of the publication of *The Wu Xun Pictorial* (*Wu Xun Huazhuan*), few individual artists were directly implicated or involved.[132] However, the general effects of these two events on art circles were by no means insignificant. Artists who had previously objected to art being used solely for political purposes, who had objected to being "loyal court painters" (*yuyong huajia*), who had been against the popularization of art and the placing of political considerations before artistic ones, and who had strongly advocated improvements

in artistic techniques, were all said to have been severely criticized, and their "misguided tendencies" suppressed.[133] Self-criticisms were made even by prominent individuals in the art world, such as Hu Qiao and Yan Han, who admitted that their work tended towards formalism, as a result of their over-emphasis on western art, particularly its technical aspects.[134]

The main thrust of the rectification, however, was directed not so much at individuals as at art institutions, particularly the Central Academy of Fine Art, which came under attack for the "bourgeois ideology" that was said to permeate the educational policies of its leadership.[135] Because the main criticisms were directed more at institutions, most artists survived this movement relatively unscathed.

Nevertheless, in bringing art much closer to politics by forcing artists to participate actively in a political movement, the authorities were able to gain greater compliancy from artists over the demand that "art should serve politics". Though it is extremely difficult to find concrete evidence, some commentators have observed that following this movement, the number of art works directly reflecting political themes increased dramatically.[136]

The criticism of Yu Pingbo's research on Dream of the Red Chamber

In September 1954, Li Xifan and Lan Ling, two undergraduates at Shandong University, published an article in the University's academic journal *Literature, History and Philosophy* (*Wen Shi Zhe*) criticising the "idealist" views of the scholar Yu Pingbo as expressed in his research on the classical Chinese novel *Dream of the Red Chamber*. Mao Zedong, on the pretext that the *Literary and Art Gazette*, the official organ of the Association of Chinese Writers and Artists, had refused to publish the article, accused the magazine of using its powerful position to put up obstacles against those without privilege and he thus inflated the significance of the whole affair. It grew into another political campaign comparable to the furore over the film *The Story of Wu Xun*.[137] During this campaign, Mao and other Party ideologues first defined the school represented by Yu Pingbo and Hu Shi[138] in the field of classical literary research as the "idealist school", which was associated with "bourgeois" ideas.[139] Mao personally dictated the style and tempo of the campaign, and, as in the case of the previous movement, it

was also not limited to one narrow area but covered the entire cultural and social science field. Cultural and academic journals published articles attacking Yu Pingbo and Hu Shi; and in the cultural field, so-called "bourgeois idealism" became the target of attack.

Once the *Literary and Art Gazette* editorial board had, under pressure from Mao, been forced to make a self-criticism for excluding "small figures" (*xiaorenwu* — a reference to its failure to publish the original article that had initiated the campaign, written by the two students Li Xifan and Lan Ling), the editorial board of *Fine Art* also came under pressure to make its own self-criticism. Finally, it gave way and in December 1954 admitted that it had failed to be vigilant against "bourgeois idealism" in its work, to use the correct political criteria in selecting works of art to be published in the magazine, and to go all out to support and promote the younger generation of artists and art critics. It ended by saying that it would do its best to overcome all shortcomings.[140] In the same issue, in an article entitled "We Must Clear away Bourgeois Views in Art Criticism", the influential woodcut artist, Li Hua, was attacked as an advocate of idealism in art criticism.[141] An interesting point to note is that, although these political campaigns were mainly targeted against non-Party artists or intellectuals as part of the process of integrating them into the system, the campaigns almost always affected some Party art cadres, like Li Hua, who were accused either of being too lax in executing their authority over artists or of not being completely in line themselves with a particular policy.

The campaign against Hu Feng[142]

Of the three campaigns, the one against the writer, Hu Feng, was the most severe and extensive. Hu Feng and members of his so-called "clique" were not only criticized academically and politically, but their works were also labelled "poisonous weeds" and disappeared from bookstores overnight. They themselves were condemned as counter-revolutionaries and were sent to prison and labour camps or exiled to remote areas. Mao called them "a counter-revolutionary clique secretly hidden in the revolutionary camp."[143]

In addition to criticizing Hu Feng's "bourgeois idealism", Mao also emphasized the incorrect nature of one of Hu Feng's key viewpoints — "sameness in public opinion" (*yulun yilü*), which Hu had on several

occasions used to describe a lack of diversity not only in public opinion, but also in general cultural debate. In an article countering Hu's opinions, Mao put forward his own interpretation of the term "sameness in public opinion", which, he stated, meant denying counter-revolutionaries the chance to spread their views. He claimed that in a socialist system, there was only freedom of speech "among the people" (*renmin neibu*), and anyone who wanted to use freedom of speech for "counter-revolutionary purposes" would be denied that freedom and would be punished. For such people there would only be "sameness in public opinion".[144] Mao drew a line between "the people" and "the enemy" (or "counter-revolutionaries") to support his argument. However, responsibility for deciding who would be placed in which category rested firmly with the Party.

Following the issue of Mao's guidelines, the campaign against Hu Feng was extended to encompass all cultural domains. This can be seen from the table of contents in any issue of the *Literary and Art Gazette* during 1955, which mainly comprised articles criticizing either Hu Feng and his political and aesthetic ideas, or those individuals who were considered to be under his negative influence. Many articles focused on the criticism of one of his key concepts — the "subjective struggling spirit" (*zhuguan zhandou jingshen*), which embodied the idea that of primary importance to the artist was individual subjective expression.[145] This idea, which was tantamount to advocating freedom of expression, naturally posed a serious threat to the authorities' monopoly of all aesthetic ideas and creative work.

As with the *Literary and Art Gazette*, several issues of *Fine Art* in 1955 carried articles criticizing Hu Feng. The most influential artists and art cadres in the Artists' Association jointly wrote an open letter condemning Hu Feng in the strongest terms and supporting the campaign against him.[146] The July edition of the *Fine Art* reported how artists throughout China were taking an active part in criticizing Hu Feng by holding meetings, writing articles and producing cartoons. Cartoons appeared more regularly in official publications during this campaign than any other art form because they were considered to be the best vehicle for satirical attacks, particularly on "enemies of the people",[147] who were conventionally depicted as being wicked and, at the same time, laughably foolish. The message conveyed was that counter-revolutionaries might be cunning and evil, but they were no match for "the people".

Following the sometimes brutal denunciations of Hu Feng, artists were warned that they

> must learn from the experiences and lessons they have gained from this event, they must go further in recognizing the complexity and sharpness of the class struggle during the transitional period, they must overcome the liberal tendency of paying attention only to their own art work and forgetting politics. Finally, they must reinforce further their study of Marxism-Leninism, reform their thinking and closely unite around the Party.[148]

Although it is true that artists did not become major targets for criticism, the three campaigns still caused reverberations throughout the art world, most notably in terms of politicizing art discourse.[149] In addition, the term "bourgeois liberalism" became increasingly a label to fear, and artists began to be more circumspect about the views they expressed and the kind of work they produced. While the authorities may have achieved their goal of bringing artists and other intellectuals into line by purging any signs of dissent, they had also turned the cultural and artistic field into a periodic political battleground.

Notes

1. See B. McDougall, *Mao Zedong's "Talks at the Yan'an Conference on Literature and Art": A Translation of the 1943 Text with Commentary.*
2. M. Goldman, *China's Intellectuals: Advise and Dissent*, p. 9; C. L. Hamrin and T. Cheek (eds.), *China's Establishment Intellectuals* (Introduction).
3. Xinhua News Agency (ed.), *Zhonghua quanguo wenxue yishu gongzuozhe daibiao dahui jinian wenji*, p. 32.
4. Zhong Chengxiang (ed.), *Xin Zhongguo wenxue jishi he zhongyao zhuzuo nianbiao (1949–1966)*.
5. Xinhua News Agency (ed.), *Zhonghua quanguo wenxue yishu gongzuozhe daibiao dahui jinian wenji*, p. 3.
6. Ibid., p. 5.
7. Ibid., p. 33.
8. Ibid., pp. 227–234.
9. "Progressive" art refers to the art produced before 1949 in the Guomindang-held areas by artists who were not closely associated with the Guomindang and who had some sympathy with left-wing politics without becoming directly involved in Communist activities. Xu Beihong is, perhaps, the most obvious example of a "progressive" artist.

10. Xinhua News Agency (ed.), *Zhonghua quanguo wenxue yishu gongzuozhe daibiao dahui jinian wenji*, p. 234.
11. Mao Zedong, *Mao Zedong xuanji*, pp. 969–995.
12. Xinhua News Agency (ed.), *Zhonghua quanguo wenxue yishu gongzuozhe daibiao dahui jinian wenji*, p. 588.
13. Liao Jingwen, *Xu Beihong — Life of a Master Painter*, pp. 348–349.
14. Red Guard publication, *Meishu zhanxianshang liangtiao luxian douzheng dashiji*, p. 9.
15. Jiang Feng, *Jiang Feng meishu lunji*, p. 322.
16. B. Liu, *Cultural Policy in the People's Republic of China: Letting a Hundred Flowers Bloom*, pp. 26–30.
17. Zhong Chengxiang (ed.), *Xin Zhongguo wenxue jishi he zhongyao zhuzuo nianbiao (1949–1966)*, p. 5.
18. Jiang Feng, *Jiang Feng meishu lunji*, p. 323.
19. Interview with Li Xianting, Beijing, 1989.
20. Zong Ze, "Zhongguo meishujia xiehui zhangcheng", *Fine Art*, 1954, No. 2, p. 10.
21. Zhong Chengxiang (ed.), *Xin Zhongguo wenxue jishi he zhongyao zhuzuo nianbiao (1949–1966)*.
22. Red Guard publication, *Meishu zhanxianshang liangtiao luxian douzheng dashiji*, pp. 4–5; Jiang Feng, "Sinian lai meishu gongzuode zhuangkuang he quanguo meixie jinhoude renwu", *Fine Art*, 1954, No. 1, pp. 5–6.
23. Chen Yingde, *Haiwai kan dalu yishu*, p. 315.
24. Red Guard publication, *Meishu zhanxianshang liangtiao luxian douzheng dashiji*, p. 2.
25. Zhong Jingwen, *Yan'an Lu Yi — wo dang suo chuangbande yisuo yishu xueyuan*.
26. Central Academy of Fine Art (comp.), *Zhongyang meishu xueyuan jianshi*, pp. 98–99; Song Zongyuan *et al.* (eds.), *Yishu yaolan*, pp. 25–26.
27. J. Clark, "Soviet Painting" (unpublished article, 1987).
28. Central Academy of Fine Art (comp.), *Zhongyang meishu xueyuan jianshi*, p. 99.
29. Song Zongyuan *et al.* (eds.), *Yishu yaolan*, p. 28. Although this formal link existed between the two establishments, in practice, there was little administrative connection between them.
30. Central Academy of Fine Art (comp.), *Zhongyang meishu xueyuan jianshi*, p. 99.
31. Song Zongyuan *et al.* (eds.), *Yishu yaolan*, p. 25.
32. Jiang Feng, *Jiang Feng meishu lunji*, p. 53; Jiang Feng, "Weile manzu shiji yaoqiu, meishu jiaoyu bixu tigao yibu", *Literary and Art Gazette*, 1952, No. 10, p. 16.
33. Song Zongyuan *et al.* (eds.), *Yishu yaolan*, p. 26.

34. Ibid., p. 27.
35. Chen Yingde, *Haiwai kan dalu yishu*, p. 77. Pan Tianshou was not reinstated to his former position until 1956.
36. Song Zongyuan *et al.* (eds.), *Yishu yaolan*, p. 27.
37. Central Academy of Fine Art (comp.), *Zhongyang meishu xueyuan jianshi*, p. 99.
38. Ding Shouhe, *Qu Qiubai sixiang yanjiu*, p. 449.
39. Ibid., p. 454.
40. Chen Tiejian *et al.* (eds.), *Qu Qiubai yanjiu wenji*, p. 202. For further relevant information on Qu Qiubai see Chen Tiejian, *Qu Qiubai zhuan*, pp. 403–436; Ding Jingtang *et al.* (eds.), *Qu Qiubai yanjiu wenxuan*, pp. 196–212.
41. When this painting was completed in 1953 it was sent to Zhongnanhai to be examined by the top Party leaders, Mao Zedong, Liu Shaoqi, Zhou Enlai and Zhu De.
42. *People's Art* editorial, "Wei biaoxian xin Zhongguo er nuli", *People's Art*, 1950, No. 1, p. 15.
43. Jiang Feng, "Sinian lai meishu gongzuode zhuangkuang he quanguo meixie jinhoude renwu", *Fine Art*, 1954, No. 1, pp. 5–12.
44. Against corruption, waste and bureaucracy.
45. Against bribery, tax evasion, theft of state property, cheating on government contracts and stealing state economic information.
46. *Literary and Art Gazette* editorial, "Shanghai wenyijie ying jiuzheng sixiang hunluan xianxiang", *Literary and Art Gazette*, 1952, No. 3, p. 18.
47. Zhang Leping, *The Adventures of San Mao the Orphan* (trans. by W. J. F. Jenner and C. M. Chan).
48. Ibid.
49. Mao Zedong, *Mao Zedong lun wenhua yishu*, p. 84; Zhou Yang, *Jianjue guanche Mao Zedong wenyi luxian*, pp. 24–30 for further details on combining political content with aesthetically pleasing art forms.
50. Including New Year pictures, paper-cuts, clay statues and so on.
51. D. Holm, *Art and Ideology in Yan'an*, p. 144.
52. Ma Keh, "The Weifang New-Year Pictures", *Chinese Literature*, 1960, No. 8, pp. 153–158; Luo Qirong and Ou Renxuan, *Zhongguo nianjie*, pp. 7–8.
53. Ye Qianyu, "Cong jiu nianhua kan xin nianhua", *People's Art*, 1950, No. 2, p. 46.
54. Artist Magazine (comp.), *Zhongguo xiangtu yishu*.
55. Holm, *Art and Ideology in Yan'an* (Introduction).
56. Red Guard publication, *Meishu zhanxianshang liangtiao luxian douzheng dashiji*, pp. 2–3.
57. Ibid.
58. Holm, *Art and Ideology in Yan'an*, p. 143.
59. Jiang Feng, *Jiang Feng meishu lunji*, p. 62.

60. "'New Year Pictures', An Old Custom Serves the New China", *China Reconstructs*, 1953, No. 2, p. 26.

61. For examples, see relevant articles in *Literary and Art Gazette*, 1953, No. 23.

62. Yu Feng, "New Year Pictures", *China Reconstructs*, 1 March 1953, p. 14.

66. Wang Chi, "Modern Chinese Woodcuts", *China Reconstructs*, 1 May 1953, p. 27.

64. Holm, *Art and Ideology in Yan'an*, p. 143.

65. Ibid., p. 35.

66. Ibid.

67. Wang Chaowen, "Guanyu xuexi jiu nianhua xingshi", *People's Art*, 1950, No. 2, pp. 25–26.

68. Shi Lu, "Nianhua chuangzuo jiantao", *People's Art*, 1950, No. 2, p. 30.

69. Shaanxi, Gansu, Ningxia.

70. Shi Lu, "Nianhua chuangzuo jiantao", *People's Art*, 1950, No. 2, p. 31.

71. Ye Qianyu, "Cong jiu nianhua kan xin nianhua", *People's Art*, 1950, No. 2, p. 46.

72. Wang Chaowen, "Guanyu xuexi jiu nianhua xingshi", *People's Art*, 1950, No. 2, pp. 23–24.

73. Ibid., p. 24.

74. Shi Lu, "Nianhua chuangzuo jiantao", *People's Art*, 1950, No. 2, p. 30.

75. Cai Ruohong, "Nianhua chuangzuo ying fayang minjian nianhuade youliang chuantong", *Fine Art*, 1954, No. 3, p. 5.

76. Shi Lu, "Nianhua chuangzuo jiantao", *People's Art*, 1950, No. 2, p. 30.

77. Paintings were divided by the authorities into one of three categories — "beneficial", "harmful" and "harmless". Landscapes and particularly flower-and-bird paintings were considered as having no great political value, but they were also thought to constitute no great threat, so they were usually placed in the "harmless" category. It was permissible for artists to occasionally produce such work, as long as they spent most of their time on paintings possessing clear "socialist content". See Ye Qianyu, "Tan renwuhua chuangzuode jige wenti", *Fine Art*, 1980, No. 5, p. 33.

78. Mao Zedong, *Mao Zedong lun wenyi*, pp. 1–38.

79. M. Sullivan, *Chinese Art in the Twentieth Century* (Chapter on traditional Chinese painting).

80. "Breath resonance" — "implies a cosmic harmony, energy or rhythm whose reverberations produce the movement of life" (Sullivan, *Chinese Art in the Twentieth Century*, p. 33).

81. Li Hua, "Gaizao Zhongguohuade jiben wenti", *People's Art*, 1950, No. 1, p. 39.

82. Ibid., p. 40.

83. Cai Ruohong, "Guanyu 'guohua' chuangzuode fazhan wenti," *Fine Art*, 1955, No. 6, p. 14.

84. Hong Yiran, "Guanyu guohua chuangzuozhongde liangge wenti", *Fine Art*, 1955, No. 3, p. 13.

85. Zhang Shaoxia, Li Xiaoshan, *Zhongguo xiandai huihuashi*, p. 231.

86. However, Shi Lu's son, Shi Qiang, has argued that Shi Lu, far from agreeing that drawing should be the basis of traditional Chinese painting, emphasized the importance of cultivating good calligraphic skills. Shi Lu apparently stated that with drawing, one is only able to reproduce the outward appearance of things; this goes against the main aim of traditional Chinese painting, which is to express the spirit of things. See Shi Qiang, "Shi Lu tan Zhongguohua wenti", *Fine Art*, 1980, No. 11.

87. Jiang Feng, *Jiang Feng meishu lunji*, pp. 66–67, 92.

88. Fu Baoshi, *Zhongguode renwuhua he shanshuihua*.

89. Mo Pu, "Tan xuexi Zhongguo huihua chuantongde wenti", *Fine Art*, 1954, No. 7, p. 13.

90. Ibid.

91. Zhang Shaoxia and Li Xiaoshan, *Zhongguo xiandai huihuashi*, pp. 213–214.

92. Zhang Ding, "Guanyu guohua chuangzuo jicheng youliang chuantong wenti", *Fine Art*, 1955, No. 6, pp. 17–19.

93. Zhou Yang, "Guanyu meishu gongzuode yixie yijian", *Fine Art*, 1955, No. 7, pp. 15–18.

94. The painting appears in "Huadong meishu zuopin xuanji", 1951 — catalogue of an exhibition held in Shanghai in April 1951 by the Shanghai Society for the Study of New National Painting.

95. A. Chang, *Painting in the People's Republic of China: The Politics of Style*, pp. 34–35.

96. *Fine Art* journalist, "Wei zhengqu meishu chuangzuode geng da chengjiu er nuli — lai jing canguan di'erjie quanguo meizhande meishu gongzuozhe dui zhanchu zuopinde yijian", *Fine Art*, 1955, No. 5, p. 11.

97. Ibid.

98. Chang, *Painting in the People's Republic of China*, pp. 33–34.

99. Zhang Shaoxia and Li Xiaoshan, *Zhongguo xiandai huihuashi*, Chapters 2 and 3.

100. Zhao Yongmao, *Mao Zedong zhexue sixiang fazhan shigao*.

101. Mao Zedong, *Mao Zedong lun wenhua yishu*, p. 33.

102. Jiang Feng, "Yidali Wenyifuxingde meishu", *People's Art*, 1950, No. 1, pp. 69–74.

103. Jiang Feng, *Jiang Feng meishu lunji*, p. 76.

104. "Formalism" — an overriding preoccupation with form, rather than content.

105. Song Zongyuan *et al.* (eds.), *Yishu yaolan*, pp. 7–15.

106. Zhang Shaoxia and Li Xiaoshan, *Zhongguo xiandai huihuashi*, p. 201. Lin and his artistic mentor, Wu Dayu, were both temporarily relieved of their teaching duties in 1949.

107. Ibid.

108. Ibid., p. 201–202.

109. Chou Yang, "Mao Tse-tung's Teachings and Contemporary Art", *People's China*, 16 Sept. 1951, p. 7.

110. Red Guard publication, *Meishu zhanxianshang liangtiao luxian douzheng dashiji*, p. 17.

111. Chen Liao, *Makesizhuyi wenyi sixiang shigao*.

112. J. H. Brumfitt, *The French Enlightenment*, pp. 87–132.

113. C. Ritter, *The Essence of Plato's Philosophy*.

114. C. Taylor, *Hegel*, pp. 225–350.

115. K. Marx, *Maliezhuyi meixue lilun*, Vol. II, p. 699.

116. A. Walicki, *A History of Russian Thought*, pp. 136–142.

117. E. Valkenier, *Russian Realist Art, The State and Society: The Peredvizhniki and Their Tradition*.

118. P. Link (ed.), *Roses and Thorns: The Second Blooming of the Hundred Flowers in Chinese Fiction, 1979–1980*, p. 6.

119. E. J. Laing, *The Winking Owl — Art in the People's Republic of China*, p. 21.

120. Liao Jingwen, *Xu Beihong — Life of a Master Painter*, p. 50; China Cultural History Publishing House editorial department (comp.), *Yishude zhaohuan — wenxue yishujiade zishu*, pp. 13–20.

121. Zhang Shaoxia, Li Xiaoshan, *Zhongguo xiandai huihuashi*, pp. 237–238. For a useful list of Chinese artists who studied in the Soviet Union and Eastern Europe, see J. Clark, "Realism in Revolutionary Chinese Painting", *The Journal of the Oriental Society of Australia*, Vols. 22 and 23, 1990–91, pp. 23–24.

122. Song Zongyuan *et al.* (eds.), *Yishu yaolan*, p. 31; Zhang Shaoxia and Li Xiaoshan, *Zhongguo xiandai huihuashi*, p. 238.

123. Zhang Shaoxia and Li Xiaoshan, *Zhongguo xiandai huihuashi*, p. 238. For a list of Chinese artists who trained with Maximov during this period, see Clark, "Realism in Revolutionary Chinese Painting", p. 24.

124. T. T. Rice, *A Concise History of Russian Art*, p. 238.

125. Zhang Shaoxia, Li Xiaoshan, *Zhongguo xiandai huihuashi*, p. 239.

126. Ibid. John Clark has indicated, however, that Maximov may have been more liberal in his teaching approach than official reports allow, cautioning against the blind imitation of Soviet models and supporting the Sinicization of oil painting. See Clark, "Realism in Revolutionary Chinese Painting", pp. 11–12.

127. *Fine Art* journalist, "Guanyu youhua jiaoxue, jifa he fengge deng wenti — quanguo youhua jiaoxue huiyide ruogan wenti taolun jiyao", *Fine Art*, 1956, No. 12, p. 7.

128. Red Guard publication, *Meishu zhanxianshang liangtiao luxian douzheng dashiji*, p. 5.

129. Zhou Yang, "Fan renmin, fan lishide sixiang he fan xianshizhuyide yishu", *Literary and Art Gazette*, Sept. 1951, Vol. IV, No. 45, p. 9.

130. Ibid., p. 14.

131. Hu Qiaomu, "Wenyi gongzuozhe weishenme yao gaizao sixiang?", *Literary and Art Gazette*, Dec. 1951, Vol. V, No. 52, pp. 7–9; Zhou Yang, "Zhengdun wenyi sixiang, gaijin lingdao gongzuo", *Literary and Art Gazette*, Dec. 1951, Vol. V, No. 52, pp. 10–13.

132. Red Guard publication, *Meishu zhanxianshang liangtiao luxian douzheng dashiji*, p. 5.

133. Hua Junwu, "Qingchu meishu gongzuozhongde fei wuchanjieji sixiang", *Literary and Art Gazette*, Dec. 1951, No. 52, pp. 24–25.

134. Hu Qiao, "Xiaomie wo sixiangshangde diren", *Literary and Art Gazette*, Jan. 1952, No. 54, pp. 15–16; Yan Han, "Zai meishu chuangzuozhong genchu xingshizhuyide yingxiang", *Literary and Art Gazette*, Jan. 1952, No. 55, pp. 18–19.

135. Jiang Feng, "Jianjue jinxing sixiang gaizao, chedi suqing meishu jiaoyuzhongde zichanjieji yingxiang", *Literary and Art Gazette*, Jan. 1952, No. 55, pp. 5–7.

136. Central Academy of Fine Art (comp.), *Zhongyang meishu xueyuan jianshi*, p. 100.

137. Mao Zedong, *Mao Zedong lun wenhua yishu*, pp. 112–113.

138. Hu Shi — one of the most well-known Chinese scholars of the twentieth century, who established his name in several areas of Chinese culture. A substantial part of his scholarly work was devoted to research on Chinese literature. He left China for America before 1949. He was regarded by the Communists (with some justification) as having close links with the Guomindang. See Liu Xianbiao (ed.), *Zhongguo xiandai wenxue shouce*, pp. 279–282.

139. Relevant articles can be found in the *Literary and Art Gazette*, 1954, Nos. 20, 21 and 22.

140. *Fine Art* editorial, "Yinian lai *Meishu* bianji gongzuode zhuyao quedian he cuowu", *Fine Art*, 1954, No. 12, pp. 5–6.

141. Wang Rong, "Bixu suqing meishu pipingzhongde zichanjieji guandian", *Fine Art*, 1954 , No. 12, p. 7.

142. Hu Feng — Chinese literary critic and essayist. For further information on Hu Feng see Liu Xianbiao (ed.), *Zhongguo xiandai wenxue shouce*, pp. 277–279; Wang Zhangling, *Zhonggongde wenyi zhengfeng*, pp. 99–117.

143. Red Guard publication, *Meishu zhanxianshang liangtiao luxian douzheng dashiji*, pp. 14–15; Mao Zedong, *Mao Zedong lun wenhua yishu*, pp. 114–127.

144. Mao Zedong, *Mao Zedong lun wenhua yishu*, pp. 114–115.

145. For examples see Qin Zhaoyang, "Lun Hu Feng de 'yige jiben wenti'", *Literary and Art Gazette*, 1955, No. 4, p. 5; Lu Yuan, "Wo dui Hu Feng de

cuowu sixiangde jidian renshi", *Literary and Art Gazette*, 1955, No. 4, p. 14.

146. Artists' Association, "Jianyi ba Hu Feng cong wenyijie duiwuzhong qingxi chuqu", *Fine Art*, 1955, No. 6, p. 6.

147. *Fine Art*, 1955, No. 6, p. 13; *Fine Art*, 1955, No. 7, pp. 8, 11, 41–45.

148. *Fine Art* journalist, "Quanguo gedi meishu gongzuozhe jixu canjia suqing Hu Feng fangeming jituande douzheng", *Fine Art*, 1955, No. 7, p. 13.

149. Zhang Shaoxia and Li Xiaoshan, *Zhongguo xiandai huihuashi*, p. 226.

The Vacillating Years, 1956–1966

T he years between 1956 and 1966 were years of uncertainty for Chinese artists and intellectuals in general. The early fifties had been marked by general optimism regarding China's future and the Party had enjoyed wide support from the majority of intellectuals. From 1956 on, however, divisions began to appear between pragmatists and radicals in the leadership, and intellectuals started to waver in their support for the authorities, with some going so far as to challenge the Party's legitimacy. The major movements of this period were mainly precipitated by external events, particularly Khrushchev's denunciation of Stalin in 1956, and the Hungarian uprising, both of which shook the Communist world and betrayed the first signs of trouble in the Communist camp. As a reaction to this, in China, political campaigns directed against intellectuals were used as the main means of control. Policy differences and power struggles amongst the top Chinese political leaders began to affect cultural circles in a much more direct way than had earlier political disputes, such as the one that led to the purge of Gao Gang.[1] A consequence of the unstable situation that prevailed in China after 1956 was the shifting nature of the relationship between art and politics as the authorities alternated between relatively liberal policies and tight ideological control. This relationship can be examined by dividing the period into four major socio-political stages:

(1) The Hundred Flowers movement and the Anti-Rightist campaign.

(2) The Great Leap Forward and Anti-Rightist Deviation movement.

(3) Re-adjustment and relaxation following the Great Leap Forward.

(4) The Socialist Education movement and the lead-up to the Cultural Revolution.

The Hundred Flowers movement and the Anti-Rightist campaign

At a meeting of the Supreme State Conference held on 6 May 1956, Mao first put forward the idea of "Letting a Hundred Flowers Bloom, Letting a Hundred Schools of Thought Contend",[2] thus signalling a new direction in policy that was to be referred to by Mao and other Party leaders on several occasions over the next few months. On 26 May, the Party Propaganda Chief, Lu Dingyi, gave a speech explaining Mao's ideas in greater depth. He emphasized the need to secure a united ideological front with all sectors of society, and advocated a diversity of themes in cultural and intellectual endeavours. He went so far as to say that it would be permissible in cultural work to refer to "celestial beings (or immortals) in heaven, and birds and beasts that can speak",[3] apparently encouraging writers and artists to use their creative imagination to go beyond the conventional political framework. Shortly after this, Zhou Yang, the Deputy Chief of Propaganda, echoed Lu's sentiments. Whilst chairing a meeting on the "Preparations for the Twelve Year Development Plan for Culture and Science", he stated that "If you want artistic activities to flourish and artistic levels to improve, then the best line [to take] is liberalization."[4]

Though there is still some debate amongst scholars as to why Mao initiated the Hundred Flowers policy, there were some general factors which most would agree contributed significantly to his decision. The first was the international dimension. The denunciation of Stalin at the Twentieth Party Congress of the Soviet Union caused great confusion in socialist countries, and led to instability in Eastern Europe, particularly in Hungary and Poland.[5] Doubt was cast on Stalinist policies, and in China this led to a re-appraisal of the ideological orthodoxy that had been imposed since 1949.

At the national level, by 1956 China's socialist reforms seemed to be going well. In the countryside collectivization had almost been completed, as had the system of joint state–private ownership for enterprises in the cities. The economic situation was much improved, stability had been achieved and the First Five-Year Plan was progressing successfully.[6] The mood in the country was more optimistic, and the Party was confident that its authority had been fully established. Now the task was to encourage the intellectuals to participate in the next stage of socialist construction.

However, on the negative side, the initial attempts at the socialist transformation of society had led to a highly centralized political system which generated a host of bureaucratic problems. The reforms had affected the interests of certain social groups, and mistakes that had been committed in the process began to damage the image of the Party amongst some sectors of the society. In 1956 and 1957, under the influence of events in Hungary and Poland, various locations in China witnessed small-scale workers' and students' strikes, people went to Beijing to present petitions and air their grievances, and former rich peasants even attempted to withdraw from the collectives. As Mao said: "contradictions amongst the people are beginning to intensify."[7] There was clearly a pressing need to improve the old functional mechanism of Party organization in order to solve these social problems, and for that a more relaxed policy was needed.

The importance of involving intellectuals in the process of resolving the various social contradictions and continuing to build on the initial achievements of socialist reform was brought out in many of the speeches of the top political and cultural leaders. Liu Shaoqi, Vice-Chairman of the Party and second in rank only to Mao, on several occasions set down the main parameters of the Hundred Flowers movement and highlighted the importance of participation in it by intellectuals: "We must utilize the power of the bourgeois and petty-bourgeois intellectuals to build up socialism."[8] Full participation in the movement was to entail: "learning to think independently, to have one's own views and judgement. Do not blindly worship other people and do not be afraid. Everything can be doubted."[9]

On another occasion, Liu, referring specifically to the Hundred Flowers movement as it was to apply to cultural work, stated that a variety of forms was to be allowed to exist, that each person had their own way of doing things, and that these differences were to be tolerated. Elements

of western and traditional literary and art works could be utilized, though this only applied to "desirable" elements. One of the most noticeable departures from previous policy was Liu's assertion that the opinions of non-experts (indicating Party bureaucrats) should be discussed with experts, and that non-experts should not attempt to place themselves above professionals. Literary and art workers were also told that they should respect the opinion of the masses but not necessarily follow them.[10]

Zhou Yang, in one of his important speeches to cultural workers on the Hundred Flowers movement, gave a more detailed indication of why the policy was thought necessary. He acknowledged that intellectuals had some reasons for dissatisfaction towards the Party, and that the best way to resolve the situation was to adopt the principle of ideological relaxation. "Their [intellectuals] social and economic foundation has disappeared, so they can only follow the socialist road, but it is also not good for socialism to make intellectuals feel that the situation is unbearable." He particularly emphasized that only one opinion, i.e., that of the Party, had previously been allowed because a "decisive victory had not been achieved between capitalists and socialists, counter-revolutionaries had not been purged and capitalists were still exploiting the people." Now, however, the class struggle was basically over, intellectuals had progressed greatly since the socialist reforms had been initiated, and the Party could use the Hundred Flowers movement to "enlarge democracy amongst the people, in order to further the process of uniting all social groups. Without this unity, socialism will collapse, particularly as socialist construction consists of a cultural and scientific revolution. We have to unite all intellectuals, particularly senior ones, to join in this construction. If we cannot achieve that, our country cannot get rid of its backward state."[11]

Mao also emphasized the need for a more liberal approach to cultural activities if China was to develop and progress. The Hundred Flowers policy had been "put forward in the light of the pressing need for China to speedily develop its economy and culture … it is a guiding principle which promotes artistic development and scientific progress."[12] Diverse forms and styles in the arts were to be allowed to develop freely, any administrative pressure used to promote one style or school at the expense of all others being detrimental to the comprehensive process of development. Rather than absolute and orthodox theoretical standards deciding the criteria

governing artistic activity, questions that arose were to be solved through "free discussion" and "artistic practice".[13]

Mao's theoretical justification for the Hundred Flowers policy was based on Lenin's "Theory of the Unity of Opposites",[14] whereby truth could only be highlighted by comparison with falsity, to be followed by a period of struggle against this falsity; beauty could only be highlighted by comparison with ugliness, goodness with evil, and so on. A "fragrant flower" in the cultural realm could only be regarded as such by comparing it with a "poisonous weed". Therefore, from a philosophical point of view, opposites were necessary for the healthy development of positive and desirable conceptual categories.

However, seen in this light, the Hundred Flowers policy was, for intellectuals, somewhat double-edged. It allowed greater relaxation in cultural circles, but largely in order to bring dangerous tendencies in the arts out into the open so that they could act as a foil for what was considered beneficial. Once exposed in this way, these dangerous tendencies were then to be criticized. Mao at one point stated quite clearly that the Hundred Flowers movement was the best way to reform intellectuals, about whom he continued to hold deep suspicions. He believed that "bourgeois" and "petty bourgeois" thinking would always be reflected in political and cultural ideology in one form or another, and that one of the best ways to deal with it was not through suppression, but by allowing its full expression and then by giving it "appropriate criticism".[15]

Changes in organization due to the Hundred Flowers policy

A striking feature of the application of the Hundred Flowers policy to cultural circles was an unprecedented emphasis after 1949 on the professional status of writers and artists and on their particular creative expertise. "Artists are to guide art, musicians are to guide music. We have to have experts guiding experts",[16] pronounced Zhou Yang, signalling that during this particular stage of socialist construction the "expert" dimension of the Party's "red and expert" formula was to be predominant. It was to be artists, rather than Party bureaucrats, who would largely decide how general Party directives were to be interpreted and applied to their own field of expertise. Zhou's encouraging words were clearly used as an attempt to assuage artists'

fears about expressing their thoughts, following their recent experience of the heavy criticism sessions mounted against Hu Feng.[17] Zhou also declared that the Artists' Association should be regarded as a virtually autonomous organization run by artists themselves, and largely free of Party interference. He said of the Association, "it is their [the artists'] organiza- tion, and it should not be subordinate to the government. The Artists' Association should be independent."[18]

Zhou Yang's speech was later discussed by the Party group of the Artists' Association, which included Jiang Feng, Cai Ruohong, Wang Chaowen and other influential figures. They all expressed support for the main content of the speech and, on the basis of it, they produced a working plan for 1957. It was the outline of a programme concerned with improving the standard of art work produced by artists and with making the necessary organizational adjustments in order to allow artists to carry on free debate and to provide them with the conditions for unhampered creative freedom. To achieve these aims, the Party group put forward several proposals. First, they stated that in the future the main form of art exhibitions should change from that of the large-scale or national format, with many artists from all over China contributing one or two pieces, to the individual or small group exhibition. They went on to work out the provisional methods for arranging and holding such exhibitions, declaring that anyone could apply for an exhibition slot. The content of exhibited pieces was to be the sole responsibility of the artist and so, rather than having to undergo the usual cumbersome process of selection, the artist was to be allowed the freedom to choose his or her own work for exhibition.[19] On the basis of the Artists' Association Party group's recommendation that artists should set up their own art groups, "art salons" that did not come under the direct control of the Association began to appear. One such example was a group set up at the Central Academy of Fine Art to discuss the question of impressionism, a subject formerly considered taboo.[20]

The Party group also advocated the setting up of art periodicals or journals by artists working in the same style. Within a short period, artists were indeed organizing their own semi-official periodicals which, though still needing the tacit support of the Artists' Association and relying on official printing, publishing and distribution facilities, did not come under the direct control of the Department of Propaganda, as was the case with

Fine Art and the *Literary and Art Gazette*. The cartoonist, Hua Junwu, together with several other colleagues, edited one such periodical, titled *Multi-Image*, whilst another group set up the art magazine *Sun Wukong*. A group in Shanghai even set up a periodical, called *Bees*, which specifically aimed at publishing work rejected by all other art magazines.[21]

In addition to these semi-official periodicals, early 1957 saw the establishment of *Fine Art Research* (*Meishu yanjiu*), an official publication on general art theory. Jointly edited by the Central Academy of Fine Art and its East China Campus in Hangzhou, and published by the Shanghai People's Art Publishing House, its first three issues clearly reflected the era's relatively liberal atmosphere. The editor's note in the inaugural issue set out the principles according to which articles were to be selected for publication:

> *we require that articles have content possessing some substance. As long as [an article] expresses an original opinion, even if it is a one-off opinion, it is very welcome.*[22]

The journal was at the forefront of a major debate on impressionism in 1957, publishing several articles in support of an art form that since the Yan'an days had been condemned as a sign of "bourgeois decadence".

Changes were planned for the main official organ of the Artists' Association, *Fine Art*. An editorial in its 1957 new year issue detailed the wide-ranging scope of these changes. It opened with the surprising declaration that *Fine Art* should not be regarded as the official organ of the Artists' Association, even though it had hitherto given the impression that it represented the official line of the Party's cultural policy. The editorial acknowledged that many complaints had been received from readers about the poor quality of articles and illustrations, and the editorial board had decided that its practice of setting restrictions on themes and topics for artists and art critics would be dropped. Artists would be encouraged to use their own initiative and offer a variety of opinions. In addition, there was an implicit admission that not enough attention had been paid by the periodical to problems relating specifically to the creative process, and too much to long tracts on Marxist art theory. In future, the editorial declared, *Fine Art* would ensure that questions of creative work and theory would be closely combined, but with slightly more emphasis on the creative aspect,

reflecting the general policy in cultural circles to focus on the "expertise" rather than the "redness" of all cultural workers. With regard to non-Chinese art, in an attempt to break with the blanket coverage of Soviet and Eastern European art featured in the periodical, the editorial board stated its intentions to strengthen the introduction of art and art theory from other countries. The format of Fine Art was also to be changed. There was to be an increase in the number of pages and a larger page size to allow for the inclusion of more materials, and the selection and editorial procedures for art works to be published were to be modified.[23]

Further signs of relaxation in the art world

In April 1957 the Beijing branch of the Artists' Association organized a series of meetings for Beijing artists to discuss Mao's Hundred Flowers speech. For the first time after 1949 major criticisms were voiced by many of those present, including Situ Qiao, Li Qun, and Zuo Hui.[24] Their main objection to the policies pursued over the previous six years was that a blind and dogmatic application of Marxist theory to art had caused serious problems. It had resulted, they said, in a lack of independent thinking amongst artists, preventing them from properly assessing the relative merits of western art (by, for example, the continual denigration of impressionism) and China's own artistic tradition. The sculptor, Liu Kaiqu, stated bluntly that all restrictions on the creation of sculpture and cartoons should be completely done away with, whilst Pang Xunqin's assessment was that the problem of bureaucratism in the field of arts and crafts was even worse than the situation described in Wang Meng's story The Young New Arrival at the Organization Department.[25] The problem had become so acute that in the Academy of Arts and Crafts in Beijing a "democratic programme for the management of the Academy" was put forward,[26] whereby a secret ballot would elect an Academy Council to act as the highest organ of the establishment. It was the Council that would decide the principles guiding the educational programme, personnel appointments and the financial management of the Academy, and the Council would democratically elect the Principal and Vice-Principal. The programme represented, in fact, the first demand since 1949 from an art education institution for independent control of the decisions that affected it.

With the implementation of the Hundred Flowers policy, there was a marked increase in literary and art works critical of the shortcomings and problems of Chinese society and, in particular, of bureaucratic Party cadres. In the field of reportage, Liu Binyan's *Internal News from This Newspaper* and *On the Bridge-Construction Site*, and in creative literature, Wang Meng's *The Young New Arrival at the Organization Department* were but a few examples.[27] In the art world, overt criticism came mainly in the form of cartoons, such as those that appeared in a National Exhibition of Cartoons in January 1957. A substantial proportion of those exhibited were devoted to satirizing Party bureaucratism and the wastefulness of the state. *Lengthy Speeches All Day* criticized the amount of time wasted by Party cadres on delivering political sermons, and *Expert at Spending Money* implied that even the Empress Dowager Cixi, of the Qing dynasty, a woman notorious for her profligacy, would have to concede defeat to Party cadres in the area of extravagant spending.[28] Cartoons had previously been used for the purpose of criticism both at Yan'an and since the founding of the People's Republic, but their main function had been to expose and satirize external enemies, or encourage a more radical outlook amongst ideological waverers. During the Hundred Flowers movement, however, the cartoons focused much more on criticizing the Party itself and the bureaucratic practices generated by its policies.

Another change that occurred during the Hundred Flowers movement was a renewed interest in western impressionism, a topic which had not been seriously debated since the early 1940s in Yan'an, when the advocates of some features of impressionism had lost out to their more ideologically-motivated colleagues.[29] In the February 1957 edition of *Fine Art*, a cluster of articles on impressionist painting appeared, along with the reproductions of representative impressionist works by Monet, Degas, Renoir, Toulouse-Lautrec and Pisarro.[30] The articles were mainly translations of essays by Soviet theorists,[31] hence many of them had strongly critical overtones. However, there was some recognition of the technical usefulness of impressionism in the history of art. And the very fact that this form of modern western art, which, to the Chinese authorities, was most closely associated with decadent bourgeois society, was allowed to appear in *Fine Art* was a telling sign of the prevailing atmosphere of liberalization. By simply acknowledging its existence, the periodical opened the way for

possible further examination of impressionism by Chinese critics in the future. Following these articles, a series of discussions took place nation-wide on the relative merits and defects of impressionism. The Zhongnan[32] School of Art and the Wuhan branch of the Artists' Association, for example, both held three meetings to debate impressionism, at which it was accepted that something could and should be learned from impres-sionism, and that it should be regarded as a "flower".[33]

"Observing and learning from real life"

During the Hundred Flowers movement many of the fundamental prin-ciples on which art policy had been based were questioned and debated in the public arena. The idea of "observing and learning from real life" was one of these. It had been used as an instruction to artists to forego the cosy surroundings of their art studios in favour of a commitment to mix with "real people" and witness "real events" first hand. It was intended as a means by which artists could enrich the socialist content of their work and avoid the pitfall of "conceptualism", which would inevitably occur if artists remained in their "ivory towers".

During 1956 and 1957, though no one dared to challenge it as a concept, voices were raised in protest over how it was being dogmatically interpreted by Party cadres in charge of art work. An article which ap-peared in *Fine Art* in January 1957 by Xiao Caizhou[34] was a typical example of such a protest. Xiao's main argument was that the over-emphasis on "observing and learning from real life" at the expense of taking into account the "unique qualities and characteristics of art" (i.e., its technical or formal dimensions) had greatly damaged artistic development in China. He criticized those who condemned artists for their defence of these unique qualities, claiming that under the influence of such misguided people many artists had set aside their brushes, had spent some time in factory or village, but upon returning home had been unable to produce successful work on appropriate themes because they had not "observed and learned from real life" according to the "special characteristics of art". He asserted that the whole process of "observing and learning from life" had become mechanical, because it was a theoretical concept applied to all forms of culture, and did not address the central question of how it was actually to

be applied to the process of artistic creation. Artists were left to rely on information on the latest political line gleaned from newspapers, political documents and so on, and then on the basis of this information produced the required image. As a consequence, artistic work had become a direct illustration of political concepts or ideas in a standard and abstract form. The writer ended with an appeal to avoid over-simplifying the interpretation of "observing and learning from life" and to pay more attention to the different requirements of the various cultural forms. Here, Xiao was not only questioning the Party's application of one of its key principles to cultural circles, but was also using that principle to stress the independent and unique qualities and requirements of art, as opposed to other cultural forms. He was thus undermining a cornerstone of cultural policy — that all areas of cultural endeavour should have the same theoretical principles applied to them, and that all "cultural workers" should be equally successful in putting them into practice; that no cultural form could carve out an independent domain for itself, separated from all other cultural activities.

The question of "observing and learning from real life" was just one of the problems aired openly in art circles in particular and in cultural circles in general. From the avalanche of criticisms, it was clear that artists and writers, dancers and musicians were frustrated with the restrictions placed upon them and were fully aware of the negative consequences generated by limiting their creative capacities. At emotionally charged meetings of the Writers' Association to discuss the implementation of the Hundred Flowers policy, Mao Dun, Lao She and other prominent figures strongly criticized the limited range of subject-matter and the lack of variety in the style of Chinese literature, which they put down to a dogmatic and one-sided understanding of the principle that "the arts are to serve the workers, peasants and soldiers", to a narrow interpretation of Socialist Realism, to crude and simplified literary criticism and to inappropriate administrative interference.[35]

Many artists shared the views of the writers, facing as they did the same set of problems. One of the most daring and comprehensive diatribes exposing the more glaring shortcomings of the art world was written by Jin Ye, a highly outspoken lecturer from the Zhejiang Academy of Art. In his article published in *Fine Art*,[36] he tried to tackle some fundamental questions of concern to artists. His assessment of the current situation in the

Chinese art world was extremely pessimistic, and he declared that work with unimaginative repetitive content expressed in tasteless forms was a virtually universal phenomenon. His view as to why this had come about (and it was a view expressed several times by other artists and art critics) was that artists were not allowed to carry on their profession according to the natural laws governing art, nor was their starting point a "real feeling for life". The artist's perception of reality, he said, had been relegated to an insignificant position, forcing artists into producing empty themes from abstract political concepts. Jin claimed that the aesthetic dimension of art had been ignored, and he stressed the need to produce a vivid visual image if art was to portray real life successfully. Speaking from his own experience as an art teacher, he believed that art colleges were not paying proper attention to cultivating the creative individuality of the students. In addition, there had been too narrow an understanding of the social function of art, so that the only way for artists to serve the workers, peasants and soldiers was by directly depicting the activities they were involved in.

Jin's answer to these problems was to focus more on the technical skills of the artist, as both the content of and the means of expression in art were equally important and interrelated. As he stated, "Even Socialist Realism requires a variety of forms of expression."[37] So, rather than setting political content and technical methods against each other, as had too often been the case, Jin argued that the importance of both should be recognized. Having said that, however, he nevertheless made it clear that, in his opinion, what made someone a good artist was not his political commitment but the level of his professional artistic skills.

Art exhibitions during the Hundred Flowers movement

Perhaps one of the most noticeable signs of liberalization in art during the Hundred Flowers movement was the proliferation of exhibitions in China which covered a wide spectrum of art both traditional and contemporary, from China, as well as overseas. Exhibitions held in Beijing in particular revealed a diversity ranging from Ai Zhongxin's oil paintings and the traditional Chinese paintings of Guan Shanyue and Chen Banding to Ming and Qing portraits.[38]

The Second National Exhibition of Traditional Chinese Painting (11–23 July 1956), held in the China Art Gallery was said to comprise a "variety of subject-matter and style ... far above the works displayed at the First National Exhibition of Traditional Painting and the traditional paintings shown at the Second National Exhibition of Fine Arts."[39] Notably failing to mention Socialist Realism or the requirement for art to serve a political purpose, one article simply stated that "the artists are able to give realistic and charming portrayals of the new life and new people in our country; but they also create beautiful landscapes, they paint flowers and animals, and they give us visualizations of ancient folk tales."[40] Included in the exhibition were Qi Baishi's peonies, wonderful white magnolias by Yu Fei'an, and Wu Hufan's magnificent mountain scenes. Although praise was given to some traditional Chinese paintings reflecting contemporary political themes, in particular, Li Xiongcai's *Flood Prevention at Wuhan*,[41] the comment was made that the exhibition's weak point was the "painting[s] of the human figure, in which respect nothing at the exhibition was equal to the excellent landscapes, flowers and birds".[42]

An additional development was an increase in the number of exhibitions displaying art pieces from countries other than the Soviet Union and Eastern Europe. These shows were said to have "contained something new, something entirely different from anything we have seen before".[43] An exhibition of British graphic art was staged in Beijing, the first of its kind in China.[44] The 220 exhibits, including woodcuts, etchings, lithographs, silkscreen prints and book illustrations, covered the last five hundred years of British graphic art. Particular note was taken of the political and social caricaturists such as William Hogarth ("the father of political satirical art"), Thomas Rowlandson, James Gillray and Richard Newton, perhaps because they echoed the political satire that permeated the work of many Chinese cartoonists during the Hundred Flowers movement. There was also in 1956 the first ever exhibition of Mexican art in China, featuring work from the last twenty years by thirty artists, including the woodcuts of Leopold Mendez and the lithographs of Pablo O'Higgins.[45] News of the exhibition and reproductions of exhibits appeared in the *People's Daily*, the *Guangming Daily*, the *Peking Daily*, *Fine Art* and other publications, and the exhibition boasted among its viewing public several prominent Chinese graphic artists, such as Gu Yuan, Li Hua, Li Qun and Zheng Yefu.

It was followed in succession by displays of the work of six contemporary Italian artists, a Vietnamese exhibition, an exhibition of contemporary Greek art and a second Mexican exhibition comprising paintings, murals, woodcuts and engravings, and featuring the work of amongst others, Diego Rivera and D. A. Siqueiros.[46] However, perhaps the most significant indication of the extent of liberalization was an exhibition of works in Beijing by French artists. This small show, consisting of only twenty-seven paintings, presented to a Chinese audience the work of outstanding western art figures, such as Picasso, Matisse, Bonnard, Dufy, Utrillo, Marquet, Roualt, Läger and Lurìat.[47]

Rectification

The period of "blooming and contending" was disappointingly short-lived. Early on in the movement, at the second plenary session of the Central Committee of the Eighth Party Congress (November 1956), Mao announced a rectification drive to run concurrent with the Hundred Flowers campaign to oppose bureaucratism, factionalism and subjectivism. He warned: "If the problems of the masses are not dealt with, the peasants are going to revolt, the workers will go to the streets to demonstrate and the students are going to make trouble."[48]

From the start, Mao seemed to have intended to use the Hundred Flowers movement largely as a means of releasing social tensions, reducing social contradictions and improving the overall efficiency of the Party. However, within a short time things may have gone further than he expected, and he may have underestimated the frustration and dissatisfaction (as well as the courage) of the intellectuals. The criticisms levelled at the Party became overwhelming, and were directed not only at individual Party members and specific policies, but also at some fundamental principles and even the socialist system itself. This first concerted attack against the Party after 1949 must have been highly alarming to Mao and the other leaders.

By May 1957 Mao was ready for a counter-attack against those whom he chose to label as Rightists (those who had voiced dissenting opinions). This first took the form of an article entitled "Things Are in the Process

of Transformation" which was circulated amongst Party members. In it, Mao outlined a change of tactic from criticizing dogmatism to criticizing revisionism, which he now regarded as a greater threat: "In the last few months, everyone has been trying to criticize dogmatism, but they have let revisionism escape. Obviously dogmatism should be criticized, but now we should begin to criticize revisionism.... Some of the dogmatism being criticized ... is actually Marxism."[49] By 8 June, the Central Committee had already issued a "directive on organizing forces to prepare for a counter-attack on the attack made by the Rightists."[50]

Mao outlined how his interpretation of the scope of the Hundred Flowers movement differed from many of the dissenters: "We only want people to speak out on [matters of] cultural and academic work, but the Rightists want to extend it into the political sphere."[51] Here, Mao clearly drew a line on what could and could not be questioned. When intellectuals challenged fundamental principles, all freedoms previously granted were to be taken away. Mao's continuing suspicions regarding the reliability of intellectuals (which it seemed to him had been proven correct) was clearly an important factor behind rectification and the Anti-Rightist campaign. When analysing the class nature of intellectuals as a social group he stated that China's five million intellectuals were "quite cultured" and possessed technical expertise, but that many were from the old society and had close links with the old mode of production. "Now the old economic foundation has been transformed, but what is in their heads cannot be changed overnight. So, some of them waver.... They do not wholeheartedly come down to stand with or serve the proletariat."[52] Based on Mao's assumption that "in the transitional period of the Socialist society, the main social contradiction is that between the proletariat and the bourgeoisie",[53] intellectuals, with their "bourgeois" mentality, would of necessity become the main focus of any political movement.

In a *People's Daily* editorial on 1 July, written by Mao himself, entitled "*Wenhui bao's* Bourgeois Direction Should Be Criticized" the official signal for a nationwide campaign against Rightists was given.[54] Many articles criticizing Rightists soon appeared in national and local newspapers and periodicals, and the authorities organized several meetings with the purpose of attacking Rightists. Inevitably, cultural circles became one of the most important areas of struggle.

At an enlarged meeting of the Party group of the Writers' Association, Lu Dingyi and Zhou Yang made two important speeches to set down some of the guidelines for the Anti-Rightist campaign. They described it as a "social revolution on the political and ideological front", and drew parallels between the movement in China and that against Trotsky in the Soviet Union and the "Petofi Club leaders" in Hungary. Lu Dingyi declared it to be a "very serious class struggle". In analysing the reasons for the existence of "bourgeois intellectuals" in a socialist society, Lu and Zhou made the following points. Ideology always lagged behind social existence. Intellectuals from the old society, not having undergone proper thought reform, had been unable to come to terms with the new reality; bourgeois ideas would exist for a long time; in the cultural realm, the "struggle between two lines" had never ceased since the Yan'an Talks in 1942, the main difference between the two being their approach to the relationship between politics and the arts, the Party and the arts, and the status art and cultural workers should have in society.[55]

Lu and Zhou reiterated the importance of politics leading the arts, the arts accepting the leadership of the Party, the arts serving the workers, peasants and soldiers, and the subordination of aesthetic criteria to political considerations. They stressed that these basic principles were to comprise the main issues in the Anti-Rightist campaign. Lu said that cultural workers should wholeheartedly and unconditionally go to the countryside and the factories, and he expressed the hope that within eleven years, 70% of writers would go to farms and factories to be re-educated and reformed. He also tried to emphasize the importance of Socialist Realism, accepting that though it was not the only method of artistic creation, it was the best. In the final part of his speech, Lu declared that cultural workers should adopt the "three resolutions" — to thoroughly oppose Rightists, improve their work, and reform their own thoughts.[56]

Rectification in the art world

With the emphasis during this period on attacking Rightists, major changes in the cultural world involved the dismissal and removal of individuals who were unlucky enough to fall under suspicion. In literary circles, Ding Ling, Chen Qixia, Liu Shaotang, Gong Liu, Ai Qing, and

others received severe criticism; in music, it was individuals such as Zhang Quan who came under attack; in drama it was Wu Zuguang, amongst others; in film, Zhong Dianfei; and in the news media, Chu Anping and Liu Binyan.[57]

In the art world, a host of prominent figures lost their positions and were forced to do menial tasks or were sent to the countryside for re-education. The list included Mo Pu, head of the Hangzhou Academy of Art; Zheng Yefu, the Deputy Secretary-General of the Artists' Association; Yan Han, the Association's cadre in charge of creative work; Ye Gongchuo, head of the recently established Chinese Painting Academy; Wang Xuetao and Xu Yanxun, also from the Academy; Liu Haisu, Head of the East China Academy of Art; Yang Jiao and Zhang Xiaojie, President and Deputy President of the North East Art College, who were also its Party Secretary and Deputy Party Secretary (they were accused of being the "backbone" of Jiang Feng's Rightist group); Wang Liuqiu, Head of the Department of Painting at the Zhejiang Academy of Art; Liao Bingxiong, Executive member of the Chinese Artists' Association and Deputy President of its Guangzhou branch; Wang Zimei, Sichuan cartoonist; Ren Qianqiao, the Art Section Chief of the Shandong branch of the All-China Federation of Literary and Art workers; Jing Qimin, a young Liaoning artist from a peasant background, who worked in the office of the *North Eastern Pictorial*; Pang Xunqin, Head of the Central Academy of Arts and Crafts; Yuan Baitao, a Xi'an artist; and Wang Maihan, an artist from Tianjin. Several cartoonists such as Shen Tongheng and Li Bingsheng were also indicted, as the cartoonists had been particularly active during the Hundred Flowers movement.[58]

This selective list of people attacked by name in official publications gives some indication of the scale and scope of the Anti-Rightist campaign as it affected the art world. These were the main figures targeted in art journals, but throughout China the numbers implicated were very much larger. The campaign had a wide geographical spread, and it affected artists at every level of society and in every field, from oils and traditional Chinese painting to arts and crafts and cartoons. Many individuals had held important positions in education institutions and art organizations such as the Artists' Association, and many had been associated with the revolutionary Communist movement since the 1930s and early 1940s. Loyalty to the

Party was no guarantee of protection from criticism and dismissal. This could be seen most poignantly in the case of the main target of attack, Jiang Feng, who was the First Deputy Chairman of the Artists' Association, Head of the Party Group of the Association and acting President of the Central Academy of Fine Art.

The case of Jiang Feng

The first criticisms of Rightists in the art world appeared in *Fine Art* in July 1957, and they came from Liu Kaiqu, Wu Zuoren, Gu Yuan, Hua Junwu and Jiang Feng himself.[59] The campaign was still in its early stages, and the criticisms were at this point still couched in fairly abstract language and no specific targets were named. The abrupt change in official policy no doubt created confusion on the part of the top art leaders over how the campaign should proceed and they may, therefore, have fallen back on rhetoric to mask their uncertainty. The vagueness of the initial criticisms, however, can also be largely attributed to an unresolved power struggle at the highest levels of the art administration.

By August and September, another spate of articles appeared, written by Cai Ruohong, Hua Junwu and a group of prominent traditional Chinese painters. This time the attacks were well organized and directed against a specific target. Ironically, it turned out to be Jiang Feng, the most senior Party figure in the Artists' Association, who was accused of being the source of all Rightist tendencies, and dubbed the "head of the arsonists in the art world".[60] On 28 and 30 August the Ministry of Culture held two meetings to reveal Jiang's "anti-Party words and actions". He was criticized for being consistently against the Hundred Flowers policy and ignoring the historical legacy of traditional Chinese painting by claiming that it was unscientific, its linear images were backward and had no perspective, and its expressive form was therefore highly limited and unable to reflect modern life properly or serve political needs. With this as an excuse, it was claimed, he had tried to reject traditional Chinese painting, and failed to pay attention to the work of uniting traditional Chinese painters. Under his presidency, the Traditional Chinese Painting Department at the Central Academy of Fine Art had been changed to the Colour Ink Painting

Department. (Though it was not merely the name that had been changed, Jiang had introduced the use of western drawing techniques, shading, perspective, and so on, to serve as the basis of traditional Chinese painting, rather than encouraging students to copy the work of the old Chinese painting masters. This was the main point of contention.) He had, therefore, attempted "to set tradition and revolution against each other".[61]

Jiang was accused of a series of additional mistakes against the Party; of forming a revolutionary group against Party policy, especially against the Hundred Flowers policy which he was said to disagree with in a "dogmatic" way; of complaining about problems in the Party, such as a lack of democracy; of blaming the increasing non-politicization of artists and art students on the resolution of the Eighth Party Congress which stated that more professionalism was needed to address the main contradiction between the advanced socialist system and backward economic forces; of warning about the consequences of stressing "expertise" at the expense of "redness"; of not working out properly the relationship between himself and the Party, refusing to take part in meetings organized by the Minister of Culture, the Party Committee of Beijing city and even Premier Zhou; of claiming that the criticisms against him by the Ministry of Culture and the Party group of the Artists' Association were personal attacks, the result of factionalism and Cai Ruohong's personal ambition to oust him in order to become himself President of the Central Academy of Fine Art; of carrying out behind-the-scene manipulations to encourage others to criticize the Ministry of Culture; of supporting Pang Xunqin's "anti-Party programme" and of generally giving encouragement to many Rightists.[62]

Jiang Zhaohe, Li Keran,[63] and other traditional Chinese painters joined in the attacks on Jiang, accusing him of being too western-oriented in his outlook, of aiming to replace traditional Chinese line painting with western drawing, and of offering little or no financial support to traditional Chinese painters who wished to go on field trips to paint the local scenery. They claimed that some traditional Chinese painters had been forced to give up their painting, others had been left without work, whilst still others had had to take up extremely lowly employment like "painting nine *fen* book-marks".[64] Most damning, however, were the criticisms voiced by the Party Chairman himself, Mao accusing the unfortunate Jiang of lacking a dialectical approach to traditional Chinese painting.[65]

It is extremely ironic that Jiang Feng, arguably the most powerful figure in the art world and with a long history of faithful service to the Party (which he joined in 1932), should become the main target of the Anti-Rightist campaign, accused of a whole host of crimes. If we compare his background to Cai Ruohong, who many believe was his main political rival and who finally replaced him when he was dismissed, we see that there were very few differences in their revolutionary credentials. Both showed inclinations towards revolutionary art work at an early stage, Jiang with his woodcuts (he was a student in Lu Xun's early woodcut programme) and Cai with propaganda posters. Both joined the Shanghai Alliance of Left-Wing Artists in 1931, both went to Yan'an and joined in the art activities at the Lu Xun Art Academy. Since 1949 they had both held important and responsible positions in various art institutions.[66]

The difference between them probably lay much more in their personalities. Jiang seems to have been more inflexible in his approach towards art policy, adhering more closely to the principles he had imbibed at Yan'an. His mistake during the Hundred Flowers movement appears to have been a failure to comply quickly with the new policies, which left him stranded on the side-lines. Mao hinted at this when he said, referring to Jiang, "Old cadres have to think now — before there was a set of methods, but now we have contradictions among the people."[67] Zhou Yang, in his early speech on the Anti-Rightist campaign, accused Jiang Feng and others of "individualistic thinking. With their individualism they cannot be faithful to the Party."[68] However, it was clear that Jiang was not "individualistic" because he wanted to break away from Party control or to go against the Party as such, but simply because he was not flexible enough to change direction every time the Party did. Conformity to the prevailing dominant line of the Party was of the utmost importance, and failure to understand this could lead, as in Jiang's case, to the loss of position and good name. This was why Cai Ruohong could claim that "although Jiang Feng appears very left, he is, in fact, very right."[69] Cai demonstrated that he could be more flexible than Jiang, and except during the period of the Cultural Revolution, Cai managed to remain Vice-Chairman of the Artists' Association right into the 1980s. He had obviously learned the skill of how to flow with the political tide, however many times it turned. When the Hundred Flowers policy was announced, he applauded it

enthusiastically; when the Anti-Rightist campaign was initiated, he was at the forefront denouncing Rightists. His ability to change political direction ensured his survival; Jiang's failure to do so contributed to his downfall.

It is also clear that a general power struggle amongst the top art leaders, and personality conflicts between them and with individuals in the Ministry of Culture and the Department of Propaganda, as well as policy clashes, all had important roles to play in Jiang's demise, thus revealing the complexity of political movements in China. Simply dividing individuals into Leftists and Rightists as the authorities attempted to do cannot always explain the reasons for and the outcome of events. For instance, when Chen Qitong (from the cultural section of the political department of the People's Liberation Army) and three others wrote a letter to Mao declaring their reservations about the Hundred Flowers movement, even though Mao at first criticized them, they later avoided being branded as Rightists.[70] Jiang Feng, on the other hand, suffered that fate. Therefore, when Cai accused Jiang of being a Rightist, it seemed to be largely a pretext to bring disgrace upon him, rather than having any substantial theoretical justification. If we look at accusations of Jiang's reservations regarding the emphasis on "expert" rather than "red" in creative work during the Hundred Flowers movement, we see that his only crime was being temporarily out of step with the then current policy. Within a short period, policy shifted once again towards an emphasis on "redness". Jiang's "Rightist cap", however, was not removed.

Jiang may have had some views on traditional Chinese painting which differed from those of many traditional Chinese painters, but to say, as several individuals did in speeches against him, that his attitude towards it was completely nihilist[71] is somewhat over-stated. Jiang's reservations about traditional Chinese painting were only a reflection of the general Party view of it as elitist and decadent. In addition, as was discussed in Chapter One, several traditional Chinese painters shared Jiang's view that it was difficult to combine traditional painting techniques with revolutionary themes.[72] Jiang's transformation of the Traditional Chinese Painting Department at the Central Academy of Fine Art into a Colour Ink Painting Department emphasizing western drawing could be regarded as a sensible way to tackle this problem. It was certainly supported as an idea by Wu Zuoren and Liao Jingwen, the widow of Xu Beihong. Xu had

always regarded a solid grounding in drawing as the basis of all good art.[73] However it must be acknowledged that Jiang's firm belief that traditional Chinese painting could not adequately serve political purposes undoubtedly angered several traditional Chinese painters. As soon as the Hundred Flowers movement began, complaints were voiced by them that since 1949 insufficient attention had been paid to traditional Chinese painting and that "some people" still had the attitude of slighting China's national heritage.[74] This was surely an implicit criticism of Jiang, who was well-known for his views on traditional Chinese painting and who, as the most prominent Party figure in art circles, had the greatest influence over how much support should be given to it.

The evidence would suggest, however, that Jiang did not become the major victim of the Anti-Rightist campaign solely because of his attitude towards traditional Chinese painting.[75] The disunity within the Artists' Association leadership is probably a more important factor. Interviews with artists and art critics[76] suggest that the origin of Jiang's problems lay in a power struggle between Jiang and Cai Ruohong.[77] After 1949, the main control of the Chinese art world rested with four individuals, namely, Jiang, Cai, Hua Junwu and Wang Chaowen, the first two being particularly powerful. At the beginning of the Anti-Rightist campaign it appeared that Cai had the backing of Hua against Jiang (Cai and Hua had been friends since the Yan'an days), whilst Wang remained neutral. Jiang may have suffered from the lack of a substantial power-base, because of his failure to form close associations with most of the individuals from the extremely influential group whose roots could be traced back to the Yan'an days and the Lu Xun Art Academy. An unnamed member of Jiang's "Rightist clique" disclosed that during the Yan'an period Cai Ruohong was already part of one group that comprised amongst others Hua Junwu, Li Qun, Zhou Yang, Qian Junrui (the Deputy Minister of Culture in 1957) and Liu Baiyu (Deputy Head and Deputy Party Secretary of the Writers' Association), whilst Jiang may only have had close links with individuals such as Ding Ling and Chen Qixia, both of whom were discredited as early as 1955.[78] There was also some suggestion of enmity between Jiang and Qian Junrui. Qian was opposed to Jiang's decision to replace the Traditional Chinese Painting Department at the Central Academy of Fine Art with a Department of Colour Ink Painting, and had indirectly accused Jiang of

suppressing China's national heritage.[79] Jiang had, in turn, angered Qian by referring to "people in the Ministry of Culture who don't understand art".[80] Jiang's inability to build a lasting power-base and his mistakes in offending influential figures such as the Deputy Minister of Culture and several traditional Chinese painters, clearly played a substantial role in his spectacular demise.

Cases similar to Jiang's were replicated many times, at different levels and in different cultural fields and geographical locations. As we might surmise from the example of Jiang, of the 300,000–400,000 people labelled as Rightists, it is highly probable that a large proportion had not genuinely attempted to challenge Party principles at all, and many had probably been falsely accused for personal motives. Thousands were sent to labour camps for re-education, and Jiang Feng himself was demoted to a lowly art worker in an art studio. His Rightist label was not removed for twenty years.[81]

Those artists who were lucky enough to escape labelling[82] were sent to rural areas to "support socialist reconstruction in the villages", and to "further their thought reform". Beijing, Shanghai and Tianjin all had a "wave of going to the countryside". In Shanghai, 90% of the members of the Artists' Association, including prominent artists like Zhang Leping, volunteered to go to the countryside.[83] From Beijing, Wu Zuoren, Huang Yongyu, Ye Qianyu and Li Hua were just a few of those artists who went to live and work in rural areas.[84]

At the Central Academy of Fine Art and the Central Academy of Arts and Crafts the teaching programme was reformed as part of the general drive against Rightists. "Class line" was once again emphasized, as were both halves of the formula "red and expert" (during the Hundred Flowers movement, the focus had been, of course, on the "expert" part of the formula).[85]

All the old dogmas now returned to artistic discourse,[86] and the orthodox line became firmly re-established, even strengthened. Mao and the Party had learned that even a slight relaxation on the ideological front could cause great problems, so the constraints on artists became tighter than ever before. The campaign had created an environment of fear and suspicion which ensured that artists would respond more obediently to the next stage of Socialist construction. The initial euphoria had largely disappeared, leaving behind a growing sense of disillusionment and betrayal.

The dissent of individual voices had been ruthlessly suppressed and replaced by a more rigid uniformity that lay the foundation for the radical social programme of the Great Leap Forward.

The Great Leap Forward and the Anti-Rightist Deviation movement

Background

The Great Leap Forward was a movement based on what was known as the "general line of socialist construction". This general line was formulated after 1957 against a background of the successful completion of the first Five-Year Plan which provided a substantial material basis for economic development, as well as against a background of the successfully conducted Anti-Rightist campaign.

The Great Leap Forward also had its roots in the international scene. As Taiwan and its ally the United States continued to exert pressure on China, and as Taiwan attempted to form a North East Asian Alliance with Japan and South Korea, China's discomfiture increased.[87] In addition, following its Twentieth Party Congress, the Soviet Union began to adopt a less confrontational stance towards western countries. But towards China, it continued its long-term policy of domination by attempting to establish a joint submarine fleet with China and to set up a long-wave transceiver on Chinese soil (both refused by the Chinese authorities).[88] All these events constituted important conditions for the formulation of the general line of socialist construction, as they made China aware of the urgency and necessity of catching up economically with the western powers and with her strong Communist neighbour. In 1958, Mao stated that the Chinese economy was backward and China's material foundation weak. Furthermore, he said that "Spiritually, we feel we have been constrained. In this respect, we have not been liberated, so we have to push ourselves, gather our strength and go forward."[89] The external challenge and the relatively successful implementation of the initial attempts at reforming China's political and economic structures constituted the necessary pre-conditions for the Great Leap Forward.

Great Leap Forward policies

In March 1958 at a Working Conference of the Central Committee in Chengdu, the principles for the general line of socialist construction were first put forward using the formulation, "Go all out, aim high and achieve greater, faster, better and more economical results in building socialism". The main objective was to achieve rapid results. Mao also emphasized at the meeting that "we should break superstition, liberate our thought and develop the style of daring to think, daring to speak and daring to act."[90]

The theoretical justification for this policy was the radical leftist standpoint which was promoted and strengthened during the Anti-Rightist campaign. It comprised three main elements. The first was an emphasis on the role of individual subjective activity at the expense of objective necessity and economic laws. Mao suggested that as long as one had enthusiasm and determination one could achieve anything. The second element was a disregard for balanced development. Mao was against the idea of balanced development because he believed that it led to a lack of dynamism. Only by going against the vulgar and mechanical view of "proper" balance could progress be achieved. The third element was an emphasis on the theory of continuous revolution. Mao stated his view in 1958 that "Our revolutions come one by one", an idea which rejected the proposition of change through stable progression.[91] It revealed Mao's belief that a society should be continuously pushing forward, without any need for consolidation.

Above all, the most important driving force in Mao's thinking was his ambitious pursuit of a unique route to transform Chinese society from its economically backward state to a prosperous and ideal Communist utopia in a relatively short period so as to equal and even out-do the achievements of its Soviet neighbour. It represented a continuation of Mao's search for socialism with Chinese characteristics that had begun with his earlier idea of socialism moving "from the countryside to the city", which was against the Soviet Comintern's theory that revolution should move in the opposite direction.[92]

The main characteristics of the Great Leap Forward can be seen from two of its major propositions, namely "everyone to become a steelmaker" and the People's Communes. Both were based on the same principles. First,

they shared the "high target" aspiration, regardless of whether or not the targets set could be realistically attained. In agriculture, Party cadres strove to out-do each other in the amount their crops yielded. Hubei, Fujian and other provinces submitted grossly exaggerated figures for their wheat, cotton, peanut and rice production, in order to meet the demands of the high target plan. The same was true for steel. In 1957 the total annual steel output amounted to only 5,350,000 tons, and the authorities had the ambitious plan of doubling this during 1958. Some places seemed to have exceeded even the authorities' expectations, as Henan province first proudly proclaimed in early September 1958 that its steel production was 780 tons per day; then by 15 September it announced that output had miraculously soared to a staggering 18,693 tons per day![93]

Second, both objectives were to be achieved by means of a mass campaign. Mao had never placed a great deal of faith in hierarchical, bureaucratic systems using modern scientific management methods. He still believed results could be most effectively obtained by using the technique of the mass movement, which had played such an important role in the events leading to the Communist take-over in 1949. Now, social construction was to be conducted in the same way as guerrilla warfare, by mobilizing the enthusiasm and potential of the 600 million people who were to participate in this process.[94]

At the outset of the Great Leap Forward the entire cultural sphere was also mobilized to play a supporting role. Following the suppression of the first signs of independent thinking during the Hundred Flowers movement, artists were now intimidated into accepting the absolute leadership of the Party. The advent of the Great Leap Forward forced artists to abandon their private work and join the "great tide of socialist construction".

The organization of professional artists during the Great Leap Forward

Soon after Mao's call for a Great Leap Forward in all areas of society, the Artists' Association put forward five proposals to be heeded and implemented by all local branches of the Association and, in fact, by all artists throughout China. The first proposal was to produce a work plan for 1958

for a Great Leap Forward in the field of art. Concrete measures were to be designed to ensure its fulfilment. Next, artists were exhorted to pay attention to the ideological and artistic dimensions of art work. In stressing this point, the Association was trying to ensure that, amidst all the pressures on artists to produce large quantities of work, the quality of that work would not suffer. Third, artists were told to give their utmost support to the popularization of art works, which meant producing more New Year pictures, picture-story books, cartoons, propaganda posters and illustrations. The fourth proposal advocated more emphasis on training "the masses" in the technical aspects of art, in order primarily to facilitate the production of large numbers of amateur works of art. The final proposal emphasized the need for artists to go to the countryside or to factories at least once during the year.[95]

To fulfil these recommendations, artists in Beijing attended a series of meetings from March onwards to discuss the best way to implement the Great Leap Forward plan. As in industry and agriculture, art production was to be governed by the necessity to achieve the "high target".[96] In the course of these meetings thirty-nine cartoonists decided they would create 5,800 cartoons in 1958, and, to meet the needs of amateur cartoonists, they would send coaching teams to the countryside and to factories. A Great Leap Forward cartoon exhibition was also planned. Another fifty-four artists aimed to create six hundred paintings reflecting Great Leap Forward themes in a "popular style" that the workers, peasants and soldiers would understand and like. Staff from the Central Academy of Fine Art stated their intention to set up twenty evening schools in Beijing, as well as several correspondence schools. Ninety-six sculptors said they planned to hold two exhibitions and write a theoretical work of around 120,000 words on China's sculptural heritage. In keeping with the spirit of the Great Leap Forward, they also expressed their intention to learn from folk artists and craftsmen. Not to be outdone, woodblock printers aimed to produce 2,112 woodblock prints during 1958, and to organize a workshop in Beijing on the study of woodblock printing techniques. Finally, thirty-nine New Year picture painters set an ambitious target of completing within the year 3,812 New Year pictures, eight books, and various articles on New Year pictures totalling 160,000 words. These Beijing artists then challenged other branches of the Artists' Association to surpass their goals, and

Shanghai art circles seemed to have risen to that challenge, boldly stating that in 1958 they would complete a total of 10,000 pieces of art work.[97]

The idea of a "high target" in art production may seem absurd, but it was one which affected all cultural fields in 1958. For example, pressure was placed upon writers to devise figures for the amount of literary work they expected to contribute to "the Great Leap Forward in the cultural arena". Tian Han promised to write ten stage plays as well as ten film scripts within a year. Mao Dun planned to write one long novel and three novelettes, as did Ba Jin. Perhaps not so ambitious as his colleagues, Cao Yu only committed himself to composing five one-act plays.[98]

The emphasis during the Great Leap Forward, then, was to be on quantity, rather than quality; and in a complete turn-around from the Hundred Flowers movement, "redness" was to take precedence over "expertise". Figures for art production were set in much the same way as those for agricultural and industrial production, without any great discussion on "quality control". The aim was to create a competitive atmosphere between regions, so that each area would attempt to out-do others in terms of the sheer number of pieces to be produced. In the event, works of art did appear in great numbers, even though the high targets were not universally reached. Figures published in early 1960 revealed that between 1953 and 1957, "professional artists" (presumably those belonging to the national Artists' Association) produced slightly more than 3,000 pieces of work. In just one year, 1958, when Great Leap Forward enthusiasm was at its height, they apparently managed to complete 8,216 pieces, nearly three times as many as during the preceding five years![99] As long as ample materials were available, and considerations of quality remained secondary, "high targets" in art were apparently not quite as unrealistic as they eventually turned out to be in agriculture and industry.

In addition to setting targets, artists were obliged, as on other occasions during the previous nine years, to visit rural areas and factories to be re-educated and to help with the artistic training of the local populace. This time, however, it was not simply a question of a limited number of individuals going; the majority of artists went. All students and teachers from art institutions also had to undertake to spend between three and six months in the countryside or in factories. Several prominent artists, such as Gu Yuan and Shao Yu, even wrote enthusiastically about their experiences

and achievements.[100] Cheng Shifa, Jian Hanting and others went to the famous ceramics factory at Yixing,[101] whilst Lin Fengmian, Guan Liang and Shao Keping went to work in a cooperative on the outskirts of Shanghai.[102]

The emphasis on "national" and "popular" art and mass participation in artistic activities

The emphasis on national and popular art during the Great Leap Forward had its roots to a large extent in international factors. Faced with a continuing threat from the United States, and increasingly deteriorating relations with the Soviet Union, the Chinese authorities began to stress the need to develop a Chinese route to socialism. To achieve this, a strong sense of national identity needed to be fostered in order to harness nationalistic fervour for China's unique socialist construction programme. In the realm of art this essentially meant focusing on the types of art, mainly traditional Chinese painting and folk art, which were of purely Chinese origin. China's art (and general cultural) resources were thus utilized as a means of legitimizing prevalent political purposes.

A change in the official attitude towards traditional Chinese painting could be clearly seen from the indictments against Jiang Feng during the Anti-Rightist campaign. At this time the tide was already beginning to turn and one of the major criticisms against Jiang — and the only one directly concerned with his ideas on art itself — was that he had suppressed traditional Chinese painting and ignored China's historical legacy. In believing that only oil painting could express revolutionary themes, according to his critics, Jiang had thus revealed a wish to deny his own national identity.[103] However, as we have also seen, the authorities had always had an ambivalent attitude towards traditional Chinese painting, acknowledging its uniquely Chinese characteristics, yet also aware of its elitist associations and often doubting its usefulness in successfully portraying political themes. It had led to such anomalous situations as Qi Baishi being honoured with the position of President of the Artists' Association, whilst other prominent traditional Chinese painters were put to sweeping floors.[104]

During the Great Leap Forward, however, the ambivalence was largely pushed to one side, and artists and art critics were warned not to adopt a

"nihilistic attitude towards China's national heritage, nor worship foreign things".[105] Early in 1958 a spate of articles were published on the achievements and artistic legacy of Qi Baishi as the chief representative of China's traditional heritage. He was described in glowing terms as having "inherited and developed the best in the cultural and artistic legacy of ancient Chinese traditions."[106] The praise of Qi may not be so much in genuine honour of his achievements as it was borne out of political necessity. He was after all only a flower-and-bird painter, however skilled, who had never really made any attempt to reflect "the intense revolutionary struggle" or the lives of workers, peasants and soldiers in his work. The prominent position given to him in 1958 was more as a figurehead to link Chinese tradition and Chinese national identity with the Communist authorities, and unite artists ideologically under the banner of nationalism.

Though the importance of traditional Chinese painting was reaffirmed in 1958, it was China's popular arts which became the dominant art form during the Great Leap Forward. In line with general Great Leap Forward thinking, results were to be obtained through the methods of mass mobilization and mass campaigns, by utilizing the energies of the peasants, in particular. At a National Working Conference on Rural Culture held in Beijing between 20–30 April by the Ministry of Culture, Qian Junrui outlined two possible directions in which Chinese culture might henceforth develop.[107] The first he described as serving the socialist revolution and socialist construction and the vast mass of the people, its characteristics being summed up in the phrase "large numbers, speedy, good, economical" (*duo, kuai, hao, sheng*). The success of this line would depend on the mass participation of ordinary people, and it was therefore, by definition, anti-elitist. It represented a continuation of Mao's early ideas which went back to 1927 on the need to tap the energy and enthusiasm of the population as a whole if spectacular results were to be achieved. The second possible direction Qian described as "bourgeois and revisionist" ("bourgeois", referring to America and the West, and "revisionist", implicitly to the Soviet Union, though only Yugoslavia was actually mentioned). This line was characterized by a belief in "art for art's sake" and by being "a few in number, slow, poor-quality/bad, and extravagant/wasteful" (*shao, man, cha, fei*). Qian emphasized that it was the duty of artists to follow the first direction and thereby set the tone for the Great Leap Forward in the art

world. During the conference it was proposed that professional and amateur artists should work side-by-side with the people to create an "artistic high-tide". Caught in the general excitement, Hebei province promised to produce 100,000 paintings, Hunan promised 350,000 and Hubei 2 million! The intention was to ensure that "all villages would have murals, and slogans would be everywhere".[108]

The main thrust of the Great Leap Forward policy was to expand the ranks of amateur artists. Hubei, for example, planned to adopt a "Five-Combination Model", encompassing experimentation combined with coaching, group training combined with individual teaching, travelling art units combined with teaching at fixed locations, the taking of apprentices by artists and craftsmen combined with mutual learning between the people, and "exchanging experiences" combined with one or two centres where resources were to be concentrated. Using this model, Hubei intended to train up to eighty thousand amateur artists in 1958 to serve as the core force for carrying out the Great Leap Forward in art in the province. Other provinces followed suit. Heilongjiang, for instance, declared its intention to train twenty thousand core amateur artists, as well as promising that every agricultural collective in the province would have an art group before the following year.[109]

During the conference, "popularization" was affirmed as the top priority in cultural activities, and rural cultural clubs (planned for every collective farm) were seen as the main centres for organizing participation in these activities. However, art training or art production was not to be viewed in isolation, but had to be closely combined with political tasks and the usual demands for agricultural production. The six main principles put forward at the end of the conference were to serve as the ideological and practical basis for mass participation in artistic activities. They emphasized that art was to directly serve political needs and that artists should resolutely adhere to the "mass line". They also called for the establishment of a proletarian cultural army that was both "red" and "expert", and stressed that art activities should be carried out in close cooperation with the local Party leadership and other relevant departments.[110] The intention was for the movement to be directed not so much by the central Party apparatus, by means of decisions and plans formulated at the top, but more at the grass roots level under local Party leadership, which would integrate art

activities with all other facets of local social and economic life. One of the principles did relate to the importance of the Hundred Flowers policy, though it was made clear at the conference that the policy was to be interpreted not in terms of freer and more open artistic expression, but as a guide for solving the relationship between Chinese and foreign art, and between tradition and the present, which was more in line with the Great Leap Forward ethos.

Shortly after the conference, a cultural mass movement was initiated throughout China. A *People's Daily* editorial declared that "the entire party" was asked to collect folk songs.[111] Artists, writers and actors left their workplace and went to the streets and into the villages. Writers produced leaflets with poetry and short stories reflecting Great Leap Forward events, artists drew cartoons and painted traditional Chinese paintings that illustrated commune life and the growth of iron and steel production, and singers performed on construction sites and in the fields.[112]

Magazines and periodicals began to publish stories, paintings and poems by workers, peasants and soldiers. For example, the July issue of Shanghai's *Literature and Art Monthly* (*Wenyi yuebao*) was devoted entirely to short stories written by workers.[113] *Fine Art* also gave increasing coverage in 1958 to work by amateur artists, with special issues on peasant murals (September), and paintings and sculptures by workers and servicemen (November). The January 1959 issue of *Fine Art* had a series of articles featuring the discussions of worker and peasant artists on their own experiences as amateurs. A group of paintings with evocative Great Leap Forward titles, such as *Everybody Is Making Steel* and *The Liquified Iron Rushes Down* accompanied these articles.

Throughout 1958 almost every issue of *Fine Art* included paintings and articles produced by "artists from the masses". The percentage of their work in the magazine increased over the year, sometimes dominating entire issues, and inevitably there was a concomitant decrease in the work by professional artists. The People's Fine Art Publishing House also began in 1958 and 1959 to publish a whole series of worker, peasant and soldier painting albums, which brought together the best examples of this amateur art. The stated policy was to feature work that "displays the characteristics of the times".[114]

Exhibitions

A national exhibition of worker, peasant and soldier art was organized for the end of 1958.[115] It covered a whole range of popular forms, particularly New Year pictures and paper-cuts which displayed typical Great Leap Forward themes such as steel-production, "getting rid of the four pests" and building new roads in the countryside. Similar though smaller exhibitions were then held all over China. The Artists' Association at both national and branch levels paid great attention to exhibitions as a vital aspect of their Great Leap Forward activities. With the demand for gallery space at a peak, it had to devise makeshift means to ensure that as many as possible of the huge numbers of paintings and prints being produced were allocated exhibition slots. In Chongqing, ten or so long picture boards, each with the capacity to exhibit fifty to sixty pieces of work, were used as a gallery for amateur art. The exhibits on the boards were changed every two weeks, thereby facilitating a sizeable turnover of work. In Tianjin around two hundred large paintings were hung along the two busiest streets in its commercial centre, and people were encouraged to put up propaganda posters and Great Leap Forward paintings in their own homes.[116] The leadership of a Tianjin textile factory organized three hundred worker-artists to produce paintings to reflect the history of their factory as educational material for the workers' political training.[117] Throughout China, similar experiments took place in industrial and commercial units and rural communes.[118]

The mass campaign spread throughout the countryside. To fulfil the ideological requirements of the Great Leap Forward which required art work to become truly "popularized", special effort was needed in China's rural areas, which had hitherto been relatively neglected. Great attention was therefore paid to developing the technical skills associated with traditional peasant art, such as paper-cuts and New Year pictures. The most important development in art in the countryside was the new mural, which appeared everywhere and featured prominently in the art periodicals.

The new mural

Murals had existed in China for many centuries,[119] and were used original-ly for ceremonial or ritual purposes. Obvious examples were the tomb-tiles

from the mortuary shrines of wealthy and influential Warring States and Han officials, which depicted fantastic quasi-human figures, routine events of social life or ceremonial activities.[120] Following the arrival of Buddhism in China during the first century A.D., religious murals displaying scenes from the life of the Buddha, or illustrating the Buddhist sutras became widespread. Some impressive examples, like those in the Dunhuang Caves, have survived to the present day.[121] Others, such as those produced for the Buddhist temples in Luoyang by the celebrated Tang dynasty painter, Wu Daozi, are no longer extant.[122]

The propaganda potential of murals had not been fully exploited by the Communists prior to the Great Leap Forward. Although some murals were produced in Chinese villages during the War against Japan,[123] greater attention had been paid to developing the potential of New Year pictures in the communist base areas after Mao's Yan'an Talks.[124]

During the Great Leap Forward, however, whilst New Year pictures continued to enjoy a prominent position, it was the new mural that played an increasingly important role. It not only shared with New Year pictures the characteristic of being a purely Chinese art form, but it also used fewer resources and required less technical skill than even the humble New Year picture. This was a crucial factor, given the scale of the mass art movement envisaged by the authorities. Murals could be painted at any time, anywhere, as long as a spare wall was available, and only the simplest of materials were required. Murals were also highly visible, obvious to anyone walking down a village street or passing by a peasant's home. The mural thus constituted a highly appropriate tool for fulfilling Great Leap Forward requirements.

At the National Working Conference on Rural Culture, a speech made by Gao Xueqian, head of a peasants' club in a village in Changli county, Hebei province, outlined how the peasants had been inspired in the village. They had based their activities on the slogan "Great Leap Forward in production, culture follows closely, murals lead at the front, singing is the vanguard", and within only three days they had painted 164 murals. Each house had "six sides brightly coloured" and the face of the village was said to have been completely transformed.[125] Nor was this village an exception. Every town in Changli county was decorated with brightly-coloured murals and slogans painted in large elegant characters.

The murals displayed visions of the agriculture of the future, as well as exhortations to repair irrigation works, improve soil quality, and increase crop yields. Everywhere, there were pictures of peasants studying, rearing pigs, collecting pig manure and planting trees. Model peasants or workers from the locality were of course prominently featured.[126] In one village, the peasants' club published every ten to fifteen days a magazine of paintings by its members and showed it around the local brigades and during market days.[127]

In mid-August, the editorial office of Fine Art organized a small group to visit Pi county, Jiangsu province. The group later reported on the peasant murals and other activities of what became in effect a model county for amateur art work. It was discovered that the county had some 1,800 village art groups, boasting 6,000 amateur artists. In July alone, more than 23,300 murals and 15,000 propaganda posters had been completed. Every village reported more than ten murals and every brigade more than five. By August, even these figures had been surpassed, with 15,000 core amateur artists completing 105,000 murals and 78,000 propaganda posters. In half of the villages, it was reported, every house had painted on it between one to five murals, and in one of the towns, Guan Hu, there were 25,000 murals, though the town itself had a population of only 20,000.[128] Though it is impossible to confirm these figures, they do give an indication of the vast quantities of work produced. Most surprisingly, as reports showed, there was not one single professional artist living and working permanently in Pi county, and the huge number of paintings had been produced by amateurs, and generally as a sideline activity, secondary to the demanding requirements of agricultural production.

In addition to support given by the local Party committees, there were probably two main factors that contributed to the achievements of Pi county in popularizing art. First, professional artists from the Provincial People's Cultural Centre, Nanjing, visited the county to organize short-term training classes for the peasants. After training, these peasants then went on to train others in the villages, thereby quickly building up a substantial pool of individuals with the necessary rudimentary artistic skills. Second, the methods of organizing artistic activities were basically the same as those for "smelting iron" — mass participation and "getting on with the job using local methods", that is to say, improvising according to

the particular needs or resources of the locality. The first problem the Pi county peasants encountered was how to obtain the pigments needed to produce their murals. Initially they used household paint, but this meant each mural cost two yuan to produce, which was far too much if large numbers were to be painted. In addition, the process was too slow, with three art teachers being able to paint only three murals a day between them. As neither the cost nor the speed met Great Leap Forward requirements, other measures, drawing on local resources, had to be used. Red soil was dug from the mountains and roasted to obtain a red pigment; blue and purple came from the residue in the peasants' dyeing pots; kitchen chimney soot provided black and lime was used for white and crushed leaves for green. Brushes to apply the colour were made from palm leaves. For only a few yuan the peasants were thus able to paint their murals,[129] a situation reminiscent of the Yan'an days, when artists were able to produce woodcuts and New Year pictures at an extremely low cost.

Murals did not only appear on external walls but also on walls inside houses. They tended to feature the standard themes of Great Leap Forward aspirations. Yang Wei village in the Taihang Mountain district produced murals with titles such as *Women Carry a Load of 1,000 Jin, Sing for Socialism*, and the *Great Leap Forward Horse*. Typically for peasant paintings at this time, the content of Yang Wei village murals mainly reflected topics of local interest, with which the peasants were familiar, and which illustrated the daily activities of their village. For instance, the main crops of the village were Chinese potatoes and corn, and in one mural, stalks of corn were depicted as rockets and potatoes as satellites, both being launched at high speed towards Tiananmen Square. Its title was *Drive the Rockets, Fly in the Satellites; Every Mou of Land Has Produced 1,000 Jin for Beijing City*.[130]

A typical feature of the new mural was its close association with folk songs, as the words of folk songs were often written on or beside murals during the Great Leap Forward. With regard to this combination, it was commented: "Whatever cannot be expressed on the surface of a painting, poetry can provide. The image visible on the surface of a painting can also strengthen the effectiveness of poetry. Peasants say there is poetry in painting and painting in poetry. When you can unite painting and poetry, then you are a real expert".[131] These two popular cultural forms were thus

deliberately combined to maximize their educational effectiveness. In addition, one of the major aesthetic qualities said to characterize traditional Chinese painting and poetry, i.e., "In every painting there is a poem, and in every poem there is a painting" (*huazhong you shi, shizhong you hua*)[132] was here reinterpreted in a popular and one might say cruder form, without the subtleties that lay behind the original saying. Aesthetic elements of Chinese high culture were thus borrowed and transformed into an effective means of mass political propaganda, and an idea that once captured the imagination of China's cultural elite was now widely used for educating her semi-illiterate peasants.

A typical example of the combination of mural and folk song was in Xiao Pu River village, Changli county. The mural, titled *Bumper Harvest*, depicted a huge single stalk of corn, under the shadow of which peasants laboured in the fields. The words of the folk song on it went thus:

> One stalk of corn 1,000 zhang high.
> It breaches the blue sky and enters the clouds.
> If you ask who is planting in the fields
> It is not a spirit, it is not the Buddha, it is not a god
> It is the members of the commune.
> They have liberated their thought and are in high spirits.
> They dare to speak, dare to think, dare to work.
> The revolutionary peasants can plant a sprout that will shoot towards
> the sky.[133]

There are obvious affinities between the mural and the folk song. The content of both is characterized by a sense of great optimism and vivid imagery that is exaggerated almost to the point of absurdity, consonant with the idealistic ethos of Great Leap Forward aspirations. It is expressed in a direct and simple way, leaving no room for doubt as to the message being conveyed, an essential consideration when addressing barely educated peasants.

Wang Chaowen, when discussing the characteristics of murals, stressed their affinity with folk songs. He stated that each had been affected by the other and both possessed features of imagination, fantasy and speculation. Both followed the principle of Revolutionary Romanticism (a concept to be explained later), and revealed strong idealistic and romantic overtones. He provided many examples of how these features were

expressed — peanut shells as big as boats, stalks of corn as tall as trees, requiring long ladders to reach the top of them, three happy children carrying one huge ear of wheat, a balanced scale with a bean pod on one side and a child on the other, and a large Chinese cabbage with three children playing hide-and-seek inside it, accompanied by the folk song:

> *The Chinese cabbage has grown really big.*
> *Children can hide behind it,*
> *Xiao San Er has become really anxious*
> *Da Niu and Xiao Gou Wa are delighted.*[134]

In an article in *Fine Art* (December 1958), Wang Chaowen analysed the artistic features of peasant paintings, including murals.[135] His object was to challenge the view that peasant painting did not require any real skill, an opinion that probably originated from professional artists who were unhappy with the unprecedented emphasis on amateur folk art. Wang asserted that peasant painting had its own approach, and that people should not "blindly worship" any artistic technique, even those based on science, such as perspective or anatomical dissection. He stated that "any artistic principle, if it departs from practice and becomes absolute, is erroneous", and he warned artists that they "should not blindly follow foreign dogma". "In art", he stressed, "we have to emphasize subjectivity, rather than subjective laws".[136]

Wang was clearly trying to defend the techniques of the peasant artists and, in particular, the new murals. He was attempting to substantiate the Great Leap Forward assumption that in art, as in all other areas of socialist construction, it was wrong to worship scientific principles as absolute dogma. At the same time, however, he unintentionally confirmed that the peasant paintings were produced with little or no technical skill. He revealed that they were characterized by a lack of perspective, shading, focus and dissection and, as may be inferred from his remark on subjectivity, they ignored any notion of proper dimensions based on reality and objective laws. However, what Wang also made clear was that this apparent lack of skill was unimportant in the context of China in the late 1950s. The murals were not originally intended to be technically proficient, but were the fruits of a massive social experiment to engage uneducated peasants in creative work for the first time. In terms of its sheer

scale, the mural movement seemed to be, temporarily at least, largely successful.

New Year pictures

The second most important popular art form during the Great Leap Forward was the New Year picture. Discussions about New Year pictures had been given a prominent position in art periodicals since 1949, and in virtually every year a substantial debate took place on the subject, 1958 and 1959 being no exceptions. Because of the wide circulation of New Year pictures and their deep cultural roots amongst the peasants, the official policy was to use them as a major cultural weapon for political and social propaganda. However, due to the persistence of so-called "feudal" characteristics in many New Year pictures, the authorities had never been completely satisfied with previous attempts to combine revolutionary themes with this art form. The official view thus remained somewhat ambivalent.

We can see the importance of New Year pictures in terms of propaganda value from the statistics on their print-runs. It was estimated that in 1958 some 100 million pictures were printed, and that approximately half of the Chinese population (300 million people) regularly looked at one or more.[137] In one Chinese source, the 100 million prints were divided into 664 different themes, which were then grouped under a number of general categories:[138]

(1) Chinese folklore and traditional Chinese drama and theatre (196 themes)
(2) Children and plump babies (139 themes)
(3) Scenes from contemporary life (172 themes).

Two thirds of these, it was claimed, featured sport, acrobatics, dancing and "beautiful women" (*meinü*), and only a few, 8.6%, actually reflected the "revolutionary struggle" or "socialist construction". Only one theme was concerned with collectivization, which compared very unfavourably with pictures on the theme of horoscopes, which comprised a fifth of the total and numbered as many as 20 million copies![139]

The problems associated with New Year pictures were further illustrated in the following table:

Year	Themes			
	The lives of workers, peasants, soldiers and other political themes		Traditional Chinese opera, plump babies and other non-political themes	
	No. of prints	% of total	No. of prints	% of total
1955	859,000	38.0%	281,000	12.4%
1956	257,000	8.8%	1,700,000	56.6%
1957	346,000	7.3%	2,648,000	57.1%
1958	211,000	2.6%	5,829,000	72.4%

Source: See note 140.

From this table we can see that between 1955 and 1958 there was a drastic decrease in the number of New Year pictures on political themes; those that directly reflected the lives of workers, peasants and soldiers dropped from 38% to only 2.6% of the total. At the same time there was a concomitant increase in those depicting traditional themes, from 12.4% to 72.4%.

These figures tell us that by 1958 there still seemed to be a strong resistance amongst the people, and especially amongst peasants, to politicized art forms. They also confound the assumption that all art under the communists directly reflected political themes. Whilst murals were reasonably easily politicized, New Year pictures proved more of a problem for the authorities. Their continuing conservative nature was partly influenced by the buying power of the peasants. New Year pictures were generally bought individually by peasants for their own houses on a voluntary basis, unlike other types of paintings, which were normally purchased by work units, hotels, institutions, and so on.[141] It appears that the peasants' tastes in art were more difficult to change than the authorities might have hoped, and reveals that traditional tastes could exhibit a stable pattern and a strong resistance to change, even when there was a drastic transformation of the economic and political environment. Institutional change could be brought about fairly rapidly and easily through the establishment of powerful and comprehensive organizational structures. In comparison, deeply-rooted cultural habits, rituals, symbolic forms and their cultural associations, popular beliefs and aesthetic values proved much

more resistant to change. Popular forms of art often have an inner resilience, a mechanism that defies political interference.

The New Year picture for example is not just an abstract art form, but, from a social anthropological point of view, like ancestor worship, it is an integral part of the Chinese social ritual system. As a social ritual it cannot be separated from ancestor worship. Ancestor worship and the hanging up of New Year pictures are two of the most important aspects of the New Year, the latter because it is supposed to bring good luck.[142] The two actions are complementary and, in a chain of continuity, they link the past, present and future, symbolically ensuring prosperity for the following year. Therefore, changing the content or form of the New Year picture at a deep level involves in reality a process of changing people's social psychology, social ritual and the symbolic structure of their social life. Traditional aspects of the New Year picture thus inevitably persisted after 1949.

A *Fine Art* journalist who made an investigation in 1958 of New Year pictures had to acknowledge that people still preferred traditional themes to the political subjects favoured by the authorities:

> Old male peasants like beautiful scenery, and flora and fauna. Old female peasants like plump babies. They all like figures taken from folklore, stories from historical dramas and mythical stories. These kinds of things are most welcomed by peasants. In some counties, peasants say they particularly like "The White Snake Legend", "Havoc in Heaven", "The Cowherd and the Girl Weaver", stories from the "Three Kingdoms", "The 108 Heroes from the Water Margin", "Liang Shanbo and Zhu Yingtai".[143] These are the most familiar and favourite [subjects] of the masses."[144]

According to the Xinhua Bookstore, the main retailing outlet for New Year pictures, regardless of how many there were available with traditional themes, all could be sold out immediately. One of a series on "Liang Shanbo and Zhu Yingtai" titled *Transformed into Butterflies* sold out six times in succession.[145]

This *Fine Art* journalist revealed not only that peasants still greatly favoured traditional themes in their New Year pictures, but also that they most disliked those with any strong political message such as "Wang Gui and Li Xiangxiang"[146] and "Soviet Experts Visit a Collective Farm". It seemed that even though the modern New Year pictures often attempted to imitate the bright and vivid colours of their traditional counterparts (certain bright colours were important because they were thought to bring

good luck), they obviously lacked the cultural resonances and symbolic associations that endeared the traditional New Year picture to the peasants.

During the Great Leap Forward, however, the resistance of the New Year picture to Communist ideology came under renewed pressure. The authorities were fully aware of the strong influence of the New Year picture as one of China's most popular art forms, and realized that problems with it continued to exist. Articles expressing forceful criticism of traditional influences on New Year pictures began to re-appear,[147] and some practical measures were also taken to reform them.

A typical example of this occurred in Shandong province, where the cultural authorities attempted to use New Year pictures to convey political ideas by introducing new subject matter. Shandong's traditional New Year pictures depicted a wide range of themes and, in common with those elsewhere, exhibited exaggerated, decorative and brightly-coloured images displayed in a symbolic and highly generalized form. Each of the main subjects and types had a specially allocated place inside the house:

> The "Door-God" on the front door of the courtyard.
> The "Painting and Character Lamp": on the courtyard wall and on the various lamps in the house.
> "Foreign strips" and "Moonlight pictures" on the internal doors.
> Special paintings called "Beside the Window" and "Above the Window": round the window areas
> The "Stove Horse" (a type of Chinese peasant calendar): by the stove.
> "Surrounding the Table" (pieces of cloth with simple printed or embroidered patterns hung around or placed upon the table): to decorate the table.
> The "Small Horizontal Slope" — a mixture of poetry and pictures: above the kang.
> "Wooden Squares" (wooden blocks with carved or painted images): for alcove decoration.
> A "Vertical Drape (Roll)", paintings of beautiful women: on the walls, on screens.
> "Stable Door Paintings": on stable doors
> "Cow" paintings (of farm animals): on both sides of farm carts.

During the Great Leap Forward the Shandong art authorities attempted to imbue these various pictures with political messages. For example, the Door-God was deliberately transformed into the "Bumper Harvest"; the "Moonlight" pictures had to reflect contemporary women and children themes; the beautiful women on the screens became women

working in the people's communes and the small horizontal scrolls of poetry and painting were to include new revolutionary folk songs.[148]

These innovations in Shandong were subsequently lauded by the Beijing art authorities and by the mid-1960s Shandong had become a model for the reform of the New Year picture. In the introduction to a collection of Shandong's New Year pictures published in 1965 it was pointed out that progress had been made in toning down the exaggerated and naive features of the earliest post-1949 efforts, and that the New Year picture could now more effectively reflect real life and contemporary events.[149] However, in China as a whole, the authorities still needed to maintain their vigilance over the tendency to favour traditional themes and forms in New Year pictures, particularly during periods of political relaxation when official pressure to produce highly politicized work was eased. At such times, even artists in the "model" province of Shandong often returned to the motifs commonly found in traditional New Year pictures, as can be seen from Shi Banghua's picture, *Carp Jumping over the Dragon Gate* produced in Weifang in 1959 (Fig. 5).

Propaganda posters

The propaganda poster was an important means of conveying Party ideology, particularly during mass movements such as the Great Leap Forward. This newest art form to China had since 1949 reflected virtually every political movement and issue. In terms of artistic technique, it drew on traditional Chinese art forms, such as the bright, unmodulated colour of New Year pictures, as well as on Soviet propaganda posters with their use of shading and perspective, simple political slogans and prominent positioning of human figures.[150]

At the end of 1959 a conference on propaganda posters was organized to coincide with a ten-year poster retrospective held in Beijing.[151] Statistics cited at the conference reveal that between 1950 and 1957, the People's Fine Art Publishing House published 286 varieties of propaganda poster and printed 16,530,000 copies. During the Great Leap Forward, the yearly average increased dramatically and in just one twelve month period 241 varieties were published and 11,340,000 prints made. This constituted more than two-thirds of the output for the previous eight years. There was

a uniform increase across the country. The Tianjin Fine Art Publishing House, for example, published only 17 varieties of propaganda poster and printed 144,000 copies in 1957. In 1958 the figures were respectively 130 varieties and 13,200,000 copies, and in 1959, 120 varieties and 3,416,000 copies. In 1958, a particularly popular propaganda poster, titled *The People's Communes Are Good*, attained a sales total of 8,230,000. It was explained that, if not for a shortage of paper, 15 million copies would have been printed to satisfy public demand.[152]

An increasing number of professional artists were enlisted to work on propaganda posters during 1958 and 1959. It was noted at the conference that artists had previously been reluctant to engage in such work but that with the beginning of the Great Leap Forward they were "voluntarily knocking on the doors [of the authorities in charge of art] to offer their services for propaganda poster work",[153] a measure, perhaps, of the success of the Anti-Rightist campaign in ensuring the compliance of artists in subsequent political movements.

In order to coordinate poster publication and printing with other Great Leap Forward activities, posters were produced at a tremendous pace. New designs were shaped up in a few hours and sent directly to the printing press where the entire process was monitored by editors. Posters of particular importance could be produced in around ten hours from conception and design to final printing. The poster thus became an almost instantaneous expression of Party policy, reflecting the smallest changes in leadership thinking almost as quickly as did official statements. However, since speed and quantity were the two most important considerations in poster production, quality was inevitably sacrificed in many cases.

In order to maximize the propaganda effects of posters, stylistic changes were recommended at the poster conference, the most pressing of these being the incorporation in the posters of more of the features to be found in popular art forms, such as the vivid colours of New Year pictures, and a reduction in those features that characterized the Soviet propaganda poster, such as shading, or strong contrasts between black and white. Speakers at the poster conference implicitly acknowledged that the poster in its present form was receiving only a tepid response from peasants, and that greater use should be made of traditional methods.[154]

Art education

From the outset of the Great Leap Forward, art education was targeted as a major area for reform. In February 1958 the Ministry of Culture held a five-day meeting specifically to discuss the issue, which centred on the need "to combine art education with practice". The Central Academy of Arts and Crafts in Beijing worked out a plan for 1958 to implement comprehensive reforms. Purely classroom-based teaching was replaced by practical work in production units or workshops, where students would acquire skills from experienced craftsmen.[155] Students and teachers from all other art institutions were also required to work in rural areas or factories as part of their standard curriculum. In an effort to narrow the gap between traditional Chinese painting and popular arts and crafts, several artists from the Shanghai Traditional Chinese Painting Academy, such as Cheng Shifa, Tang Yun and Wang Geyi, were sent to the Shanghai Enamelware Factory to work in conjunction with craftsmen there to improve the designs of industrial products.[156]

An important development was the re-appearance of "the class line", which required the training of working-class artists who were both "red" and "expert". A five-year plan formulated at the February meeting on art education directed that the percentage of peasant and worker students in all art institutions should reach 60-70%, from which we can infer that it had originally been far below this level. It was also declared that the proportion of so-called "leftist" teaching staff should reach 70%,[157] suggesting that the Ministry of Culture still felt that a substantial proportion of the staff in art institutions were of questionable loyalty.

Soon after this meeting, the Zhejiang Academy of Art (formerly the Eastern Branch of the Central Academy of Fine Art) began to recruit workers to its courses, and several provinces organized special classes to train a core body of worker-peasant-soldier artists.[158] In addition, new "amateur" art schools to train peasants in rudimentary artistic skills were set up in rural areas. In Ji River county, Hebei for example, one such school was established on 21 July 1958. It operated on an essentially part-time basis, students attending classes during the slack season. At other times, teachers would go out to coach students in groups or even individually. The professional woodcut artist Gu Yuan was appointed as Deputy Head

and the local Party Secretary as President. The student body consisted
entirely of peasants.[159] This tripartite system, bringing together profes-
sional artists, Party cadres and peasants, represented a new form of Great
Leap Forward art education. Combining professionals and amateurs ful-
filled the formal principles that had been elaborated in earlier Great Leap
Forward policy documents.

Revolutionary Realism and Revolutionary Romanticism

An important theoretical idea underpinned these practical changes intro-
duced during the Great Leap Forward. It was put forward by Mao himself
during the second plenary session of the Central Committee when the
general direction of socialist construction was first outlined. Mao stated
that proletarian literature and art should adopt a creative method based on
a combination of Revolutionary Realism (i.e., Socialist Realism) and
Revolutionary Romanticism.[160] From the outset, the concept of socialist
construction and that of Revolutionary Realism and Revolutionary
Romanticism had strong associations, and a close theoretical link existed
between them. Revolutionary Romanticism, as an aesthetic concept
brought to prominence during the Great Leap Forward, was a direct
manifestation of Mao's ideas concerning subjective idealism and his belief
that initiative and enthusiasm could overcome and transcend all objective
conditions, and thus realize Communist ideals. Those with an idealistic
and romantic revolutionary spirit, with imagination and determination,
could transform romantic ideas into reality.[161]

The concept of Revolutionary Romanticism, like that of Socialist
Realism, can be traced back to Soviet theorists. Andrey Zhdanov, Polit-
buro member and hard-line ideological chief in the Soviet Union during
and after the Second World War, made the first major pronouncement on
it in 1934 when he stated:

> The whole life of the working class and its struggle consist of combining the most
> severe and sober practical work with grand heroics and great prospects. Roman-
> ticism, a new type of Romanticism, a revolutionary Romanticism, cannot be alien to
> Soviet literature.[162]

In his Yan'an Talks Mao asserted that life, as reflected in works of
literature and art, could be and ought to be on a higher plane, more

intense, more generalized, more typical, more idealized and, therefore, with more universality than ordinary life and reality.[163] Clearly, for Mao, mirror-images or realism were not appropriate or adequate for the needs of Socialist art. His commitment to romanticism was evident in the poems he wrote himself and in his personal taste in classical Chinese poetry. He always favoured the romantic, imaginative Li Bai more than the realistic and descriptive Du Fu.[164]

Mao's inclination towards romanticism was also clearly manifested in Great Leap Forward sentiments which stressed heroic, idealistic ambition, romantic imagination and human subjectivity at the expense of real conditions and objective laws. The emphasis on creating anew, on going beyond natural laws to transform the ordinary processes of life by using non-conventional means, established the environment for the development of Revolutionary Romanticism as the major principle governing art during the Great Leap Forward years. Zhou Yang described it as an idea put forward by Mao which accorded with the Marxist theory of the unity between continuous revolution and progressive stages of revolution, claiming that Mao had succeeded in dialectically uniting the two methods of realism and romanticism in artistic creation.[165] The combination of Revolutionary Realism and Revolutionary Romanticism was elsewhere described as being best understood in terms of the relationship between the two philosophical categories of phenomena and essence.[166] A further explanation came from the artist Ge Lu: "If the philosophical foundation of critical realism is materialism, then that of the unity of Revolutionary Realism and Revolutionary Romanticism is dialectical materialism."[167]

These three statements by Mao, Zhou and Ge all in their own way defined the core ideas which formed the basis of Revolutionary Romanticism. Dialectical materialism is a synthesis of aspects of Hegelian dialectical idealism and eighteenth century French materialism. Dialectical materialists, of whom Mao was one, wish to describe or reflect the objective world, but at the same time, unlike the proponents of naturalism, they are not satisfied with simply constructing a mirror-image of that world. They aim instead to project their ideas or their imagination onto reality, as its essence, so that these ideas can be fulfilled in the objective process. They emphasize the unity between phenomena and essence and between the objective world of concrete things and subjective knowledge and ideas.[168]

The relationship between Revolutionary Romanticism and Socialist or Revolutionary Realism requires clarification, since in many respects the two ideas appear to be similar. Socialist Realism, in contrast with western naturalism or realism, embodies elements of romanticism. It does not attempt to reflect randomly objects or events from the concrete world, but in accordance with a Socialist world view or Socialist principles. It thus carries within itself aspects of realism and to a lesser degree, romanticism. This is manifested, for example, in the depiction of the typical Socialist hero who is meant to be the embodiment of Communist ideals, but whose human figure in terms of artistic representation is depicted largely in accordance with objective laws. Major events represented in Socialist Realism are highly selective and often tinged with romantic overtones, such as evocative splashes of red colour or dramatic expressions on the faces of individuals (Fig. 4). However, although the overall effect can at times be melodramatic, themes are normally based on historical fact or drawn from real life, and the images produced are on the whole constructed in standard proportions and perspectives. The difference between Socialist Realism and Revolutionary Romanticism is mainly one of degree — the latter involves an over-emphasis on the romantic dimension, often to the point of absurd and implausible over-exaggeration, whilst the former attempts to maintain some degree of balance between objective representation of certain features of reality and emphasis on specific aspects of that reality. Revolutionary Romanticism is more deeply rooted in the philosophical foundation of objective idealism than in materialism.

This exaggerated characteristic of Revolutionary Romanticism appears most clearly in the folk arts, particularly in the new folk songs, murals and New Year pictures of the Great Leap Forward era. The folk songs were full of vivid verbal imagery, describing the superhuman efforts of the Chinese people to change their environment and lauding their power to overcome nature: "In Heaven there is no Jade Emperor, On Earth there is no Dragon King.[169] I am the Jade Emperor, I am the Dragon King. When I give a command the three mountains open a path for me — I'm coming!"[170] Peasant paintings, as we have already seen, depicted an idealized world of the future, in which wheat and corn and other grain crops grew several metres high and in which vegetables attained such prodigious proportions that children were able to play games inside them (Fig. 6). They were

usually vibrant with the frenetic activity associated with the Great Leap Forward (Fig. 7). Often there appeared in them row upon row of peasant figures joyfully engaged in the sowing or harvesting of crops and in the rearing of animals, with innumerable figures set against a background of unmodulated and contrasting primary colours to achieve a more vivid and startling effect.

It is, perhaps, unsurprising that it was the works by peasant artists which most clearly manifested the principles of Revolutionary Romanticism. The concept itself, as it applied to art, would not have seemed all that alien to the peasants, their own folk art tradition being to a great extent based on highly imaginative images of larger-than-life individuals, divinities, birds and beasts, all represented in fantastic dimensions and brilliant colours. In terms of picture-making, the work of peasant artists during the Great Leap Forward was the more satisfying, and the overall effect was fresher, livelier and less forced and constrained than earlier attempts by professional artists to translate more prosaic subject-matter, such as the PLA man, into the traditional mode of the New Year picture. The peasants, as amateurs, were limited neither by the need for adherence to objective, scientific dimensions and scale as required by realism (and, hence, Socialist Realism), nor by the conventions of spatial relations, an overall sense of harmony, and so on, that normally applied to traditional Chinese painting. Largely unfettered by the aesthetic considerations that constrain professional artists, they were able to give free reign to their imagination and, using brushwork that was both spontaneous and lively, they produced the idealized images of a future Socialist society that so characterized Revolutionary Romanticism.

Revolutionary Romanticism could however be double-edged. Its emphasis on imagination and romantic expression could allow it to be used in opposition to official policy and in support of individual subjectivity. After all, during the Great Leap Forward there was much talk by the authorities of unleashing the "subjective force" of the masses, though paradoxically within the parameters of Party policy. However, there was the possibility that artists, in the name of "subjective romanticism", might challenge the old framework based on Socialist Realism and thereby pose a threat to the uniformity dictated by political priorities.

The authorities, aware of this possibility, were forced to define

romanticism in their own terms to limit any unwelcome side-effects of their policy. In numerous articles published in the *Literary and Art Gazette* and *Fine Art* and in the speeches of Zhou Yang and other Party ideologues, there was severe criticism of "negative romanticism" based on "bourgeois individualism", and a constant attempt to differentiate between this and Revolutionary Romanticism, or even "progressive" romanticism. One writer equated practitioners of "negative" or "reactionary" romanticism both with those who wanted to "return to the old traditional kinship-based medieval mode of life", rejecting Enlightenment aesthetics based on materialism and realism, and with those who indulged in "pure aesthet-icism" and who followed modernist tendencies in art. The so-called "progressive" romanticism of Europe, as manifested in the works of the writers Byron, Hugo and Lemontoff, the composers Schubert, Chopin and Liszt, and the French Romantic artist Theodore Gericault, was endorsed since it expressed the "fighting spirit of capitalism against feudalism" from the eighteenth century onwards.[171] In fact, during 1958 and 1959, with the exception of work from the Soviet Union and Eastern Europe, the only western paintings referred to positively in art periodicals were those of the French Romantics.

As part of the general attack on "individualistic" romanticism, examples were made of artists whose work fell into this category. These included Wang Shiqiu, Yuan Yunsheng and Wu Jing, who, capped as Rightists during the Anti-Rightist campaign, were again accused in 1958 of "impos-ing their own fantasies on empty imaginations" and "attempting to release and express their own individualistic emotions".[172]

For the authorities, then, the concept of Revolutionary Romanticism when applied to art needed to be handled with care. It perfectly embodied Great Leap Forward aspirations, not only because it depicted Great Leap Forward activities, but also because it could be easily practised by the great mass of the Chinese people and thus fulfilled one of the Great Leap Forward objectives, namely that everyone could be an artist.[173] However, it could also be manipulated, particularly by professional artists, to negate this very purpose. Though supposedly rooted in the entire community and intended to reflect the collective consciousness or will, Revolutionary Romanticism could also be re-interpreted as a means of allowing individual subjective expression that fell outside of the authorities' political programme.

The further tightening of ideological control during the Great Leap Forward and the Anti-Rightist Deviation movement

During the Great Leap Forward there was continuous reference in official publications to the importance of criticizing Rightists, individualism, and the tendency to over-emphasize being "expert" at the expense of being "red". There were also repeated reminders that "politics was in command", and numerous calls for unconditional subordination to the Party. In February 1958, the Artists' Association organized a meeting in Beijing that was attended by cadres from branches nationwide to summarize the results of the Anti-Rightist campaign and to counter remaining Rightist tendencies.[174] During this meeting, in order to prepare the political and ideological climate for the implementation of the Great Leap Forward in the field of art, the leading role of the Communist Party in art was stressed, and condemnations were voiced of the view that artistic technique should take precedence over politics. An earlier editorial in *Fine Art*, titled "Uniting with Workers and Peasants Is the Necessary Route for Revolutionary Artists", outlined a list of dangerous ideas advocated by Rightists, the foremost of these being emphasizing artistic technique above all else, advocating creative freedom and "bourgeois individualism", all of which were "opposed to Socialism and the Party's policy on art."[175]

Throughout the Great Leap Forward years, an ideological campaign was waged against any deviation by artists from the imposed orthodoxy, and any sign of independent expression was consistently and severely curtailed. Strict control was maintained over artists, beginning with the Anti-Rightist campaign and re-enforced through the constant criticism of "bourgeois individualism" and of any reticence on the part of artists over participating in the mass campaign. There was strong and concerted pressure on artists to re-evaluate their values and their creative goals in order to bring them into line with current policy. In the Central Academy of Fine Art and other art institutions, occasions were staged during which artists had to undergo a ritual self-examination and self-criticism. They had to "open their heart to the Party", in order to purify their thinking and so become "a cog in the huge revolutionary machine".[176] This sustained political pressure was, in fact, an integral part of the entire mass social engineering movement of the Great Leap Forward. It forced many artists

into an acceptance of what proved to be an irrational course, the validity of which went initially largely unquestioned.

Nevertheless, there were still discordant voices to be heard. In 1959, during a debate on landscape and flower-and-bird painting, the artist He Rong published two articles claiming that this kind of painting was being discriminated against and deliberately suppressed because it was a traditional form of art that was unable to reflect important social and political themes. He argued against this discrimination, and the general practice of differentiating between "main" (zhu) themes (themes with heavy political overtones) and "secondary" (ci) themes, which included landscape and flower-and-bird painting: "When building a machine, iron and steel are important, but when one constructs a park, flowers are essential."[177] Clearly, He Rong was advocating a broader and more generous interpretation of what should be politically acceptable in creative work, and voicing doubts over the heavy over-emphasis on paintings whose content was overtly political.

However, even small sparks of dissent such as this were quickly snuffed out as the Great Leap Forward pursued its course. On 2 July 1959, an enlarged politburo meeting was held at Lushan in Jiangxi province, during which the Defence Minister, Peng Dehuai, wrote a letter to Mao criticizing the Party's (and, hence, Mao's) mistakes in handling the movement, attributing its excesses to "ultra-leftism" and the "crazy enthusiasm of the petty-bourgeoisie".[178] His opinions had some support among other members of the Party elite, particularly Zhang Wentian, the Deputy Foreign Minister, Zhou Xiaozhou, the First Secretary of the Hunan Party Committee, and Huang Kecheng, Chief-of-Staff of the People's Liberation Army and Deputy Defence Minister. These three, along with Peng, were subsequently condemned as an anti-Party Rightist opportunist clique and removed from their posts.[179] Shortly after, on 7 August, the Party issued a directive which stated that Rightist Deviation (in reality, opposition to the excesses of the Great Leap Forward) had become a major obstacle to successfully implementing the movement, and that steps would have to be taken to overcome it.[180] At all levels and in different fields people were again targeted for criticism and labelled as Rightist Deviation Opportunists. In all, it is estimated that some 3,650,000 Party cadres and Party members, and a further 3 million non-Party people were implicated.[181]

Party dogma was pushed to an even greater extreme, further away from the reality of the prevailing situation or from rational consensus.

In the realm of art, there was continuous criticism of "bourgeois" and "revisionist" views and a renewed emphasis on the importance of Mao Zedong Thought as a guiding principle in art work. During 1960, both in the *Literary and Art Gazette* and *Fine Art*, there was a spate of articles concerning "the Party principle of proletarian literature and art", they insisted that politics should be in command, and that everyone should seriously study Mao's thought and struggle against revisionist and bourgeois ideas on the art front. The editorial office of *Fine Art* even issued a self-criticism for losing its vigilance against such ideas, referring to two discussions that had been published on landscape and flower-and-bird painting that included "mistakes of principle".[182] The discussions, of course, were the work of He Rong who, in 1960, became the main embodiment of Rightist ideas in the art world. He, along with Zhang Wang and Chen Shuliang were severely criticized in a series of articles in *Fine Art*.[183] *Literary and Art Gazette* even compiled a set of four articles by He Rong into an "internally circulated booklet" for a limited readership to peruse and criticize.[184] He was accused of attempting to attach equal importance to all types of paintings, regardless of whether or not they reflected Great Leap Forward themes:

> In discussing landscape and flower-and-bird painting, placing them in an inappropriate position will serve to downgrade our most important art work which reflects the lives and struggles of the people. It will create confusion amongst artists, blur their correct direction, affect their enthusiasm, and the result will reduce the combative role of proletarian art.[185]

In another implicit attack on He Rong, the art critic, Yi Wen, went further by defining the class nature of Chinese landscape painting. He asserted that it was erroneous for some to claim that landscape painting had no class nature, that it was simply a copy of nature, and nature itself was classless. In line with Leninist and Maoist thinking, he reiterated the point that artistic creation, like all human activity, would inevitably reflect a particular social consciousness, and, similarly, people's aesthetic tastes would also display a class bias. His view was supported by others who affirmed that when discussing traditional Chinese painting one should not

ignore the fact that there was no such thing as beauty, whether of nature or otherwise, that went beyond the boundaries of class.[186]

A point that deserves mention here is that, even as ideological control was being tightened within China, and virtually only those works of art that directly reflected Great Leap Forward themes were allowed for exhibition or for publishing in art periodicals, those paintings sent abroad for exhibition did not necessarily need to fulfil these requirements. In December 1958, the paintings contributed by China to the "Socialist Art Exhibition" in Moscow did not all reflect Great Leap Forward themes or other political movements, as could be seen from some of the titles — *Peonies, Goldfish, The Flower Basket, Water Lilies, Guilin Landscape*, and traditional themes such as "Chang E", motifs from *The White Snake Legend*, and "Dai Yu Reading", from the traditional novel *Dream of the Red Chamber*. In addition, paintings sent to Paris in January 1959 for an exhibition entitled "Chinese Painting over the Last Hundred Years" comprised mainly works painted by traditional Chinese painters, such as Ren Bonian, Wu Changshuo, Huang Binhong and Qi Baishi, none of which could be said to reflect the "revolutionary struggle".[187] In these two exhibitions, the artistic dimension certainly did not seem to have been subordinated to the political one.

This suggests that when the audience was foreign, the artistic dimension of exhibited art work could be at least as important as the political dimension, which reveals that the ideological principles of the Chinese authorities could, when necessary, be flexible. It also shows that the authorities were not ignorant of or blind to what we might call the aesthetic value of art. Internally, they pursued a deliberate policy of manipulation and indoctrination, placing severe constraints on what kind of art work was politically acceptable. When it came to foreign audiences, however, the authorities seem to have been aware that maximum propaganda value abroad could not be reaped from exhibiting heavily political works, and that high quality art with less marked propagandist overtones would show China in a more favourable light on the international stage.

Although it appeared superficially that the movement against Rightist Deviation was going to constitute a re-enactment of the earlier Anti-Rightist campaign, in reality, there seemed to be far less enthusiasm in art circles for yet another political upheaval. No major figure fell victim to this

later movement (although it could be argued that at this stage there was a much smaller pool of people to choose from, with many prominent artists and art cadres already dismissed from their posts and sent for "re-education"). The Anti-Rightist campaign and the Great Leap Forward had evidently drained some of the energy and enthusiasm of artists and Party ideologues alike. In addition, the Anti-Rightist campaign of 1957 was directed more against intellectuals and specifically against erroneous ideological thinking, so that a large number of cultural figures were discredited. It also never really spread to China's rural areas. The Anti-Rightist Deviation movement, on the other hand, targeted above all the political and economic spheres, and it affected all sections of Chinese society in both urban and rural areas. In this case, artists and writers were not the primary targets. But perhaps one of the most important underlying reasons for the lack of a strong response by artists during this latter movement was a gradual realization regarding the disastrous consequences of the Great Leap Forward, which were becoming apparent in 1960, and which were to lead to yet another re-adjustment of Party policy.

The disastrous consequences of the Great Leap Forward, the rise of a more pragmatic approach

By 1960 it was becoming increasingly obvious that the Great Leap Forward policies had been disastrous, particularly in the economic sphere. In the countryside, time devoted by the peasants to producing useless low-grade steel should have been spent tending crops in the fields. Agricultural output in 1960 dropped by 13.6% on the previous year and total grain production only managed to reach the 1951 level. Similar situations prevailed with cotton, rapeseed and livestock.[188] In industry, too, the entire value in renminbi of industrial output was down by a third in 1961 compared with the 1960 figures, while the state's total financial income dropped by almost half between these two years. There were shortages everywhere and mass starvation in the countryside.[189] The economic situation was aggravated by political events as the worsening relationship between China and the Soviet Union led to the withdrawal of Soviet technical assistance, aid and expertise. A potential crisis over Party

credibility loomed as the mistakes made with the economy revealed the scale of incompetence and gross mismanagement. The Party leadership was obliged finally to move from an unsustainable ultra-left policy to a more pragmatic, more realistic position. At an enlarged Central Committee working meeting in 1962, Liu Shaoqi, on behalf of the Party and Central leadership, accepted responsibility for the errors committed during the Great Leap Forward and acknowledged the necessity of making policy adjustments.[190]

The first obvious sign of the new pragmatic policy was Mao's "retreat from the first line of politics to the second", and his replacement by Liu Shaoqi, Deng Xiaoping and Chen Yun, all known to be less radical and more pragmatic in their approach. There followed a series of policy adjustments that were not limited to the economic front, but also covered the political, scientific and cultural fields. There was a return to more realistic economic planning, and the people's communes were re-organized so that the distribution of agricultural products and, indeed, effective control of production lay increasingly in the hands of the small-scale production brigades.[191] In industry, there was a renewed emphasis on improving efficiency and cost effectiveness and in commerce and craftwork there was more stress on the basic principle of commodity exchange in order to help revitalize the market.[192]

New Party documents on education ("Sixty Points on Higher Education"), on science ("Fourteen Opinions on the Present Work in Natural Science Research Institutions") and on culture ("Eight Points on Culture") established the new pragmatic direction for intellectuals. The document on culture was issued in 1962,[193] though adjustment had already been under way since 1960. It implicitly acknowledged that during the Great Leap Forward, the arts had been adversely affected by leftist mistakes, crude criticism, inappropriate interference and a too rigid administrative system. It called for the encouragement of artistic work which provided enjoyment and satisfied the people's aesthetic needs, as well as educating them in socialist ideology. In contrast to the highly uniform nature of art produced during the Great Leap Forward, it stated that themes should be rich and varied, that there should be a variety of styles and schools, and that individuality in creative work was to be supported. It also mentioned that time for creative work should be guaranteed by giving appropriate attention to

the need of writers and artists for both work and rest. It thus implied that the policy of sending those involved in cultural activities to the countryside should be drastically modified. Finally, the document made clear the need to ensure that cadres in charge of culture should have a certain level of understanding and expertise in their own particular cultural field. In line with adjustments in other areas, a certain degree of professional knowledge and technical expertise was to be required of cultural cadres. The qualification of being "red" alone was no longer sufficient.

Organizational changes

One of the first steps the authorities took in the early 1960s was to correct their previous mistakes over personnel during the Anti-Rightist Deviation movement and to a lesser extent the earlier Anti-Rightist campaign. In all, more than 3,650,000 Party members and cadres and an additional 3,700,000 non-Party people were rehabilitated.[194] Zhang Wang and Chen Shuliang were openly rehabilitated in *Fine Art*,[195] and the Party leading group in the Artists' Association reversed its decision on He Rong, declaring the harsh attacks against him to be a mistake.[196] Li Keran and Li Qun, who had been implicitly criticized, though not actually by name, during the Anti-Rightist Deviation movement, were also offered an apology.[197]

Another sign of the less radical atmosphere was a change in the constitution of the Artists' Association. Anyone who had published theoretical essays or exhibited work of a high artistic standard three times in exhibitions organized by the Artists' Association was to be allowed to become a member of the Association at the national level.[198] There was no mention of a knowledge of political history, or ideological enthusiasm as being a prerequisite for membership. A shift in the publishing principles of the People's Fine Art Publishing House and in two other famous publishing houses, Rongbaozhai and Duoyunxuan ("In the South, there is Duo, in the North, there is Rong"), also reflected the more liberal atmosphere and a return, once again, to the acknowledgement that aesthetic, as well as political, considerations were important. Rongbaozhai Publishing House stated its aim was to publish work of a high artistic standard, rather than the more popular art forms; and Duoyunxuan too, specializing in the photocopying, printing and publishing (as well as the retailing) of

traditional Chinese paintings, planned to specialize mainly in paintings it considered to be of "high quality".[199]

A statistical comparison reveals the changing focus of publications nationwide in 1962 when compared with 1958. The table below gives the various percentages of all paintings published throughout China in the form of painting collections and albums, according to three main thematic categories:[200]

Year	Themes		
	The lives of workers, peasants and soldiers, current policies, revolutionary history	Traditional themes*	Foreign art — mainly from the Soviet Union, Eastern Europe and the Third World
1958	53%	35%	12%
1962	31%	61%	8%

* Such as characters from dramas and novels, landscapes, flower-and-bird, ordinary scenes from daily life (not directly political).

From this table we can see that in 1958, at the height of the Great Leap Forward, the work published in collections and albums reflecting overtly political themes comprised more than half of the total, whilst those consisting of traditional and non-political themes with a strong aesthetic dimension amounted to only just over one third of the total. By 1962, however, the situation had changed dramatically. Political themes constituted only one third of the total and work belonging to the second category comprised almost two-thirds. Obviously, these figures represent only a part of the entire sum of publications, but they are a good indication of the general trend in the content of art during the early 1960s. For example, in 1962 the number of New Year pictures with non-political themes published by the Shanghai Fine Art Publishing House comprised an overwhelming 97.2% of the total number published, whilst those reflecting the revolutionary lives of the workers, peasants and soldiers amounted to a mere 2.8%.[201] In *Fine Art* too there was a sharp decline after January 1959 in the amateur paintings of the Great Leap Forward, which disappeared completely from the magazine by the end of the year as the work of professional artists began to take precedence again.

Theoretical changes

Although signs of liberalization in the cultural arena were clearly visible from as early as the end of 1959, the first major meeting at which policy changes were systematically outlined was the Third National Congress of Literary and Art Workers held in Beijing between 22 July and 13 August 1960. Attended by more than 2,300 cultural delegates, it, like the two preceding congresses, served the function of summarizing past problems and achievements and setting out a cultural plan for the medium-term future. Speeches were delivered by all the most prominent figures from the various cultural organizations, as well as from the Propaganda Department, but the most pertinent speech to our discussion here was given by Zhou Yang, Vice-Chairman of the All-China Federation of Literary and Art Circles. Diverging from the basic tenor of most of his pronouncements during the 1950s, this speech was more in line with the general sentiments of the original Hundred Flowers movement to which Zhou and other delegates referred on several occasions. Zhou warned:

> Monotonous life and monotonous art alike are frowned upon by people. Since the people's life is rich and varied, the literature and art reflecting their life should be rich and varied too. Each writer and artist can, according to his sense of political responsibility, his personal experience of life, his interests and special talents, decide what themes to choose and what forms of expression to adopt.[202]

In defence of the greater freedoms to be allowed in cultural activities, Zhou explained:

> The people need inspiration and encouragement in their spiritual life, but they also need things that give pleasure and delight. Provided these do not run counter to ... the socialist path and the leadership of the Communist Party, works of art of all forms, themes and styles can be allowed to develop.[203]

Nor did Zhou neglect to mention the art training that would be necessary to achieve this new period of "blooming". He insisted that everyone should "continuously raise [their] artistic skill", describing artistic technique as:

> a product of highly skilled and meticulous labour.... Contempt for technique means contempt for human labour and wisdom, and is utterly wrong. Only by means of a highly developed technique can correct political ideas be integrated with beautiful artistic forms to the greatest perfection, can the moving power of art be generated.[204]

Zhou was clearly enunciating a more liberal, more technique-oriented and therefore more professionalized line than could ever have been contemplated during the Great Leap Forward. However, Zhou went even further in a series of proposals drafted by himself, Cai Ruohong and Lin Mohan, as well as others from the Department of Propaganda. The proposals took the form of a set of "Opinions on Current Literary and Art Works", otherwise known as the "Ten Points on Literature and Art",[205] and they formally became policy in April 1962. The "Ten Points" were extremely mild in tone, and although, as political expediency required, reference was made to some of the general principles of the Yan'an Talks, there was an obvious lack of much of the political rhetoric that had characterized the Talks. The document stressed that there should be no undue interference in the arts by political cadres and it allowed for a much broader range of content and style. In contrast with Great Leap Forward policies, which virtually compelled artists to spend long periods in the countryside or in factories, the "Ten Points" would only commit itself to saying that artists should maintain contact with workers and peasants, and that direct involvement in manual labour should only be undertaken in the light of the special circumstances of each individual artist's particular field of work, his age and his health. Clearly, Zhou Yang and the others responsible for the "Ten Points" were, in reality, acknowledging that professional artists should be treated as a special group in society, something that the Great Leap Forward movement had been specifically designed to eradicate. This was made even more apparent when the "Ten Points" advocated that artists should receive material incentives as an encouragement for their work, such as financial rewards and the guarantee of better living conditions. It was a strong indication of the extent to which the Party felt it had lost the confidence of artists, and the extent to which it was prepared to go to win back their support.

That some measures would be needed to achieve this objective was evident from a meeting of Beijing artists in 1962 ostensibly to commemorate the twentieth anniversary of Mao's Yan'an Talks. During their discussions there was a great deal of criticism against the dogmatic policies pursued by the Party during the Great Leap Forward and their disastrous influence on art. Wishing to highlight the unique nature of each art form, and in protest against the blanket application of certain ideological

principles to all cultural activities, the Beijing artists stressed the need to maintain and develop the special characteristics of individual art forms, and warned against forcing any one type of art to follow the aesthetic rules of another, for example, trying to produce a traditional Chinese painting in the same way as a western-style oil painting. They commented on the over-emphasis of political content to the detriment of formal considerations, concluding that yet again not enough attention had been paid to technique, form, colour and composition. One participant stated: "As artists, how can we do our work without paying sufficient attention to the formal dimension of art?"[206]

As the liberalized atmosphere of the early 1960s began to permeate art circles, many articles in *Fine Art* and other periodicals concentrated on questions relating mainly to the technical skills of the artist and the aesthetic qualities of art, rarely mentioning any kind of political criteria and avoiding the use of Marxist slogans. Creative originality was considered as "a symbol of the development of art",[207] and even Cai Ruohong contributed an article on the need to improve basic artistic technical training in art institutions.[208] Questions such as these had been barely touched upon, let alone discussed at any length, by art critics during the Great Leap Forward.

The new mood of relaxation was perhaps most noticeable in discussions on traditional Chinese painting, particularly landscape and flower-and-bird painting, which enjoyed something of a revival at that time. A group of articles in the February 1962 issue of *Fine Art* re-affirmed the important role of landscape and flower-and-bird painting, constituting a complete reversal of the official opinion during the Anti-Rightist Deviation movement that this type of art should be criticized for its inability to depict themes of "revolutionary struggle". Other articles covered specific problems concerning the aesthetics of landscape painting,[209] its general features and the principles governing it,[210] whilst some, such as "The Grand Artistic Achievements of Ten Great Artists of Ancient China",[211] chronicled the development of traditional Chinese painting prior to the twentieth century. All these articles shared in common a focus on purely aesthetic problems and considerations and largely ignored the political propaganda dimension of art that had been so marked during the Great Leap Forward.

As a strong reflection of these changes, the paintings produced during the early 1960s revealed a sharp contrast with the highly politicized work that immediately preceded them. In early 1961, the organization at Beihai of a "Welcome Spring Exhibition", comprising mainly landscape, flower-and-bird paintings and portraits of beautiful women in traditional China,[212] was symbolic of a "new spring" for Chinese art. The idea of a "new spring", was evidently prevalent in art circles at that time because it formed the title of another exhibition held in Beijing in 1963. Interestingly, the reviewer of this exhibition seemed pointedly to avoid any lengthy discussion on the content of the exhibitions, concentrating instead on matters of style. In summary, she said: "Our motto is: Our art must satisfy the aesthetic tastes of all kinds among our people building socialism."[213]

During the first half of the 1960s the overriding consideration for artists and art critics seemed to be what one western writer has described as the "poetic",[214] or the formal aspects of art which appealed to the artist's and the viewer's aesthetic sensibilities. Paintings reproduced in official publications were largely devoid of the strong political overtones that characterized those of the late 1950s, and essays on art were low on political rhetoric and more concerned with exploring formal matters of technique, the success or otherwise of the overall compositional arrangement, aesthetic strengths and weaknesses. Though content was discussed, form was never neglected. On the contrary, in many cases it took precedence, as reviewers of exhibitions or painting collections eulogized the artist's creative genius or pondered at length over some delightful detail that gave them particular pleasure. Shao Yu, for example, was described as a "tireless explorer of the poetic, of rhythms in the contrast of colours and the possibilities of modern design or compositional innovations based on the national traditional style."[215] In the same vein, Ni Yide said of Pan Tianshou's paintings, "He weaves them into delightful compositions like a skilful tapestry-maker with a fecund imagination, turning them into exquisite patterns of natural beauty."[216] Ni described Pan's painting *Bathed in Dew* (Fig. 8) in lyrical terms: "*Bathed in Dew* depicts a lotus pond in the early morning; shrouded in mist the dew-drenched lotus flowers rise fresh and serene, accenting the coolness of dawn",[217] and at another point: "His painting *Bathed in Dew* ... is like a poem describing the lotus pond wrapped in morning mist, with its flowers, heavy with dew, swaying gently on their

stems and only partly visible."[218] The paintings of Lin Fengmian, which had been denigrated since the early 1950s, were now appraised in glowing terms by, surprisingly, an old Yan'an veteran, the cartoonist Mi Gu. Lin's paintings were said to be "Mellow as a cup of grape wine with a fine bouquet" and "like a jewel in a treasure box; a rare flower in a garden."[219] Mi even went so far as to quote Lin's views on painting, which singularly failed to mention anything about the need for art to serve the workers, peasants and soldiers or socialist construction, but which concentrated on important conceptual aspects of the creative process:

> *Simplification in painting should be based on a study of natural phenomena ... faced with a complex combination of natural objects, the artist should seek to depict their colours and colour relations, their character and natural qualities as they manifest themselves to the eye, and absorb trivial or accidental phenomena into a complete, integrated concept.*[220]

The cartoonist and faithful Party follower, Hua Junwu, wrote an article explaining how he always attempted to bring an element of poetry into his cartooning: "there is much that it [the cartoon] can learn from poetry".[221] In the same way that praise was lavished in the early 1960s on work with a high artistic standard, so work that was not aesthetically pleasing, regardless of its content, was open to criticism for this failing. One of Ya Ming's unpublished paintings, *Great Changes in Mountains and Streams*, produced during a trip around six Chinese provinces with Fu Baoshi, Qian Songyan and others, was disparagingly said to be "neither beautiful nor new. It is dull and direct, like a report, and it is lacking in poetic qualities."[222]

Some of the main beneficiaries of this short period of political relaxation were the traditional Chinese painters, as their efforts on the whole most skillfully and powerfully embodied the "poetic". Official publications covered at great length the works of many of the outstanding names of particularly the twentieth century, including Qi Baishi, Fu Baoshi, Pan Tianshou, Qian Songyan and Shi Lu, none of which had really any discernible political content.

Occasionally some concessions were made to political requirements, but not to the extent of intruding on the all-important aesthetic dimension. This was usually achieved by coupling a non-political work with a title that had political overtones. *Battling against the Drought* (Fig. 9) by Ya Ming and Song Wenzhi, for example, might suggest that it took as its

central theme the prominent figures of peasants engaged in a flurry of activity, as was common in paintings during the Great Leap Forward. In fact, it is basically a traditional landscape painting which focuses on the traditional elements of mountains and trees. The human figures in the picture are so small that it is almost impossible to tell in which activity they are engaged. The entire tenor of the scene is so tranquil, one might never guess that the individuals concerned are involved in such a hectic pursuit as drought-prevention. Shi Lu's painting, *Horses Drinking by the River Yan*, is another example. There is nothing in this tranquil nature scene that even hints at anything political — only in the title do we get an indication that this is meant to be a portrayal of the Communists' revolutionary base at Yan'an. One commentator explained the painting by saying "Instead of expressing outright praise of Yenan [Yan'an], the cradle of the revolution, by painting a few horses resting there for a while before going back to the front, he [Shi Lu] conveys the idea that Yenan served as a haven of rest for revolutionaries as well as their starting point".[223] The striking thing about this comment is the way it reveals how in times of political liberalization, even those paintings most devoid of obvious political content could have attributed to them a positive political meaning.

Great efforts were made by commentators to justify the proliferation of landscape and flower-and-bird paintings in official publications. This was particularly true in the case of flower-and-bird painting which is extremely difficult to infuse with political content. One of the two articles selected by the periodical *Chinese Literature* to commemorate the twentieth anniversary of Mao's Yan'an Talks was, ironically, a vindication of Chinese landscape painting, and appeared to have no relevance to the radical line on art set down by Mao in 1942. The opening sentence of the article, written by Wu Zuoren, gave an indication of its entire tone: "A friend asked me: How does one appreciate Chinese landscape painting?" Later in the article Wu asserted: "Although landscape and flower-and-bird paintings may not reflect politics directly, since the labouring people who are the masters of our country have a positive cheerful attitude to nature, it is easy to see what the spirit of such paintings should be today".[224]

Such Great Beauty Like This in All Our Landscape, a wonderful panoramic mountain scene bathed in red light from the sinking sun, was painted in 1959 by the traditional Chinese painters, Fu Baoshi and Guan

Shanyue, and now hangs in the Great Hall of the People in Beijing. Devoid of even the token signs of human presence or human activity that we see in several traditional Chinese paintings of this period, it was nevertheless lauded as a great contribution to socialist art. As one commentator stated, the painting was to be admired because, "It invokes in the viewer a feeling of love for and pride in the motherland".[225] Cui Zifan, himself a prominent flower-and-bird painter, defended in similar terms the kinds of paintings he produced by saying, "through them the artist arouses in his audience a love of beauty, of life and of the land of their birth."[226] Landscape and flower-and-bird paintings were thus justified on the ground that, as traditional Chinese art forms that echoed the aesthetic sensibilities of the Chinese people, they symbolized a feeling of national pride. Even Cai Ruohong felt compelled to offer a defence of flower-and-bird painting. Without any real justification for his claim, he asserted that "Our paintings of flowers and birds are no longer pretty toys for the leisured class, but express our people's love of life and their artistic sense."[227]

In reality these paintings were fundamentally no different from those that had been produced for generations, indicating that as soon as artists were provided with a conducive political atmosphere, they returned to the kind of work with which they were most familiar, and that which most appealed to their individual aesthetic tastes. What had changed, however, was the attitude the authorities had decided to adopt towards traditional Chinese painting at this stage for purely pragmatic reasons. Unfortunately, although the early 1960s was something of a golden era for Chinese art, when artists were once again able to express themselves through a diversity of themes unprecedented since 1949, this relaxation in policy was still directed and controlled by the political leadership and was therefore, contingent on primarily political considerations. Once the policies of the leadership changed, which they had done several times in the previous decade, artists were inevitably forced to do likewise.

The Socialist Education movement and the lead-up to the Cultural Revolution

The era of relaxation for artists did not, unfortunately, last long. Even

during the period of pragmatic re-adjustment, the more radical line as-
sociated with Mao did not die out completely, but re-surfaced periodically
as Mao attempted to regain control in the political arena. As early as July
1962 at a working meeting of the Central Committee, Mao talked again at
great length about class struggle and social contradictions, and began to
cast doubt on the policies of adjustment. Then, at the tenth plenary session
of the Eighth Party Congress (September 1962), Mao's opening speech
affirmed that class and class struggle still existed in socialist China, and
that the "bourgeois capitalist class" still wanted to restore its former posi-
tion.[228] Mao's assessment of the political situation in a socialist society thus
laid the foundation for an ultra-leftist backlash against the realistic ap-
proach of the pragmatists. At the two meetings mentioned above, there
were already signs of criticism of a "dark wind" as represented by Liu
Shaoqi, Zhou Enlai and Chen Yun, as well as an attack on the "wind of
reversing decisions", referring to the political rehabilitation of Rightists
and Right Deviationists at the beginning of the period of relaxation.[229]

In the following year Mao initiated another political campaign,
the Socialist Education movement, also known as the "Four Clean-ups"
movement:[230]

> In agriculture, he sought to halt the trend toward "capitalism".... In culture, he
> sought to reverse the trend toward "revisionism" or ideological erosion and the
> re-emergence of an intellectual elite that had resulted from the party's effort to win
> the cooperation of the intellectuals.[231]

From this time, Mao and his associates began to pay specific attention
to the ideological and cultural front, and cultural circles experienced a
gradual reversal of the former atmosphere of relaxation, as control was
tightened once more. Mao severely criticized the Ministry of Culture as
being full of "emperors, kings, generals and ministers" and of being "The
Ministry of Gifted Scholars and Beautiful Ladies" and "The Ministry of
Dead Foreigners"[232] because of, as he saw it, its leading role in directing
more liberal policies.

In December 1963, Mao issued a set of written instructions in which
he asserted that many problems continued to exist in all areas of the arts,
and that socialist reforms had had in fact very little impact on them. In a
further document issued in June 1964, Mao elaborated on the ways in

which he felt the reforms had actually achieved little in the cultural field. In a terrible indictment of cultural activities in China, Mao stated bluntly that of all the various cultural associations and the arts journals published by them, very few were good. His assessment was that over the last fifteen years (i.e., since 1949):

> they basically (though not all) fail to carry out the Party's policies … they do not get close to the workers, peasants and soldiers, and do not reflect the socialist revolution and socialist construction. In recent years, they have even slipped to the brink of revisionism. Without earnest reform, one day they are all going to become like the Hungarian Petofi club.[233]

Within a short period, Mao's attack on cultural policies began to take effect. In March 1963, the performing of "ghost" dramas ceased, and some, such as *Li Hu Niang*, were criticized. In addition, the *Literary and Art Gazette* began to refer to the representation of "middle characters" or characters without any clear political orientation, as a "bourgeois artistic demand" that sidelined positive images of the workers, peasants and soldiers, and socialist "proletarian heroes and heroines".[234] By excluding the possibility of depicting "middle characters", the scope of artists' creative work was severely reduced to a narrow range of characters and life situations, and the wide variety of themes advocated during the period of relaxation suffered a serious setback. The new era of tightening ideological control was one in which the representation of socialist heroes and heroines was one of the most important aspects of socialist art. Revolutionary slogans and political rhetoric with increasingly radical overtones were the order of the day. Some of the more prominent figures in cultural circles began to come under attack, including the Deputy Cultural Minister Qi Yanming, the Deputy Chairman of the All-China Federation of Literary and Art Workers Yang Hansheng, Xia Yan and Tian Han.[235] Criticism then began to be levelled against the views on Marxist aesthetics of Wang Qi, a professor at the Central Academy of Fine Art, who had written an article, "On the Exploration of Art Forms", which implied that Marxist doctrine was really only relevant in appraising the content, not the form, of a work of art. He was also attacked for his approval of Gaugin, Matisse and Cezanne, whom he regarded as artistic innovators, but whom the authorities had always classed as "bourgeois formalists".[236]

Fine Art began again to publish an increasing number of paintings

featuring workers, peasants and soldiers as the central subjects. In addition, as in the days of the Great Leap Forward, articles written by these same groups began to appear, giving their (mildly critical) opinions on the art journal itself.[237]

As pressure increased on artists and Party ideologues alike to radicalize their thinking, the Party Propaganda chief Lu Dingyi and the Ministry of Culture felt compelled to issue a joint official document forbidding the use of nude models in art institutions, presumably believing that this practice would be classified eventually as "bourgeois decadence". Ironically, however, Mao himself intervened with a written instruction that totally contradicted the prohibition order. He stated:

> *The use of nude models — whether they are men or women, young or old, is a basic necessary technique of oil painting and sculpture, and we must have it. To forbid it is inappropriate, it is feudalistic thinking.*[238]

Here we can see the complexity of Mao's ideas (something which must have caused many an artist and art critic to feel perplexed over the years). On the one hand, Mao was against any aspects of what he would have termed a "bourgeois mentality", but on the other, he was also against "feudalistic thinking". In this particular instance, unfortunately for Lu Dingyi and the Ministry of Culture, Mao decided that the issue of feudalistic ideology amongst members of the Party took precedence over any other issue. This event also gives us an insight into the predicaments in which the Party propaganda chiefs found themselves in when interpreting Mao's vague directives. Not sure of what actions would be safe and appropriate in this case, they ended up, in desperation, banning anything they felt might cause some problem in the future.

The Rent Collection Courtyard

The most significant piece of art to come out of this period in its scope, aesthetic level, and also in its clear representation of the more radical and politicized direction in which art was moving, was the series of sculptures known as *The Rent Collection Courtyard* (Fig. 10). The work re-created a vast scene based on real life in China before 1949 in which Sichuan peasants brought along their extortionate rents to the local tyrant landlord

Liu Wencai. It showed their cruel treatment at his hands, their increasing anger at the situation and finally their successful fight for freedom, with the help of the Chinese Communist Party.[239] The sculpture was a major undertaking, comprising 114 clay figures, and measuring ninety-six metres in length. It was created over five months by four teachers and four students from the sculpture department of the Sichuan Academy of Fine Art,[240] along with a former student of the Academy working in the Sichuan museum, a clay craftsman, three artists who had never formally studied sculpture and a small number of art teachers from primary schools. To increase its authenticity, the work was built up on the actual tax-collecting courtyard in the landlord's manor, and so the original house, doors, pillows and other items became an integral part of the entire exhibition. The technique adopted was that traditionally used by craftsmen to create figures for the earth and town god temples. Instead of the plaster of Paris (a foreign import) usually employed in sculpture-making in the art academies, the artists used straw and soil mixed with cotton and fine sandy earth to produce a material that was both simple and inexpensive.[241]

Upon completion, the series of sculptures was opened to the public on 1 October 1965, China's National Day. In order to increase its propaganda value, photographs were later taken of it, and together with several of the figures which had been reproduced by Beijing artists, it was exhibited in the China Art Gallery.[242] During the Cultural Revolution several revisions of the work were undertaken, with extra figures added, some done away with and others remodelled in order to convey more convincingly the radical message of that era. This was most strikingly apparent in the figures situated at the end of the sculpture, some of whom now held aloft Mao's writings and political slogans emblazoned on wooden placards.[243] The whole tenor of the exhibition had, in fact, subtly changed by this later stage, with the replacement of pathetic and sorrowful-looking peasant figures that might be construed as "negative" by others full of revolutionary fervour: "Whereas in the autumn of 1966 there were still figures who made a tragic impression or aroused one's sympathy, one year later they were all suffused with a relentless fury".[244]

The Rent Collection Courtyard became one of the most prominent pieces of art work prior to and during the Cultural Revolution. Not only was it exhibited in Beijing, but photos of the exhibits and discussions on

them also appeared in *Fine Art* and in various English-language journals for foreign consumption, such as the *Peking Review* and *Chinese Literature*. In addition, the terms in which the sculpture was described made it clear that it was considered to be something of a "model" to be emulated by artists, in the same way as a small selection of revolutionary operas became "models" for people working in the field of drama during the Cultural Revolution.

The prominent position given to *The Rent Collection Courtyard* was due to several factors. First and foremost, it was an ideal representation of the political line espoused by Mao and reiterated by him at intervals over the years. It revealed clearly and unambiguously the existence of class struggle and confirmed the necessity of the Chinese revolution and the leadership of the Chinese Communist Party in liberating the peasants from the exploitation and oppression of the landlords. At a time when Mao believed that many members of the Party were slipping into Soviet-style "revisionism" and that people in general were becoming too comfortable and ideologically lax in their daily lives, and beginning to forget the cruel hardships of the past, the sculpture was a sharp reminder of why and how the revolution had been fought. It thus served the political purpose of acting as an educational tool for the ongoing Socialist Education movement and, later, for the Cultural Revolution.

As a series of clay sculptures which drew heavily on folk art traditions, it fulfilled the Party's aim to utilize folk art in presenting new revolutionary content. Its creation was a collective, rather than an individual, effort, and it was thus an expression of Mao's desire to expunge the elitist nature of art, partly by encouraging more collective work. It was evidence of the commitment of several professional artists to radical Party policies and so set an example for other professional artists to follow. It harked back to Great Leap Forward aspirations of combining the skills of professional artists and craftsmen with the overall leadership of the Party. In addition, *The Rent Collection Courtyard* was a good illustration of the Party's aim to achieve a "unity between political theme and artistic form". A great deal of attention was paid by the creators of the sculpture to both political content and details of artistic design in order to maximize the overall impact. With such a large number of sculpted figures involved, it would have been easy to fall into the trap of repetition and uniformity. Care was taken therefore to ensure that each figure was given as far as possible its own physical

characteristics. There was also a deliberate attempt to include in the sculptures men, women and children of all ages, and to position them striking a variety of poses. The entire exhibition conveyed a story, and was thus meant to be "read" by the viewer, much as he or she might read an historical novel. There was a stress therefore on continuity so that each of the six main sections[245] of the exhibition ran smoothly from one into the next. At the same time, however, in the event of the exhibition being divided and different figures being sent to other parts of the country for showing, each section or even each individual figure or group of figures could exist as a separate entity.[246] The images produced were both simple and vivid, and easily appreciated by ordinary people who were left in no doubt as to the message being conveyed:

> *Its content unfolds as it would in a picture-story book. Thus, the groups of people are presented in a simple, straightforward way, with clear and obvious patterns ... a series of characters and stage sets, like actors on a stage who have been fixed (in place) following continuous rehearsals and corrections by the Director.*[247]

The Rent Collection Courtyard thus became an exemplary piece of work, embodying all the aspects of a work of art advocated by the Party. It constituted one of the clearest manifestations of the radical aspirations of Mao and his associates as well as being a strong indication of the new direction in which political events were developing.

In Shanghai, control of the city had been in the hands of radical left-wingers since the mid-1950s. By 1962 the First Secretary of the Shanghai Party Committee, Ke Qingshi, and the Shanghai Party propaganda chief, Zhang Chunqiao, were emphasizing that all cultural work had to represent only those events that had occurred during the previous thirteen years, and they rejected all foreign influences. In addition, Mao's wife, Jiang Qing, had became Mao's main representative in the cultural field. She began to organize a "revolution" in Peking opera, which became the prelude to Mao's most ambitious social movement to date — the Cultural Revolution.[248]

Notes

1. Zhu Zongyu and Yang Yuanhua (eds.), *Zhonghua renmin gongheguo zhuyao shijian renwu*, p. 40.

2. Mao Zedong, *Mao Zedong xuanji*, Vol. V. pp. 363–402 for the text of the speech outlining the theoretical basis of the Hundred Flowers movement.
3. Red Guard publication, *Meishu zhanxianshang liangtiao luxian douzheng dashiji*, p. 20.
4. Ibid.
5. Zheng Derong *et al.* (eds.), *Xin Zhongguo jishi 1949–1984*, p. 166.
6. Zheng Derong *et al.* (eds.), *Zhongguo shehuizhuyi jianshi*, pp. 32–38.
7. Zhu Yang *et al.* (eds.), *Zhonghua renmin gongheguo sishinian*, p. 148; Mao Tse-tung, *Unselected Works of Mao Tse-tung*, p. 40.
8. Red Guard publication, *Meishu zhanxianshang liangtiao luxian douzheng dashiji*, p. 22.
9. Ibid.
10. Liu Shaoqi, *Liu Shaoqi xuanji (xia)*, p. 192.
11. Zhou Yang, *Zhou Yang wenji*, pp. 493–514.
12. Mao Zedong, *Mao Zedong lun wenhua yishu*, p. 143.
13. Ibid.
14. Ibid., p. 137.
15. Ibid., p. 146.
16. Red Guard publication, *Meishu zhanxianshang liangtiao luxian douzheng dashiji*, p. 20.
17. M. Goldman, *Literary Dissent in Communist China*, pp. 158–161.
18. Red Guard publication, *Meishu zhanxianshang liangtiao luxian douzheng dashiji*, pp. 22–23.
19. Ibid., p. 24.
20. Ibid.
21. Ibid., p. 26.
22. Editor's note, *Fine Art Research*, 1957, No. 1, back page.
23. *Fine Art* editorial, "Yinian zhi shi", *Fine Art*, 1957, No. 1, pp. 4–5.
24. *Fine Art* journalist, "Shoudu meishujia jihui zuotan, jielu 'ming' he 'fang' de zhang'ai", *Fine Art*, 1957, No. 5, p. 4.
25. G. Barmé and B. Lee (trans.), W. J. F. Jenner (ed.), *Fragrant Weeds — Chinese Stories Once Labelled as "Poisonous Weeds"*.
26. Liu Jian'an, "Ji Zhongyang gongyi meishu xueyuan fanyoupai douzhengzhongde da bianlun", *Fine Art*, 1957, No. 12, p. 12.
27. G. Barmé, B. Lee and W. J. F. Jenner, *Fragrant Weeds — Chinese Stories Once Labelled as "Poisonous Weeds"*.
28. Mi Gu, "Zhangwo manhua yishu texing, chuangzuo chu duozhong fenggede manhua lai — canguan quanguo manhuazhan yougan", *Fine Art*, 1957, No. 2, pp. 4–6.
29. Zhong Jingwen, *Yan'an Lu Yi — wo dang suo chuangbande yisuo yishu xueyuan*.
30. For relevant articles on impressionism by Soviet writers see *Fine Art*, 1957,

No. 2, pp. 37–46. The reproductions of impressionist paintings can be found in the same issue of *Fine Art*, pp. 24–29. For a selection of articles on impressionism by Chinese artists and art theorists, see *Fine Art Research*, 1957, Issues 2 and 3.

31. The fact that Chinese artists and art critics were at this stage unwilling to come forward and present their own views, or that *Fine Art* was not prepared to publish them, may be an indication of a residual feeling of caution about "freely blooming and contending". Offering the views of Soviet theorists first was a safer way of gauging initial response to the whole question of impressionism. The Soviet art world had for some months been engaged in a debate similar to that taking place in China following an exhibition of modern French art the previous year in Moscow. See Jiang Feng, "Yinxiang zhuyi bu shi xianshi zhuyi", *Fine Art Research*, 1957, No. 2, p. 1.

32. Including the provinces Hunan, Hubei, Henan, Guangdong and Guangxi.

33. Red Guard publication, *Meishu zhanxianshang liangtiao luxian douzheng dashiji*, p. 26. By March 1957 the political tide had turned and impressionism was once again labelled a sign of "bourgeois decadence". The anti-impressionism debates which lasted until 1961 may have been initiated by Luo Gongliu "to secure his personal standing in the Chinese art world". See Clark, "Realism in Revolutionary Chinese Painting", p. 12.

34. Xiao Caizhou, "Meishu gongzuozhe ruhe tiyan shenghuo", *Fine Art*, 1957, No. 1, pp. 43–44.

35. "Zhongguo zuojia xiehui yanjiu zhixing 'baihua qifang, baijia zhengming' de fangzhen", *Literary and Art Gazette*, 1956, No. 14, pp. 20–21.

36. Jin Ye, "Tan muqian meishu chuangzuozhong cunzaide wenti", *Fine Art*, 1956, No. 11, pp. 17–20.

37. Ibid., p. 20.

38. "Beijing meishu zhanlan jianshu", *Fine Art*, 1956, No. 11, p. 12.

39. "Exhibition of Traditional Painting", *Chinese Literature*, 1957, No. 1, p. 192.

40. Ibid., p. 191–192.

41. The painting commemorates an incident in 1954 when the people of Wuhan successfully averted a flooding of the Yangtse river. It was considered at the time to be the most successful painting in terms of combining traditional techniques with a depiction of "real life". See Chen Fengzhi, "Xuexi he yunyong chuantong jifa zhi yilie", *Fine Art*, 1957, No. 2, p. 33.

42. "Exhibition of Traditonal Painting", *Chinese Literature*, 1957, No. 1, p. 192.

43. "Foreign Art Exhibitions in Peking", *Chinese Literature*, 1957, No. 1, p. 195.

44. "Exhibition of British Graphic Art", *Chinese Literature*, 1956, No. 3, pp. 206–207.

45. "Exhibition of Mexican Graphic Art", *Chinese Literature*, 1965, No. 3, pp. 209–210.

46. "Foreign Art Exhibitions in Peking", *Chinese Literature*, 1957, No. 1, pp.

195–198.

47. J. Chen, "Picasso in Peking", *People's China*, 1 Jan. 1957, p. 41.
48. Zhu Yang *et al.* (eds.), *Zhonghua renmin gongheguo sishinian*, pp. 153–154.
49. Mao Tse-tung, *Unselected Works of Mao Tse-tung*, p. 211.
50. Zhu Yang *et al.* (eds.), *Zhonghua renmin gongheguo sishinian*, p. 156.
51. Mao Tse-tung, *Unselected Works of Mao Tse-tung*, p. 340.
52. Ibid., pp. 251–252, pp. 359–364.
53. Ibid., p. 341.
54. *People's Daily*, 1 July 1957 (editorial).
55. "Lu Dingyi, Zhou Yang zai zuoxie dangzu kuoda huiyishang zuo zhongyao jianghua", *Literary and Art Gazette*, 1957, No. 25, pp. 1–3.
56. Ibid., p. 2.
57. Primary Sources Editorial Team, *Zhonggong zenyang duidai zhishifenzi* (zhong), pp. 12–147.
58. For relevant articles on Rightists in the art world see *Fine Art*, 1957, Nos. 7–12.
59. *Fine Art*, 1957, No. 7, pp. 4–6.
60. *Fine Art*, 1957, No. 9, pp. 4–20, 34–49; *Fine Art*, 1957, No. 10, pp. 4–20, 34–44.
61. Cai Ruohong, "Cong geren yu dangde guanxi lai kan Jiang Feng shifo fandang", *Fine Art*, 1957, No. 9, pp. 4–7; Li Keran, "Jiang Feng weifan dang dui minzu chuantongde zhengce", *Fine Art*, 1957, No. 9, pp. 19–20; Jiang Zhaohe, "Jiang Feng dui Zhongguohua xuwuzhuyide guandian", *Fine Art*, 1957, No. 9, pp. 36–37.
62. *Fine Art*, 1957, No. 9, pp. 4–20, 34–49.
63. According to certain sources, Li also denounced the well-known traditional Chinese painter, Li Kuchan, as a Rightist. See Clark, "Realism in Revolutionary Chinese Painting", p. 8.
64. *Fine Art* journalist, "Beijing Zhongguohua huajiade yijian", *Fine Art*, 1957, No. 6, pp. 4–6.
65. Mao Tse-tung, *Unselected Works of Mao Tse-tung*, p. 153.
66. For Jiang Feng's biography see Jiang Feng, *Jiang Feng meishu lunji* (Preface by Lin Mohan). For Cai Ruohong's biography see Cai Ruohong, *Cai Ruohong meishu lunji* (Introduction).
67. Mao Tse-tung, *Unselected Works of Mao Tse-tung*, p. 155. Mao apparently personally named Jiang Feng as a Rightist. See Chen Yingde, *Haiwai kan dalu yishu*, p. 320.
68. "Lu Dingyi, Zhou Yang zai zuoxie dangzu kuoda huiyishang zuo zhongyao jianghua", *Literary and Art Gazette*, 1957, No. 25, p. 3.
69. Cai Ruohong, "Lun 'zuo' you tongyuande Jiang Feng fandang wenyi sixiang", *Fine Art*, 1957, No. 10, pp. 8–10.
70. Mao Tse-tung, *Unselected Works of Mao Tse-tung*, p. 153.

71. Jiang Zhaohe, "Jiang Feng dui Zhongguohua xuwuzhuyide guandian", *Fine Art*, 1957, No. 9, p. 36.

72. Jiang Feng, *Jiang Feng meishu lunji*, p. 9.

73. *Fine Art* journalist, "Beijing Zhongguohua huajiade yijian", *Fine Art*, 1957, No. 6, p. 4.

74. *Fine Art* journalist, "Changsuo yuyan hua 'zheng ming'", *Fine Art*, 1956, No. 8, p. 11.

75. Ironically, during the Hundred Flowers movement, Cai Ruohong also came in for criticism from traditional Chinese painters, who accused him of being "cold towards and separated from" them and their colleagues. Cai, however, managed to escape being labelled a Rightist. See Chen Yingde, *Haiwai kan dalu yishu*, p. 83.

76. Interviews with Shui Tianzhong (1989, Beijing) and Chen Dehong (1988, London).

77. Personal animosity between Jiang and Cai may have gone back many years. See Chen Yingde, *Haiwai kan dalu yishu*, p. 83.

78. Hua Junwu, "Jiang Feng fandangde fabao zhiyi 'zongpai daji", *Fine Art*, 1957, No. 9, pp. 8–9. It has been suggested that there was already open conflict between Jiang Feng and Zhou Yang and his supporters at Yan'an. See Chen Yingde, *Haiwai kan dalu yishu*, p. 320.

79. *Fine Art* journalist, "Jiang Feng shi meishujiede zonghuo toumu", *Fine Art*, 1957, No. 8, p. 11.

80. Ibid.

81. When Jiang was finally rehabilitated in 1979, he continued to come into conflict with traditional Chinese painters by making renewed calls for figurative traditional Chinese painting that "reflected the times". See Chen Yingde, *Haiwai kan dalu yishu*, p. 209.

82. A small minority of artists, including Wu Zuoren and Dong Xiwen, may have been protected from the worst of the Anti-Rightist campaign by some powerful political backer. See Chen Yingde, *Haiwai kan dalu yishu*, p. 83.

83. "Shanghai meishujie che qi shangshan xiaxiang rechao", *Fine Art*, 1957, No. 12, p. 10.

84. "Looking at Flowers", *Peking Review*, 17 June 1958, p. 5; "Xiaxiang xiaoxi", *Fine Art*, 1958, No. 3, p. 35.

85. Central Academy of Fine Art (comp.), *Zhongyang meishu xueyuan jianshi*, p. 102; Song Zongyuan *et al.* (eds.), *Yishu yaolan*, p. 32.

86. "Weile shehuizhuyi wenyi jianshede bainian daji", *Literary and Art Gazette*, 1957, No. 26, p. 1.

87. Mao Jiaqi (ed.), *Taiwan sanshinian 1949–1979*, pp. 54–55; Zhu Yang *et al.* (eds.), *Zhonghua renmin gongheguo sishinian*, p. 165.

88. Zheng Derong *et al.* (eds.), *Xin Zhongguo jishi 1949–1984*, p. 239.

89. Zhu Yang *et al.* (eds.), *Zhonghua renmin gongheguo sishinian*, pp. 165–166.

90. Ibid., pp. 169–170.

91. Chinese Research Publishing Co. (comp.), *Zhishifenzi ping wannian Mao Zedong* p. 64.

92. Sun Wuxia, *Gongchan guoji he Zhongguo geming guanxi shigang*.

93. Chinese Research Publishing Co. (comp.), *Zhishifenzi ping wannian Mao Zedong*, pp. 63–64.

94. Xiao Yanzhong (ed.), *Wannian Mao Zedong*, p. 190.

95. "Meixie xiang fenhui he meishujia tichu changyi", *Fine Art*, 1958, No. 4, p. 5.

96. *Fine Art* journalist, "Meishujie dayuejin", *Fine Art*, 1958, No. 3, pp. 4–5.

97. Ibid., p. 5.

98. "Yangfan gulang, lizheng shangyou", *Literary and Art Gazette*, 1958, No. 6, p. 20.

99. Shi Lu, "Gaoju Mao Zedong wenyi sixiangde qizhi pandeng wuchanjieji yishude gaofeng", *Fine Art*, 1960, No. 4, p. 8.

100. Gu Yuan, "Hui dao nongcun qu", *Fine Art*, 1958, No. 1, p. 6; Shao Yu, "Cong xiaxiang shangshan xiangqi de", *Fine Art*, 1958, No. 1, p. 7.

101. "Gedi meishujia xiafang canjia laodong duanlian", *Fine Art*, 1958, No. 2, p. 46.

102. *Fine Art* journalist, "Meishujie dayuejin", *Fine Art*, 1958, No. 3, p. 5.

103. Zhang Shaoxia and Li Xiaoshan, *Zhongguo xiandai huihuashi*, p. 262.

104. Interview with Li Xianting, 1989, Beijing.

105. He Chengying, "Tan Zhongguohua, sumiao", *Fine Art*, 1958, No. 4, pp. 32–33.

106. *Fine Art*, 1958, No. 2, pp. 32–35.

107. Fine Art journalist, "Shengchan dayuejin, wenhua yishu jinjingen — ji quanguo nongcun qunzhong wenhua yishu gongzuo huiyi", *Fine Art*, 1958, No. 5, pp. 20–21.

108. Ibid.

109. Ibid.

110. Ibid.

111. Liaoning University (ed.), *Wenyi sixiang zhanxian sanshinian*, p. 244.

112. *Literary and Art Gazette*, 1958, No. 6, pp. 20–26.

113. *Literature and Art Monthly*, 1958, No. 7.

114. "Meishu chubande zhuliu wenti", *Fine Art*, 1958, No. 5, p. 18.

115. *Fine Art*, 1958, No. 12, pp. 44–45.

116. Guo Sheng, "Chongqingde 'hualan'", *Fine Art*, 1958, No. 7, p. 12; *Fine Art* journalist "Tianjin meishujia ganjin da, liangtiao dajie jin shi hua", *Fine Art*, 1958, No. 7, p. 13.

117. "Tianjin guo mianchang hua changshi", *Fine Art*, 1958, No. 6, p. 35.

118. For examples see "Nanjingde gongren meizhan", *Fine Art*, 1958, No. 6, p. 20; "Gongnongye dayuejin huazhuan", *Fine Art*, 1958, No. 7, p. 13.

2. The Vacillating Years, 1956–1966

119. For the origins of murals in Chinese tradition and for mural techniques see
Qin Lingyun, *Minjian huagong shiliao*, pp. 41–46 and Li Lang, *Dalu meishu pingji*, pp. 136–161.

120. O. Siren, *Chinese Painting: Leading Masters and Principles*, Vol. I, pp. 17–18.

121. J. Cahill, *Treasures of Asia: Chinese Painting*, pp. 21, 23.

122. Sullivan, *The Arts of China*, p. 123.

123. Li Qun, "Xin bihuade chuxian shi yijian dashi", *Fine Art*, 1958, No. 8, p. 20.

124. Holm, *Art and Ideology in Yan'an*, p. 87.

125. *Fine Art* journalist, "Shengchan dayuejin, wenhua yishu jinjin gen — ji quanguo nongcun qunzhong wenhua yishu gongzuo huiyi", *Fine Art*, 1958, No. 5, p. 20.

126. *Fine Art* journalist, "Wenhua yuejin da touchende nongcun yeyu meishu dajun", *Fine Art*, 1958, No. 6, pp. 17–18.

127. Ibid.

128. "Pixiande qunzhong meishu huodong", *Fine Art*, 1958, No. 9, p. 3.

129. Ibid., p. 9. For further relevant information see Artists' Association Nanjing Branch (comp.), *Meishu zhanxianshangde yike weixing — Jiangsu Pixian nongminhua wenji*; Jiangsu Literature and Art Publishing House (comp.), *Zhuanlun Pixian nongminhua*, (Vol. I.).

130. "Nongmin re'ai xin bihua", *Fine Art*, 1958, No. 8, p. 21.

131. Bo Songnian, "Shi hua he bi", *Fine Art*, 1959, No. 2, p. 38.

132. S. Bush, *The Chinese Literati on Painting: Su Shih (1037–1101) to Tung Ch'i-ch'ang (1555–1636)*, pp. 24–25.

133. Bo Songnian, "Shi hua he bi", *Fine Art*, 1959, No. 2, p. 38.

134. Wang Chaowen, "Gen minge bimei", *Fine Art*, 1958, No. 8, p. 29.

135. Wang Chaowen, "Gongnongbing meishu hao!", *Fine Art*, 1958, No. 12, pp. 11–17.

136. Ibid.

137. Xu Ling, "Nianhua gongzuozhong cunzaide zhuyao wenti", *Fine Art*, 1958, No. 4, p. 6.

138. Red Guard publication, *Meishu zhanxianshang liangtiao luxian douzheng dashiji*, p. 32.

139. Ibid.; Zhang Wang, "Cong 1958 nianhua shuoqi", *Fine Art*, 1958, No. 2, p. 14.

140. Red Guard publication, *Meishu zhanxianshang liangtiao luxian douzheng dashiji*, p. 32.

141. From the huge numbers of New Year pictures on traditional themes supplying the demands of the peasants we see that, to some extent, market forces played a role in determining certain aspects of art creation in China in the 1950s.

142. Li Qianyan, *Chinese Propitious Patterns*.

143. For examples of traditional Chinese stories reflected in New Year pictures see

Lin Qun, *Zhongguo minjian zhushen*; Ji Xing (ed.), *Zhongguo minsu chuanshuo gushi.*

144. *Fine Art* journalist, "Qunzhong xihuan shenmeyangde nianhua", *Fine Art*, 1958, No. 4, p. 10.

145. Huang Xuanzhi, "1957 nian quanguo xin nianhua zhanlan qingkuang he qunzhong yijian", *Fine Art*, 1958, No. 6, p. 34.

146. Wang Gui and Li Xiangxiang — two characters created by the revolutionary poet Li Ji at Yan'an. He used the northern Shaanxi folk song form combined with some new elements to compose poetry with revolutionary themes. In this particular long poem he relates the story of how peasants in northern Shaanxi were exploited by landlords and how they rebelled under the leadership of the Communist Party.

147. Zhang Wang, "Cong 1958 nianhua shuoqi", *Fine Art*, 1958, No. 2, p. 14.

148. Xie Changyi, "Xiang minjian nianhua xuexi — Shandong sheng xiang jianguo shizhounian xianlide muban nianhua chuangzuo jingguo he tihui", *Fine Art*, 1960, No. 2, pp. 30–31.

149. Shanghai People's Fine Art Publishing House (comp.), *Shandong nianhua xuanji* (Introduction); Shanghai People's Fine Art Publishing House (ed.), *Shandong nianhua chuangzuo jingyantan* (Introduction).

150. For Soviet influence in propaganda posters see B. Kamenev, *Tigao zhengzhi xuanchuanhuade sixiang yishu shuiping*, Si He *et al.* (trans.); W. Ivanov, *Tan zhengzhi xuanchuanhua*, Wu Lanhan (trans.); M. Ioffe, *Tan nongye ticaide xuanchuanhua*, Li Jiabi (trans.).

151. *Fine Art* journalist, "Cujin xuanchuanhua chuangzuode geng da fazhan — shinian xuanchuanhua zhanlanhui zuotanhui", *Fine Art*, 1960, No. 2, pp. 5–12.

152. Ibid., p. 8

153. Ibid., p. 6.

154. Ibid., pp. 6, 12.

155. *Fine Art* journalist, "Meishu jiaoyu lai yige dayuejin", *Fine Art*, 1958, No. 3, pp. 6–7. The Great Leap Forward caused a considerable amount of disruption to art education. Prior to 1958, approximately one hundred students were enrolled annually at the Central Academy of Fine Art, but in 1958, this number was reduced by half. From that time, up until 1978, new students were not necessarily enrolled every year. On occasions, there was a break of two to three years between enrolments. See Chen Yingde, *Haiwai kan dalu yishu*, p. 29.

156. "Shanghai Zhongguo huayuan guohuajia xiachang xiaxiang", *Fine Art*, 1958, No. 4, p. 30; "Traditional Painting is Linked with Industrial Art", *Chinese Literature*, 1958, No. 5, pp. 140–141.

157. *Fine Art* journalist, "Meishu jiaoyu lai yige dayuejin", *Fine Art*, 1958, No. 3, p. 7.

158. Song Zongyuan *et al.* (eds.), *Yishu yaolan*, p. 31.

159. "Nongcun zibande meishu xuexiao", *Fine Art*, 1958, No. 8, p. 26.

160. Mao Zedong, *Mao Zedong lun wenhua yishu*, p. 176; Liaoning University (ed.), *Wenyi sixiang zhanxian sanshinian*, pp. 243–244.

161. Chinese Research Publishing Co. (comp.), *Zhishifenzi ping wannian Mao Zedong*, pp. 61–62.

162. J. E. Bowlt, "The Virtues of Soviet Realism", *Art in America*, Vol. 60, Nov.–Dec. 1972, p. 104.

163. McDougall, *Mao Zedong's "Talks at the Yan'an Conference on Literature and Art"*, p. 70.

164. For a comparison of the two poets see Guo Moruo, *Li Bai yu Du Fu*.

165. Zhou Yang, "Wo guo shehuizhuyi wenxue yishude daolu", *Fine Art*, 1960, No. 7, pp. 17–21.

166. Jin Weinuo, "Xianxiang yu benzhe, xianshi yu xiangxiang", *Fine Art*, 1959, No. 2, p. 12.

167. Ge Lu, "Wo dui geming xianshizhuyi he geming langmanzhuyi jiehede lijie", *Fine Art*, 1959, No. 2, p. 9.

168. Ai Siqi, *Bianzheng weiwuzhuyi he lishi weiwuzhuyi.*

169. The Jade Emperor — The supreme deity of Taoism; the Dragon King — The god of rain in Chinese mythology.

170. He Jinzhi, "Mantan shide geming langmanzhuyi", *Literary and Art Gazette*, 1958, No. 9, p. 3.

171. Wu Dazhi, "Shijiu shiji Faguode langmanzhuyi yishu", *Fine Art*, 1958, No. 10, pp. 37–40.

172. Ji Lan, "Shenme teng jie shenme gua", *Fine Art*, 1958, No. 10, p. 6.

173. M. Meisner, *Mao's China : A History of the People's Republic*, p. 234.

174. *Fine Art* editorial, "Gonggu fanyou chengguo, zai shehuizhuyi sixiang, yishu shang dayuejin — zai jing meishujia zuotan 'wenyi zhanxianshangde yi chang da bianlun'", *Fine Art*, 1958, No. 5, p. 3.

175. *Fine Art* editorial, "Yu gongnong jiehe — geming meishujiade biyou zhi lu", *Fine Art*, 1958, No. 1, pp. 3–5.

176. *Fine Art* journalist, "Xiang dang jiaoxin, shaojin zichanjieji sixiang", *Fine Art*, 1958, No. 5, pp. 7–10.

177. He Rong, "Shanshui huaniao yu baihua qifang", *Fine Art*, 1959, No. 2, p. 7; He Rong, "Mudan hao, dingxiang ye hao", *Fine Art*, 1959, No. 7, p. 8.

178. Li Rui, *Lushan huiyi shilu*, pp. 121–134.

179. Ibid., p. 278.

180. Zhu Yang *et al.* (eds.), *Zhonghua renmin gongheguo sishinian*, pp. 196–207.

181. Ibid., p. 207.

182. *Fine Art* editorial, "Jiaqiang Mao Zedong wenyi sixiangde wuzhuang, jiji zhandou, fenyong qianjin", *Fine Art*, 1960, No. 3, pp. 3–4.

183. Wang Chaowen, "Bixu jianchi zhengzhi biaozhun diyi — bo Zhang Wang

tongzhi", *Fine Art*, 1960, No. 3, pp. 46–50; Zhang Ding, "Gongyi meishu shiye burong zichanjieji sixiang fushi — ping Chen Shuliang tongzhide liang pian wenzhang", *Fine Art*, 1960, No. 3, pp. 51–55.

184. Red Guard publication, *Meishu zhanxianshang liangtiao luxian douzheng dashiji*, p. 42.

185. Hua Xia, "Guanyu 'zhuyao' yu 'ciyao' — ping 'Mudan hao, dingxiang ye hao'", *Fine Art*, 1960, No. 1, p. 12.

186. Qiu Wen, "Ye tan shanshui huaniaohua", *Fine Art*, 1960, No. 5, pp. 51–54; Cheng Zhide, "Huaniaohua he meide jiejixing", *Fine Art*, 1960, No. 6, pp. 46–50.

187. Red Guard publication, *Meishu zhanxianshang liangtiao luxian douzheng dashiji*, pp. 35–36.

188. Zhu Yang *et al.* (eds.), *Zhonghua renmin gongheguo sishinian*, pp. 214–215.

189. Ibid., pp. 215, 217, 236.

190. Liu Shaoqi, *Liu Shaoqi xuanji (xia)*, pp. 349–431.

191. Zhu Yang *et al.* (eds.), *Zhonghua renmin gongheguo sishinian*, pp. 218–228.

192. Ibid., pp. 228–231.

193. For "Eight Points on Culture" see Liaoning University (ed.), *Wenyi sixiang zhanxian sanshinian*, pp. 301–306.

194. Zhu Yang *et al.* (eds.), *Zhonghua renmin gongheguo sishinian*, pp. 253–255.

195. Red Guard publication, *Meishu zhanxianshang liangtiao luxian douzheng dashiji*, p. 49.

196. Ibid.

197. Ibid.

198. Ibid., p. 44.

199. Ibid., p. 46.

200. Ministry of Culture, *Quanguo zongshumu* (1958, 1962).

201. Red Guard publication, *Meishu zhanxianshang liangtiao luxian douzheng dashiji*, pp. 57, 72.

202. Zhou Yang, "The Path of Socialist Literature and Art in Our Country: Report Delivered to the Third Congress of Chinese Literature and Art Workers on 22 July 1960", *Chinese Literature*, 1960, No. 10, pp. 34–35.

203. Ibid.

204. Ibid.

205. "Before and After the Publication of 'Ten Points on Literature and Art'", *Issues and Studies*, Oct. 1972, Vol. 9, No. 1, p. 71.

206. *Fine Art* journalist, "Beijing meishujia zuotan jiyao", *Fine Art*, 1962, No. 4, p. 3.

207. Lei Meng, "Duchuang, yishu fazhande zhenghou", *Fine Art*, 1961, No. 1, p. 13.

208. Cai Ruohong, "Guanyu meishu jiaoxuezhong jiben xunlian kechengde gaijin wenti", *Fine Art*, 1961, No. 5, pp. 61–67.

209. He Tianjian, "Zhongguo shanshuihuade meixue wenti", *Fine Art*, 1962, No. 1, pp. 21–24.

210. Yu Jianhua, "Yi xing xie shen", *Fine Art*, 1962, No. 2, pp. 64–66.

211. "Shida huajia yishu chengjiude tantao", *Fine Art*, 1961, No. 3, pp. 4–6. The ten artists were Gu Kaizhi (341–402), Li Sixun (651–716), Wang Shen (1036–?), Li Gonglin (1049–1106), Mi Fei (1051–1107), Mi Youren (1086–1165), Ni Zan (1301–1374), Wang Fu (1362–1416), Xu Zhou (1521–1593) and Zhu Da (1626–1705). This article reported on an exhibition held in Beijing (March 1961), comprising more than one hundred exhibits produced by the ten great masters.

212. Red Guard publication, *Meishu zhanxianshang liangtiao luxian douzheng dashiji*, p. 46.

213. Yu Feng, "New Things in an Old Art", *Peking Review*, 22 March 1963, p. 27.

214. Laing, *The Winking Owl*, p. 41.

215. "Sketches by Four Artists", *Peking Review*, 8 Sept. 1961, pp. 18–19.

216. Ni Yi-teh, "Pan Tien-shou's Paintings", *Chinese Literature*, 1961, No. 10, p. 100.

217. Ibid., p. 102.

218. Ibid., p. 103.

219. Mi Ku, "Lin Feng-mien's Paintings", *Chinese Literature*, 1963, No. 1, pp. 101–108.

220. Ibid., p. 108.

221. Hua Chun-wu (Hua Junwu), "Some Thoughts on Cartooning", *Chinese Literature*, 1963, No. 10, p. 86.

222. Yu Feng, "Kan 'Shanhe xin mao' huazhan suiji", *Fine Art*, 1961, No. 4, p. 63.

223. Hua Hsia, "The Paintings of Shih Lu", *Chinese Literature*, 1962, No. 1, p. 95.

224. Wu Tso-jen, "A Reflection on Landscape Painting", *Chinese Literature*, 1962, No. 7, pp. 102–105.

225. Chang Wen-tsun, "Fu Pao-shih's Paintings", *Chinese Literature*, 1962, No. 7, p. 99.

226. Tsui Tzu-fan, "Two Flower-and-Bird Painting Exhibitions", *Peking Review*, 11 Aug. 1961, p. 20.

227. SCMP, No. 2750, p. 22.

228. Mao Zedong, *Mao Zedong ziliao xuanbian*, pp. 273–276.

229. Zhu Yang *et al.* (eds.), *Zhonghua renmin gongheguo sishinian*, pp. 267–271. For further information on the dispute between Mao and the pragmatists see Pang Xianzhi, "Mao Zhuxi he tade mishu Tian Jiaying", *New China Digest* (*Xinhua wenzhai*), 1990, No. 3, pp. 137–147.

230. Zhu Yang *et al.* (eds.), *Zhonghua renmin gongheguo sishinian*, pp. 272–278.

231. M. Goldman, *China's Intellectuals: Advise and Dissent*, p. 88.

232. Zhu Yang *et al.* (eds.), *Zhonghua renmin gongheguo sishinian*, p. 299.

233. Ibid.; Mao Zedong, *Mao Zedong ziliao xuanbian*, pp. 302–303.

234. For relevant articles see the *Literary and Art Gazette*, 1964, No. 9, pp. 3–20.

235. Liaoning University (ed.), *Wenyi sixiang zhanxian sanshinian*, pp. 315–324; Zhu Yang *et al.* (eds.), *Zhonghua renmin gongheguo sishinian*, p. 399.

236. Liu Gangji, "Makesizhuyi meixue yu zichanjieji xingshizhuyi meixuede genben duili — ping Wang Qi dui Makesizhuyi meixuede kanfa", *Fine Art*, 1964, No. 5, pp. 37–42.

237. For examples see *Fine Art*, 1964, No. 5.

238. Red Guard publication, *Meishu zhanxianshang liangtiao luxian douzheng dashiji*, p. 70.

239. Foreign Languages Press, *Rent Collection Courtyard — Sculptures of Oppression and Revolt*.

240. In 1958, during the Great Leap Forward, students and teachers from the Sculpture Department, together with individuals from the Workers Teachers College, travelled to Dazu in Sichuan, and spent two years copying the ancient sculptures in the famous Dazu grottoes. Altogether, more than two hundred reproductions were made and more than two thousand photographs taken, which were subsequently published in a picture album titled *Stone Carvings of Dazu*. See Chen Yingde, *Haiwai kan dalu yishu*, p. 112.

241. "*Shouzuyuan* nisu chuangzuode gousi sheji", *Fine Art*, 1965, No. 6, pp. 4–8.

242. "New Year Holiday Attractions", *Peking Review*, 1 January 1966, p. 31; "Exhibition of the Newly Reproduced Clay Sculptures 'Compound Where Rent Was Collected'", *Chinese Literature*, 1967, No. 4, p. 138.

243. "Exhibition of the Newly Reproduced Clay Sculptures 'Compound Where Rent Was Collected'", *Chinese Literature*, 1967, No. 4, p. 139.

244. D. W. Fokkema, *Report from Peking: Observations of a Western Diplomat on the Cultural Revolution*, p. 82.

245. The six sections were 1. Handing over taxes in the form of grain; 2. Examining the grain; 3. Checking the weight of the grain; 4. Working out the accounts; 5. The extortion of land rent; 6. The seizing of power by the peasants.

246. "*Shouzuyuan* nisu chuangzuode gousi sheji", *Fine Art*, 1965, No. 6, pp. 4–8.

247. Chen Yingde, *Haiwai kan dalu yishu*, p. 21.

248. Liaoning University (ed.), *Wenyi sixiang zhanxian sanshinian*, pp. 325–337.

The Stormy Years of the Cultural Revolution, 1966–1976

Its origins and main features

The outbreak of the Cultural Revolution was the continuation and culmination of the radical line associated with Mao and his like-minded colleagues. It officially began in May 1966 with the issue of the so-called "May 16th Circular", though its origins can be traced back to Jiang Qing's "revolution" in Peking opera, Yao Wenyuan's critique of *Hai Rui Dismissed from Office*, or even the beginning of the Socialist Education Movement. Here, it is important for us to look at the underlying social conditions that culminated in this unprecedented social movement, in order to glean some insights into the main characteristics of art during this period.[1]

The causes of the Cultural Revolution include social, economic and political factors, as well as Mao's own ideas and personality. The conflict between the radical and the pragmatic lines in the Party quickly manifested itself after the Communists took power in 1949, and became particularly sharp during and after the Great Leap Forward when the ideological gulf widened between Mao and his associates on the one hand, and Liu Shaoqi, Deng Xiaoping and their associates on the other.[2] It was Mao who played the crucial role in initiating the Cultural Revolution, and an analysis of his ideas and intentions provides an indication of the

ideological basis for the movement, giving insights into how art developed over the ten years of the movement.

Mao's fear of losing the power struggle with Liu Shaoqi and the other pragmatists was one motive for setting the Cultural Revolution in motion, but more important were Mao's political ideas, on which he had plenty of time to reflect after the failure of the Great Leap Forward. His main ideological premise can be seen in a letter later called the "May 7th Directive" (1966) in which he outlined his vision of a new society. He first mentioned the PLA, stating that it should be like a big school. As well as being a fighting force, the PLA should also study politics and culture, be involved in agricultural production, set up medium and small-scale factories, and participate in mass work. The reason for this was to create a strong bond of unity between the army and the people, who would then join in the revolutionary struggle against the bourgeois class. Mao then referred to the workers, stating that in addition to taking industrial work as their major concern, they should also participate in political, agricultural, military and cultural life. He went on to apply the same formula to peasants, students, and those working in the commercial sector, in service industries, and in all branches of Government and Party organizations and institutions.[3]

In this vision of a new society, Mao aimed gradually to bridge the gap between workers and peasants, between the city and the countryside, and between manual labour and intellectual work. A *People's Daily* editorial on 1 August approved by Mao before publication stated that it was his intention to change seven hundred million Chinese into critics of the old world, as well as constructors and defenders of the new. According to his plan, every individual was to be able to take up the hammer to engage in industrial work, take up the hoe and the plough to cultivate the fields, take up the gun to fight the enemy, and take up the pen to write articles and stories. The entire country would thus become "a huge school of Mao Zedong Thought and Communism".[4]

Mao's vision of a new society had been developing since his Yan'an days, and it had been put into practice during the Great Leap Forward with the setting up of the agricultural communes and mass mobilization. Though the disastrous consequences of the Great Leap Forward temporarily frustrated Mao's ambitions, the gradual recovery of the economy as a

result of the subsequent adjustments, and Mao's belief that these adjustments constituted a shift away from his vision of the ideal society, regenerated his eagerness to continue his social experiment. However, Mao's prestige in the Party had fallen after the Great Leap Forward and his absolute power was no longer guaranteed. To ensure, therefore, that his programme would be implemented, and to deal with any opposition from the pragmatists in the Party and the bureaucracy, he turned once again to the tactic of the mass campaign, relying on the Chinese people to rebel at the grass roots level. The mass movement of the Cultural Revolution was thus, in Mao's revolutionary thinking, both an important means and an end.

As its name suggests, the starting point for the Cultural Revolution was in the cultural sphere. For Mao, this was the "point of breakthrough" because, in his view, cultural activities were completely dominated by bourgeois intellectuals, and any political campaign should therefore begin with a shake-up in this field. The movement began with attacks on Wu Han's play *Hai Rui Dismissed from Office* and on the so-called "Three-Family Village", which referred to the three writers Deng Tuo, Liao Mosha and Wu Han. It then moved on to criticize the more prominent intellectuals, such as key figures in the Propaganda Department, including the Propaganda Minister Lu Dingyi, and Deputy Ministers Zhou Yang and Lin Mohan, all of whom were accused of being "Black Factionalists". The Propaganda Department itself was called a "Palace of the King of Hell" and was accused of protecting Rightists, suppressing Leftists, and working against the revolution.[5]

In the first major official document outlining Mao's plans for the cultural and educational fields, the "May 16th Circular", a sharp indictment was made of the "bourgeois and reactionary" content not only of the media, but also of film, drama, music, dance and art. The document declared:

> *Now we have to hold high the great banner of the Proletarian Cultural Revolution and thoroughly expose the bourgeois reactionary position of a group of anti-Party, anti-socialist academic authorities; we must thoroughly criticize bourgeois reactionary thinking in the academic field, the media, publishing and the arts, and seize the power of leaders in the cultural arena. In order to achieve this, we must at the same time criticize the representatives of the bourgeoisie who have sneaked into the Party,*

the government, the army, cultural circles, and all other areas. We have to get rid of
these people. These people ... are a group of counter-revolutionary revisionists.
Once the opportunity is ripe, they will attempt to grasp power, to transform the
proletarian dictatorship into a dictatorship of the bourgeoisie.[6]

Evidently, Mao looked upon the ideological struggle in the cultural
field as an extension of a political struggle between two classes and between
two basic political lines. As in the Great Leap Forward, professional artists
once again found themselves in an extremely precarious position as they
became the natural targets in what was fundamentally an anti-elitist,
anti-liberal and anti-pragmatic movement. In the preceding period of
relaxation, as well as during the Hundred Flowers movement, they had
unfortunately shown that in a conducive political atmosphere they would
readily reject many of the ideals that the Party had been trying to inculcate
into them. Their struggle to attain a measure of independence in their
work was to prove particularly costly during this last and most turbulent
political movement before Mao's death.

The movement's impact on art institutions

Following the initial criticism and later purge of all the main figures in the
Propaganda Department, the Ministry of Culture and the Beijing Party
Committee, the new locus of organizational power rested with the Cultural
Revolution Small Group, which was closely identified with Mao's radical
policies. Chen Boda was its nominal head, but Jiang Qing was its leader in
practice. Other members included Zhang Chunqiao, Wang Li, Guan Feng,
Qi Benyu and Yao Wenyuan.[7] As time went on this group even replaced
the Politburo and the Party Secretariat as the movement's *de facto*
decision-making body, gaining direct control of cultural policy. Virtually
the entire cultural establishment, much of which went back to the Yan'an
days and the Lu Xun Academy of Art, was replaced by the group which,
enjoying the support of Mao, became the main guiding force for the new
cultural policy. There were similar drastic changes at all levels of cultural
activity. Physical attacks were even made on some individuals. Victims
included Jiang Guangnian, editor-in-chief of the *Literary and Art Gazette*
and a secretary of the Writers' Association; Zhang Tianyi, editor of *People's*

Literature; Tian Han, Chairman of the Writers' Association, and the Peking opera performer, Zhou Xinfang.[8]

Information on organizational changes in the Artists' Association over the period is extremely hard to come by because *Fine Art*, as well as all other official arts journals except *Chinese Literature*, ceased publication in 1966. What information we do have comes mainly from *Chinese Literature* and one or two of the Red Guard tabloids, most of which lasted for only a few issues. The national newspapers occasionally provide useful details. From these sources, it is possible to make some sense of the chaotic situation during the initial period of the Cultural Revolution.

The Party leading group in the Artists' Association, like those in other cultural associations, came under increasing attack, particularly because of its alleged role in supporting the pragmatic policies of the early 1960s. Cai Ruohong, Hua Junwu and Wang Chaowen, as the most powerful figures in the Association after the political demise of Jiang Feng, were especially vulnerable. In June, the three were asked to "stop work and reflect on their mistakes" and large-scale meetings were organized to criticize Hua Junwu.[9] Six months later, on 11 January 1966 Hua and Cai were openly attacked in the *People's Daily*, the *PLA Daily* and the *Guangming Daily* as "counter-revolutionary revisionists", for their part in causing the Artists' Association to degenerate "into a counter-revolutionary body like the Petofi Club in Hungary."[10] They were said to have opposed the theory that "subject matter or content plays the leading role", and Hua Junwu was accused of stating that artists should not "divide subjects into major and minor. There's nothing wrong with painting people or flowers."[11] One of the biggest criticisms levelled against them was that, for an exhibition arranged by the three in 1962 to commemorate the twentieth anniversary of Mao's Yan'an Talks, they had:

> *carefully seen to it that the exhibits chosen were all feudal dregs or bourgeois junk which should have been consigned to the rubbish heap of history and which in no sense supported the Talks. They included paintings of lemons, cherries, dead fish, girls with flowers, lohans conquering tigers and similar trash.*[12]

The selection criteria devised by the three for the exhibition were apparently devoid of any political content. They merely expected that the exhibits should have been completed since 1942, they should come from

all over China (the sticking point about this during the Cultural Revolution being that many areas of China before 1949 were held by the Guomindang, so that paintings from these "white" areas should not have been included in the exhibition), and they should possess a fairly high degree of artistic excellence.[13] No mention was made of the need to reflect the revolutionary lives of the workers, peasants and soldiers. Cai and Hua were accused of touring the country and personally inviting "black artists to exhibit black works".[14] They were said to have allowed the "cultural spy", Ye Qianyu, famous for his "reactionary and lewd cartoons", to exhibit eight items (the largest number of work for any artist participating in the exhibition), including his cartoons, illustrations and traditional Chinese paintings.[15] More than 60% of the 1470 works in the exhibition were said to consist of "goldfish, fat babies, water melons, prawns, and so on."[16]

Cai's part in drafting the "Ten Points on Literature and Art" in 1961 was vehemently condemned, but exposures of Hua Junwu's "crimes" went back as far as the 1930s. He was labelled "an old hand at producing black, anti-Party cartoons",[17] referring particularly to his activities after 1938 and his decision to go to Yan'an. There, during 1942, at a time when the Communists were experiencing great difficulties, vulnerable to attacks from both the Japanese and the Guomindang, Hua, along with Cai Ruohong and others, organized an exhibition of satirical art to reveal the darker side of life at Yan'an. For his critical cartoons, such as *The Relationship Between the Army and the People*, *A Question of Line* and *I Attended the Rally*, Hua was later severely reprimanded by Mao.[18] During the Cultural Revolution, Hua's name was constantly linked with that of Ding Ling and Wang Shiwei, both of whom had dared to write about the negative aspects of Yan'an,[19] and both of whom were criticized (Wang was later executed)[20] for attempting to undermine the morale of the Communists at this critical period of the early 1940s. Hua was said to have continued his anti-Party stand even after 1949, with cartoons such as *The Weathercock* (which portrayed a Party cadre as half man and half weathercock — the implication being that cadres, having no firm principles of their own, simply follow whichever way the political wind blows), *Something Wrong* (which depicted a dragon dance with the leader leading the dragon by the tail instead of by the head. This supposedly "Criticises our Party leadership as giving orders at random and losing sight of the general direction"), and a

whole series of cartoons directed against the Great Leap Forward.[21] All of these were taken as evidences of a "long, thick, malodorous black line" running "through all his [Hua's] so-called cartoons ... from the thirties to the sixties."[22]

Two days after the criticism of Cai and Hua in the three major national newspapers, one of the many "rebel" groups that had sprung up at the behest of Mao to carry out the Cultural Revolution officially "seized power" from the Artists' Association, which in any event had not been functioning meaningfully for months.[23] The final blow came in July 1969 when all the members of the various cultural associations, including the Artists' Association, which had once come under the direction of the Ministry of Culture, were sent to "May 7th" cadre schools[24] and military farms to participate in agricultural labour.[25]

These upheavals in the Artists' Association were justified by the radicals' assertion that its members were "bourgeois intellectuals, Rightists and feudal remnants". Statistics provided at the time did reveal that in 1964, of the somewhat exclusive membership of the national Artists' Association (not including local branches) totalling 1,116 individuals, only 46 (3.2%) were from worker-peasant-soldier backgrounds. Of the 112 council members, only 5 (4.1%) were from worker-peasant-soldier backgrounds. But when one looked at the Secretariat, the Presidium, and the 23 permanent council members, not one individual came from these backgrounds.[26] The statistics showed the extent to which intellectuals dominated the different levels of the Artists' Association, occupying all key positions, and this provided the justification for abolishing the Association and drastically altering art policies.

In addition to the suspension of the Association and the discontinuation of its publication, *Fine Art*, all art education institutions stopped recruiting students for at least four years.[27] Only after 1970 did some institutions, such as the Zhejiang Academy of Art, once again open their doors, though now most students were either from worker-peasant-soldier backgrounds, or young people who had been to the countryside for at least three years and were therefore considered politically sound. Any artistic skills prospective students might possess were disregarded.[28] After 1972 family background and political performance became the dominating factors in deciding admission to art schools.[29]

During the Cultural Revolution and particularly in its early stages, many artists were attacked and works of art destroyed. All work produced before 1966 was designated "the products of feudalism, revisionism and bourgeois thinking". Red Guards entered the homes of artists, art galleries and temples to burn paintings and art books and smash statues. Especially targeted were foreign language publications, treatises on traditional Chinese art, images of nudity and paintings with classical Chinese quotations.[30] Lin Fengmian and Pang Xunqin felt compelled to destroy their own work for fear of repercussions from Red Guards.[31] Pan Tianshou's traditional Chinese painting, *A True Portrayal of the People of Yiqiao Township, Shandun District, Hang County, Eagerly Presenting Their Agricultural Taxes to the Authorities* (Fig. 11), completed in 1950 to meet the political demands of the time, was cited as evidence of Pan's "counter-revolutionary stance". The village government in the painting was said to resemble a landlord's courtyard, and the peasants looked as if they were handing taxes over to a landlord, rather than to a representative of the people's government.[32] Qi Baishi's grave was desecrated and Xu Beihong's Commemorative Hall was attacked.[33]

Apparently due to protection afforded by well-placed political backers, Guan Shanyue was one of the few professional artists to escape the Cultural Revolution unscathed. His traditional Chinese painting, *Shepherd's Song in the Tian Mountains* (Fig. 12), though basically a conventional landscape devoid of overt political content, was even widely publicized as a model for traditional Chinese painters to emulate,[34] ironically at a time when the so-called "black painters" (to be discussed below) were being severely criticized for paintings that in most cases were no less "revolutionary" than this example of Guan's work.

These were, perhaps, the darkest days for artists since 1949. They were faced with a wave of cultural nihilism that denied the importance of China's traditional high culture, and denigrated many of the works of art produced since 1949. The turbulent events of 1966 revealed one of the main characteristics of this initial stage of the Cultural Revolution — a break with the past and the promotion of the "new Cultural Revolutionary artistic style".

Art during the Cultural Revolution

Throughout the Cultural Revolution, despite the massive dislocation of art organizations, publications and education, art continued to play an important role in the movement. In addition to the large number of propaganda paintings to promote the Cultural Revolution and the many cartoons designed to ridicule and attack "Black Factionalists" and other targets, one of the most prominent features of art at that time was its contribution to the creation of a personality cult around Mao Zedong. This deification of Mao was directed and encouraged by the Cultural Revolution Small Group as a means of bolstering Mao's (and therefore its own) position, restoring his prestige and strengthening his political power base to ensure his political programme was carried out.[35]

The cult of Mao was one of the most important aspects of the Cultural Revolution. It had its origins both in Chinese political traditions, in which the Emperor was revered as mediator between Heaven and Earth, and in the cult of Leninism and, particularly, Stalinism, which shared many features with the cult of Mao in the late 1960s. The Chinese theoretician Wang Ruoshui stated: "The reason that the Cultural Revolution was able to come about depended mainly on the absolute, unchallengeable authority of Mao. In turn, the Cultural Revolution pushed the worship of Mao to an extreme."[36] Another scholar, Yu Shifang, pointed out:

> The acceptance of Mao's personality cult by the masses and by a large number of Party members, which turned the Cultural Revolution into an irresistible force across the entire country, was inseparable from the methods of agitation and forms of organization based on traditional religion that were skillfully utilized by Mao, Lin [Biao] and the Cultural Revolution Small Group.[37]

The deification of Mao took many forms. It was manifested in the creation of a pseudo-religious ritual in revolutionary form, consisting of several integral components associated with traditional religion. For example, the notion and the image of a "saviour" in the person of Mao was represented by, or depicted in, countless numbers of statues, portraits and badges. The image of the "saviour" permeated all aspects of life: statues of Mao were erected in public places, such as city squares, university campuses,[38] and in front of important institutions; his portraits were hung in every office, factory, classroom, shop and home; and Mao badges were worn

by individuals everywhere. There was thus achieved an integrated and
effective structure in visual form of Mao's personality cult from the social
or collective level to the individual level. An all-pervasive visual presence
of Mao thus registered his overwhelming dominance and authority. The
"little red book" or quotations of Mao, of which 740 million copies
were said to have been sold during the Cultural Revolution, became almost
a bible for the Chinese people, with its simple homilies and moral
guidance.[39] Also, Mao's inspection of the Red Guards in Tiananmen
Square on 18 August 1966 generated an emotional ecstasy comparable to
the fervour engendered in some religious sects. In addition, it could be said
that the use of terms which traditionally referred to evil spirits, such as
"monsters and demons" (*niugui sheshen*) and "demons and ghosts" (*yaomo
guiguai*) by Mao and his supporters to criticize their opponents conveyed in
part at least a sense of religious disapproval or even disgrace.

Much has been written about the Cultural Revolution and new de-
tails of the practice of Mao's personality cult are constantly emerging.
Apparently, one important aspect of it was the establishment of ritual
activities in which visual imagery played a crucial role. When "Loyalty
Halls" (Zhongzitang), whose function was similar in many respects to
churches or temples, were set up, they were decorated with red banners and
red lamps, and Mao's portrait was placed in a central position, flanked on
either side by quotations from his works. The atmosphere within the halls
was designed to engender a sense of solemnity and respect. Visitors (and
everyone was expected to visit often) went there to "ask for instruction"
and "report on all their activities". They were expected to wish Mao a long
life, to sing "The East Is Red" and to read out a liturgy of Mao's quotations.
"Believers" had to struggle against their own selfishness, reform their soul
and become absolutely loyal to Mao. In a ritual similar to those of many
religions, "devils" were brought along to the "Loyalty Halls" to confess their
(political) crimes and beg forgiveness.40 On occasions, actual churches were
taken over and the painted or sculpted images of Christ, the Virgin Mary
and the saints were replaced with that of Mao.[41] In another ritual which
usually took place in public areas such as city squares, total obedience to
Mao's thought was displayed by means of a "loyalty dance" to Mao, in which
individuals held red banners, embraced his portrait or clutched his "little
red book" in an orgy of emotional sobbing and fevered enthusiasm.[42]

Due to the development of these social rituals as an important dimension of the early stages of the Cultural Revolution, and the key role played by the creation of a "saviour's" image, throughout China efforts were made to place portraits of Mao in all public and private spaces. Perhaps at no other time since 1949 had there been such a fusion of art, political ideology, social consciousness and individual psychology. The ubiquitous presence of Mao's portraits and their pseudo-religious aura ensured that art became less of an external and voluntary experience for individuals, who would have to deliberately seek it out in exhibitions or purchase it in shops, but more an integral part of social life providing a powerful means of shaping the collective consciousness and of ensuring personal "salvation".

Comparisons between the portraits of Mao and European religious painting in terms of social function and methods of execution are striking. Both were designed to be morally uplifting, to contribute to a process of self-cultivation, to engender a feeling of deep solemn respect and reverence towards the person whose image was represented, and all that he stood for. In Christian churches, the major events of Christ's life are regularly depicted to reveal the various facets of his persona. Portraits of Mao, too, covered all the stages of his revolutionary career, from his student years in Hunan, through the 1920s and the early founding of the CCP, the Jinggang Mountains period, to the Long March (particularly the Zunyi Conference of 1935, which saw Mao emerging for the first time as leader of the Communists), the Yan'an period, the civil war, liberation and after. Mao was presented in the roles best suited to increasing his personal prestige — as founder of the Communist Party, as the great Red Army commander, as the wise teacher and Party theoretician, as the kind leader and saviour of ordinary Chinese folks, and as the solitary thinker planning the next stage of the revolution.

An example of a Cultural Revolution painting with striking similarities to European religious painting is Zhou Shuqiao's *Hunan Communist Group* (Fig. 13). Mao is shown as a young man addressing a group of Communist adherents in a small, dimly-lit room. As the only person standing, he is obviously the central figure within the composition, and his importance is highlighted further by the intense and rapturous gazes of his audience who incline their heads and upper bodies towards him, hanging on to his every word. In Christian iconography Christ is often depicted

standing and surrounded by seated or kneeling apostles who lift their heads and fix their eyes upon him. In Zhou's painting the compositional arrangement of the figures forms a triangle with Mao's head at the apex. The viewer's eyes are inexorably drawn towards him as the central focus. The pose Mao has adopted is also reminiscent of images of Christ, his hand extended in an open gesture similar to that of Christ's denoting peace and goodwill. The overall mood is one of solemnity and spirituality, engendered by the mainly muted brown and russet tones and the light of the overhanging lamp which casts a soft ethereal glow on the faces of the figures below. Only the rather jarring portrait of Marx on the wall and the pile of scattered political tracts and Communist newspapers tell us that this is not the depiction of a Christian Saviour, but a gathering of the embryonic Communist Party.

An interesting development in the portrayals of Mao during the Cultural Revolution was something of a move away from the usual representations of him encircled or flanked by the smiling masses, and an increasing tendency to depict him far removed from the masses, as a figure towering above the earth who instigates the mass movement of a quarter of the world's population and who dares to challenge nature itself. *Follow Closely Chairman Mao's Great Strategic Plan* (Fig. 14) is a prime example of this genre, with Mao positioned in the clouds, gazing into the far distance, his hand outstretched as if reaching towards some bright future. Below him, the teeming masses, insignificant and barely visible, recede into the background as far as the eye can see. They carry banners with political slogans and hold aloft their Mao portraits, so that Mao's image is multiplied several times within the single painting. Here he resembles not so much a political leader, but a god or a Buddha, with superhuman qualities capable of bringing about momentous changes on earth. It is an example of the deification process taken to extremes.

Perhaps the most ubiquitous painting of the Cultural Revolution was also a clear expression of Mao's personality cult. *Chairman Mao Goes to Anyuan* (Fig. 15) shows a youthful Mao, attired in a long Chinese robe, with a furled paper umbrella tucked under one arm, and with one fist clenched as he strides across hilly terrain. His figure totally dominates the scene, seemingly filling the gap between the ground and sky, symbolic of a Chinese emperor mediating between Heaven and Earth. Liu Chunhua, the

young Red Guard who painted the picture after its initial planning by a group of Beijing students, explained the thinking behind it:

> We placed Chairman Mao in the forefront of the painting, tranquil, far-sighted and advancing towards us like a rising sun bringing hope to the people. We strove to give every line of his figure significance. His head held high and slightly turned conveys his revolutionary spirit, dauntless before danger and violence, courageous in struggle and daring to win. His clenched fist depicts his revolutionary will, fearless of sacrifice, determined to surmount every difficulty to free China and mankind, confident in victory.[43]

The utilization of art to re-create history

One of the more disturbing uses of art during the Cultural Revolution was to distort historical reality to a degree unprecedented since 1949, with the purpose of discrediting individuals who had once made significant contributions to the Party but who had now fallen out of favour. Such art was also intended to sustain the prestige of those occupying leading positions and directing Cultural Revolution policies. Many pre-1966 paintings displayed events and individuals in revolutionary history in a way that did not conform with Cultural Revolution rhetoric. To affirm the new orthodoxy, figures were erased from paintings, while others were placed within certain contexts that did not wholly conform with the historical facts. In the revised Cultural Revolution version of the oil painting *The Joining of Forces at Jinggang Mountain* (an event that took place in 1928), for instance, the original figure of Marshal Zhu De, discredited by 1966, was re-worked into that of Lin Biao who, in 1928, far from having the authority and stature within the Party to lead the united Communist military forces, was only in fact a mere platoon head.[44] Lin's status during the Cultural Revolution as a leader second only to Mao, however, ensured his (temporary) place in the revised version of Communist Party events. Dong Xiwen's famous painting *Founding Ceremony* was also altered by removing the prime target of the Cultural Revolution, Liu Shaoqi, from the line-up of Communist Party leaders.[45]

Many portraits of Mao, to heighten his personal prestige, linked him inaccurately with important milestones in Party history. Paintings hung in the Commemorative Hall of the First Communist Party Congress in Shanghai that depict the founding of the Party in 1921, invariably present

Mao as the key participant, dominating the proceedings. The reality was that at the time, Mao was little-known, merely one of two representatives from Hunan, the central figure at the meeting being Chen Duxiu.

The best-known example of a work of art distorting historical fact is the oil painting *Chairman Mao Goes to Anyuan*, for which some explanation of the historical background is required. Following the founding of the Chinese Communist Party in 1921, Party members began to organize the workers and encourage them to strike against employers in order to gain redress for various grievances such as long hours, low pay and poor working conditions. Their efforts were concentrated in the three cities of Anyuan, Hanyang and Daye in Hunan. Communist activity amongst the Anyuan miners was of particular importance, because the Anyuan miners group was the first major union led exclusively by the Chinese Communist Party. The Communists were able to organize a successful strike there in 1922, and Anyuan became a bastion of support for the Party, providing cadres at the Whampoa Military Academy and other political schools from amongst its ranks of workers.[46] As one of the earliest successes of the Party amongst China's industrial workers, Anyuan represented a landmark in Chinese Communist history, and reflected glory on those Party leaders associated with it. Unfortunately for Mao, however, although he participated in organizing the strikes in Hunan, his role was minimal and at the periphery of the major action. Much more important were the parts played by Liu Shaoqi, Li Lisan and others. Liu Shaoqi had always been more involved in the organization of workers in towns and cities, whilst Mao had focused his attention on the growing Hunan peasant movement.

In 1961, an oil painting by Hou Yimin, *Liu Shaoqi and the Anyuan Miners* (Fig. 16), portrayed Liu as the forceful leader of the Anyuan striking miners. In it, he is shown striding forward purposefully, with a determinedly-set face, flanked by workers whose expressions reflect his own look of steely will.[47] The following year, in *The Earth Is Burning*, a film covering the Anyuan strikes, Liu's leading role was again highlighted, with some of the scenes even implying that Liu, and not Mao, was the Chinese people's "sun".[48] The prominence given to Liu at that time reflected his enhanced position following the demise of the Great Leap Forward and the triumph of his pragmatic approach over the radical policies pursued during the late 1950s.

By 1967, however, Liu's political downfall was virtually complete, and his reputation as a key player in the shaping of Party history lay in ruins. It has already been mentioned that in *Founding Ceremony* he was eliminated from the line-up of Party leaders when Mao declared the establishment of the new People's Republic on Tiananmen Square. Now his role in earlier Party events was also discredited. In 1967, Hou Yimin's painting of Liu and the Anyuan miners was attacked as a "poisonous weed",[49] and efforts were made to insinuate that it was Mao, not Liu, who had actually helped lead the workers' strikes. An exhibition was arranged in Beijing with the title "Mao Zedong's Thought Illuminates the Anyuan Workers' Movement", a product of which was Liu Chunhua's painting *Chairman Mao Goes to Anyuan*. The propaganda value of the painting was acknowledged when it was labelled one of the "two gems of art", the other being the music for the Peking opera, *The Red Lantern*.[50] It was also, unusually for a painting, widely reproduced in all the major national newspapers on 1 July, the anniversary of the founding of the Communist Party, along with criticisms of Liu Shaoqi's role in the Anyuan miners' strikes and praise for the part played in the strikes by Mao.

It is interesting to consider why this particular painting merited such unprecedented media coverage. Clearly, its prominence was not due to technical excellence or conceptual originality. Instead, its popularity must be attributed to political factors. By distorting the historical reality of events in Anyuan and implying that it was Mao who had led the miners' strikes, the painting achieved two things. It firstly served as a blatant rejection of the positive images of Liu Shaoqi's contribution to the strikes. Second, its *de facto* replacement of Liu with Mao ensured that an important gap in Mao's revolutionary pedigree was filled. Earlier paintings had depicted Mao in his military role, as the leader of the Autumn Harvest Uprising and as the great military strategist in his redoubt in the Jinggang Mountains; they had also represented him as the revolutionary leader of the peasants, giving instruction to Party cadres at the Guangzhou Institute of the Peasants' Movement, for instance; *Chairman Mao Goes to Anyuan* was the means to assert Mao's pre-eminence in the urban Communist movement. The impression was thus created that Mao had been pivotal in the revolutionary history of the three most important sectors of the society — the workers, peasants and soldiers. Rather than being associated with

the peasant movement primarily and to a lesser extent with PLA activities, Mao could now lay claim to a pre-eminent role in all areas of the Communist revolution, and thus more forcefully and convincingly legitimized his position as the supreme leader. An article in *Chinese Literature* summarized the comprehensive nature of Mao's revolutionary activities in the following words:

> He (Mao) led the miners in the fight against the feudal power and capitalists, lit the flame in Anyuan and later led some of the revolutionary miners to the Chingkang mountains, China's first revolutionary base, thus combining the workers' movement with the peasant movement. From Chingkang mountains to Yenan, and from Yenan to Peking, the revolution eventually advanced to victory.[51]

Another article specifically linked the miners' strikes with the Autumn Harvest Uprising, when workers and peasants came together to form a division of the Red Army and accompanied Mao to the Jinggang Mountains.[52] *Chairman Mao Goes to Anyuan* was thus an integral part of a strategy to enhance Mao's prestige and to consolidate Mao's position as the undisputed leader.

Worker and peasant paintings

At an early stage of the Cultural Revolution the popular art forms of the workers and peasants were, as during the Great Leap Forward, brought into prominence, and several national exhibitions were organized to show worker and peasant paintings. In fact, during the Cultural Revolution, as professional artists fell into disgrace, worker and peasant paintings were regarded as the artistic mainstream and the most important dimension of art activities. They were popularized throughout the basic units of the society — the villages, factories, shops, workshops and on the streets. They became the vehicle for translating more abstract political propaganda and political slogans into concrete images, accessible to ordinary people through the use of popular forms to illustrate the lives of the amateur artists themselves. These paintings played an important role in a large-scale movement like the Cultural Revolution because, in a country like China where the communication structure was so poor, amateur artists were able to adopt simple means like wall posters, blackboard drawings, and street propaganda paintings to convey Mao's message.

To see how deeply politicized art became after 1966, and how integral worker and peasant paintings were to the wider ideological stance taken by Mao and the Cultural Revolution Small Group, we can compare statistics on the contents of picture albums and painting collections published during the Great Leap Forward with those that appeared during the Cultural Revolution. Referring back to figures given previously in Chapter Two, in 1958, at the height of the Great Leap Forward, approximately one eighth of the published painting collections and picture albums were of foreign origin, more than a third were on traditional themes, such as landscapes and flowers-and-birds, and just over half covered the lives of workers, peasants and soldiers, and directly reflected prevailing policies. In 1973, however, at a time when the Cultural Revolution had already passed its most radical phase, we find that no foreign paintings were included amongst picture albums and painting collections, there were no landscape or flower-and-bird paintings and only one collection was on a classical theme — a reprint of traditional woodblock prints originally published in 1958, titled *Collection of Famous Ming Woodblock Print Illustrations*. The vast majority of the albums and collections covered the lives of workers, peasants and soldiers and contemporary political events. For example, of the sixty-one works included in the *Tianjin Collection of Worker, Peasant and Soldier Paintings* (1973), all but one featured contemporary political themes.[53] In this respect, 1973 is not an exceptional year. Between 1970 and 1975 one sees little variation in these general trends.[54]

The most important aspect of the re-emergence of worker-peasant paintings during the Cultural Revolution is that the strong emphasis on amateur painting and the role of workers and peasants in cultural activities was directly linked with Mao's grand vision of the new Chinese Society. Participation in such activities by workers and peasants was not viewed merely as a spare-time pursuit and a means of enriching cultural life as in the Great Leap Forward, but more as an indispensable component of the new stage of socialist construction, which viewed direct involvement by the masses in the artistic process as a vital step in bridging the gap between manual and mental labour, rural and urban areas, and between workers and peasants on the one hand and intellectuals on the other. The importance attached to the participation of workers and peasants in art activities can be seen from the way in which workers (and on occasions, soldiers) took

over from officials the running of art institutions in 1966; it can also be
seen from the sending of professional artists to the countryside and fac-
tories, not to be advisers to workers and peasants, but to "learn" from them
as their students. This reversal of roles between professional and amateur
artists was a deliberate attempt by Mao to fundamentally reform Chinese
society.

The "Shanghai, Yangquan, Lü Da Workers Art Exhibition"

The "Shanghai, Yangquan, Lü Da Workers Art Exhibition", held in
Beijing in 1974, was perhaps the most famous worker art exhibition.
Comprising 172 pieces, it was said to have attracted some 400,000 visitors,
and a collection of the exhibits was later published.[55] The exhibition
covered a wide range of political themes, including positive images of the
Cultural Revolution, criticism of Lin Biao and Confucius (*Grasp Criticism
of Lin Biao and Confucius, Promote Coal Production*), comparison of the
present lives of workers with that before 1949 (*We Have Changed the
World*) and China's constant search for industrial independence and self-
sufficiency (*Advance Triumphantly* (Fig. 17)). Encompassing the entire
range of artistic media from oils and traditional Chinese paintings to
woodblock prints, New Year pictures, picture-story books, water colours,
propaganda posters and blackboard pictures, the subject-matter was mainly
drawn from the amateur artists' own lives and experiences as workers. The
artists came from a highly diverse range of industries and occupations; they
were employed in shipyards, on construction sites, in machine factories,
steel mills, textile factories, shops, mines, on the railways, in banks and the
navy, and this diversity was reflected in the themes of their work.

It is clear from the exhibition that the workers had been advised by
professional artists in matters of technique — most of the amateurs having
achieved a level of technical competence one would not normally associate
with the completely uninitiated. It was later admitted by them that their
skills had been acquired through the efforts of professional artists who went
to the factories and workshops to hold classes. However, they also stressed
that these professionals had limited their role to explaining the basic skills
of composition, colour, knife techniques, and so on, "according to the
practical needs of the workers". Their help was only solicited when specific

problems were encountered.[56] The themes of the exhibits were decided by the workers themselves and they tended to reflect particular problems in the workplace. For instance, more than fifty pieces criticized wastage in factory production and encouraged a more responsible attitude towards the use of factory materials.[57]

In order to popularize good practices within the workplace, as well as to propagate a broader range of Cultural Revolution policies, exhibitions of workers' art were regularly held in factories. In addition, their illustrations for blackboard and wall newspapers contributed to the general propaganda drive. These were replaced every week by new illustrations to ensure that the workers could keep abreast of the latest developments in the political movement.[58]

Hu county peasant paintings

The Hu county peasant paintings were held up as a model for other peasant art groups to emulate.[59] The peasants from Hu county, Shaanxi province, had been involved in art activities since 1958, as a direct result of Great Leap Forward policies. Between that year and 1972 approximately 550 amateur artists from amateur art groups in twenty of the twenty-two communes in Hu county had reportedly produced some forty thousand pieces of art work.[60] However, since 1959 they had lost their prominent position in official publications and there had been little coverage of their artistic endeavours. In 1972, articles began to appear about them again and an exhibition of their work was held in Beijing in October 1973. During a trip to China, the oil painter, Zhao Wuji (Zou Wu-ki), one of the most admired Chinese artists in the West, was apparently impressed by the peasant paintings and decided to show them abroad. With his help, eighty of the paintings were exhibited in the Ninth Paris Biennial Exhibition, held in the autumn of 1975. As one of the rare occasions (at that stage) that Communist China participated in an international exhibition, the paintings attracted a good deal of interest.[61]

Much was made of the fact that all the Hu county peasant artists were amateurs, which conformed to the ideological line that art could and should be practised by everyone in society, regardless of their class backgrounds. Individual peasants recounted their personal experiences working

in the various art groups, and their stories almost always emphasized their poor backgrounds and how, despite these circumstances, they had managed successfully to participate in the art activities of the county. Liu Zhide, who painted *Old Party Secretary*[62] (Fig. 18), was himself Party secretary of one of the brigades. He was from a poor peasant background and originally his only contact with any form of art was the occasional paper flowers his father used to make. He recalled that in 1963 he had become involved in art activities for the first time and since then he had produced some five hundred pieces. Despite becoming Party secretary of his brigade in 1968 he continued to paint.[63] Another amateur, a female peasant called Li Fenglan, recounted that she was originally illiterate, and had no experience of painting prior to the Great Leap Forward. Like many peasants, her only previous contact with art work of any kind was paper-cuts. During the Great Leap Forward, however, she began to make contributions to the ubiquitous blackboard newspaper illustrations and murals, moving on later to painting. Since then she claimed to have produced more than three hundred paintings.[64]

Thematically, the Hu county peasant paintings were similar to the Shanghai, Luda and Yangquan worker paintings in that they attempted to reflect the lives of the artists themselves and, in the case of the peasant paintings, the changes that had taken place in the villages during the Cultural Revolution. Obviously, the aspects of the peasants' lives represented in the Hu county paintings, like almost all of the art produced in the ten years after 1966, were highly selective, with strong political overtones. *Old Party Secretary*, referred to above, depicts an elderly Party secretary studying Mao's writings during a break in his work. His devotion to Mao is highlighted by the fact that even whilst he is preparing to strike a match to light his pipe his eyes never stray from the pages in front of him. *A Big Meeting to Criticize Lin [Biao] and Confucius* by Zhao Kunhan is, as the name suggests, an encouragement to the peasants to join in a new mini-movement against Lin Biao and Confucius. Other works promoted efforts to increase agricultural production, construct irrigation channels, dig wells and hoe the soil. There was even an example of the old Great Leap Forward favourite of peasants making their own steel agricultural implements.

Despite evident politicization, however, the Hu county peasants, adhering mainly to the traditional rural art forms of the New Year picture

and the woodblock print, still managed to retain in their work a sense of liveliness and endearing simplicity that was lacking in many other examples of Cultural Revolution art. They used the time-honoured artistic traditions of bold and vivid primary colours in large blocks over the picture surface (*Take Grain as the Key Link, Develop a Diversified Economy*, Bai Tianxue), simple compositional structures whereby almost the entire picture area is crowded with look-alike figures (*Impregnable Fortress*, Song Houcheng) or a repetitive arrangement of a particular motif (*Production Brigade Ducks*, Li Zhenhua; *The Brigade's Chicken Farm*, Ma Yali (Fig. 19) and *Bumper Harvest of White Lotus Seeds*, Jiao Caiyun), to maintain the highly decorative effect of these popular art forms.

A distinction should be drawn, however, between the Hu county peasant paintings of the 1970s with the earlier peasant paintings of the Great Leap Forward. Unlike many of the latter, which were painted without the help of professional artists from towns and cities, a great deal of professional help was offered to the Hu county peasants.[65] Some of them later became semi-professionals themselves, devoting an increasing amount of time to painting, rather than to agricultural production.[66] In contrast to the flat, single-dimensional figures of Great Leap Forward peasant paintings, with their lack of perspective and their exaggerated dimensions of motif, many of the Hu county peasant paintings reveal a higher level of artistic sophistication. There is much greater evidence of modelling to produce figures that appear three-dimensional, as in *Old Party Secretary*, where the use of shading and bold dark strokes in the clothing of the figure help create the desired effect. There is also an increased use of perspective, as in the paintings *Spring Hoeing* (Fig. 20) and *Commune Fish Pond* (Fig. 21), both of which include an arc of figures, larger in size in the foreground and receding into the background. *The Morning Sunlight Shines on the Village of Painting*, too, employs this technique to create a grand vista of tended fields, factories and houses which are depicted in detail in the foreground, but merged into a mass of intermingled blocks of colour towards the top of the painting.

The Hu county peasant paintings thus manifested three important characteristics, which probably explains why they were taken as a model to be emulated. Their themes were of a highly political nature, valuable as propaganda in their depictions of an idyllic rural life, with happy and

enthusiastic ruddy-faced peasants busily engaged in agricultural produc-
tion, political meetings and study sessions. Secondly, they had their origins
in traditional popular art forms, rendering them easily accessible to a wide
audience. Thirdly, they had progressed from the purely amateur peasant art
of the Great Leap Forward to a standard that was even considered present-
able on the international stage. The contrast between professional paint-
ing, which exhibited a high level of technical achievement and amateur
painting, which was normally characterized by extremely rudimentary
artistic skills, had thus been lessened. The Hu county peasant painters,
with their blend of professional techniques and popular art forms, could
therefore be shown as a good example of Mao's idyllic vision of a society
whose people were adept at a whole range of skills, whether agricultural,
industrial, military or artistic.

The "black painters"

After 1969 and the Ninth Party Congress, the first stage of the Cultural
Revolution ended. Although the radicals, headed by Mao and Jiang Qing's
Cultural Revolution Small Group, were still dominant, the political and
social situation gradually stabilized following three years of upheavals and
factional fightings.

By late 1971, the Lin Biao events, during which Lin, Mao's appointed
successor, died in a plane crash whilst apparently defecting to the Soviet
Union, led to a setback in radical policies and a temporary relaxation of the
harsh treatment of artists. One of the results of this relaxation was the
emergence of what was later called the "Hotel School". The improvement
in China's international relations after 1971 gave rise to discussions in the
Ministry of Foreign Affairs concerning the most appropriate means of
decorating the hotels and restaurants that would cater to the vastly in-
creased numbers of foreign dignitaries visiting China. The Ministry
favoured traditional Chinese paintings, and this revealed once again the
double standard of the Chinese authorities in their view that what was
inappropriate for home consumption was perfectly acceptable, even highly
desirable, when reserved for foreigners alone. When the matter was taken
to Premier Zhou Enlai he was said to have agreed readily, stating that the
paintings should be flowers-and-birds and landscapes. He felt that, in

addition to beautifying the hotels and restaurants for foreigners, such paintings, as well as China's traditional arts and crafts, could be exported to earn foreign currency for the country. Any work that was not "reactionary, feudalistic, ugly, superstitious or pornographic" would be acceptable. Landscape painting was no longer to be regarded as one of the "four olds" ("old thinking, old culture, old customs, old habits"). In order to provide the Ministry of Foreign Affairs with the many paintings it required, professional artists were called back from the countryside. They were mainly traditional Chinese painters and woodcut artists, and included Huang Yongyu, Li Keran, Yan Han, Gu Yuan, Tao Yiqing and Huang Runhua.[67] Artists went to work almost immediately, producing landscapes, flower-and-bird paintings and various items of traditional Chinese crafts in large numbers.

On 23 November 1973 a meeting reportedly took place in the Friendship Hotel in Beijing, attended by three prominent artists from the Artists' Association, Shao Yu, Gao Jingde and Gu Yuan, together with Wang Mantian, the person appointed by Mao and Jiang Qing to take charge of art. During this meeting to discuss the paintings being produced for foreign consumption, there was the first indication of a possible radical backlash. Shao Yu pointed out that there were political problems with the paintings, specifically mentioning Huang Yongyu's *The Winking Owl*. Wang Mantian then offered her view that investigations should be carried out and a report made to Jiang Qing in order to ascertain the political implications.[68]

When Jiang Qing was informed about these paintings produced by the very artists she considered to be the most elitist and bourgeois, she became incensed and gave the artists the collective epithet the "Hotel School". However, it was only during the movement to "criticize Lin Biao and Confucius", which was in reality an implicit attack on Zhou Enlai, that Jiang Qing was able to take action against these artists. Linking together the work displayed in the Beijing Hotel, the International Club, the Cultural Relics Store and the Beijing Art Academy, Jiang Qing and the other radicals collected together more than seven hundred pieces and held a "Black Painting Internal Exhibition" on 8 February 1974. Wang Hongwen, a member of the Cultural Revolution Small Group, attended the exhibition and criticized the "black paintings" as being worse than

Antonioni's famous documentary, *China*.[69] Another observer, Yu Huiyong, an official with responsibilities in cultural affairs, declared the exhibition pieces to be a "restoration of everything criticized before 1966". Subsequently, meetings were organized throughout the country to attack the paintings, the one in Beijing drawing a crowd of ten thousand people. From the original "Black Painting Internal Exhibition" 215 pieces were selected for restricted viewing at the China Art Gallery from 13 February to 5 April.[70] Many articles critical of the paintings began to appear in newspapers and magazines, and it seemed as though a major political campaign against professional artists was about to begin. Criticism was not limited to Beijing. Several so-called "black exhibitions", which purportedly provided evidence of "a restoration of the black line", were held in cities such as Shanghai and Guangzhou.[71]

Though it is obviously difficult to ascertain to what extent the "black painters" genuinely intended to attack the policies of the Cultural Revolution and the leadership of the Cultural Revolution Small Group, it is certainly the case that Jiang Qing and the other radicals chose to read political dissent and dissatisfaction into virtually all of the "Hotel School" paintings, even the seemingly most innocuous. Huang Zhou's paintings of asses were interpreted as satirizing the radicals.[72] The Chinese characters accompanying one of these paintings, meaning "The Task Is Difficult and the Road Is Long", were said to be an implicit criticism of economic stagnation and a negation of the Cultural Revolution.[73] Li Keran's *Our Motherland Has Such Beautiful Rivers and Mountains* and *Mountain Village after Rain* were castigated as "black mountains and black waters".[74] Li's "over-use" of black, the universal symbol of darkness and despair, was taken as a sign of his pessimism about China's future and his opposition to the authorities. Shi Lu's traditional Chinese paintings were classed as "wild, strange, chaotic, black", proof of his "counter-revolutionary programme".[75] Chen Dayu's *Welcome Spring* (Fig. 22) came in for some of the most vitriolic criticisms. The cock depicted in it was said to have "fierce glaring eyes" and its upturned tail was a sign of arrogance or "cocking-a-snook" at the authorities. It was also said to "show extreme hostility towards the joyful picture of the spring of socialism."[76]

Huang Yongyu's *The Winking Owl* (Fig. 23) was eventually to become one of the most famous of all the "black paintings". It was taken by

Jiang Qing to be a sign of Huang's "hatred for the Great Proletarian Cultural Revolution and the Socialist Revolution,"[77] and, as a result, Huang underwent several months of criticism sessions at the Central Academy of Fine Art.[78] His practice of using animal representations in his art to satirize political figures was well-known in the art world. It had even led to him being branded as a counter-revolutionary in 1962, when his simple sketch-like paintings and accompanying "Animal Crackers" poems caused offence in official circles.[79] What is particularly interesting about the *Winking Owl*, however, is that we can read into it layers of meaning that go beyond the superficial political level (as interpreted by Jiang Qing and the radicals) to a deeper, more philosophical level.

Ellen Johnston Laing, in her seminal work, *The Winking Owl*, has pointed out a possible interpretation of the painting by analysing one aspect of the symbolism traditionally attached to the owl by the Chinese. She states quite correctly that the owl has been regarded in China as a bird of ill-omen, and a symbol of darkness and evil, with the implication that Huang's owl may have been intended to convey a feeling of darkness, despair and pessimism.[80] However, it is also true that in modern times, the Chinese attribute to the owl the same quality as we do in the West, i.e. wisdom, and I would suggest that Huang's owl, rather than being a harbinger of evil, is intended here to be a symbol of wisdom. In addition, rather than conveying a sense of despair, the image carries a subtle hint of mischief, expressed in the artist's playful brushstrokes and the owl's act of winking, which is reminiscent of Huang's earlier humorous pictorial representations of animals.

The kind of wisdom that the artist implies in the painting is not a bookish knowledge but a higher form of wisdom and understanding, an almost mystical power that makes the owl at once mysterious and difficult to fathom, yet endlessly fascinating. It is also quite plausible that the owl signifies the artist himself or Chinese intellectuals in general. The fact that the owl has one eye opened and one eye closed is an important clue. It reminds us of the attitude of the principled scholar-officials who, at times of dynastic decay and social and political turmoil, though completely aware of the drama unfolding before them, nevertheless maintained a spiritual distance from what they saw as the unclean world. In this sense, the owl can be understood as conveying almost Daoist sentiments, an inner

wisdom, useful during times of political pressure and social change or
chaos. It reflects the dilemma of the Chinese intellectual who is forced to
participate in events in which he does not believe or which he knows to be
based on falsehood, and yet he still wishes to maintain his own integrity. In
a way, the use by the artist of one open and one closed eye in his portrayal
of the owl creates a dynamic tension that would not exist if both eyes were
completely open. By having one eye open, clear and all-seeing, the owl
(and by implication, the Chinese intellectual) maintains a Confucian link
with the mundane world. Its closed eye reveals its moral and intellectual
superiority. Like a Daoist monk, the owl is able to observe the world from
the shadows, and yet maintain a semi-transcendent distance from it. It sees
everything and is fooled by nothing. Chinese history is scattered with
stories of intellectuals who adopted such an attitude, like the poet Tao
Yuanming who, under the force of political pressure, gave up his official
career and moved away from the centre of political activity to view the
world at a distance.[81] Huang Yongyu, on a 1978 version of the original
Winking Owl, wrote in a colophon: "How many people's faces this bird has
gazed upon!", to indicate the detached observation by the owl of the
external world.

This attitude adopted by the owl and the Chinese intellectual is
passive, but it is evidently not pessimistic, as seen from the general
demeanour of the owl. At a time like the Cultural Revolution, keeping a
sense of humour, as well as detachment, was a mechanism for survival; and
a sense of wisdom or superiority, whether or not self-deceiving, no doubt
provided some consolation for the very real impotence experienced by
Chinese intellectuals in the face of uncontrollable social and political
forces.

It is clear from paintings like *The Winking Owl* that even during the
Cultural Revolution, the sophisticated cultural traditions familiar to the
Chinese art world were still able to find expression. Huang and other
"black painters" did not need to limit themselves to direct and crude
political attacks on the authorities (which, in any case, would have imme-
diately brought them trouble). They were instead able to draw on a whole
range of rich cultural resources to implicitly question or make subtle
comments on the complexities and absurdities of life. Mao himself under-
stood this. When the matter of the "black paintings" reached him, he

wrote rather enigmatically in an instruction which was to actually end the campaign: "How could black paintings not be black? The owl always has one eye closed and one eye open."[82] Unlike Jiang Qing and the other members of the Cultural Revolution Small Group who interpreted the paintings in a narrow way, Mao reveals here a much deeper understanding of traditional Chinese cultural values and the thinking processes of Chinese intellectuals. He seems to accept that pieces like *The Winking Owl* are not a particular attack against any one political faction, and therefore not a direct political threat, but signify a more general disillusionment towards life. Perhaps under different circumstances, Mao might still have used the "Black Paintings" to attack the intellectuals. But by 1974 his main perceived opponent, Zhou Enlai, was already on his sick-bed with what proved to be terminal cancer. Rather than beginning a new purge for no particular benefit, Mao decided instead to let the entire matter drop.

The original criticism of these paintings by Jiang Qing was, then, not simply a criticism of the paintings themselves, but, more importantly, linked to political motives, and specifically to the struggle between the radicals who wanted to push the Cultural Revolution ever forward, and Zhou Enlai and the pragmatists, who desired a period of stability and consolidation. Following the Lin Biao events, many of the old guard who had been purged during the early years of the Cultural Revolution, such as Deng Xiaoping and Hu Yaobang, had made a comeback. As the pragmatic faction of the Party increased its influence, the radicals became worried about their own position.[83] Zhou Enlai's implicit instruction to relax some areas of artistic creation brought about a direct confrontation between the two sides, particularly as Jiang Qing and Zhang Chunqiao looked upon the cultural field as their prime sphere of influence. Most of the people directing cultural activities at the national level by this time had been directly appointed by Jiang and her associates. Wang Mantian, the person in charge of art, for example, was a niece of Mao's. Therefore, when Zhou attempted to take a more pragmatic initiative in the art field, the radicals used the "Black Exhibition" as a means of re-affirming their own ideological line. Once again, art had come into play to support different factions within the Party.

The characteristics of art and basic art theory during the Cultural Revolution

The standard for all forms of cultural creation during the Cultural Revolution was established by the "model operas", which emerged as a result of reforms undertaken by Jiang Qing between 1961 and 1966 to purge the theatre of any remaining "bourgeois" or "feudalistic" elements. There were originally five model operas, *The Red Lantern*, *Taking Tiger Mountain by Strategy*, *On the Docks*, *Shajiabang* and *The Raid on White Tiger Regiment*, with three more added later — *Ode to Dragon River*, *Azalea Mountain* and *Fighting on the Open Plains*; the eleven "models" also included two ballets, *The Red Detachment of Women* and *The White-Haired Girl*, and the music for the opera *Shajiabang*.[84] As models not only for the theatre, but for all areas of creative work, we can briefly examine the four major features they possessed and assess how these features were adapted to the realm of art, in order to understand some of the general points of theory underlying the art of the Cultural Revolution.

First, while each of these theatrical productions was able to stand as an independent entity, it could also be linked to the other model theatrical productions to form a complete system in order to reflect the entire process of revolutionary history as it was shaped by the Party. Thus, *Azalea Mountain* and *The Red Detachment of Women* represent the years 1927 to 1937, the period known as "the land revolution"; *The Red Lantern*, *Fighting on the Open Plains* and *Shajiabang* cover the War against Japan between 1937 and 1945; *Taking Tiger Mountain by Strategy* takes Party history from the end of the war to Liberation; whilst *On the Docks*, *Ode to Dragon River* and *The Raid on White Tiger Regiment* deal with post-1949 China, the last specifically with the Korean War.[85]

Second, all eleven productions had as their main figures proletarian heroes and heroines, like Ke Xiang, the female Party representative for the peasants' guerrilla brigade in *Azalea Mountain*; the underground Party worker, Li Yuhe, in *The Red Lantern*; and Yang Zirong, the PLA platoon leader in *Taking Tiger Mountain by Strategy*. The portrayal of these central figures has echoes of Mao's personality cult. It becomes clear that it is Mao who provides them with the attributes of a hero or heroine, such as strength, wisdom and so on.[86] This is not only made explicit through open

acknowledgement of Mao's inspiration by the characters in the operas, but also implied through the use of stage lighting to represent the sun or sunshine, which, in turn, was one of the most ubiquitous symbols of Mao himself. During the production of *Taking Tiger Mountain by Strategy*, "rays of powerful sunlight through the forest … symbolise Yang Tzu-jung's advance under the brilliance of Mao Tse-tung's Thought."[87] In the film made of the *Red Detachment of Women*, the hero, Hong Zhangjing, "is brought out in red and bright lights to contrast sharply with the Tyrant of the South",[88] the lights being an obvious allusion to Mao as "the reddest, reddest red sun in our hearts".

In the operas, the principle of "three prominences" was applied: all characters had to give prominence to positive figures; all positive figures had to give prominence to heroes and heroines; all heroes and heroines had to give prominence to the principal hero or heroine.[89] Although a formula originally put forward by Jiang Qing, it is evidently a development of Mao's earlier idea that any form of culture should represent characters and events in a way that is "more intense, more concentrated, more typical, nearer the ideal and therefore more universal than actual everyday life". The main task of these theatrical productions, and of all "proletarian art" of the Cultural Revolution, was to create "big and all-perfect" heroes and heroines based on the principle of combining Revolutionary Realism with Revolutionary Romanticism.[90]

Third, technical innovations were introduced into the old forms of opera for these new theatrical productions. Traditional Peking opera has its own fixed standard style of singing and acting, but for the purpose of the new model operas, the form was radically altered. For example, in the fifth act of *Taking Tiger Mountain by Strategy*, the horse dance combines Peking opera's standard form of acting with ballet leaps and popular dancing.[91]

Fourth, the plots involved the two major features of simplicity and clarity. Each opera or ballet develops around one central event and from the outset everything is designed to be easily understood. The unfolding of each stage of the plot is achieved without complexity and in an extremely ordered manner. The result is a standard structural affinity shared by all the model operas and ballets.[92]

These four points can be regarded as the most important features of not only the model operas and ballets, but all cultural forms during the Cultural

Revolution. Many articles were published to emphasize these basic principles,[93] which became the criteria to assess the value of any creative work.

To analyse how these principles were applied to the art world, we can take as a typical example of Cultural Revolution art the collection of ninety-six paintings commemorating the thirtieth anniversary of Mao's Yan'an Talks.[94] The collection comprised traditional Chinese paintings, oils, woodblock prints, New Year pictures, picture-story books and propaganda posters by both professionals and amateurs. Though a small percentage of the work was produced prior to the Cultural Revolution, it was included in this collection because it conformed in many respects to the four basic features outlined above, and thus to the general tenor of the collection as a whole. We can now examine these four features in turn to see the way in which they were applied to the collection.

Each individual piece could stand as an independent entity, but at the same time, it could be linked with all the other pieces to form a coherent history of the Party in pictorial form, from its founding to the Cultural Revolution. The collection as a whole also reflected every aspect of the Chinese revolutionary life, including the images of the great leaders (eleven works), the PLA and military life, the new lives of the peasants on the communes, the workers and industrial construction, the Red Guards and students going to the countryside (altogether seventy-six works), and revolutionary historical themes, such as victory in the War against Japan (seven works). There were only two pieces, both traditional Chinese paintings, which did not appear to have a very strong or very obvious political message.

The majority of the paintings were figurative representations, and of these, many clearly featured a hero or heroine. Apart from Mao, the most important hero, there were several paintings with individual figures of either workers, peasants or more commonly, PLA soldiers. These figures, which traditionally would have been depicted as minor and insignificant against the background of natural surroundings, dominate the entire picture-area. In the painting *I Am "Seagull"* (Fig. 24) by Pan Jianjun, the woman soldier, who, having repaired a telecommunication line, is shown using it to declare her code-name, is clearly depicted as a heroic figure. She covers the largest area of the painting and, thus, dominates the scene; her physical appearance is sturdy and robust and her facial features are strong

and determined, giving some clue as to her strength of character; her face is thrown into relief by some unknown source of light, the resultant illumination creating an almost religious effect — the light of Mao has been bestowed upon her; her calm and confident manner is sharply contrasted with the hostile natural surroundings, in the form of the lashing wind and rain.

Practising Acupuncture (Fig. 25) by Shao Hua is an example of a group composition where one figure is the "heroine". It shows a PLA girl teaching acupuncture to two women of a minority race. The PLA girl, though not positioned centrally, is the only figure facing forward, whilst the other two are seen from the side. Because of this, the PLA girl physically takes up more space than the other women. It is also only with her that the viewer makes eye contact. In addition, the PLA girl's green uniform is the main solid block of colour in the picture and, therefore, more eye-catching. Although the girl next to her is wearing a vivid pink blouse, she does not become the main figure because she blends too readily into the mixture of other bright colours included in the composition. In Luo Gongliu's *Guerrilla War*, (Fig. 26) too, though many figures have been included, all of them positive characters, there is one who stands out from the rest. This woman, centrally positioned as she wields her gun, attracts attention because she is wearing a bright (again almost illuminated) white hat and scarf which contrast starkly with the black background, and also because the top of her head forms the pinnacle of the triangular composition, in typically Socialist Realist fashion. In *The Red Army Attending a Political Class* (Fig. 27) by Zheng Hongliu, it is clear that the political instructor of the PLA is the "hero". He stands whilst everyone else is seated; the body postures of the soldiers lean towards the instructor, thus inexorably drawing the eye towards him. Significantly, whilst all the other soldiers are depicted in the shade of a tree, the political instructor alone is bathed in brilliant sunshine.

There is some evidence in the collection of adaptation in artistic form, particularly with regard to the traditional Chinese paintings, where we see the general use of much brighter colours (rather than the traditional black and grey tones) and light and shade, as well as the construction of figures and scenery in a way that is reminiscent of western drawing. Red is, of course, the most prominent colour, used for Mao's *Quotations*, the collar,

cuffs and hat of the PLA soldier (*Fountain* by Han Yue), the ruddy faces of the Communist positive characters (*In the Sea of Coal Blossoms the Flower of Daqing* by Li Yansheng, Huang Huabang, Ren Guisheng), and landscapes or vegetation (most strikingly in Lin Fengsu's *Commune Holiday* which comprises a splash of vivid red colour rarely seen in the usually more sober traditional Chinese paintings). In addition to red, many traditional Chinese paintings in the collection include other bright colours, such as the liberal use of green by the two professional traditional Chinese painters Guan Shanyue (*Oil City in the South*) and Qian Songyan (*Beautiful Land of Abundance to the South of the Yangzi*). Cun Yaru's painting *Cheerful People on Pine-Flower Lake* is an unusual combination of, on the upper half, a landscape scene created in the time-honoured manner of traditional Chinese painting, and on the lower, the use of an array of bright and vivid colours reminiscent of those used in Chinese popular arts, especially the New Year picture.

Most of the traditional Chinese paintings, instead of utilizing the free and spontaneous brushwork usually associated with this form of art, appear to have adopted techniques similar to those used in western drawing, resulting in a rather laboured effect. Guan Shanyue has used these techniques in his painting to depict the various stages of oil production, though he has softened the overall effect with some traditional brushwork when representing the surrounding landscape. However, in *Fire Trees, Silver Flowers, the Sky Never Darkens* (Fig. 28), the combined work of five artists, we see a rather confusing and frightening array of mechanical objects, laboriously constructed and modelled using thick black strokes. The artists' desire to create a new form of traditional Chinese painting has rendered this work devoid of any grace, spontaneity or subtlety.

Most of the paintings convey a clear, simple and unambiguous message, and where there is any possibility of doubt, the title usually ensures that any misinterpretation is avoided. Sometimes written characters actually form part of the painting to make the message clearer, as with Yu Xuegao's *The Flame of the War of Resistance against Japan is Tempered in My Red Heart*, in which the main female figure (dressed, naturally, in red) puts up a poster attacking Japanese imperialism. A mood or atmosphere is created in the paintings which allows no scope for personal interpretation. This mood is usually conveyed by means of the expressions on the faces of

the main subjects, which range from angry determination in *The Flame of the War of Resistance against Japan is Tempered in My Red Heart*, to unalloyed optimism in *Chairman Mao Inspects Wu Shun*, and ecstatic enthusiasm in *We Must Carry out the Great Proletarian Cultural Revolution to the End* as well as bravery in the face of adverse circumstances in *Chairman Mao's Red Guards*. The absence of ambiguity guarantees the increased effectiveness of the work of art as an educational and propaganda tool. Ensuring that the emotions of characters are expressed explicitly facilitate the understanding of the message by a wide audience.

The four main principles which governed most of the artwork produced during the Cultural Revolution did not wholly originate in the movement, since they were in evidence in one form or another from at least the early fifties. However, it was between 1966 and 1976 that they were re-introduced into cultural discourse in a particularly rigid and formulaic way, thus suppressing the possibility of pluralist creative visions. After 1976, and a return once again to more pragmatic policies, artists defined the art of the Cultural Revolution as sharing three main characteristics — "red, bright and vivid" (*hong, guang, liang*) — referring to the endless bright optimism which artists were forced to portray in their work. And it was precisely against this blanket banality of emotion and optimism that artists were to react once the political tide turned.

Notes

1. For detailed accounts of the Cultural Revolution see J. Esmein, *The Chinese Cultural Revolution* (trans. by W. J. F. Jenner); R. MacFarquhar, *The Origins of the Cultural Revolution*; Asia Research Centre (comp. and ed.), *The Great Cultural Revolution in China*; Tan Zongji *et al.* (eds.), *Shinianhoude pingshuo — "Wenhua Dageming" shi lunji*.

2. Ding Wang, *Zhonggong "Wenge" yundongzhongde zuzhi yu renshi wenti*, pp. 1–20; Esmein, *The Chinese Cultural Revolution*, pp. 54–63.

3. Wang Nianyi, *1949–1989 nian de Zhongguo — dadongluande niandai*, p. 35; Jin Chunming, *Wenge shiqide guaishi guaiyu*, pp. 105–106; Mao Zedong, *Mao Zedong ziliao xuanbian*, pp. 321–322.

4. Wang Nianyi, *1949–1989 nian de Zhongguo*, p. 35; Mao Zedong, *Mao Zedong sixiang wansui*, p. 642.

5. Mao Zedong, *Mao Zedong sixiang wansui*, p. 640; Jiang Qing, *Jiang Qing*

guanyu Wenhua Dagemingde yanjiangji, pp. 13–25. The term "Palace of (the King of) Hell" was used during the Cultural Revolution to connote an unassailable fortress full of evil individuals. For a comprehensive list of the main figures attacked during the early stages of the movement, see Asia Research Centre (comp. and ed.), *The Great Cultural Revolution in China*, pp. 116–193.

6. Wang Nianyi, *1949–1989 nian de Zhongguo*, pp. 13–14.

7. Zheng Derong *et al.* (eds.), *Xin Zhongguo jishi 1949–1984*, p. 399.

8. Ding Wang, *Wenhua Dageming pinglunji*, pp. 111–134.

9. Red Guard publication, *Meishu zhanxianshang liangtiao luxian douzheng dashiji*, p. 76; Cai Danye, *Zhonggong wenyi pidou lunji*, pp. 80–86.

10. *Chinese Literature* editorial note, "Repudiation of the Black Line", *Chinese Literature*, 1967, No. 4, p. 122.

11. Chao Hui, "An Art Programme Serving the Restoration of Capitalism", *Chinese Literature*, 1967, No. 4, p. 123.

12. Ibid., p. 124.

13. Red Guard publication, *Revolution in the Arts*, 31 May 1967, p. 4.

14. Red Guard publication, *Revolution in the Arts*, 9 July 1967, p. 3.

15. Ibid.

16. Red Guard publication, *Revolution in the Arts*, 31 May 1967, p. 4.

17. Hung Yu, "Hua Chun-wu [Hua Junwu] Is an Old Hand at Drawing Black Anti-Party Cartoons", *Chinese Literature*, 1967, No. 4, p. 133. The satirical cartoon exhibition was held under the auspices of the Artists' Association and was covered extensively by the *Liberation Daily*. The main themes of the cartoons were apparently attacks on bureaucratism and pedantry. The exhibition attracted 4,000 visitors in the first three days and reportedly received the approval of Li Qun, Jiang Feng and Mao himself when they attended. See D. Holm, *Art and Ideology in Yan'an*, pp. 60–61. For more on the satirical cartoon exhibition see Ai Ke'en (ed.), *Yan'an wenyi yundong jisheng 1937–1948*, pp. 316–319.

18. Red Guard publication, *The Proletarian*, 1967, No. 3, p. 4.

19. Ibid.; Hung Yu, "Hua Chun-wu Is an Old Hand at Drawing Black Anti-Party Cartoons", *Chinese Literature*, 1967, No. 4, p. 134.

20. For more on the case of Wang Shiwei, see G. Barmé, "Using the Past to Save the Present: Dai Qing's Historiographical Dissent", *East Asian History*, Dec. 1991, pp. 152–155.

21. Hung Yu, "Hua Chun-wu is an Old Hand at Drawing Black Anti-Party Cartoons", *Chinese Literature*, 1967, No. 4, p. 135.

22. Ibid., p. 133.

23. Red Guard publication, *Meishu zhanxianshang liangtiao luxian douzheng dashiji*, p. 77.

24. Named after Mao's "May 7th Directive" of 1966. Schools set up in

accordance with this directive were based mainly in rural areas for the purpose of re-educating students and intellectuals.

25. Wang Nianyi, *1949–1989 nian de Zhongguo*, p. 353.

26. Red Guard publication, *Meishu zhanxianshang liangtiao luxian douzheng dashiji*, p. 77.

27. It has been commented that most art colleges had already been emptied of students by the end of the earlier Socialist Education Movement (see J. Clark, "Realism in Revolutionary Chinese Painting", *JOSA*, Vols 22 and 23, 1990–91, pp. 12–13).

28. Song Zongyuan *et al.* (eds.), *Yishu yaolan*, p. 36; Chen Yingde, *Haiwai kan dalu yishu*, pp. 28–29.

29. Zhang Shaoxia and Li Xiaoshan, *Zhongguo xiandai huihuashi*, p. 289.

30. Ibid., p. 288.

31. Tao Yongbai, "Zhongguo youhua erbaibashinian", *On the History of Art (Meishu shilun)*, 1988, No. 3.

32. Chen Yingde, *Haiwai kan dalu yishu*, p. 87.

33. Interview with Shui Tianzhong, 1989, Beijing. The incident involving Qi's grave occurred at the height of the movement, instigated in 1967 by the Cultural Revolution Small Group, to criticize Qi Baishi as a counter-revolutionary. His gravestone was dug up, smeared with dirt, then disappeared. See Li Lang, *Dalu ming huajia tan fang lu*, p. 24.

34. Chen Yingde, *Haiwai kan dalu yishu*, p. 170.

35. Xiao Yanzhong (ed.), *Wannian Mao Zedong*, pp. 177–181.

36. Yu Shifang, "Wenhua Dageming — yichang xiandai zaoshen yundong", *The Chinese Intellectual* (Zhishi fenzi), Spring 1986, p. 38.

37. Ibid. For further relevant information on the religious aspects of the Mao cult, see A. Hsia, *The Chinese Cultural Revolution*, pp. 232–234.

38. "Statue of Chairman Mao Unveiled at Tsinghua University", *Peking Review*, 12 May 1967, p. 5.

39. Yu Shifang, "Wenhua Dageming — yichang xiandai zaoshen yundong", *The Chinese Intellectual*, Spring 1986, p. 40; D. Bloodworth, *The Messiah and the Mandarins — Mao Tse-tung and the Ironies of Power*, p. 211.

40. Yu Shifang, "Wenhua Dageming — yichang xiandai zaoshen yundong", *The Chinese Intellectual*, Spring 1986, p. 40. The practice of painting out politically disgraced figures was inherited from Stalin's Soviet Union. See Clark, "Realism in Revolutionary Painting", p. 13.

41. "Peking Churches Shut and Defaced", *New York Times*, 24 Aug. 1966, p. 1.

42. Yu Shifang, "Wenhua Dageming — yichang xiandai zaoshen yundong", *The Chinese Intellectual*, Spring 1986, p. 41.

43. Liu Chun-hua, "Painting Pictures of Chairman Mao Is Our Greatest Happiness", *China Reconstructs*, 1968, No. 11, pp. 5–6.

44. He Rong, "Jiang rensheng youjiazhide dongxi huimie gei ren kan — du

lianhuanhua *Feng* he xiangdaode yixie wenti", *Fine Art*, 1979, No. 8, p. 14.

45. Tao Yongbai, "Zhongguo youhua erbaibashinian", *On the History of Art*, 1988, No. 3. *Founding Ceremony* was in fact altered on three separate occasions. The first alteration followed the disgrace of Gao Gang in 1955, when he was painted out; the second was in 1972 when the figure of Liu Shaoqi was removed from the painting. The painting was then returned to its original state following the third plenary session of the eleventh Central Committee in November 1979. See Fan Yin, "Shi cuowude lishi haishi lishide cuowu", *Fine Art*, 1983, No. 7, p. 13.

46. Xing Guohua (ed.), *Zhongguo gemingshi xuexi shouce*, pp. 74–75.

47. Apparently, the painting originally incorporated the figure of Mao Zedong, but Hou was then sent instructions from the Propaganda Department to remove it. In 1973, Hou was persuaded to do another painting (published 1977) of the Anyuan Miners' strike, this time with Mao as the central focus. See Clark, "Realism in Revolutionary Chinese Painting", pp. 14–15.

48. Hsia, *The Chinese Cultural Revolution*, pp. 130–131.

49. Interview with Shui Tianzhong, 1989, Beijing.

50. "Birth of Two Gems of Art", *Chinese Literature*, 1968, No. 10, pp. 96–99.

51. "Great and Noble Image", *Chinese Literature*, 1968, No. 9, p. 45.

52. *China Reconstructs* staff reporters, "Following Chairman Mao Means Victory", *China Reconstructs*, 1969, No. 8, p. 8.

53. Publishing Administrative Bureau (comp.), *Quanguo zongshumu*, 1973, pp. 161–164.

54. See *Quanguo zongshumu* for the appropriate year.

55. State Council Cultural Group (comp.), *Shanghai, Yangquan, Lü Da gongrenhua zhanlan zuopin xuanji* for all the paintings mentioned in this section.

56. Shanghai People's Publishing House (ed.), *Meishu pinglunji*, p. 62.

57. Ibid., p. 51.

58. Ibid.

59. "Peasant Art Exhibition in Fukien", *Chinese Literature*, 1974, No. 9, p. 114.

60. Shaanxi Worker-Peasant-Soldier Art Centre (ed.), *Huxian nongminhua lunwenji*, p. 21.

61. *Peasant Paintings from Huhsien County* (Beijing: Foreign Languages Press, 1974), Catalogue of Huxian Peasant Paintings Exhibited in the West; Chen Yingde, *Haiwai kan dalu yishu*, p. 261.

62. For the Hu county peasant paintings discussed in this chapter see Shaanxi People's Publishing House (ed.), *Huxian nongminhua xuanji*.

63. Shaanxi Worker-Peasant-Soldier Art Centre (ed.), *Huxian nongminhua lunwenji*, p. 99.

64. Ibid., pp. 23–24.

65. SCMP, No. 5181, p. 56.

66. Zhang Shaoxia and Li Xiaoshan, *Zhongguo xiandai huihuashi*, pp. 303–304.

67. *Wenyijie boluan fanzhengde yici shenghui — Zhongguo wenxue yishujie lianhehui disanjie quanguo weiyuanhui disanci kuoda huiyi wenjian, fayanji*, pp. 529–530.

68. Huang Yongyu, "Shao Yu he 'maotouying shijian' — xiaodan Shao Yu, Fan Zeng", *The Nineties (Jiushi niandai)*, 1990, No. 8, pp. 101–102.

69. A television documentary made in 1972. It was criticized by the authorities in 1974 for showing the dark side of life in China — "old people, exhausted draught animals, dilapidated houses, poor hygiene, humans pulling carts, and an old woman with bound feet." See L. Ladany, *The Communist Party of China and Marxism, 1921–1985*.

70. *Wenyijie boluan fanzhengde yici shenghui — Zhongguo wenxue yishujie lianhehui disanjie quanguo weiyuanhui disanci kuoda huiyi wenjian, fayanji*, p. 532.

71. Interview with Shui Tianzhong, 1989, Beijing.

72. Han Suyin, "Painters in China Today", *Eastern Horizons*, 1977, No. 6, p. 20.

73. *Wenyijie boluan fanzhengde yici shenghui — Zhongguo wenxue yishujie lianhehui disanjie quanguo weiyuanhui disanci kuoda huiyi wenjian, fayanji*, p. 533.

74. *The Seventies* journalist, "Zhongguo huatan chunyi nong — Han Suyin nüshi tan Zhongguo meishujie jinkuang", *The Seventies*, 1977, No. 4, p. 22.

75. Chen Yingde, *Haiwai kan dalu yishu*, p. 84.

76. Ibid., p. 98.

77. *Wenyijie boluan fanzhengde yici shenghui — Zhongguo wenxue yishujie lianhehui disanjie quanguo weiyuanhui disanci kuoda huiyi wenjian, fayanji*, p. 533.

78. Huang Yongyu, "Shao Yu he 'maotouying shijian' — xiaodan Shao Yu, Fan Zeng", *The Nineties*, 1990, No. 8, pp. 101–102.

79. D. S. G. Goodman, *Beijing Street Voices: The Poetry and Politics of China's Democracy Movement*, p. 20.

80. E. J. Laing, *The Winking Owl: Art in the People's Republic of China*, p. 86.

81. Hunan Teachers' College (ed.), *Zhongguo lidai zuojia xiaozhuan (shang)*, pp. 279–283.

82. Huang Yongyu, "Shao Yu he 'maotouying shijian' — xiaodan Shao Yu, Fan Zeng", *The Nineties*, 1990, No. 8, pp. 101–102.

83. L. Ladany, *The Communist Party of China and Marxism, 1921–1985*, p. 366.

84. Liaoning University (ed.), *Wenyi sixiang zhanxian sanshinian*, p. 337.

85. Details of the main features of the model operas discussed in this chapter are largely drawn from Li Shulei, "Man lun 'yangban xi' de wenhua hanyi", *Towards the Future (Zouxiang weilai)*, Dec. 1988, p. 146.

86. Ibid., pp. 147–148.

87. Chiang Ch'ing, *On the Revolution of Peking Opera*, pp. 21–23.

88. "The Film *Red Detachment of Women*", *Chinese Literature*, 1971, No. 9, p. 111.

89. Yu Hui-jung, "Let Our Theatre Propagate Mao Tse-tung's Thought for Ever", *Chinese Literature*, 1968, No. 7/8, p. 111.

90. Chu Lan, "Jingju geming shinian", *Red Flag (Hongqi)*, 1974, No. 7, pp. 67–73; Liaoning University (ed.), *Wenyi sixiang zhanxian sanshinian*, pp.

341–342.

91. Liaoning University (ed.), *Wenyi sixiang zhanxian sanshinian*, pp. 342–343.

92. Li Shulei, "Man lun 'yangbanxi' de wenhua hanyi", *Towards the Future* (*Zouxiang weilai*), 1988 Dec., p. 148.

93. For examples, see "Suzao wuchanjieji yingxiang dianxing shi shehuizhuyi wenyide genben renwu" in *People's Daily*, 12 July 1974, p. 5; Chu Lan, *Tan wenyi zuopinde shendu wenti (neibu ziliao)*, Nov 1974; "Fazhan shehuizhuyide wenyi chuangzuo", *People's Daily*, 16 December 1971, p. 1.

94. State Council Cultural Group (comp.), *Jinian Mao Zhuxi "Zai Yan'an wenyi zuotanhuishangde jianghua" fabiao sanshizhounian meishu zuopinxuan*.

The Discovery of "the Self":
A New Era for Chinese Art, 1976–1984

F ollowing the death of Mao in 1976, his wife, Jiang Qing, and three of
her supporters, Zhang Chunqiao, Wang Hongwen and Yao Wenyuan
("the Gang of Four") were arrested and put on trial, charged with being
responsible for the Cultural Revolution. Hua Guofeng took over initially as
Chairman of the Chinese Communist Party but, lacking a solid power base,
he was soon replaced by Hu Yaobang. Real power, however, lay with the
pragmatist Deng Xiaoping. In December 1978, at the Third Plenum of the
Eleventh Party Central Committee, Deng outlined a new political pro-
gramme that was to have far-reaching consequences for Chinese society.[1]
His primary aim was to initiate a series of economic reforms to make China
prosperous and to guarantee her reputation on the international stage.
In order to implement this programme, generally known as the "Four
Modernizations", the new leadership once again needed to enlist the help
of intellectuals. The leadership was aware, however, that most intellec-
tuals, having suffered badly during the Cultural Revolution and the earlier
Anti-Rightist campaign, would be reluctant to participate in any further
political programmes. Therefore, in an attempt to regain the confidence of
this important social group, the Party leaders expressed regret at the ex-
cesses of the Cultural Revolution, and affirmed the intellectuals' role
within the new scheme of things.[2]

Nevertheless, the leadership was still faced with a dilemma. On the

one hand, it was forced to acknowledge the damage inflicted on the intellectuals during the "ten years of chaos" (as the Cultural Revolution was now called), and to permit an outpouring of grievances and anger against Lin Biao and "the Gang of Four" to signify its own repudiation of the policies of that era. On the other hand, it had to ensure that this tide of anger did not develop a momentum of its own, which could lead to an undermining of Party rule.

The approach of China's new leaders was essentially pragmatic. Their main concern was with practical rather than ideological matters, and they had greater interest in the economic, rather than the cultural, sphere. The dissimilarity between the post-1979 leadership and that of the three preceding decades is vividly illustrated by comparing Deng Xiaoping's practical approach — epitomized by his famous phrase "it does not matter if it is a black cat or a white cat as long as it catches mice" — with Mao's grand vision of the new socialist society and his theories of continuous revolution.

As a consequence of this new pragmatic style of leadership, as long as intellectuals were not perceived as challenging the authority of the Party or jeopardizing the economic reforms, they were allowed a degree of freedom in their work unprecedented after 1949. However, this freedom still remained contingent on the political situation and on political considerations. A statement issued by the Artists' Association following the Fourth National Congress of Literary and Art Workers (to be discussed later) made this only too clear:

> The Chinese Artists' Association will legally defend the artist's right to individual expression … as long as the artist does not subvert the goals of the Communist Party.[3]

It was a warning that freedoms granted could be freedoms withdrawn.

Organizational changes

One of the effects of Deng Xiaoping's modernization programme was a gradual erosion of the authorities' monopoly over the ideological framework that had set the artistic agenda over the previous thirty years, and over the institutional structures that had maintained it. This was primarily

a consequence of the authorities allowing an unprecedented degree of liberalization, manifested for example in a series of wide-ranging debates on fundamental issues, and mediated through the art organizations that were re-established after the Cultural Revolution. In addition, once the process of liberalization was started it seemed to gather a momentum of its own, and artists themselves began to grasp the initiative to push their new-found freedoms to the limit. In organizational terms, this resulted in a virtual two-tier system, with new structures and channels set up largely by artists themselves co-existing with the old official ones.

Art organizations

The most important official event in art circles following the end of the Cultural Revolution was the convening of the Fourth National Congress of Literary and Art Workers in Beijing in October 1979 to summarize the progress of cultural work over the previous three decades and to re-establish formally the cultural associations that had been suspended since 1966. The top positions in the Artists' Association were taken again by those who, in the early fifties, had exerted the greatest influence in the art world, but who had subsequently fallen from grace during either the Cultural Revolution or the earlier Anti-Rightist campaign. Jiang Feng, rehabilitated after twenty years of humiliation and obscurity, was once again appointed as Chairman of the Association. Cai Ruohong, Guan Shanyue, Hua Junwu, Huang Xinbo, Li Keran, Li Shaoyan, Liu Kaiqu, Wang Chaowen, Wu Zuoren and Ye Qianyu, all formerly influential figures in the Association, took the positions of Vice-Chairmen.[4]

The appointment of these key individuals from the past served several purposes. It helped to engender a sense of continuity with pre-Cultural Revolution art policy. Also, these older artists had already accumulated many years' experience as art administrators, which could be put to good use in helping to implement the reforms. Reversing previous judgements on these individuals as "Rightists" or "counter-revolutionaries" and restoring to them their previous status could help renew the confidence of artists and intellectuals generally in the new leadership.

In addition, the rehabilitation of prominent artists, regardless of where they stood in the ideological spectrum (the permanent executive of the

Association elected in 1979 included such diverse figures in terms of commitment to leftist ideology as Jiang Feng and Luo Gongliu on the one hand, and Lin Fengmian on the other[5]), helped unite artists after so many years of criticism and counter-criticism. This uniting of artists, in order to implement and oversee art policy more effectively, was evidently as important an issue in 1979 as it had been thirty years earlier. The first article of the Artists' Association's new constitution mentions the need to "unite all artists that can be united".[6] The in-fighting and false accusations over the previous twenty years were to be forgiven and forgotten for the sake of China's modernization programme. Zhu Dan, a member of the Association's permanent executive, in his speech at the Third Congress of the Artists' Association (3 November 1979), vividly pointed out:

> *What is of importance is unity. Without unity how can there be any flourishing of the arts? We should keep the cardinal principles in mind and take the overall situation into account. All of us here have had a narrow escape and we do not have many years of life left, like a calendar at the end of the year with only a few remaining pages. What is the point of going in for contradictions among the people?[7]*

The Chairman of the Artists' Association, Jiang Feng, also discussed the question of unity at great length in his speech delivered at the Congress:

> *Only if we unite can art flourish in a true and comprehensive manner. Unity is of special importance today. Lin Biao and "the Gang of Four" brought about ten years of destruction, which caused disunity amongst people and created chaos. Factionalism has still not been eliminated.... I criticized people too, during the "Three Antis" and the "Five Antis". I wrongly criticized people. In 1957 I was criticized by others. Let's not settle old scores again. My idea is to look forward to the future.... Let everybody unite together and make a contribution to our country.[8]*

The basic organizational structure of the re-established Artists' Association was virtually unchanged from the time of its suspension in 1966. It continued to come under the umbrella organization of the All-China Federation of Literary and Art Circles, which in turn was under the supervision of the Department of Propaganda. According to the new constitution of the Artists' Association drawn up in November 1979, the re-established branches of the Association at every level were to "directly receive [come under] the leadership of the Party committees at the provincial, city and autonomous region level, and receive guidance in their

professional work from the [Chinese Artists'] Association."[9] This was a clear indication that, officially, the Association was to continue to confine itself to organizational matters (the arranging of exhibitions, the publication of official art magazines, and so on), or questions relating to technical aspects of artistic work. General art policy was to be formulated, as before, by the Department of Propaganda and ultimately the Central Committee of the Chinese Communist Party.

At the Third Congress of the Artists' Association, the main worry voiced by artists concerned the tendency of the political committees of the Association at national and branch level to misuse their administrative authority. As one delegate, Du Jian, commented:

> After the 1950s, the "left" influenced every aspect of our lives, resulting in great destruction. Our artistic creativity was also badly affected. These bad effects still exist today, a typical example of which is the fate of the picture-story book The Maple Tree. The only correct thing to do when dealing with art is to let everyone discuss it. Methods of preventing publication should in the future be done away with.[10]

Wang Qi, a prominent woodcut artist from the Yan'an days, was equally firm in his opposition to political interference:

> Using the method of administrative orders to prohibit art can never succeed. The method of free competition should be used, and from amongst these competing themes and styles of art, let the viewing public choose. Let it reject those things that should be rejected, and approve those things that should be approved.[11]

Wang is echoing here remarks made by Deng Xiaoping during his conciliatory speech at the Fourth National Congress of Literary and Art Workers, in which he acknowledged the legitimate requests of artists to "give [them] more freedom. Do not place too many limitations [on them]."[12] Although Deng emphasized that Party committees at all levels were to continue to exercise leadership in the arts:

> this leadership should not be realised by issuing administrative orders or presenting demands that literature and art be subordinate to a temporary, specific, and direct political purpose. Rather, the Party committees should, based upon the characteristics of literature and art and the laws of development, help writers and artists meet the conditions for making literary and artistic undertakings flourish, elevate literary and art levels, and create excellent literary and art works.[13]

Later he again said, "The issuing of executive orders in the areas of literary and artistic creation and criticism must be stopped."[14]

These comments from Deng's speech were quoted on several occasions during the Third Congress of the Artists' Association by delegates putting forward their own case for less political interference. However, Deng's words were also open to different interpretations due to a lack of clarity of definition in some instances. How were the characteristics of literature and art and the "laws of development" to be defined by the Party committees? Deng's statement that literature and art should not be subordinated to any specific political task seemed to contradict his earlier assertion that "the sole criterion for deciding the correctness of all work should be whether that work is helpful or harmful to the accomplishment of the Four Modernizations."[15] Moreover, there was no attempt to reconcile Deng's affirmation of the leadership role of the Party committees with his view that "writers and artists must have the freedom to choose their subject matter and method of presentation based upon artistic practice and exploration. No interference in this regard can be permitted."[16] What, then, were the functions of the Party Committees? If they were to be allowed only to "help" writers and artists and denied the use of executive orders, how much control could they actually continue to have over the kind of art produced? In reality, although the situation was considerably more relaxed during the years after 1979 than it had been for the previous decade or so, art continued to be subject to some degree of political control, and "the issuing of executive orders in the areas of literary and artistic creation and criticism" certainly did not become a thing of the past.

The new art groups

New art groups, largely independent of the official Artists' Association, were formed as early as the beginning of 1978 and continued to operate throughout 1979 and 1980. Members of these individual groups usually worked in similar styles and shared similar ideas and aspirations. In many ways, they could be compared to the literati-artists of traditional China who were accustomed to gathering together to exchange views, admire each other's work and offer constructive criticism in an atmosphere of mutual support.[17]

The groups covered the entire spectrum of artistic endeavour, from traditional painting to picture-story books, oil painting and sculpture. Within these genres, artists experimented with styles ranging from academic realist to impressionist, post-impressionist, expressionist and abstract-expressionist. They were also not restricted geographically to the capital, though Beijing did produce the largest number of groups which, because of their proximity to the locus of political power, usually had a greater impact through the exhibitions they held on occasions. The most high-profile groups included Beijing's Oil Painting Research Association, the Sturdy Grass Woodcut Research Association, and the Stars, Shandong's Oil and Mural Painting Research Association, Kunming's Monkey Year Society and Chongqing's Grass Grass Painting Association.[18]

Diverse and scattered as they were, the groups shared in common the desire for greater freedom in deciding their own styles of creative expression. As one group declared, "Every artist has the right to choose the form of expression for (his or her) artistic creations."[19] At the same time, members were also concerned that people should not misunderstand their work or their motives in producing it:

> We still hope, in an environment of abundant artistic democracy, to pursue in many ways humanistic painting that is liked by the people ... [Everyone] should believe in the sense of responsibility artists feel towards these times and the nation, their sense of conscience and their integrity.[20]

When the first groups were formed and began to exhibit their work, even high-ranking officials like Jiang Feng supported and encouraged them in their artistic endeavours, stating enthusiastically:

> Freedom of association is a legal right of the people stipulated in the constitution, whilst painting associations are an organizational form of benefit to the development of art.... We should strongly advocate the organizational form of painting associations which brings so many advantages to the development of artistic creativity. The more that are set up, the better.[21]

Unfortunately for these art groups, the period of relaxation between the late 1970s and early 1980s was politically engineered by Deng and his supporters to secure his position as leader. Once that position was secure, Deng tried to re-assert organizational and ideological control of the Party over artists in the form of a mini-campaign against "bourgeois liberalism".

As a result, a ban was imposed on private group exhibitions.[22] With the ban, which in effect denied group artists access to the general public, several of the groups ceased to exist as cohesive entities. The Stars and Grass Grass were just two that disbanded during the period because of tougher government policies and, specifically, the curtailment of private exhibitions.[23]

This was not, however, the end of private groups. By late 1984, once the Spiritual Pollution campaign[24] had run its course, and a more relaxed atmosphere again pervaded literary and art circles, unofficial art groups, such as the 28 Painters' Association (formed in Zhejiang in 1985) began to appear again.

Clearly, to a large extent, private art groups were only allowed to exist and operate at the pleasure of the political leadership. They tended to function during those times when the leadership felt they were useful as symbols of the government's goodwill in allowing more diversity and freedom in intellectual pursuits. As soon as political necessity required a clampdown on such activities, as happened during the campaigns against "bourgeois liberalism" and "spiritual pollution", most groups, through fear or an inability to function effectively, disbanded.

What, then, was the significance of these groups? Certainly, the numbers of artists involved in them were small compared with the vast majority of artists who continued to work within the official Artists' Association at national and branch level. Nevertheless, this is not to say that their activities were without influence or went unnoticed. The first Stars exhibition, held in November 1979 in Beihai Park for example, was reported to have attracted over 33,000 visitors,[25] and exhibitions organized by other groups were also said to have "created a sensation".[26]

It was also significant that many of the most innovative and controversial artists of the late 1970s and early 1980s, such as Wang Keping of the Stars, and Feng Guodong, Zhong Ming and Yuan Yunsheng of the Oil Painting Research Association, belonged to unofficial groups. Artists like them, determined to break with the old ideological scheme that demanded that the content and form of art remain within strict limits, were able to gain from these groups the essential support that might not have been forthcoming from the art authorities. In an atmosphere of mutual help and encouragement, artists were able to experiment with more radical styles

and themes, finding comfort, no doubt, in the safety of numbers, particularly when exhibiting their work to the general public.

Perhaps the greatest significance of the unofficial art groups lay in the fact that they represented for the first time after 1949 an alternative to the official art organization structure. Even during the Cultural Revolution, when the art "establishment" in the form of the Artists' Association and its branches disintegrated, the use of political directive for shaping and influencing creative work was still overridingly the norm. After 1978 artists began to circumvent channels of direct political control. Though the groups they set up were usually of a temporary nature, their very existence, as forums in which to discuss and exchange ideas that the Party, at least initially, regarded as heterodox, posed an unprecedented challenge to the system of organizational control set up by the authorities. Furthermore, the groups provided a supportive base for exhibiting the often highly innovative work of their members to the general public without necessarily going through official channels. This was evidently worrying for the political leadership which, despite its rhetoric about the need to create diversity in the arts, still aimed at a high degree of ideological conformity.

Exhibitions

Official art exhibitions immediately after the Cultural Revolution continued to be an important means for the authorities to maintain control over artists and their work. Exhibitions continued to be either held in art schools and colleges, which required the approval of the heads of those educational establishments, or directly sponsored by the Artists' Association or the Ministry of Culture. The fact that official consent was required before a work could be exhibited tended to ensure that artists kept within the general guidelines of the Party. The basic content of officially approved exhibited work remained at this stage largely unchanged, as witnessed by the first major exhibition held after Mao's death to celebrate the fiftieth anniversary of the People's Liberation Army, which manifested a nostalgia for the older generation of Communist revolutionaries, including Zhou Enlai and Zhu De, as well as Mao himself.[27]

However, two developments occurred after 1978 that provided clear signals of the more liberal and relaxed atmosphere in art circles. The first was the showing of an unprecedented number of exhibitions of art from

Western Europe, Japan and America, and the second was the exhibition of work by unofficial art groups.

With the end of the Cultural Revolution and China's "open-door" policy to the West, there was soon a continuous stream of western and Japanese exhibitions in Beijing and other major Chinese cities. Some of the larger exhibitions included a "Japanese Modern Painting Exhibition" (July 1979), an "American Pictorial Posters, and Illustrations Exhibition" (March 1980), a "Finland Modern Woodblock Exhibition" (April 1981), an "Exhibition of Famous American Paintings from the Boston Museum" (September 1981),[28] an "Exhibition of Original Picasso Paintings" (May 1982), and a "French Contemporary Art Exhibition" (September 1983). These foreign exhibitions (and the above list is only a small percentage of the overall total) stimulated large numbers of publications on western art.[29] They represented a crucial stage in the awakening of Chinese artists' awareness of aesthetic ideas never previously part of Chinese cultural discourse. The uniform drabness of Socialist Realism, which dominated the numerous exhibitions from the Soviet Union and its Communist allies after the 1950s, was replaced by a much wider spectrum of styles and content, ranging from impressionism, through cubism to abstract expressionism and beyond. Never before, even during the May Fourth movement, had Chinese artists been given so much direct access to original western paintings and sculpture in China.

The ideas generated by several of these exhibitions became the focus of some important discussions in art circles, which helped to undermine the blanket uniformity imposed on artists over the previous three decades.[30] In addition, the presence of western exhibitions represented a gradual erosion of the principle that exhibited works were to fulfil an educational function. Whether it was works exhibited by Chinese artists, or those from the Soviet Union and Eastern Europe, the purpose of exhibitions arranged by the Communists since the Yan'an days had been to educate the masses in Communist policy and general world view. Now exhibitions began to lose that strictly educational/propagandist role, and to convey something more subtle, more intangible — the individual expression of the artist's own perceptions and experiences.

The holding of numerous unofficial exhibitions by mainland Chinese artists after 1979 was an even more momentous step than the showing of

modern art from abroad, which, after all, had been officially sanctioned. In Beijing alone, during the spring of 1979, some thirty small-scale exhibitions were held by various groups,[31] mostly unofficial art groups. The exhibitions generated a good deal of interest amongst art circles and the general public, even though, because of the experimental nature of much of the work, there were definite shortcomings in the overall quality of what was shown. "The Second Oil Painting Research Association Exhibition", held in October 1979 in Beihai Park, comprising a wide range of styles, and including several nude studies ("apparently the first shown publicly in the People's Republic"[32]) was the "talk of Beijing".[33] "The Monkey Year Society Exhibition" of July 1980 "created a sensation".[34] The first Stars exhibition, held in Beijing in November 1979, attracted 33,000 visitors, whilst the second, held in August 1980, drew an audience large enough to produce fourteen sizeable books of comments,[35] seventy to eighty percent of which, according to official reckoning, were favourable.[36] The high attendance at these exhibitions is noteworthy considering that, "usually the people of Beijing are not so keen to frequent such places [i.e., art galleries and museums]. One intellectual confessed … that he never went to the museum because the exhibitions were not interesting, even though they were usually of contemporary works."[37] Evidently, the audience was extremely moved by the exhibits on display, as revealed by one of the many positive comments left after the second Stars exhibition addressed to the talented young sculptor, Wang Keping:

> Comrade Wang Keping: I salute your courage. Your ruthless [sculpting] knife dissects society's cruelty, vanity and deceit. Of those so-called sculptors who have been walking corpses for a long time now, their hypocritical souls will tremble before your works, so full of life! Painting and sculpture as art is not just a colour to decorate society! It must … enlighten the people. You have done well and I hope that even more wonderful works will emerge.[38]

That exhibitions of work produced by unofficial art groups were allowed to take place is quite extraordinary, considering that during the previous three decades it would have been virtually unthinkable. What is perhaps even more surprising is that, unlike the exhibits for officially organized shows, which had to undergo lengthy selection procedures at various levels, many of the works of the unofficial group artists were not vetted in any formal way. The first group to hold an unofficial art

exhibition did so in Shanghai as early as the end of 1978. Exhibits of some of the "black" paintings produced years earlier by Lin Fengmian, Liu Haisu, Huang Yongyu and others were displayed for several days in a local Cultural Palace after the organizers had simply obtained permission from the Party leaders in charge of the Palace. Soon after, two other Cultural Palaces elsewhere in Shanghai held similar exhibitions, the exhibits of which were mainly small landscape paintings. Then, at the end of 1978 a group of artists who had never before participated in official exhibitions were allowed to hold a "Twelve Person Exhibition" in the Huangpu District Youth Palace, Shanghai. The exhibits included western-style landscapes and portraits, and a small number of traditional Chinese paintings, and the viewing audience was treated to recordings of western songs from the 1950s and 1960s. However, as the quality of the work was generally rather poor, the exhibition apparently did not have much impact outside Shanghai.[39]

Unofficial art exhibitions, like unofficial art groups, eventually won approval from important figures in the Artists' Association. Jiang Feng, in his introduction to the "New Spring Exhibition", held in February 1979 by the Oil Painting Research Association, commented:

> For these exhibits from artists who have freely come together, no censorship system has been set up. It has been left to all those who have contributed works to discuss and decide the number of works [to be exhibited] and the positions in which paintings are to be hung.[40]

Although there were artists from the unofficial groups who felt it was wiser to impose some form of censorship on themselves,[41] there were others who chose to ignore any official advice given on the suitability of a particular work. When, for the second Stars exhibition in August 1980, Wang Keping decided to go against the wishes of Jiang Feng and exhibit among others a piece, *Idol*, that parodied Mao Zedong's personality cult, it constituted a direct snub at officialdom.[42]

This element of challenge, of testing the authorities' patience to the limits, that characterized the activities of some of the unofficial groups, was no doubt one of the main reasons that drew audiences to their exhibitions. This certainly seemed to be true of the "wild cat" open-air exhibition held by the Stars in 1979 which first brought them into prominence:

> The fact that the secularization, the freeing of artistic expression was marked by an
> unprecedented act of defiance rather than silent official sanction, meant that artistic
> creation belonged to the people; it had earned its birthright and was deserving of
> serious attention.[43]

Art publications

In March 1976, the official art magazine *Fine Art* resumed publication,
after ten years of silence during the Cultural Revolution. It became once
again the most important channel for the authorities' dissemination of
information on art policy and organizational changes, and the main
vehicle for official response to developments in creative work and in the
field of art criticism and theory. Prior to the introduction of economic
reform in 1979, the illustrations and articles in *Fine Art* were barely
distinguishable from what could be found in art publications during the
most radical period of the Cultural Revolution. The scale of hagiography,
for example, was hardly reduced, and the depiction of the omnipotent and
wise leader remained as ubiquitous as ever. The main difference, of course,
was that the image of Chairman Mao surrounded by smiling peasants
was now replaced in several cases with that of the new Chairman, Hua
Guofeng. The pictorial representations of the latter, so similar to those of
Mao in terms of highlighting him as the central figure,[44] revealed Hua's
concern with legitimizing and securing his new position as leader. Most
portraits of Hua functioned purely as propaganda to achieve this aim, one
of the most blatant examples being that of the oil painting *With You in
Charge, I'm at Ease* (Fig. 29) by Peng Bin and Jin Shangyi, which showed
Mao voicing his approval of Hua as his successor.[45] The use of art to attack
political opponents also continued after 1976. *Fine Art* and other art pub-
lications regularly featured picture-stories, woodblock prints and especially
cartoons (the favoured medium for attacking political opponents) to
denigrate aspects of the Cultural Revolution and to discredit "the Gang
of Four".

After 1979, in the general atmosphere of reform, a distinct qualitative
change began to occur in *Fine Art*; and this was accelerated particularly
after 1984 when the aged editors-in-chief Wang Chaowen and Wang Qi,
two Yan'an veterans, were finally replaced by the younger Shao Dazhen.
Perhaps because he lacked the ideological tempering of his predecessors,

Shao was reportedly determined to ensure that Fine Art reflected "as wide a diversity of opinions and tastes as possible."[46] There were several alterations in the format of the magazine in the early 1980s and the quality of reproductions noticeably improved, with better colour definition through the use of expensive glossy paper and more advanced printing techniques.

The content of reproductions also improved enormously as the all-pervasive Socialist Realism of the Cultural Revolution gave way to an amazing diversity of themes and styles, both foreign and local. The general tone of articles published began to alter too, and the magazine gradually lost virtually all signs of the political rhetoric that had been so prominent in its pages. Exhortations for artists to depict "the hot revolutionary struggle" and "to serve the workers, peasants and soldiers" were largely replaced with more subtle discussions on, amongst other things, concepts of beauty, self-expression and abstractism in art. The ideas of Marx, Lenin and Mao were replaced by those of Sartre and Freud, and modern western art theorists.

In the late 1970s, there briefly existed an additional channel of publication, completely independent of official control, for a small number of artists to express their views and to show their work. This took the form of Samizdat publications, such as Today (Jintian), which originated in the democracy movement of the period and which were produced by democracy activists using simple methods and materials. They contained short stories, poems and articles on cultural issues, as well as crude print reproductions by artists like Qu Leilei of the Stars.[47] However, these publications were short-lived, most of them lasting only for a few issues, and circulation was limited due to problems with production and distribution. Later in the 1980s new art publications appeared which, unlike the earlier Samizdat magazines, were more professional in presentation, because they shared printing facilities with other official newspapers and periodicals. Fine Arts in China (Zhongguo meishu bao), for example, used the printing facilities of The Liberation Daily (Jiefang ribao).[48] This art publication, a four-page national weekly tabloid established in 1985 and produced in Beijing, may not have been able to rival the glossy look of Fine Art or cover issues in as much depth, but for the candid way it expressed opinions and for the direct manner it reported on events and trends on the national and international art scene, it became compulsory reading in Chinese art

circles. It was described by Geremie Barmé as "the most outspoken arts publication in China".[49]

The search for modernity — New developments in art practice and theory

The Fourth Congress of Writers and Artists, called together by the Third plenary session of the All-China Federation of Literary and Art Workers (May–June 1978), drew delegates from all nine affiliated organizations to review the state of cultural work since 1949 and to discuss new cultural policy directives.[50] Deng Xiaoping attended the Congress, as Mao Zedong had before him, as the prime authority on political policy. His speech, the second of the Congress, was marked by its banality, its imprecision and its lack of clear direction. Its tone, however, was moderate, in line with the political necessity to win back the support of intellectuals to help implement the economic reform programme.

Following the virtually mandatory criticisms of Lin Biao and "the Gang of Four", Deng stressed that, "Our policy on literature and art was on the right course and our achievements in this area were remarkable during the seventeen years prior to the Cultural Revolution."[51] His comment confirmed that the aim of the new leadership was to discredit those associated with the radical policies of the late 1960s and early 1970s without unduly damaging the reputation of the Party as a whole.

Deng declared that the energies of all writers and artists should be channelled into ensuring the success of the Four Modernizations. In fact, as he stated: "The sole criterion for deciding the correctness of all work should be whether that work is helpful or harmful to the accomplishment of the Four Modernizations."[52] The political restraints on cultural activities clearly remained, but he emphasized that there was a great deal of scope for what would be regarded as "helpful" to the reforms: "Geared to reach the common goal of realizing the Four Modernizations, writers and artists should broaden the horizons of their work; their creative thinking, themes, and techniques should change and adapt to the changing times, and they should be able to plough new ground".[53]

Mao's original formula of "literature and art to serve the people", and

in particular "the workers, peasants and soldiers", was mentioned by Deng, but it was balanced by his call to "Let a Hundred Flowers Bloom" once again. His entire speech was in many ways a re-working of the original Hundred Flowers policy, emphasizing as it did a rejection of undue political interference in cultural activities and encouraging writers and artists to widen the scope of their creative work.

Zhou Yang, Vice-Chairman of the Federation of Literary and Art Workers, in his four-hour address to the Congress reiterated Deng's remarks by calling for greater diversity in the cultural realm. However, he also made it clear that creative endeavour should still remain within political limits. The arts were to reflect the lives and interests of the people, but since, as Zhou stated:

> the Party has always formulated its political line and policies in the people's interests, both long-term and immediate, therefore, literature and art, when portraying the life of the people, cannot be dissociated from politics, but should be closely linked with politics.[54]

Nevertheless, in the light of the experiences of most of his audience during the Cultural Revolution, Zhou added a note of moderation, admitting that no one was infallible and that even a "proletarian politician" could not avoid making mistakes on occasions. Therefore, the relationship between the arts and politics was not to be interpreted too narrowly with the arts simply reflecting current policies. In a similar vein, he called for flexibility in the understanding and utilization of Marxism-Leninism-Mao Zedong Thought, advising that it should not be regarded as an unchanging dogma, but more as a guide to action. It was to become a starting point for action (not the decisive consideration or ultimate justification as had been the case during the Cultural Revolution) and was to be interpreted only in the light of "current reality".

The ideological basis of the speeches of both Deng and Zhou recalled in many ways periods of political relaxation prior to 1966. But it was also characterized by the contradictions that marked much of the political rhetoric during those times of liberalization. The dominance of political considerations was re-affirmed in the speeches, yet undue official interference was not to be tolerated; writers and artists were encouraged to be more adventurous in their creative work, though it was also stressed that

their work should meet the needs of the workers, peasants and soldiers. Clearly, the authorities were still failing to address the ambiguous nature of the relationship between themselves and writers and artists, and between politics and the arts.

At the Congress, much anger was expressed at the brutal treatment writers and artists had received during the Cultural Revolution. Very few had come through the experience unscathed, many had suffered terribly, and most knew of colleagues who had lost their lives. In the most poignant speech at the Congress, the playwright Yang Hansheng read out the names of over one hundred individuals hounded to their deaths between 1966 and 1976. The artists on Yan's list included Pan Tianshou, Wang Shilang, Dong Xiwen, Feng Zikai, Ma Da, Chen Banding, Qin Zhongwen and Wo Zha.[55] Of the speeches given by artists, the most striking was that by Zhang Fagen, a member of the Anhui branch of the Artists' Association. He focused entirely on the relationship between the arts and politics, and it was the first time that any artist had, at a major political forum, spoken so bluntly about such a sensitive issue. Flatly contradicting Deng Xiaoping's and Zhou Yang's rosy assessment of cultural achievements before 1966, he suggested, in a cutting indictment of the Communist cultural policies over the last thirty years, that the Party had failed to take the right course from the outset:

> After the country had been liberated and political power had come into the hands of the people, as a country and as a government there was the obligation to establish the arts as an independent domain in order to allow them to develop and flourish.... But we blindly demanded that the arts serve politics, and especially that they serve the current political struggle. But politics then were so unstable that the arts also became turbulent and vacillating.[56]

Zhang went on to outline the disastrous consequences of the policy in Anhui, even during the Hundred Flowers era. His tale of a young artist who won first prize for his painting of sparrow-hunting, but who was in the following year labelled a "Rightist" because sparrows had been re-habilitated,[57] might cause a wry smile, but it was nevertheless a vivid illustration of the hopeless situation artists could find themselves in given the vagaries of China's policy-makers. Zhang likened the state of China's art to that of her finances — "on the verge of bankruptcy"[58] — and argued for the need to free art from all political restraints, even though, with the

negative experiences artists had undergone over the previous three decades, it would be extremely difficult for them "to gain release from their [psychological] shackles".[59]

Initial new trends in art

Between 1979 and 1984, several new and distinct artistic trends emerged. Each of these trends had its own minority following, and not all the work produced in a particular style was necessarily of a high quality. However, despite the fact that they do not represent the mainstream in Chinese art, it is important to discuss them here because of their political as well as artistic significance. Sometimes this is manifested in an overt way in work which attempts directly to criticize or satirize the policies of the authorities. Often, what is most interesting is that a particular trend constitutes the individual expression of the artist. The very act of the artist striving to break with artistic conventions formulated by the authorities has political as well as artistic implications because in doing so, he or she re-interprets the world and the role of humankind within it in terms of his or her own vision.

Many of the artists dealt with in this section were, in the early 1980s, young, between twenty and thirty-five, though there are notable exceptions such as Wu Guanzhong and Zhan Jianjun who, in spite of their more advanced years, continued to produce a steady stream of increasingly experimental work throughout the 1980s. These young artists tended to have little or no connection with the art "establishment" and therefore felt they had less to lose in challenging accepted artistic conventions. They were often impatient with the traditional Chinese concept of "waiting for your turn", according to which respect for artists and their work increases proportionally with their age. As the art critics Zhang Shaoxia and Li Xiaoshan observed, this system condemned young artists to be "placed on the lowest rung of the art ladder".[60] In addition, according to the oil painter Luo Zhongli, during the Cultural Revolution the younger generation had been encouraged to rebel against authority and their elders, which made them less inclined to accept a subordinate role.[61]

"Scar Art" and the controversy over the picture-story book The Maple Tree

The period between the end of 1977 and the beginning of 1978 was in many ways a watershed for the arts in that it saw a shift in the approach to representing the individual away from the heroic and optimistic worker-peasant-soldier types that had existed previously. The first major manifestation of this shift was the new literary genre known as "Scar Literature" and later "Scar Art", both of which provided vehicles for the strong emotional response of writers and artists to the events of the Cultural Revolution: "The Cultural Revolution provided writers and artists with vividly and richly tragic material. This material caused all other literature and art to pale by comparison."[62]

The short stories *The Teacher* by Liu Xinwu and *Scar* by Lu Xinhua[63] initiated a mini literary trend of dealing with events from the Cultural Revolution in a new way. A wide range of social problems, particularly those related to young people, such as love and marriage, tragedy, injustice and disillusionment were reflected in the literature. A close connection existed between "Scar Literature" and "Scar Art". Picture-story books, for instance, were produced on the basis of the original "Scar Literature" stories, including one on Lu Xinhua's story *Scar*. "Scar Art", like "Scar Literature", dealt with the traumatic experiences mainly of the young people during the Cultural Revolution.

What became the archetypal example of "Scar Art" is an oil painting by the young artist, Cheng Conglin, called *1968 x Month x Day Snow* (Fig. 30), usually referred to as simply *Snow*. Cheng was one of the new generation of talented and committed young artists who had received their official art training after the Cultural Revolution in the Sichuan Academy of Fine Art. The painting depicts an event set in the Cultural Revolution — a battle between two Red Guard factions. It is crowded with figures, one of Cheng's favourite methods of composition at that time, repeated in his later *1978 A Summer's Night — Around Me I Feel That Our People Are Yearning (For Something)* (oil, 1980). From the bleeding of several of the figures and from the torn clothes of the girl who is centrally positioned, it is clear that something tragic has occurred. A man can be seen stooping under the weight of a heavy placard, others appear unconscious, perhaps

dead. One youth is seen ready to strike a fatal blow with the butt of his
rifle to the head of another, who is blindfolded with his hands bound.
The victors of the battle are easily discernible from the smiles on their
faces.

What is interesting about this painting is that it presents an horrific
and tragic scene without resorting to the usual exaggerated conventions.
The artist has instead used more subtle means to convey his message. The
snow of the title for example is no longer an undisturbed blanket of pure
white but has been turned into grey sludge by the fighting (a metaphor for
lost innocence?). The representation of the peripheral characters differs
greatly from the depictions of crowd scenes during the Cultural Revolu-
tion, where each individual expresses the same emotion. Here, there is a
diversity of emotions, implying disarray. One man is shown completely
absorbed in his camera. Several of the bystanders, apparently simple
country folk, stare in a blank, vaguely uncomprehending way at the
carnage wreaked in front of them. There are echoes here of Lu Xun's
recollection of the documentary film he watched showing the execution of
a Chinese man by a Japanese soldier, whilst a crowd of Chinese people
stand by watching the entire procedure with expressions of incomprehen-
sion.[64] The sense of tension is heightened by the sharp contrast drawn
between the mild curiosity of the simple peasants and the terrifying scene
being played out by the young Red Guards.

Perhaps the artist's main dramatic touch is his depiction of the young
girl placed centrally in the painting. She is obviously the key figure, as all
lines formed in the snow run to her, and her torn white blouse also catches
the eye. Her expression is one of indignation and accusation. But, unlike
the propagandist art of the Cultural Revolution, no target is set up to be
accused. The role of Lin Biao and "the Gang of Four" in the disastrous
consequences of the Cultural Revolution is nowhere suggested. It is simply
the tragic portrayal of young people in confrontation with each other for
apparently no reason.

Gao Xiaohua, like Cheng Conglin, is a young graduate from the
Sichuan Academy of Fine Art who produced work in the same style. His
oil painting *Why* depicts a small group of young people who, from
their wounds, have evidently been involved in recent factional fighting.
They are sitting, deeply engrossed in their own thoughts. The painting is

interesting because it reveals, perhaps for the first time since 1949, a sense of alienation. Though the youths all belong to the same Red Guard faction, there is no feeling of comradeship between them and, in fact, there is hardly any acknowledgement of each other's presence, with all of them looking in separate directions. We gain a sense that for them, faith in absolute certainties has been replaced by bewilderment and doubt, reinforced by Gao's choice of the title *Why*. The dark and sombre colours the artist has employed to heighten the sense of despair contrast starkly with the bright colours of Cultural Revolution art. The themes of disillusionment and uncertainty among the urban youth were to recur often in art during the next few years.

The significance of "Scar Art" from an ideological perspective is that, to a greater degree than "Scar Literature", it attempted to divest itself of the overtly propagandist trappings that had characterized so much of the art of the People's Republic and to replace it with a sense of ambiguity and uncertainty unprecedented since 1949. In "Scar Literature", there is still the notion of the "villains", on whom all the responsibility for the Cultural Revolution can be heaped. In *Scar*, Lin Biao is accused of "being responsible for persecuting a lot of old cadres".[65] Yin Dalei in *The Teacher* reflects on the fact that now "the Gang of Four" has been removed, it will not take long before their bad influence on education is expunged and "an ideal environment created".[66] The narrator in the same story later comments that, "Until 'the Gang of Four' was removed, dark and ominous clouds hung over our country".[67] In the "Scar" paintings, there was generally no attempt to lay the blame for the events of the Cultural Revolution on any individual or group of individuals. Instead, the question of why or how they happened is left to personal interpretation.

The literature also usually includes statements which indicate confidence in the new leadership. Xiaohua in *Scar* comments, "I shall never forget Chairman Hua's kindness and will closely follow the Party's Central Committee headed by him and dedicate my life to the cause of the Party."[68] In the paintings, on the other hand, the authorities are offered no such gestures of support. Nowhere are there to be found, for example, the Cultural Revolution-style banners declaring loyalty towards and love for the Party leadership. The "Scar" artists have simply declined to adopt such artistic devices.

It was "Scar Art", with its focus on tragic themes and with no ready-made explanations, embellishments or exaggerations, that constituted perhaps the first significant departure from the art of the Cultural Revolution. In one instance, this development inspired a discussion on the correct depiction of historical figures, which involved the picture-story book *The Maple Tree*.

The pictures for this story, which were produced by Chen Yiming, Liu Yulian and Li Bing, are based on a short piece of fictional writing by Zheng Yi, a young student at Fudan University.[69] The story is a simple one and can be placed firmly within the genre of "Scar Literature". It relates the events surrounding two classmates, Lu Danfeng and Li Honggang, who fall in love but then join opposing Red Guard factions during the Cultural Revolution. The story ends in tragic circumstances when they both die in separate incidents.

Following the publication of the story, the newly-appointed editor of the pictorial *The Picture-Story Book* (*Lianhuanhua bao*) invited the three artists, Chen, Liu and Li, to produce a series of pictures based on it (they were also responsible for the pictures in the picture-story book *Scar*). The finished work appeared in the August 1979 issue of *The Picture-Story Book* and distribution began in Beijing on 3 August.[70] During its first few days of sale, *The Maple Tree* apparently provoked a strong reaction amongst readers, prompting the editorial board of the pictorial to remark that there had been "an enthusiastic response to it rarely seen before".[71] However, an order was suddenly received by the board from the Bureau of Publications to "cease sales". The reason given was that in *The Maple Tree*, "Lin Biao and Jiang Qing appear as positive characters. If distributed, it would create a bad political impression".[72] This order was only later rescinded following an outcry from the publishers of *The Picture-Story Book* and some of its readers.[73]

The offending items included a picture (number one in the sequence) showing Jiang Qing meeting a group of young Red Guards , and another of Lin Biao (number eleven). The three artists, along with *The Picture-Story Book* team, had already anticipated the possible reaction to their planned presentation of these controversial figures. A meeting of the editorial board had been called prior to publication and a discussion held on alternative methods of portraying them, such as, in the case of picture number one,

replacing it with a photograph which had one corner burned. In the end, it was decided to proceed as originally planned without any alterations.[74]

The objection raised by the Bureau of Publications touched on the important question of how to deal with personalities and events from recent history. The falsification of historical fact in official records had been a common practice, particularly during the Cultural Revolution. Only half of the names of the twelve most prominent leaders who had attended the First National People's Congress were included in political documents issued after 1966 because the other half had, by that year, been branded as "negative characters".[75] "Negative characters" in the art world, too, like Yan Han and Mo Pu, disappeared from written materials on art once they had been labelled as "Rightists". This was the case even when the materials referred to art activities in the newly liberated areas where people like Yan and Mo had been highly prominent.[76] Artists had often been obliged to distort historical reality in their work to conform to current policies, as we have seen in the cases of Liu Chunhua's *Chairman Mao Goes to Anyuan* and Dong Xiwen's *Founding Ceremony*.

The methods used for such distortions were not only confined to the removal or insertion of particular figures. It was sometimes more expedient to exaggerate certain qualities or characteristics in individuals, in order to present them as "positive" or "negative" examples. These methods tended to follow set patterns or conventions, so that there was no doubt as to the artist's intention to praise or denigrate: "In artistic representation, negative characters must be distorted and ugly, cartoon-like, stereotyped."[77] More than twenty years separated the political disgrace of Hu Feng and the downfall of "the Gang of Four" but there was remarkably little change in the visual representations of these individuals as "enemies of the people". The favoured vehicle for such representations remained the cartoon, with its powerful, biting satire and its ability to distort and exaggerate. The ugly and evil-looking cartoons of Lin Biao and "the Gang of Four" thus became their standard public images.[78]

Problems arose for the artists illustrating *The Maple Tree* when they attempted to challenge this established approach by presenting Lin Biao and Jiang Qing without the standard distortions. This was in keeping with the general tenor of "Scar Art" and the artists' depiction of Lin Biao and Jiang Qing was consistent with their treatment of other characters. As the

artists themselves commented, the young people were portrayed neither as brave clever heroes, nor as wild hooligans, but simply as ordinary students of the 1960s.[79] Similarly, with regard to the depiction of Lin Biao and Jiang Qing:

> *We portrayed them directly, without any kind of embellishment, in order to expose their trickery at the beginning of the Cultural Revolution. This was the premise of the entire tragedy.*[80]

This untendentious characterization of Lin Biao and Jiang Qing had significant implications, since it undermined the official attempt to place the sole blame for the Cultural Revolution on Lin and Jiang by presenting them as evil and heterodox figures. Once the simplistic explanation of events provided by the Party was replaced by a portrayal of them that adhered more closely to reality, the public was offered the chance to make its own judgements, instead of accepting the official version of events.

The Maple Tree and "Scar Art" in general helped to open up a new relationship between art and its audience. Previously, art was for "educating" the people, making them passive receptors of current political wisdom. *The Maple Tree*, and works like it, invited them to respond in a more active way. By dropping the formulaic symbols and not "telling" the reader whether the figures depicted were "positive" or "negative", people were given the opportunity to draw their own conclusions.

However, this departure from established practice was not universally welcomed. Some readers complained that if "bad" characters were not given an ugly outward appearance then their creators were, in effect, praising them.[81] Another objected that:

> *Jiang Qing and Lin Biao were represented in such a solemn [dignified] manner. Lin Biao appeared in colour and Jiang Qing looked like a photograph. [We] felt that this was "positive characterization" and, upon seeing it, [we] felt that emotionally we could not accept it.*[82]

The three artists received a letter from a mother whose child, after reading their picture-story book, asked her teacher: "How could Lin Biao and 'the Gang of Four' be so good-looking when they were 'bad eggs' [wicked]."[83] The mother's view was that the editors of *The Picture-Story Book* should not publish such pictures, "to avoid having children no longer know the difference between right and wrong".[84] It was precisely these

attitudes that the three artists and their supporters wanted to change. They deplored the fact that "Many people still hope that the masses can remain like children, ignorant of everything".[85] One stated bluntly that "Covering up contradictions, embellishing life, creating false images and cheating the masses is not in the interests of the proletariat",[86] and, with reference to Jiang Qing, "by not deliberately making her look ugly, people will be prompted to think more deeply".[87]

The controversy over *The Maple Tree* was short-lived. Several prominent artists from the Artists' Association supported the magazine and condemned the order issued by the Bureau of Publications to stop sales. Ye Qianyu was reported to have written a letter of support from his sick-bed.[88] He Rong stated that the withdrawal of the picture-book contradicted the Central Committee's policies to "Let a Hundred Flowers Bloom" and to end the unwarranted issuing of administrative orders:

> The masses should decide whether a work of art is good or bad. Even if it is a big poisonous weed, the masses should still be allowed to see it. It is the order stopping its distribution that is the problem.[89]

Final confirmation of official approval of *The Maple Tree* came when the picture-story was awarded second prize in the "Exhibition to Celebrate the Thirtieth Anniversary of the Founding of the People's Republic".[90]

"Stream of Life" painting

"Scar Art" raised important questions about how real people and real events should be portrayed. Nevertheless, like the art that had preceded it, it still had associations with overtly political themes. From 1980 onwards, however, a new trend emerged to introduce marked changes in the subject matter depicted in art. Sometimes called "Stream of Life" (*shenghuoliu*), it was a reaction against so-called "grand themes" (*da ticai*) and the Communist theory that "theme is the decisive factor" (*ticai jueding lun*). "Stream of Life" paintings offered intimate and personal portrayals of "low-key" non-political subjects instead.

"Stream of Life" was part of a wider reaction against the standard depiction of the "model" individual, which had reached its extreme during the Cultural Revolution, but which had its origins in the Great Leap Forward

and before. As we have seen, depictions of individuals during the Cultural Revolution were basically restricted to a single type — the heroic "model" worker, peasant and soldier or Communist leader, in particular Mao Zedong. From 1979 onwards, aesthetic discourse, as part of a general negation of Cultural Revolution practices, disavowed these stereotypical images.

The "model" image had been defined as someone in whom all the qualities most desirable in the "new socialist man" were condensed and concentrated to an extreme degree. By the late 1970s, this assumption that it was artistically acceptable, and even essential, to take the representation of individuals out of reality and to place them in a world of socio-political fiction began to be increasingly undermined. Artists now saw it as an attempt by the authorities to create a mythical world, inhabited by super-human figures that were reminiscent of the gods and deities of traditional China. "The Gang of Four", far from constructing an anti-traditionalist, anti-superstitious and anti-feudalistic cultural discourse, as implied in their rhetoric, had, in a sense, perpetuated the concepts that lay behind tradi-tional images by simply replacing one set of "gods" with another:

> The artistic position of "the Gang of Four" regarding the portrayal of the progressive "model" in the Chinese masses is, in effect, a re-hashed version of feudal cultural consciousness. As it is the progressive and model elements in the masses [that are highlighted], these then form a new social stratum, that of the minority.[91]

Ironically, although the purpose of the Communist Revolution was supposedly to benefit the ordinary peasants, workers and soldiers, during the Cultural Revolution, they were never permitted to see true reflections of themselves in art:

> According to leftist creed, only that which is completely perfect and idealized can be called a model. But this is not a model, it is Utopia, and Utopia can only be found in Heaven, not in this world.[92]

The depiction of the Communist leadership, particularly in relation to the ordinary Chinese people, also came in for criticism. A complaint was voiced that leaders were represented as virtual gods, whilst the masses appeared to be of only secondary importance, as reflected in this post-Cultural Revolution ditty:

> The leader stands in the middle, head held high
> The masses are on both sides,

Men and women, old and young circle round smiling,
Red and light, the whole area is bright.[93]

In many instances, such as the oft-reproduced painting *Chairman Mao Goes to Anyuan*, there was no attempt at all to include the ordinary people or other Party leaders. Some artists commented that many portraits from the Cultural Revolution gave the impression that Mao was some kind of "saviour" who had single-handedly achieved the revolution,[94] whereas their assessment was that "The success of the revolution rests mainly with the masses. The leader plays an important role but not the only one."[95]

In "Stream of Life" art, we can perceive two main features. First, there was a rejection of the mythologized heroes and god-like figures that were seen as contributing to the lie of the Cultural Revolution and, as a corollary of this, a rejection of the cult of personality. Second, there was an embracing of the concept of the ordinary individual and an affirmation of his or her importance in the scheme of things.

In ideological terms, this development was highly significant. Since 1949, art had functioned as a tool for legitimizing and perpetuating political power. It was used to define a particular world-view solely according to political and ideological criteria. During the Cultural Revolution, it had gone to the extreme of creating a vision of society with no basis in reality. The elements of realism, even naturalism, that began to appear in art during the early 1980s reveal the rejection of a world-view determined by political leaders, and an attempt by artists to formulate their own vision of life, however naive, based on personal response and interpretation. The art work of this period is therefore associated with an emphasis on universally human, rather than narrowly political, values.

One of the striking features of "Stream of Life" paintings was the sensitive handling of rural scenes and people from the lowest levels of the society, especially poor peasants and minorities, who were portrayed without the usual exaggerated conventions. The predilection of most "Stream of Life" artists for rural settings is an interesting aspect of their work. Traditionally, rural scenes had a special significance for Chinese artists, embodying as they did an intellectual yearning to achieve universal harmony with nature. Landscape painting expressed an escape for the Chinese gentleman from the corruption and distractions of the bureaucratic world, and generated a sense of spiritual purity and peace.

The "Stream of Life" artists, with their humanistic concerns, focused more on the figures in their "landscapes". Many of these artists had been "sent to the countryside" during the Cultural Revolution; they had lived among peasants and minority peoples, and their paintings reflect a nostalgia for an innocence and a simple, pure experience of life that stood in sharp contrast to the recent upheavals and chaos of urban China. "Stream of Life" subjects are thus generally depicted as retaining a sense of human dignity, despite their materially impoverished circumstances, a method of portrayal that differentiates sharply from the anxiety, isolation and alienation which is often manifested in paintings of urban Han Chinese during the early 1980s. As the art theorist, Gao Minglu, commented on "Stream of Life" subjects: "[They reveal] a pure and clean humanity which has received no interference from class struggle".[96] And on another occasion:

> [In "Stream of Life" painting] the elevation of goodness is mainly reflected in the genre's extolling of universal humanity, and this praise is focused primarily on the simple humanity of ordinary folk and … on their honest and simple lives.[97]

Many of the "Stream of Life" artists, such as He Duoling and Ai Xuan, had previously been "Scar" artists. Now the focus of their paintings switched from a preoccupation with their own social group and its experiences to individuals and groups of individuals living outside that narrow urban framework, thus opening up endless possibilities for the exploration of new ideas relating to the general human condition.

One of the most prominent figures in the movement was Luo Zhongli, student and later teacher at the Sichuan Academy of Fine Art. His oil painting *Father* (Fig. 31) caused a great stir when it was exhibited at the Second Chinese Exhibition for Young Artists in Beijing in 1980.[98] This was partly due to the sheer size of his portrait of a Sichuan peasant (it measured 160 x 240 cm), which was on a scale, as Luo himself acknowledged, usually reserved for the portraits of Communist leaders.[99] It was also partly due to the novelty of the hyper-realistic technique he had adopted. Luo had been influenced by the American hyper-realist Charles Close,[100] though, as Chen Yingde points out, in addition to producing an almost photographic likeness of his subject, Luo adds extra touches to express his sympathy for that subject, thereby "differentiating (Luo's brand of hyper-realism) from western hyper-realism."[101] In the painting, an aged Sichuan

peasant, evidently from an extremely poor background, stares out in a mild-mannered, resigned way, his two gnarled and grimy hands clutching a broken rice bowl half-full of water. This stark image of humanity caused one critic to observe that , "art had returned from Heaven to the mundane world".[102]

Luo's deliberate attempt to represent the impoverished state of the peasants was one of the earliest examples of an artist in the People's Republic highlighting the reality of China's economic backwardness. This, in itself, was no longer a particularly taboo subject as the authorities had already acknowledged that poor economic conditions prevailed in some rural areas of China.[103] However, it was the first time that art had presented such a stark and convincing picture of these facts. *Father* raised questions concerning the efficacy of Communist economic policy since 1949 which was, after all, intended to improve the lot of the peasants:

> *After thirty years, how much better really is his [the peasant's] life compared with Old Fellow Liang[104] who lived in a grass hut near the toad riverbank at the beginning of the 1950s?*[105]

A letter to *Fine Art* from a peasant who had seen *Father* echoed this sentiment:

> *After thirty years of change in society, the re-emergence of old dregs has caused this generation of peasants to long for happy times, but it has also made them full of worry. They have discovered that to become real masters of their own fate is extremely difficult.*[106]

Luo himself stated that it was precisely this failure to improve the economic conditions of the peasants which had provided him with the main inspiration for his painting. Sent to work in a small factory in the Da Ba mountain region, Da county, Sichuan, during the Cultural Revolution, he had since been in continuous close contact with the peasants living there, becoming familiar with them and their lives.[107] He recalled that a particular event in 1975 formed the basis for *Father*. He had in that year witnessed a peasant guarding a pile of dung (dung being a valuable commodity in rural areas which needs to be guarded), and the sight of this old man sitting all day in the hot summer sun with a resigned expression on his face made a great impact on the artist, reminding him, as the peasant did, of Yang Bailao, Xiang Linsao, Run Tu and Ah Q, all fictional characters

from the lower echelons of traditional Chinese society.[108] Clearly, by making this comparison, Luo is indicating that, in his view, no fundamental improvements have taken place in the lives of the underprivileged since the early part of this century.

Luo's adoption of a hyper-realist technique for *Father*, together with the exceptionally large scale for such a portrait, rendered it visually startling. Luo claimed to have made use of the traditional Chinese belief in physiognomy by endowing the peasant with a "mole of bitter fate" (*kumingzhi*) and "rolled ears", which he said normally indicate a fear of one's wife, but here are used to symbolize the gentle nature of the peasants and their tendency to yield to others.[109] The artist's explicit sympathy for the peasant creates a vision which has much closer associations with nineteenth century Russian Social Realism than Stalin's Socialist Realism.

Father provoked strong reactions that were not always positive. Luo was criticized for failing to draw a distinction between the work undertaken by peasants in the old society, and that performed by them in the new.[110] He also received advice from a cadre "comrade" who had misgivings about the portrayal of the peasant and told Luo to include a ball-point pen behind the peasant's ear in order to imbue him with "the characteristics of the new peasant under the socialist system" (the pen would be evidence of the higher literacy and cultural levels under Socialism).[111]

Father clearly raised aesthetic questions in its rejection of the Cultural Revolution "model" figure as the only valid representation of the individual. The requirements for a "model" figure, such as a sturdy, healthy body and a ruddy complexion, were the components of a complete system of aesthetics which dictated that peasants or workers, even when involved in laborious activities, were to be portrayed in neat and clean attire, with no trace of grime or perspiration. In addition, the "model" was typically allowed to reveal no signs of aging and had ideally to appear to be in the "spring of life" (*qingchun shidai*).

Luo breaks most of these conventions. His peasant is old. On his craggy face there are beads of perspiration as a result of sitting in the hot sun. Wisps of white hair straggle from his chin and upper lip, only one tooth is in evidence and his finger-nails are filled with dirt. The painting is in stark contrast with the idealized images demanded in works of art only a few years previously. Yet, far from being widely condemned for being ugly,

on the whole it received an enthusiastic response from artists and the public alike, and it was finally selected as the first prize winner from amongst the work included in the Second Chinese Exhibition for Young Artists in 1980.[112]

How had *Father* managed to achieve such approval? Certainly, Luo's sympathy for his subject comes across strongly, adding substantially to the painting's emotional appeal. There is also an inherent dignity in the peasant himself which leaves a strong impression, despite his "ugly" characteristics. As Shao Dazhen, later editor of *Fine Art*, observed: "The 'ugly' details do not imply 'ugliness' of image",[113] but fuse to create a compelling image of the Chinese peasant and his passive suffering. The very title *Father* was felt to affirm this almost spiritual quality: "He [the elderly peasant] forcefully expresses the virtues in the Chinese people of honesty and simplicity, strength and the ability to withstand hardship".[114]

Luo, then, had used details normally regarded as ugly not to convey ugliness, but to symbolize universal human qualities. A parallel may thus be drawn between the replacement of Cultural Revolution "heroic models" with Luo's apparently "ugly" peasant, and developments in Western Europe when the decline of religious painting during the Enlightenment heralded a new aesthetic sensibility, particularly marked in romanticism, in which "beauty no longer implies beauty of appearance",[115] when the innate qualities of individuals take precedence over their outward form:

> *Whether their appearances are ugly or beautiful does not matter. What matters is their spirituality, their subjectivity or essence seeking to express itself.... In this way, the Hunchback of Notre Dame ... can be as beautiful as David, prostitutes as pure as saints.*[116]

Father and the figures in other "Stream of Life" paintings had thus come to replace the "Davids" (Party leaders) and "saints" ("model heroes") of the Communist pantheon and were thereby signs of new aesthetic standards based on the dignity of inherent human qualities, rather than the unattainable perfection of Cultural Revolution "gods".

In other "Stream of Life" paintings there is this same affirmation of the human qualities seen in *Father*. Cheng Conglin in his oil painting *A Girl and Her Younger Brother* (Fig. 32) offers an appealing image of the innocence of youth, made more touching by simple details such as the apple

clutched firmly in the little boy's hand and the uncertain expression on his face as he peers from behind his sister. The work of artists like He Duoling and Ai Xuan is in a slightly different vein, since they had been influenced by the American realist, Andrew Wyeth.[117] Their paintings, like most "Stream of Life" art, focus on rural settings and people, but they are also marked by a misty quality and a sense of anxiety that is typical of some of Wyeth's work. However, Wyeth is often concerned with exploring the very depths of the human psyche or the human condition as, for example, in his famous *Christina's World* (1948, tempera), where an atmosphere of isolation and alienation is emphasized by the vast space between "Christina" and the distant houses. The early work of He and Ai, on the other hand, tends to lack the psychological insight that is such an integral part of many of Wyeth's paintings. Ai Xuan's depictions of Tibetans, though manifesting a certain Wyeth-like isolation, are often overlaid with a sentimentality that weakens the level of philosophical profundity. He Duoling is more successful in creating a sense of psychological tension, though, unlike Wyeth, he seems to be striving to convey a feeling of expectation, of looking to a future that, while uncertain, might bring better things. His oil painting, *Revival of Spring* (Fig. 33), which aroused a good deal of interest in China's art circles when it appeared in 1982,[118] is a typical example. He explains the background to this particular painting in terms of his experience during the Cultural Revolution, shared in common with many of China's urban youth, of being sent to the countryside for "re-education":[119]

> I am the same as others of my generation. I have long since bid farewell to that world, but it hasn't at all disappeared from my heart. On the contrary, each time I think about what to paint, it appears clearly and distinctly in front of my eyes ... I roamed around that place for three years.[120]

Undoubtedly one of the most talented of the "Stream of Life" artists is Chen Danqing who studied at the Central Academy of Fine Art between 1978 and 1982. His best-known works, seven paintings on the Tibetan people, were exhibited at the Academy as part of the 1981 Exhibition for Research Students. These paintings are powerful and evocative, revealing in brush technique and colour a strong influence from the Northern European and, in particular, the Belgian School of painting (his mentor,

Wu Zuoren, studied in Belgium in the 1920s and 1930s).[121] His work at no point slides into sentimentality and the figures he paints always have a pride and dignity regardless of the activities they are engaged in. He daringly portrays all aspects of the Tibetans' lives, whether it is bare-breasted women washing in a river (*Women Washing Their Hair*), breastfeeding (*Going to Town* (Fig. 34)) or praying during a pilgrimage (*Pilgrimage*). Chen himself said his paintings were in the naturalist, rather than the realist, tradition, citing Millet as one of his greatest influences:[122]

> *I'm not a romanticist. My feelings and impressions are all completely natural, resulting directly from contact with various concrete things.... Impressions from everyday life flood my senses and I myself have no imaginative input. I love Rembrandt, Millet and Corot ... and I have been tremendously influenced by French painting, especially after attending the "19th Century French Painting Exhibition" held in Beijing in 1978, which was the first time I saw French painting in the original....*
>
> *Faced with the natural surroundings [of Tibet] and the customs of the Tibetans, I quite naturally chose to portray them in an almost classical style, using oils. Classical beauty lies in its naturalness.*[123]

Yet, at the same time, Chen claimed to feel dissatisfied with what he perceived as the over-subjective nature of his paintings.[124] A conflict had evidently arisen in Chen's mind between his admiration for naturalism and classical realism with their emotional distancing from the subject being portrayed, and his strong desire to deliberately include an element of "subjective" humanism in his art. Both aspects seem equally important to him. He stated: "I hope that the audience will unexpectedly be moved by the realistic portrayal and humanistic sentiments in my work".[125]

This comment of Chen's sums up the approach of "Stream of Life" artists. They all strove to challenge the established conventions that had dominated painting for the previous three decades by offering a vision of the individual free of political propagandist trappings. Simultaneously, they used emotionally evocative images, executed with superb technical skill, that were based on an aesthetic language meaningful to everyone. The easily comprehensible form and subjects of their work thus facilitated a clear understanding of the humanistic message that constituted an integral part of their artistic stance.

The search for the "self" and individual expression

Modern western art theory and philosophical concepts, and issues that in Communist terms have always been regarded as "signs of decadent individualism", such as the proper role and function of art, the use of abstract elements in artistic compositions, and the degree to which art should be viewed as the personal "self-expression" of the artist, rather than as some socially or politically determined and directed construct, formed the basis of much of the discussion on art from the late 1970s, and influenced the work of an increasing number of artists.

Though the Chinese authorities and some of their representatives in the Artists' Association occasionally looked disapprovingly upon and cautioned against such trends, it was the very policies instigated by the authorities that ensured the conditions were ripe for western ideas to take hold, particularly in China's big cities. An integral part of China's modernization programme to promote industrial and agricultural growth, and to increase its technical and scientific proficiency, has been its "open door" policy to the West. This has led not only to an influx of western materials and information on science and technology, but also to a whole range of, to the authorities, less welcome ideas relating to western culture in general, including those on modern philosophy, psychology, and art theory and practice. Since the implementation of the "open door" policy, with the exception of the Spiritual Pollution campaign in 1983, which was short-lived and less severe and widespread than previous political campaigns, the markedly more *laissez-faire* attitude of the authorities meant that there was little systematic attempt to prevent these ideas from entering China. In addition, as a consequence of the ideological crisis arising from the Cultural Revolution, modern western cultural concepts offered an exciting alternative, as in the early years of the Chinese Republic, to the debased political orthodoxy.

One can also argue that the social and moral ethos in China during the 1980s witnessed a shift of emphasis from the collective to the individual, a process sanctioned by government and brought about partly by deliberate government policies. These policies included the gradual dismantling of remaining communes and replacing them with leased land and private plots, a proportion of the produce from which could be sold at greater profit

on the open market; encouraging the setting up of individual enterprises specifically to enable some to "get rich fast", a system which, in addition to increasing the wealth of the trader, helped to foster a consumerist or acquisitive mentality generally; and introducing incentives in the work-place.[126] Paradoxically then, the government could be said to have been largely responsible for bringing about the situation of "selfish individualism" it often railed against, which was a reflection of, and a further impetus for, the waning of its ideological authority in the cultural field.

On the political level, the increasing attraction to Chinese artists of modern western philosophical and aesthetic theories and artistic styles inevitably signalled a concomitant decline of Party influence. There was clearly a difficulty in reconciling the mutually antagonistic stances of freedom of individual expression that characterizes the ideal in modern western art, and ideological conformity and responsibility to the wider society that marks Chinese Communist art policy. It produced a conflict that, in different ways, permeated many aspects of Chinese cultural and economic life as the leadership grappled with the dilemma of trying to liberalize in some areas, whilst still maintaining overall control. It is, in fact, the old dilemma of liberalization versus control that has been a marked feature of communist cultural policy, but in the 1980s the contradiction was brought into much sharper focus by the challenge to the rigid and inflexible Communist system from outside influences.

On the artistic level, the influx of modern western aesthetic and philosophical concepts and the Chinese artist's search for new aesthetic values opened up all kinds of possibilities for the future direction of Chinese art. It can be said that, just as China was attempting to modernize scientifically and technologically, the real problem facing Chinese artists in the 1980s (one that had faced them, indeed, since the collapse of the dynastic system) was how to "modernize" Chinese art. The difficulty in achieving this lay partly in the fact that artists had to contend with the demands of Communist ideological conformity; in addition, they had to overcome the antipathy towards notions of individualism embodied in Chinese culture itself.

Traditionally, Chinese society was dominated by Confucian values which strove to draw all aspects of social, political and cultural life into an integrated, holistic entity. This resulted in art, along with all other cultural

activities, being considered as an intrinsic part of the entire social system, inalienable in particular from prevalent philosophical-moral thinking, an attitude clearly revealed in the ancient saying "the arts are an embodiment of social-political ethics" (*wenyi zaidao*). We can see evidence of this as early as the time of the Confucian classics, in which Confucius extolled the virtues of certain types of music and poetry for contributing to universal harmony and for putting men in the right frame of mind to carry out their social duties. D. C. Lau comments: "Confucius required of music, and, by implication, of literature, not only perfect beauty but perfect goodness as well", and notes that "[to Confucius] whether a piece of music is acceptable or not depends on its moral quality."[127] Arthur Waley concurs in his assessment that "to him [Confucius], ... it [music] was important above all as an instrument of education. It promotes virtue",[128] and he also comments on the Odes in saying: "Confucius ... and his followers used them as texts for moral instruction".[129] Products of culture like the Odes were regarded as being able to perform a whole range of social functions: "The Shih [Odes] will enable you to arouse people's emotions, observe their feelings, establish social relationships, and express any sense of injustice. At home it enables you to serve your father, and abroad to serve your prince."[130]

Likewise, cultural activities which contravened this sense of harmony and ethics could have a detrimental effect on the social order. Confucius warned: "The tunes of Cheng are wanton",[131] whilst many centuries later, Liang Qichao's assessment of Chinese novels was that they were "the main source of corruption in the ethical lives of the Chinese people."[132]

From earliest times in China, then, a great deal of emphasis was placed on the social effects of the arts. For this reason, any work considered part of Chinese high culture generally had to remain within a framework of what was notionally considered to be socially and ethically acceptable and beneficial. As a result, the scholar-official class in imperial China developed a highly refined and broadly uniform style of painting, with a limited range of subject matter, technical application and materials. If one aspired to membership of the elite in imperial China there was little scope for major deviations in one's artistic work according to one's own personal predilections. In fact, major innovation on one's own initiative would simply not be part of one's general framework of reference at all. The Confucian system as a whole mitigated against tendencies deemed too "independent":

The rational principles of the moral ethics it [Confucian culture] emphasized restrained personal desire and the instinctive aspirations of men. In this cultural system, the ethical values of society and of the whole are paramount.[133]

The Chinese art critic, Deng Pingxiang, echoed these sentiments when he stated:

China's traditional cultural consciousness did not easily allow individualistic art to develop naturally. The traditional cultural consciousness of the Chinese people was identical in both its outward form and inner expression. It could only understand the world and itself in the general sense of race, nationality, community and family, and could not provide external forms and inner expressions that originated from "the person as subject".[134]

The Chinese philosopher, Li Zehou, in his book on aesthetics, even went so far as to assert that the dominance of Chinese high culture by Confucian values had resulted in "a casting aside of the aesthetic and formal laws of art itself."[135]

It is certainly the case that anything falling outside the strictly defined realms of either traditional Chinese painting or western academic realism has tended to receive a cool reception in China during most of the twentieth century. The short-lived nature of the earliest *avant-garde* group of artists in China in the 1930s, the Jue Lan Association, is one example.[136] Another is the case of Pang Xunqin, a founding member of the association and an artist of considerable talent and sensitivity, who felt compelled to burn all the more modernist paintings he had produced, because the Chinese did not respond well to them.[137] As Michael Sullivan observes:

in a society that willingly sacrifices individual freedom for the good of the whole, an artist who speaks out against orthodoxy and the suppression of individuality risks being condemned for promoting the cult of ziwo — "I myself".[138]

Neither does this seem to be a problem confined to mainland China. In Chinese communities outside of China where Confucian values still dominate (either at a conscious or subliminal level), such as Hong Kong or Taiwan, innovative art has only recently managed to gain something of a foothold.[139] John Clark, in his article "Problems of Modernity in Chinese Painting", poses the question of why so many twentieth century Chinese artists, such as Zou Wu-ki and Zhu Dequn, have decided to leave China

and live abroad, but have elected not to live in other countries with dominant Chinese cultures. His tentative conclusion is that "it is only recently that for some younger artists all the Chinese pasts can become a legacy and not a dead weight."[140]

The Chinese experience of art after 1949 comprised almost solely traditional Chinese painting or Socialist Realism, based on academic realism, both of which are inherently conservative, the former depending almost exclusively on early models, and the latter, norm-governed and constrained to achieving a certain degree of similitude *vis-a-vis* the object or scene being depicted. Such a situation was not conducive to the ready acceptance by a Chinese audience of modernist art styles. As one artist despairingly commented: "Mainland Chinese society is the most difficult for a modernist to exist in".[141]

Also, Chinese artists were, if only at a subliminal level, inevitably influenced by China's conservative art traditions. Prior to the 1980s, they had tended to produce work based on sets of strictly defined criteria, whether associated with traditional Chinese painting, western academic realism as adopted in the 1920s and 1930s, or Socialist Realism in the first three decades of the People's Republic. As Michael Sullivan comments: "[China's] culture still has a moral basis, and that is its strength. Its weakness is the overwhelming impulse to conform."[142] Modern art in the western sense, however, embodies principles that are far removed from those that govern the rigidly convention-based art styles familiar to the average mainstream Chinese artist. Its major characteristics include a refusal to be governed or limited by previously formulated rules, a freedom from any obligation to present close likenesses of subjects based on such rules, strong associations with technical innovation and stylistic experimentation, and the communication of an individual's emotions, personal world-view and values. The Chinese artist had to attempt to avoid the pitfall of simply adopting modernist styles wholesale, as though they were norm-governed. To achieve this and to move towards forms of art that incorporate some of the essential features implied in the term "modernist" would require a major paradigm shift in the Chinese artist's framework of reference.

To attain this goal required a re-evaluation of the artistic process, of the social function of art, and, indeed, of what constitutes the very essence

of art. Strictly speaking, "Stream of Life" artists had already begun this process of re-evaluation, which was then continued by others in the early 1980s. The attempts by artists to evolve styles free from the hitherto accepted conventions often resulted in work bordering on the amateurish (as several artists were, indeed, amateurs), but their efforts were nonetheless noteworthy for the precedent they set in providing some kind of basis, however tentative, for an *avant-garde* art that, given suitable social and political conditions, could eventually become firmly established. Discussions on the "modernising" of Chinese art were often lacking in theoretical depth, inconclusive and open to further debate, but they had an important role to play in airing ideas that would formerly have been considered heresy. Both the artistic work and the discussions were significant in that they were signs of a loosening of the authorities' stranglehold in the realm of art; they were also symbols of the tensions arising as a result of the conflict between the old system of imposed values, and the search for a new approach giving more prominence to the values and emotions of the individual.

The Stars

Any discussion of modernist art in China needs to include the group of artists who collectively called themselves the Stars. When they first came to the attention of the general public in the late 1970s they were young, all under thirty and mainly amateurs. Their disparate personalities and artistic styles achieved a level of cohesion through their shared links with the democracy movement of 1978 to 1979, and their shared aims of bringing new vitality to the Chinese art scene. The democracy movement was a coming together in China's main cities of people, particularly the young, to demand greater political and cultural freedom following the discrediting of "the Gang of Four" and the Cultural Revolution. Centred around the "Democracy Wall" at Xidan, Beijing, the movement originally received benign approval from Deng Xiaoping and his supporters, who hoped that it would help expose the remnants of the Maoist old guard and secure Deng's position as leader of the Party to oversee China's ambitious modernization programme.[143] It created an atmosphere in which the intellectual ideas and cultural activities of dissidents flourished. A strong connection existed

between political activists and writers, poets and painters. The Stars were closely associated with those involved in producing the unofficial publications which sprang up at the Democracy Wall, including such prominent dissidents as Liu Qing and Hu Ping from "April 5th Forum". Huang Rui, one of the principal organizers of and participants in the Stars exhibitions, was also a co-founder of *Today*, along with the poets Bei Dao and Mang Ke.[144] The literary review published some of the work of Star artists, such as the lithographs by Qu Leilei, under his pseudonym Shi Lu, in June 1979,[145] and Bei Dao's poems accompanied the work of two other Star artists, Ma Desheng and Yan Li, in the catalogue of the second Stars exhibition. In addition, it was Qu Leilei who took the courageous step of recording Wei Jingsheng's "secret" trial, and allowing transcripts of it to be distributed to the general public.[146]

Because of their close ties with the Beijing dissidents and the political content of much of their work, the Stars' initial attempts at arranging exhibition space through official channels proved fruitless. This must have been a disappointment to them as only in April, members of another unofficial group, the Oil Painting Research Association (OPRA), had come together to hold an exhibition in Zhongshan Park, for which Jiang Feng, the Chairman of the Artists' Association, wrote an opening speech praising the artists' efforts. However, these artists and their work were dissimilar in many respects from the Stars and the kind of art they produced. Most of OPRA's twenty-seven members were elderly or middle-aged art teachers and professional artists, and their work comprised mainly impressionistic landscapes or still-lifes.[147] In comparison, the Stars must have appeared to be a motley assortment of young amateurs whose highly unorthodox work might prove decidedly problematic for the authorities.

Finding all official avenues closed to them, the Stars took the bold step of arranging by themselves an open-air exhibition outside the China Art Gallery. News of the exhibition to be held between 27 September and 3 October was transmitted *via* a close network of all those involved in the dissident movement. In order to increase the impact, the exhibition was arranged to coincide with a preview of the officially organized National Exhibition for the Thirtieth Anniversary of the Founding of the People's Republic; the conventional themes and styles of the officially sanctioned

exhibits contrasted sharply with the refreshingly experimental work intended for exhibition by the Stars.

In all, more than 150 pieces were included in the dissident exhibition, contributed by twenty-three artists and ranging from oils and Chinese painting to woodcuts and sculptures. The work that drew the most attention was that of the talented sculptor Wang Keping. An actor and scriptwriter since 1976 for the drama troupe of the Beijing Central Broadcasting Station, Wang had no formal training as an artist and had only begun to experiment with sculpture by himself in 1977. In the late 1970s he began to read the absurdist plays of Beckett and Ionesco, and claimed that his work had been strongly influenced by them.[148] He submitted twenty-nine pieces for the exhibition, almost half of which could be defined as being overtly political, often with satirical undertones, the rest consisting mainly of playful, sometimes erotic renderings of the human form. His sculpture *Fake* is an attack on the hypocrisy in society and comprises a hand covering a face but with the first two fingers parted just enough to allow a bulging eye to peer cautiously out. Another, *Silence*, is clearly a statement on the oppression suffered by the Chinese people, especially intellectuals. It portrays a head with one eye open and the other closed, and a large stopper in the mouth seemingly to stifle any comments or objections to the things observed with the open eye. Wang's reflections on the Cultural Revolution included a satirical piece parodying Jiang Qing, titled *Gun*, and another, *A Long, Long Life*, is a caricature of Lin Biao who, whilst loudly shouting out Maoist slogans, holds aloft a copy of Mao's quotations in one hand and a knife in the other, presumably to stab Mao in the back. There was, in addition, an extra item that the Stars, after consideration, decided would be best temporarily left out of the exhibition. It would be another year before the public was allowed to see *Idol*, a bronze sculpture of a face with the familiar features of Mao, the cheeks bloated as they had been in his last years. His impassive gaze, and the rather odd-looking eastern-style headgear, with red star attached, presented a fused image of Mao and the Buddha, a parody of Mao's cult of personality. The Stars' initial decision not to exhibit *Idol* reveals that less than favourable allusions to Mao, even in the relatively open and daring atmosphere of the Democracy Wall, were still considered as too great a political risk.

The dissident exhibition began to attract ever-increasing crowds, so

that officials were finally unable to ignore the event. However, official response to it appeared to be somewhat confused. On one occasion, Jiang Feng came to view the exhibits and immediately gave his approval of open-air exhibitions and amateur artists who had not undergone formal institutionalized art training.[149] On another occasion, Yu Feng, Vice-Chairman of the China Art Gallery praised the exhibition in glowing terms following a visit: "There are some exhibits that, if they were included in international exhibitions, would not be inferior."[150] However, only one day after Yu's visit the exhibition was closed down by the Public Security Bureau, engendering wide suspicions that the order could only have come from the Artists' Association or the Ministry of Culture.[151]

Subsequently, although the order was rescinded and a promise given that the Stars would be provided with proper gallery space for an exhibition at some later unspecified date, the group, with much encouragement from the leading figures of the underground journals, decided to protest against the enforced closure of their exhibition on the grounds that it contravened the new constitution. The protest eventually took the form of a demonstration, deliberately organized to coincide with the National Day celebrations on 1 October.[152]

The demonstration, provocative in its timing and its prominent slogans demanding artistic freedom and political democracy, attracted a good deal of interest from foreign journalists, students and diplomats, as well as from locals, whose curiosity was aroused by the novel spectacle of the first unauthorized demonstration in the People's Republic. It also, naturally, became a matter of prime concern for the authorities, and was considered of sufficient importance to warrant the convening of an emergency meeting of the Politburo on the morning of 1 October. As a measure of the relatively tolerant attitude of a majority of the Politburo members at that time, it was decided, largely no doubt due to political considerations, that demonstrators would only be arrested if they persisted in their protest.[153] Later, at the Fourth National Congress of Literary and Art Workers convened in mid-October, a divided reaction to an event whose impact had not yet died down was apparent. Xia Yan's opening speech at the Congress criticized the Stars for diverting people's attention, and particularly that of foreign journalists, away from the main National Day celebrations and speeches; but later, Zhou Yang made a more positive

assessment of the Stars, stating that there were "people of talent involved in the Stars exhibition, and they must be protected".[154]

Whatever the disagreements amongst the cultural authorities, it was finally decided to allow the Stars to exhibit in Beijing's Beihai Park from 23 November to 2 December and again from 24 August to 7 September 1980, this time in the prestigious China Art Gallery, Beijing. Both exhibitions attracted a huge audience, with the figures for the second exhibition reportedly reaching 200,000,[155] by far the largest number ever to attend an exhibition in China's most important art gallery. In the first article on the Stars to appear in an official Chinese periodical, a favourable review of the November exhibition was provided by the young *Fine Art* editor, Li Xianting, who commented that it had:

> virtually become an important topic of conversation amongst the public and the art world, and especially amongst young people. There were those in agreement and those who opposed it. Opinion was not unanimous, but the reaction to it was very strong.[156]

This reaction was in response to both the political content of much of the work and the sheer range of styles, many of them western-inspired, with which the Stars had been experimenting. As one western observer enthusiastically commented:

> Cut off from their ancestral roots by the Cultural Revolution, they looked to the West and in a few months re-invented everything: fauvism, cubism, impressionism, surrealism, Dada, expressionism, pop-art and hyper-realism.[157]

Despite their experimentation in modernist art styles, the Stars were still concerned to emphasize the strong social significance of their work, denying that it would be irrelevant to most Chinese people. A statement by Wang Keping, the first part of which was included in the preface for the Stars first official exhibition, clearly reveals this:

> Käthe Kollwitz is our banner and Picasso our pioneer. But we place more emphasis on Kollwitz. We must not be like the scholar-artists of Ming and Qing times who, when complex social struggles took place, hid themselves away and pursued pure art.[158]

Certainly, a large proportion of the Stars' work reveals a preoccupation with political and social questions, even though it is usually couched in a modern stylistic idiom. Wang Keping's sculptures, with their

overtly political content, were easily able to strike a chord with a Chinese audience, which could share in Wang's satirical allusions to the main protaganists in the drama of the Cultural Revolution, as well as to the incompetent and insensitive bureaucrats he attacked in his work. Ma Desheng's woodcut *Six Square Metres* (Fig. 35), a criticism of the crowded conditions in which Chinese people have to live, shows the artist attempting to paint in his tiny room, which is crowded with furniture, and has a ceiling so low that the head on Ma's exaggeratedly elongated body seems to touch it. Yin Guanzhong takes a more complex problem for the subject of his oil painting *The Great Wall*, in which he implies that Chinese tradition, which is the product of immeasurable suffering on the part of the Chinese people, continues to hinder the younger generation today. In a rather ghoulish scene executed in an expressionist mode, skulls lie scattered around the foot of the Great Wall. A young girl and boy can be seen shackled together on the wall, back to back, rendered immobile and helpless. The Wall itself is an ambiguous symbol, at once representing a major feat of construction, but, having been built originally to keep out the Northern "barbarians", it also represents the isolationist nature of Chinese society and culture and the Chinese suspicion of anything foreign. Here, Yin is using it to represent China's psychological inability to throw off tradition and embrace new ideas from outside. It is also the case that the Great Wall, despite years of laborious effort on the part of the people who built it and the loss of innumerable lives, did not ultimately succeed in keeping out unwelcome intruders. Perhaps Yin is suggesting that, in the same way, obstacles in the form of tradition and the various controls put in place by the authorities over the years to keep out unwelcome outside influences will also ultimately prove flimsy defences against the modern western "barbarians".

Another concern of the Stars, as evidenced by their interest in the work of Picasso, was that their own work should be always fresh and innovative; the conscious aim of the group as a whole was to challenge their audience with new and exciting artistic forms. Ai Weiwei's watercolour landscapes, highly reminiscent of Cezanne, were a means of bringing the revolutionary modelling techniques of the "father of modern art" to the attention of the Chinese public, as well as a celebration of the new atmosphere of artistic freedom. Yan Li's *Conversation* (Fig. 36), like many

of his paintings, owes an obvious debt to both the Cubists in its rendering of the bottle and table in the foreground and to Mondrian for the horizontal and vertical lines and flat areas of unblended colours that comprise the simple background. Xiao Dayuan's *Fish and Net* would have previously been considered a prime example of a formalist painting. It has some affinity with the brushwork of traditional Chinese painting, but the overall effect of the apparently random and incoherent swirling patterns created by the mass of lines and small blocks of colour can be more closely associated with Jackson Pollock's abstract expressionist "sand" paintings. The merest hint of piscine forms prevents it from becoming purely abstract.

Whatever the merits of the Stars' work, they still avoided addressing fully a dilemma that faced not only them, but many artists since the late 1970s — that of how to produce art that has social worth or significance, whilst still ensuring a high level of freshness and vitality through constant change and innovation. If art was to have social meaning in China in the 1980s, could it do so and yet develop along the lines envisaged by the Stars? And when they and other artists talked about wanting their work to have relevance to society, what did they actually mean by the term "society"? Did it really include everyone, even workers and peasants?

With artists no longer compelled to direct their efforts at any particular social group through a process of political control, their "art with social meaning" in reality was bound to become a reflection of their own social conscience, a personal interpretation of what was socially important. When their ideas were then given expression in artistic forms that were constantly changing and developing, the difficulties of ensuring that art was accessible to everyone were compounded. One of the charges levelled against modern western artists has been that their insatiable impulse to find self-expression through innovative forms has led to art becoming incomprehensible and, therefore, irrelevant to all but a minority. Whether one agrees with this accusation or not, it is the case that many Chinese artists, in attempting to develop modern modes of art for China in the 1980s, have had to come to terms with the fact that, although they see innovation as necessary if Chinese art is seriously and meaningfully to reflect a society in transition, experimentation beyond certain boundaries can and does lead to complaints of "ivory-tower" elitism.

Many of those who attended the Stars exhibitions appreciated the artists' courageous stand against the authorities and their daring and clever exposés of the political machinations of the old Cultural Revolution leadership, as well as of bureaucratic corruption and other social ills. But there was still some public unease with the more abstract exhibits. According to Yan Li, the more abstract or experimental an exhibit, the more criticism it tended to receive.[159] Chen Yansheng's collage-like sculpture of miscellaneous objects, *From Out of the Sky*, drew the comment that it was "broken and fragmented, like the unclear and ambiguous shattered pieces of a nightmare".[160] Even Wang Keping's generally popular exhibits provoked some adverse comments. The natural knotty scars on some of the wooden sculptures were described by one viewer as looking like "a skin tumour, so ugly! After seeing them one wants to vomit as though one had eaten a fly."[161]

Another observer, though basically sympathetic to the aspirations of the Stars, had reservations about the large number of exhibits he and several others had failed to make sense of:

> If other people are unable to understand your work and thereby appreciate your emotions, then you have lost the aim of creativity. What use does your work have then? ... Fine art is a category of ideology. It should be a means of educating the people, so that when someone looks at a work of art, it exerts an imperceptible influence and thereby inculcates Communist morality and cultivation of character. Therefore, it needs to have a definite content.[162]

The Chairman of the Artists' Association, Jiang Feng, when explaining why he had given official permission for the Stars to hold their second exhibition in the China Art Gallery, echoed this feeling: "When these people [the Stars] realize that the mass of the people don't understand their work, they will learn and change their ways."[163]

Although the Stars' exhibitions attracted an unprecedented level of interest, their influence was short-lived. By the end of 1981, the official criticism of Bai Hua's screenplay, *Bitter Love*,[164] altered the political atmosphere once again, and the group was refused permission to hold further exhibitions. In addition, following their second exhibition, they lost the support of their most important and influential sympathizer, Jiang Feng. They had ignored his advice and included in the exhibition various works that he considered too abstract, as well as Wang Keping's bronze sculpture,

Idol, the parody of Mao as an aspiring Buddha-figure. This sculpture, which was the first publicly exhibited work of art to mock China's hallowed leader, caused a great deal of excitement amongst the audience and consternation amongst the gallery authorities. When the matter came to Jiang Feng's attention, he was extremely displeased, claiming that, as it was he who had granted official approval for the exhibition, he was ultimately responsible for everything shown there. He had apparently come under attack from his more conservative-minded colleagues in the Artists' Association, particularly Hua Junwu, for allowing dubious works to be exhibited.[165] Huang Rui, one of the Stars, cited no names but claimed that "some bureaucrats" used the exhibition to attack Jiang and thus accelerated the decline in Jiang's health.[166] Whatever the case, the withdrawal of his support and his death soon after ensured the decline of the group, and by 1982, they had apparently "dropped out of sight".[167]

In 1983 Ma Desheng, Huang Rui and Wang Keping held a joint exhibition in Beijing, but it was soon closed down by officials.[168] Yan Li succeeded in arranging a self-financed, one-man exhibition in Shanghai in 1984, the first solo modern oil painting exhibition to be held in the People's Republic. Attendance was reasonable but nowhere near on the scale of the group exhibitions in Beijing.[169] The Stars could no longer generate the kind of excitement they had in the late 1970s and early 1980s. They were very much a product of their time, able to respond to a need in the public, which, weary of political upheavals, allowed itself to be briefly inspired by the courage, humour and naive enthusiasm of these young men and women. Only a few years later, the group's political attitudes were considered *passé* and their experiments in modernism had to vie for attention with all the other *avant-garde* trends that were becoming increasingly fashionable. Frustrated with the difficulties of showing their work in public and faced with the continuing uncertainty of cultural policy, the core members of the group began to leave China in succession and settle abroad. The high profile they had attained amongst the foreign community in Beijing, the romantic interest of foreigners in art and artists considered "dissident", and the undoubted ability of several members of the group, ensured their relatively easy passage out of China. By 1988, nine of the core members had left for Japan, Europe and America in search of a more conducive cultural atmosphere. Only four, Bo Yun,

Mao Lizi, Yin Guanzhong and Yang Yiping, remained in China to carry on their work.

Art as "self expression"

The role of the artist

The view held by the Chinese authorities on the role of the artist was, as we have seen, based on Mao's Yan'an Talks in 1942. Mao had stated at the time that artists, like all other individuals in China, are an integral part of society, and must serve the needs of society as dictated by the Party. His approach took as its basic premise the social theory of human nature, derived primarily from the writings of Marx and developed by Russian and Soviet theorists, which laid down the principle that the nature of a human being is the sum of all his social relationships. The individual is viewed in terms of his social role and social relationships, and his work judged in the light of its social usefulness and desirability. This approach was manifested in China in numerous cultural directives after 1949 and "art workers" (as they were usually known) were constantly reminded of the educative role of their work, the social reality it should reflect and the social groups at which it should be directed.

A new view emerged in the 1980s. Discussions often focused on parallels between changes that have occurred in the West during the twentieth century and those affecting China in the 1980s, emphasizing the need for a re-assessment of the social role of art and the artist in the light of these changes. It was observed that there was an awareness in the West, following two world wars and other momentous events, that many of the old values and beliefs of the western world had been shattered, and that this had led to a re-thinking of the individual's place in the world. It was commented that, likewise in China, as a result of the enormous upheavals that had taken place in society, a spiritual crisis had arisen regarding values and the very meaning of life, and this had created a need for the individual to assert his autonomy and question the nature of his existence. For the artist too, the world was changing and art would inevitably need to reflect this change. After all, it was argued, even Marx had said that developments in the material aspect of a society would affect other areas of

social life.[170] Du Jian, art critic and theorist, went so far as to state that some parts (unspecified) of Mao's Yan'an Talks needed to be reviewed, and even Marxism itself needed to meet the challenge of the new era; otherwise, "it cannot maintain its scientific system under the new historical conditions", because:

> over these past few years, young people who have come into contact with all kinds of foreign modern art and foreign philosophical thinking have often begun to have suspicions about a whole series of questions, such as [the slogans] art is to serve politics, art is to reflect life, and so on.[171]

The mood in cultural circles in general was changing rapidly. In the field of literature, for example, many debates were held on whether and how the Chinese novel, in particular, should develop during the 1980s. This quotation from the periodical *Reading* (*Dushu*) in support of the Post-Modernist novel is typical of the more radical views expressed:

> We cannot run back to the arms of nineteenth century bourgeois realism. During the first half of the twentieth century there have occurred great changes — Freud, Einstein, two world wars, the Russian revolution, the sexual and technological revolutions.... Tolstoy's realism has now become passé. Writers and readers with modernist thinking do not miss it.[172]

In such a climate of ideological uncertainty, Jean-Paul Sartre's existentialism became one of the more popular western theories within Chinese cultural circles, to the extent that one conservative critic complained that "some people were using Sartre's existentialism to replace Marxism-Leninism".[173] During the first fifteen years of the People's Republic, existentialism had been labelled a bourgeois philosophy, and Sartre's friendship visit to China in the 1950s had apparently elicited a generally negative response from the Chinese leadership.[174] Following ten and more years of complete silence on the subject as the Cultural Revolution ran its course, Sartre's work began to interest a number of Chinese artists when they were translated into Chinese in the late 1970s and early 1980s.[175] Existentialism clearly provided a theoretical model for artists who now found themselves lacking any philosophical basis for their life and work. An amateur artist, Zhong Ming, became one of the most vocal proponents of the theory, and his views, together with his painting *Sartre — He Is Himself* (Fig. 37) caused a stir when published in *Fine Art*, and generated a

debate in the periodical on the extent to which art should be regarded as
the "self-expression" of the artist.

The painting was originally produced for the Oil Painting Research
Association's third exhibition, held in November 1980, in the China Art
Gallery. Zhong Ming, then an editor in the People's Literary Publishing
House in Beijing, painted in his spare time.[176] The composition of this
particular painting was unusual in that it featured a life-like portrait of
Sartre in the lower right-hand corner and a half-full glass of water in the
diagonally opposite corner. Both Sartre and the glass were set against a
bright red background bordered by a thin white line. The existential mes-
sage seems to be embodied in the relationship or, to be more precise, the
lack of meaningful relationship between the figure of Sartre and the every-
day object, the glass. For those unfamiliar with Sartre's ideas, the painting
must have appeared incomprehensible; many who visited the OPRA
exhibition had never even heard of the great philosopher.[177]

Zhong Ming's defence of existentialism in *Fine Art* revealed the extent
to which the ideas of some artists were beginning to come into conflict
with official policies on culture, since Sartre's views on human existence
conflict in many ways with Marxist theory. His ideas that no individual has
a pre-determined place or function within a rational system, and that
no-one can deduce his supposed duty through reasoning,[178] seem to strike
at the heart of the Marxist theory that society can be organized and
determined according to certain laws and social structures. Further, Sartre's
view that each self-aware individual understands his own existence in
terms of his experience of himself and of his situation[179] contradicts the
Marxist view that man's existence can only be understood in terms of his
social relationships and social role. Sartre emphasizes the isolated nature of
the human condition, and the anxiety that man faces over choices he must
make using his own free-will, and this sense of isolationism and anxiety
permeated the work of several young artists in China during the early
1980s. Zhong Ming himself, when explaining his painting on Sartre,
declared it to be "the isolation of the individual in a modern urban
context".[180]

Zhong Ming also brings out in his article Sartre's ideas on the central
role of the artist in the creative process, quoting the words of the
philosopher: "I feel that in the relationship between myself and a work of

art, I am the essence",[181] and "each artist, in his creations and his actions, expresses himself."[182] Sartre's emphasis on the role of the artist, rather than on what he produces, i.e. the work of art, conflicts with the Marxist view that, although the artist is an important element in the process of artistic creation, it is the work he produces that fulfills a social function, because it is his work itself that is educational. The artist's identity as a social being is inextricably linked to the tasks he performs and the works he produces. It also links him to others who perform the same tasks. The artist's thoughts and emotions are primarily fashioned by social reality and art itself is regarded as a social phenomenon requiring both an artist to produce it and an audience to appreciate it. However, as Zhong Ming points out in his defence of Sartre, existentialism declares that the nature of an individual is not fixed or dictated by outside influences, but by the individual himself, through the choices and decisions he freely makes. In the relationship between the artist and his work, it is the artist himself who is of primary significance.

The concept of art

As the social and didactic role of the artist came under challenge, so too did the conventional Communist view of art itself. As discussed earlier, this view is based on Mao's assertion at Yan'an that art must serve politics and society. Art was perceived as a tool in the revolutionary process before 1949 and continued to be a tool of the Party as society moved towards the goal of Communism. It needed, therefore, to have social relevance, acting as a reflector and interpreter of society according to Communist principles, this to be achieved through a process of conscious, directed effort on the part of the artist. This view, as we have seen, was based on the "reflection theory" (*fangyinglun*), which merged the material (mechanical) realist approach with objective idealism. Socialist Realism was the result of a synthesis of these two components, the blanket application of which to all forms of cultural endeavour led to criticisms in the 1980s that:

> artists do not know how to differentiate between the use of Socialist Realism in art, literature, music and so on, and so they have to rely on grasping the general principles of Socialist Realism even though its mechanical expression of ideas and its conceptual level is superficial.[183]

All three of the above theories, i.e. materialism, objective idealism and the synthesis of the two in the form of Socialist Realism, share the same fundamental ground — they relegate individual subjectivity to a relatively insignificant position. One of the major concerns in Chinese art circles in the 1980s was an attempt to re-dress this balance and give added prominence to individual subjectivity, thereby undermining one of the fundamental tenets of Marxist ideology as applied in the cultural field. Art began to be discussed increasingly in terms of the individual expression of the artist, rather than as a manifestation of the cognitive understanding of reality.[184] These developments signalled a rejection of the theory put forward by the nineteenth century Russian philosopher, Nikolai Chernyshevski, and popular during the first three decades of the People's Republic, that the basic purpose of art is to replicate reality; indeed, the new theories being propounded had more in common with Benedetto Croce's ideas regarding the preeminence of individual perception in artistic creation. As one art critic commented: "It [art] can have a cognitive value, and it can also not have. That is to say, art need not necessarily perform a purely cognitive function."[185] Wu Guanzhong, a respected member of the Artists' Association, put forward forcefully the case against the theory of reflection and the cognitive approach to art:

> *Emotion and rationality are … often antagonistic…. Rationality demands objectivity, pure objectivity; emotion leans towards the self or subjective experience. It carries within itself misconceptions…. If you strictly demand training in the depiction of the objective world, this is not moving along the natural road of art. Sometimes, it is, on the contrary, the wrong road and can even run counter to the true purpose of art!*[186]

Another critic of Socialist Realism praised the achievements of primitive art because of its aura of human spirituality and its being devoid, as he saw it, of human rationality. He stated that a work of art must be "permeated by the artist's individual mood, aspirations, individuality and disposition, and even his sub-conscious. In sum, the artist's soul must be allowed … free manifestation".[187]

One consequence of this new interest in the concept of "individual expression" (*ziwo biaoxian*) was the evident influence in the work of some artists of Freudian ideas, which began to circulate in China at the end of the 1970s for the first time after the founding of the People's Republic.

There were serious ideological implications in this for the cultural authorities because emphasis on the sub-conscious implied a concomitant downgrading of the role of the conscious, which is associated with the social aspects of human activities, social norms and moral conventions. According to Freud, it is the social collective which suppresses individual instinct. His ideas provided the rationale for Chinese artists in their argument that art should be a reflection of the artist's inner consciousness and that the sub-conscious itself can be a reservoir for creative activity or "a means to express complex and contradictory spiritual feelings".[188] Even the official publication *Fine Art* allowed the critic Li Zhengtian to voice positive opinions on Freudian psychology, with an editorial comment prefacing the article stating that, previously, questions relating to art had been approached almost wholly from a "social" perspective, and not enough from the perspective of the natural sciences and psychology. Li emphasized the importance of Freud's ideas on the sub-conscious in modern art, claiming that the theory of reflection was an inadequate vehicle for conveying the concepts that underpinned modern art. He stated "Art should give reign to artists' ... inner impulses.... These inner impulses or the sub-conscious are feelings that are sincere, with no trace of falsity."[189]

Freud's theories on symbolism and the sub-conscious, as well as their major influence on art as manifested in the work of western surrealists, had an impact on several Chinese artists during the early 1980s. Feng Guodong, a young member of the Oil Painting Research Association, reveals in his paintings some of the earliest attempts to express the sub-conscious in art. His *Self-Portrait*, shown in the OPRA exhibition in Beihai Park, Beijing, reveals a frightening world of red broomsticks swirling around the head of the artist, who is depicted as a strange, red-bearded figure with a despairing look on his face. In 1966 Feng was sent to work as a cleaner in a canvas factory and the painting is a powerful evocation of that unhappy experience. A second painting of his, *People at Ease* (Fig. 38), which was shown at the third OPRA exhibition in Beijing's China Art Gallery, is a surrealist setting of curious creatures apparently hovering in space. Feng claimed the picture was based on a strange dream, and he had evidently used techniques from early western surrealists, such as Salvador Dali, after seeing samples of their work.[190] Xie Jun's oil painting *Symphony of a Gloomy*

Soul and Crazed Thoughts is highly reminiscent of Dali's disembodied figures set in a strange and barren landscape. Xie himself did not feel the painting was a success artistically, but he thought that it was at least "truthful".[191]

Later in the 1980s, symbolism with obvious sexual overtones began to appear on the Chinese art scene. It has been suggested by J. Lebold Cohen in her book on the Yunnan School of modern art that the depiction by many Yunnan School artists of flying females based on the demi-gods or apsarases in Dunhuang may have been used as a sexual metaphor taken straight from Freudian psychology.[192] Xing Shenghua's sculpture *Conversation* (Fig. 39), of two water pipes facing each other, which appeared in an exhibition in Beijing in 1985, leaves the viewer in no doubt that they are symbols of the male and female anatomy. This may show the influence of Freud because in Freudian psychology, water pipes are suggestive of the urinary apparatus.[193] Perhaps one of the most striking examples of a work of art that also may have been influenced by the surrealists and Freud is Meng Luding's and Zhang Qun's oil painting, *In the New Era — The Enlightenment of Adam and Eve* (Fig. 40). Although the artists do not refer to Freudian influence in their comments on the painting,[194] there is considerable evidence leading to that conclusion. Its portrayal of a young naked couple, a Chinese "Adam and Eve" who have tasted the fruit of enlightenment has all the suggestiveness of a personal sexual awakening and psychological liberation. The mode of representing the landscape is highly reminiscent of much of Dali's work, and there are obvious surrealist touches, such as the time piece which seems suspended above the ground. In addition, the image of boxes receding into the distance around a central figure hovering in mid-air is similar to Dali's oil painting, *The Station of Perpignan*, where parallel lines run to the centrally-positioned figure, which appears also to be suspended in mid-air.

The question of form

As some in the Chinese art world brought to prominence the concept of "self-expression" as the main creative driving force and the subjective inner impulse of the artist, so others became interested in the function of form in art. Inevitably, many artists were concerned not only with what to express in their work, but also how to express it, because only by means of

a diversity of forms would they be able to convey a greater range of individual thoughts, emotions and values.

There had long existed official opposition to "formalism" (*xingshi zhuyi*), or an overriding emphasis on the formal aspect of the arts, extending back to the Yan'an days. At that time, impressionism had become the main target of criticism, perceived as it was by the leadership in charge of art as the most significant threat to Mao's pronouncement at the Yan'an Talks that form should be subordinate to content. Subsequently, impressionism had had more negative labels attached to it than any other art genre, including "naturalism", "aestheticism", "art for art's sake", "opposing tradition", "pure subjective perception", "pure objective portrayal", "opposing realism", "decadent", "opposing the people", and so on.[195] After 1949, only during the Hundred Flowers movement was the question of impressionism briefly re-assessed, receiving rather timid affirmation from a few individuals.

In the relatively relaxed ideological climate of 1979, the issue of impressionism re-surfaced, only this time the reaction to it was almost wholly positive. In June and July of that year, an exhibition was held in Zhongshan Park, Beijing, to show printed reproductions of impressionist paintings. Significantly, the exhibition was organized by art officials, specifically, the Beijing branch of the Artists' Association, together with the Central Academy of Fine Art. Though small-scale, it apparently attracted the attention of a sizeable number of passers-by, most of whom were favourably impressed by what they saw; they left behind written comments such as: "My goodness! So this is what frightening impressionism is all about ... it really is too lovely!"[196]

The exhibition inspired several artists and art critics, among them, Shao Dazhen, the future editor of *Fine Art*, to re-open the discussion on impressionism. Wu Guanzhong, the artist who was subsequently to be at the forefront of a five-year debate on the question of form in art, came out strongly in support of the genre in an article published in *Fine Art Research* at the end of 1979. His only real reservation regarding impressionism was not based on ideological considerations, but because it had long since become *passé* as a major art genre in the West:

> It really is too backward if we only study impressionism, since it belongs to the category of old painting, and much of it can only be thought of as inaugurating modern painting![197]

An additional sign of interest in the question of form was the series of murals commissioned for the Beijing international airport, which were completed and unveiled to the public in 1979. Two of the murals in particular, which are ostensibly on the theme of reflecting aspects of contemporary life in China, stand out as striking experiments in the creative use of artistic forms. In Xiao Huixiang's *Spring of Science* (Fig. 41), the human figures are elongated to exaggerated proportions and portrayed in most instances as floating effortlessly in the air like the apsarases in a Dunhuang Buddhist mural. The abstract symbols accompanying the figures contribute to the overall impression that this is less a work striving to convey a readily meaningful message on the triumphs of science in contemporary China but more a playful study in line, shape and space.

The second mural, Yuan Yunsheng's *The Water Sprinkling Festival — Song of Praise for Life* (Fig. 42), on the Dai minority in South-west China, was to become the subject of a controversy that extended all the way up to the highest echelons of the Chinese leadership. Yuan Yunsheng himself had been a controversial figure in art circles since the 1950s, when his outspoken views and, for that time, experimental work had caused him to be branded as a Rightist and exiled into the artistic wilderness for some twenty years. When given the opportunity Yuan consistently sought to enlarge the boundaries of what could be achieved through the creative use of form. His airport mural is an exercise in pure aestheticism, combing lush colour and exquisite form to present a visual feast. The Modigliani-like snaking elongated curves of the female figures, a number of them naked, add a touch of rich sensuality, though imbued with a natural innocence that is highly reminiscent of Gauguin's depictions of native Tahitian women.

Such creative exuberance was clearly too much for some, who objected to the "distorted" figurative representations as being an insult to the Dai people. Finally, on a visit to the airport to view the murals, Deng Xiaoping was said to have been highly disapproving of Yuan Yunsheng's unclad female figures, and he ordered the offending section of the mural to be boarded over.[198] Ironically, this action only served to attract the attention of the Chinese art world and the foreign press, and the work became a highly publicized example of the interest some Chinese artists were showing in the issues of the formal and aesthetic dimensions of art.

On the theoretical level, one of the first individuals to raise the question of the importance of form in art was Wu Guanzhong, artist and professor at the Central Academy of Arts and Crafts. Wu had initially studied traditional Chinese painting, and had subsequently spent some time in the art academies in France. Competent in both western-style oil painting and traditional Chinese painting, Wu had a long-standing interest in formal experimentation, even during the repressive years of the Cultural Revolution, when he continued to produce work that clearly fell outside the parameters of Socialist Realism, such as his expressionistic *Wild Chrysanthemums*, painted in1972. Throughout the late 1970s and early 1980s, his colour ink paintings became increasingly abstract. In three articles during 1979 and 1980, Wu gave his views on what he termed the "beauty of form". According to Wu, a feeling of beauty is engendered primarily by means either of aesthetically pleasing forms or the clever organization of colour, and therefore, "beauty of form is the crucial element in artistic creativity".[199] In his second article, Wu asserts that artists need not necessarily use basic elements in art, such as colour or line to "express a concrete objective phenomenon, but to use them ... to create an artistic image, which is 'absolutely' independent."[200] He also reassures artists that this will not lead to formalistic work incomprehensible to ordinary people, since "abstract beauty is the core of beauty of form. The love of people for beauty of form and abstract beauty is instinctive."[201] Wu even refers to abstract elements in Chinese folk art, such as line and colour, to prove his point that they can be admired "by workers, as well as intellectuals".[202] In essence, what Wu is saying is that form and content in art are inherently interlinked, with even the most abstract elements, such as shapes, lines and colours, possessing layers of intrinsic meaning. Rather than putting forward the more contentious idea that there can somehow be form without content, he argues instead that the formal aspects of art embody within themselves a kind of content, even if of a more abstract nature. The logical consequence of this argument is that artists need not limit themselves to producing only the kind of work that has a strong storyline; instead they should be free to explore a range of artistic forms so as to produce a greater diversity of aesthetic effects. Although Wu's views may be open to question, their significance lies "not in whether they themselves are right or wrong. More important is that [he] stirred the pool of stagnant water of theoretical enquiry."[203]

Others took up Wu's interest in problems relating to the abstract or formal elements of art. The artist and art theorist Du Jian, for example, wrote on the significance of the "rhythm of form", concurring with Wu in his assessment that "beauty of form" and "abstract beauty" were "essentially the same thing."[204] At the same time, he pointed out the inadequacy of using Marxist theory to tackle questions of "beauty of form", saying that because of "various factors" (new developments in human psychology, social progress, and the like), Marxism had not really been able to provide a proper solution.[205]

Others highlighted the abstract elements in traditional Chinese painting, stating that although traditional Chinese painting had never fully abandoned the "concrete image", "its 'brush and ink' images composed of lines and dots not only were not subordinated to those imitations of concrete things, but were 'absolutely' independent things in themselves."[206] It was even asserted that traditional Chinese painting had been progressing gradually since its inception as an art form from reflecting concrete to increasingly abstract images.[207] Some discussed the evidence in primitive art of a gradual progression towards abstractism;[208] at the other end of the chronological scale, the "cold" and "hot" abstractism of Piet Mondrian and Jackson Pollock were also discussed to see how they might fit into the notions of abstract form being discussed.[209]

These discussions affirming the importance of the formal aspect of art in China during the 1980s were of some significance, because it was only through a liberation of the means of expression that the new artistic conceptual scheme being formulated and developed could be accommodated. Evidently, it would be impossible for the established formal realism to act as a vehicle for the wide range of concepts that were becoming popular in Chinese art circles, such as existentialism, the notion of the unconscious, post-modernism, and so on. And as the decade progressed, artists began exploring the question of form, not only from the perspective of modern western cultural discourse, but also by drawing upon the rich resources of traditional Chinese culture; there was a renewed interest in Chinese primitive art and Daoist philosophy, which found expression in the modern Chinese context not in the figures of Daoist Immortals or sages, but in a highly symbolic form, utilizing traditional Daoist symbols such as Yin and Yang.

In political terms, the ascendency of form as an independent entity, worthy of discussion and experimentation in its own right, represented an undermining of the official view that all cultural endeavour should be a concrete reflection of society and that form should be subordinated to content.

The Spiritual Pollution campaign

During the early 1980s, the influence on Chinese cultural circles of modern western cultural products in the form of western *avant-garde* literature, films and plays and western abstract painting did not go unnoticed by the authorities. Following the closing down of Beijing's Democracy Wall, the kind of critical self-exploration that had been a marked feature of dissident activities came under attack in the form of a "Campaign against Bourgeois Democratism". The script writer, Bai Hua, was initially singled out for condemnation due to his controversial screen play, *Bitter Love*, which depicts a young idealistic painter, Ling Chenguang, who gives up a comfortable life in San Francisco to return to China in 1950, only to be imprisoned in a labour camp during the Cultural Revolution because of his foreign connections. Ling finally dies of exhaustion whilst fleeing from the camp and from individuals he erroneously believes to be labour camp guards, but who ironically turn out to be cadres who have come to tell him that he has been exonerated from committing any crime.

The authorities, sensitive to criticism, overt or otherwise, suppressed the film in 1980, despite protests, because of its "negative" message. Other literary works were subsequently attacked, including in particular several sombre and introspective poems written in 1979 and 1980. Then, in July 1981, Deng Xiaoping issued a document titled "A Talk on Problems on the Ideological Front", in which he criticized by name Bai Hua and the theoretician Wang Ruoshui, amongst others. A new ideological campaign was clearly gathering momentum and, finally, in October 1983, at a meeting of the Party's Central Committee, the conservatives, Deng Liqun and Hu Qiaomu, called for the elimination of what they termed "spiritual pollution", directing their attacks against Zhou Yang's and Wang

Ruoshui's theories of humanism and alienation.[210] Although artists did not become the prime targets of the Spiritual Pollution campaign, they were by no means left unscathed. In addition to the authorities' general condemnation of "decadent artistic practices", certain individuals were cited as the main purveyors of "spiritual pollution" in the art world. The editorial board of *Fine Art* was criticized for providing a platform for "erroneous views" and one of the editors, Li Xianting, a consistently staunch supporter of modernist trends in art, was temporarily "relieved of his duties".[211]

Some of the strongest criticisms were reserved for a group of ten Shanghai artists who, on 6 September, held an exhibition at Fudan University without going through the normal official channels. The ten artists, mainly from the Art Department of the Shanghai College of Drama, contributed some forty exhibits, many of them semi or fully abstract works. At the end of the second day, the exhibition was closed down by Fudan University's Party Committee; the reason given was that some of the paintings were "feudal", "foreign" and "black". Following consultations with the Drama College's Party Committee, which felt that the exhibition contained nothing that could be construed as anti-Communist Party or anti-Socialist, Fudan University's Party Committee reluctantly decided to allow the exhibition to continue for a further two and a half days, after a break of one and a half days.[212]

However, with the commencement of the Spiritual Pollution campaign in October 1983, the Drama College's Party Committee, perhaps in order to deflect any possible criticism, together with the Shanghai branch of the Artists' Association, wrote a report to the Shanghai branch of the Propaganda Department condemning the exhibition. The report was then circulated among various cultural and educational groups. It was described by one of the artists who participated in the exhibition as even more vehement in its attack than similar reports during the Cultural Revolution.[213] On the basis of the report, the Shanghai branch of the Propaganda Department took the exhibition as one of the two principal examples of "spiritual pollution" in the cultural field in Shanghai, the other being the choreography of certain modern dance routines by Hu Jiale, a member of staff at the Shanghai College of Dance. The artists named in the report were subjected to long interviews by the Party Committees at their respective work units, during which fairly spurious charges were laid against

them. Several members were temporarily relieved of their teaching duties, and all had to write reports explaining their misguided thinking.[214]

At the end of 1983, the Artists' Association called a working meeting in Suzhou, to discuss the problem of "spiritual pollution" in the art world. Though its participants remained generally vague over naming specific individuals, they made it clear that the main targets of attack were those theories and works that reflected a "bourgeois artistic standpoint" and the "bourgeois" ideas of humanism, freedom and individualism.[215] An editorial in *Fine Art* re-iterated the point:

> *Some comrades have a mistaken understanding of creative freedom, and they have confused it with bourgeois liberalization. In their art, they advocate abstract "humanity", "the value of human existence", "self-expression" and "pure art" that transcends class and politics. In their creative work, they blindly model themselves on western modernist schools. Over the past few years, there has appeared in our art a minority of works which are ideologically unhealthy, and which, in terms of form, are so strange that the masses cannot understand them, so that to a certain extent they have given rise to spiritual pollution.*[216]

The broader impact of the Spiritual Pollution campaign was perhaps most evident in the Sixth National Art Exhibition (October 1984), the biggest ever to be held in the People's Republic. During a meeting in Shenyang at the end of October to discuss the oil paintings in the exhibition, several problems were highlighted, the most serious being the influence of Communist concepts, such as "theme being the decisive factor" and "grand themes", an over-emphasis on the didactic function of art to the detriment of its aesthetic function, and the formal dimension of the paintings being overly bland and simple. The art theorist, Gao Minglu, pointed out that the traditional Chinese paintings in the exhibition were even less satisfactory, with much of the audience complaining that they revealed nothing new or fresh. Of the 207 traditional Chinese paintings that finally won awards, approximately 70 could be defined as "grand themes" or depictions of socialist construction, 60 were depictions of China's minorities or rural scenes and 60 were landscapes, flowers-and-birds and figures from antiquity.[217]

On 15 January 1985, long after the campaign had ended, another meeting was held at the Central Academy of Fine Art to review the exhibition in its entirety. Scathing comments emerged from the discussion

on the harmful influence the campaign had exerted on the preparatory process for the exhibition by inhibiting the creative experimentation of participating artists. As a result, most of the themes were said to be extremely limited in range, comprising predictable subject matter, such as:

> *women's volleyball, economic construction, rehabilitated old revolutionaries, changes in the lives of the peasants, young people hard at study, etc. Previously, [artists] painted "grasp revolution, promote production". Now they paint "construct the Four Modernizations". Previously, [artists] painted Red Guards wearing PLA uniforms, now they paint young people wearing bell-bottom trousers. In terms of creative methods and artistic concepts, there is almost no difference between this kind of art and that of the Cultural Revolution.... Over the past few years, we have become aware of the problem [of leftist influence] ... several relatively good works have emerged, such as [Chen Danqing's] series of paintings on the Tibetan people and other oil paintings from Sichuan.... But at this exhibition, we had a return to the old ways, which shows that you cannot take lightly the influence of leftist thinking in the art world.*[218]

If deemed politically necessary, the Communist leadership was clearly still prepared to use the political movement or campaign as a means to bring those involved in cultural activities into line, and it was still able to rely upon established organizational structures to achieve its intended aims. However, what was noticeably different about the Spiritual Pollution campaign when compared with earlier ideological movements (and this applies equally to other political campaigns throughout the 1980s, with the exception of the conservative backlash following the Tiananmen Incident in 1989) was the speed with which it fizzled out. Quickly broadened to encompass the economic, scientific and agricultural fields, as well as cultural activities, the campaign finally met with opposition from the reformist faction of the Party, most notably Premier Zhao Ziyang, and it was brought to an end after a mere twenty eight days. Though reverberations were still felt throughout the art world for some time once the campaign had been halted, as can be seen from the quality of the work that appeared in the subsequent Sixth National Art Exhibition, the campaign was not sufficiently prolonged and thorough to put any real brake in the long-term on artistic experimentation. In fact, by the end of 1984, the art world had recovered almost completely from this temporary setback and by 1985, there had evolved an art movement which, in terms of creative innovation

and confident maturity of style, surpassed anything previously witnessed in the People's Republic.

Of the three means of control that the Party had used since 1949 to keep artists politically and artistically in line, i.e. organizational structures, political campaigns and an ideological scheme, only the first two remained workable options by the 1980s, and even they had been considerably weakened. With regard to the third means, many artists simply refused to heed official pronouncements, now widely regarded as empty political rhetoric. The debased Communist orthodoxy which resulted from the excesses of the Cultural Revolution could no longer generate a viable ideological framework.

Notes

1. Xinhua News Agency (comp.), *Shinian gaige da shiji 1978–1987*.
2. CCCPC Cultural Research Group (ed.), *Shiyijie sanzhong quanhui yilai zhongyao wenxian xuandu (shang)*, pp. 116–124.
3. Quoted from J. L. Cohen, *The New Chinese Painting 1949–1986*, p. 23.
4. M. Lamb, *Directory of Officials and Organizations in China 1968–1983*.
5. "Zhongguo meishujia xiehui disanci huiyuan daibiao dahui xin xuanchu zhuxi, fu zhuxi, changwu lishi, lishi", *Fine Art*, 1979, No. 12, p. 6.
6. "Zhongguo meishujia xiehui zhangcheng", *Fine Art*, 1979, No. 12, p. 5.
7. Xia Jun, "Zhongguo meishujia xiehui disanci huiyuan daibiao dahui zai Jing zhaokai", *Fine Art*, 1979, No. 11, p. 10.
8. Ibid.
9. "Zhongguo meishujia xiehui zhangcheng", *Fine Art*, 1979, No. 12, p. 5.
10. Xia Jun, "Zhongguo meishujia xiehui disanci huiyuan daibiao dahui zai Jing zhaokai", *Fine Art*, 1979, No. 11, p. 11.
11. Ibid.
12. "Zongjie jingyan, fanrong chuangzuo — Zhongguo meishujia xiehui zhaokai changwu lishi kuoda huiyi", *Fine Art*, 1979, No. 12, p. 9.
13. H. Goldblatt (ed.), *Chinese Literature for the 1980s: The Fourth Congress of Writers and Artists*, p. 13.
14. Ibid.
15. Ibid., p. 9.
16. Ibid., pp. 13–14.
17. C. T. Li and J. C. Y. Watt (eds.), *The Chinese Scholar's Studio: Artistic Life in the Late Ming Period*.
18. Zhang Shaoxia and Li Xiaoshan, *Zhongguo xiandai huihuashi*, pp. 322–323.

Useful information on the unofficial groups is also provided by J. L. Cohen, *The New Chinese Painting: 1949–1986.*

19. Introduction in "Twelve Person Exhibition" catalogue, Shanghai, 1979.

20. Ibid.

21. Jiang Feng, *Jiang Feng meishu lunji*, pp. 126–127. These words, originally from an introduction to OPRA's "New Spring Exhibition", quickly spread through the Chinese art world and provided the impetus for the subsequent establishment of several unofficial art groups. See Chen Yingde, *Haiwai kan dalu yishu*, p. 325.

22. J. L. Cohen, *The New Chinese Painting: 1949–1986*, pp. 81–82.

23. Ibid., pp. 62, 66.

24. For details, see Li Shengping and Zhang Mingshu (eds.), *1976–1986 Shinian zhengzhi dashiji*, pp. 397–414.

25. "'Star' Amateur Art Exhibition", *China Reconstructs*, June 1980, p. 54.

26. Cohen, *The New Chinese Painting: 1949–1986*, p. 70.

27. Lu Peng and Yi Dan, *Zhongguo xiandai yishushi*, p. 20; Gao Minglu *et al.*, *Zhongguo dangdai meishushi: 1985–1986*, p. 26.

28. This exhibition visited Beijing and Shanghai between September and November 1981. Originally, several abstract expressionist works were rejected for exhibition by Chinese officials. The American co-organizers then insisted that, since abstract expressionism constituted an integral part of modern American art history, the exclusion of these works would render the entire exhibition pointless and it would, therefore, have to be cancelled. The impasse continued for some days until the Chinese authorities decided to drop their demand and the exhibition went ahead as planned. See Chen Yingde, *Haiwai kan dalu yishu*, p. 219.

29. China Edition Library (comp.), *Quanguo zongshumu 1986*, pp. 670–673 cites 93 titles of painting albums and collections of printed western art reproductions, as well as general books on western art and art theory; Beijing Library (ed.), *Zhongguo guojia shumu* for years between 1979 and 1986.

30. As an example, a series of articles in *Fine Arts in China*, 1985, No. 22, pp. 1, 4 discuss the work of the contemporary American artist Robert Rauschenburg.

31. Gao Minglu *et al.*, *Zhongguo dangdai meishushi: 1985–1986*, *p. 28*.

32. J. L. Cohen, *The New Chinese Painting: 1949–1986*, p. 53.

33. Ibid.

34. Ibid., p. 70.

35. Zhang Shaoxia and Li Xiaoshan, *Zhongguo xiandai huihuashi*, p. 324.

36. M. Sullivan, "Bliss Was It That Dawn to Be Alive", Hui Ching-shuen (ed.), *Xingxing shinian*, p. 6.

37. J. Blaine and A. Gipouloux, "'The Stars': A New Art Movement in China", G. Benton (ed.), *Wild Lilies and Poisonous Weeds*, p. 208.

38. "Visitors Comments on the Second 'Stars' Exhibition", Hui Ching–shuen (ed.), *Xingxing shinian*, p. 70.

39. Chen Yingde, *Haiwai kan dalu yishu*, p. 320.

40. Jiang Feng, *Jiang Feng meishu lunji*, p. 126. When Jiang Feng was head of the Central Academy of Fine Art during the early 1950s, he was apparently already an advocate of artists freely getting together to organize exhibitions and sell paintings in order to help solve their economic difficulties. See Chen Yingde, *Haiwai kan dalu yishu*, p. 320. At the time of the "New Spring Exhibition", Jiang had not as yet received full political rehabilitation. However, in May 1979, he was re-appointed as head of the Central Academy of Fine Art and by November, as Chairman of the Artists' Association.

41. One instance of this is the Oil Painting Research Association's rejection of a nude by Zhao Yixiong titled *Awakening of Tarim* — "because of the green streak on the woman's buttocks — an Expressionist gesture that was apparently thought to be offensive", see J. L. Cohen, *The New Chinese Painting: 1949–1986*, p. 56.

42. Ah Cheng, "Stars and Sparks and Flickers and Flutters", Hui Ching-shuen (ed.), *Xingxing shinian*, p. 18.

43. Hui Ching-shuen (ed.), *Xingxing shinian*, p. 5.

44. As an example compare "We Must Carry Out the Revolution to the End", *Fine Art*, 1976, No. 1, pp. 24–25 with "Chairman Hua and Ourselves Are Joined Heart to Heart", *Fine Art*, 1977, No. 1 (front cover). In 1977, a quarter of all the art works published in *Fine Art* were of Party leaders.

45. There exists at least one other version of this painting, executed in 1978 by Shen Beixin, Huang Naiyuan, Qin Tianjian and Liu Wenxi.

46. Interview with Shui Tianzhong, 1989, Beijing.

47. *Today* (Samizdat publication), 1979, No. 4, pp. i and ii; *Today*, 1979, No. 5, pp. i–ii.

48. Interview with Li Xianting, 1989, Beijing.

49. G. Barmé, "Critics Now Chip Away at China's Concrete Eyesores", *Far Eastern Economic Review*, 17 November 1988, p. 54.

50. China Literary and Art Federation (ed.), *Zhongguo wenxue yishu gongzuozhe disici daibiao dahui wenji*.

51. Ibid., p. 1.

52. Ibid., p. 3.

53. Ibid., p. 5.

54. Ibid., p. 36.

55. Ibid., p. 140.

56. China Literary and Art Federation (ed.), *Kaipi shehuizhuyi wenyi fanrongde xin shiqi*, p. 495.

57. Ibid., p. 497.

58. Ibid., p. 499.

59. Ibid.
60. Zhang Shaoxia and Li Xiaoshan, *Zhongguo xiandai huihuashi*, p. 316.
61. Interview with Luo Zhongli, 1989, Chongqing.
62. Shao Zenghu, "Lishide zeren — chuangzuo *Nongji zhuanjia zhisi* de ganxiang", *Fine Art*, 1980, No. 6, p. 11.
63. For examples of "Scar" Literature see Lu Xinhua, Liu Xinwu et al., *The Wounded: New Stories of the Cultural Revolution, 1977–78* (trans. by G. Barmé and B. Lee). For the Chinese text see Liu Xinwu et al., *Shanghen* (duanpian xiaoshuo he jüben).
64. Lin Zhihao, *Lu Xun zhuan*, p. 40.
65. Lu Xinhua, Liu Xinwu et al., *The Wounded: New Stories of the Cultural Revolution 1977–78* (trans. by G. Barmé and B. Lee), p. 14.
66. Ibid., p. 150.
67. Ibid., p. 152.
68. Ibid., p. 24.
69. The story was also made into a film, which was subsequently banned due to its controversial portrayal of Red Guard violence during the Cultural Revolution.
70. He Rong, "Jiang rensheng youjiazhide dongxi huimie gei ren kan — du lianhuanhua *Feng* he xiangdaode yixie wenti", *Fine Art*, 1979, No. 8, p. 13.
71. Ibid.
72. Li Qun, "Lun yishu jiagong", *Fine Art Research*, 1979, No. 4, p. 21.
73. Ibid.
74. Li Song, "Yougong youwei zhi shi, youzhi youxin zhi ren — fang *Lianhuanhua bao* bianjibu", *Fine Art*, 1981, No. 4, p. 19.
75. "Zhiyou zhongyu shishi caineng zhongyu zhenli", *Historical Research* (*Lishi yanjiu*), 1979, No. 7, p. 1.
76. He Rong, "Jiang rensheng youjiazhide dongxi huimie gei ren kan — du lianhuanhua *Feng* he xiangdaode yixie wenti", *Fine Art*, 1979, No. 8, p. 14.
77. Ibid.
78. For more information on the cartoons of the "Gang of Four", see for example, Shanghai Art Office, "Pujiang liang'an, manhua rechao", *Fine Art*, 1977, No. 1, p. 35; Bi Keguan, "Yilang geng bi yilang gao, manhua chuangzuode xin jieduan", *Fine Art*, 1985, No. 4, p. 18.
79. Chen Yiming, Liu Yulian and Li Bing, "Guanyu chuangzuo lianhuanhua *Feng* de yixie xiangfa", *Fine Art*, 1980, No. 1, p. 34.
80. Ibid., p. 35.
81. Li Qun, "Lun yishu jiagong", *Fine Art Research*, 1979, No. 4, p. 21.
82. "Women dui lianhuanhua *Feng* de yijian", *Fine Art*, 1979, No. 8, p. 33.
83. Chen Yiming, Liu Yulian and Li Bing, "Guanyu chuangzuo lianhuanhua *Feng* de yixie xiangfa", *Fine Art*, 1980, No. 1, p. 35.
84. Ibid.

85. Ibid.
86. Li Qun, "Lun yishu jiagong", *Fine Art Research*, 1979, No. 4, p. 22.
87. Ibid.
88. Li Song, "Yougong youwei zhi shi, youzhi youxin zhi ren — fang *Lianhuanhua bao* bianjibu", *Fine Art*, 1981, No. 4.
89. He Rong, "Jiang rensheng youjiazhide dongxi humie gei ren kan — du lianhuanhua *Feng* he xiangdaode yixie wenti", *Fine Art*, 1979, No. 8, p. 14.
90. "Qingzhu jianguo sanshizhounian meizhan huojiang zuopin tulu", *Fine Art*, 1980, No. 5, p. 3.
91. Deng Pingxiang, "Chuyu liangzhong wenhua tiaodangzhongde qingnian huajia", *Contemporary Currents of Thought on the Arts (Dangdai wenyi sichao)*, March 1986, p. 104.
92. Ibid.
93. Xiao Feng, "Wei xin shiqide xin renwu chuangzao xinde tuhua", *Fine Art*, 1979, No. 1, p. 4.
94. Ibid.
95. Gao Gang and He Kongde, "Yao yong lishi weiwuzhuyide taidu duidai geming lishihuade chuangzuo", *Fine Art*, 1979, No. 1, p. 11.
96. Gao Minglu, "Zhongguo dangdai meishu sichao", *Hsiung Shih Art Monthly (Xiongshi meishu)*, 1989, No. 216, p. 97.
97. Gao Minglu *et al.*, *Zhongguo dangdai meishushi*, p. 44.
98. Wang Lin *et al.* (comp.), "Realist and Naturalist — On Neo-Realism", essay in *New Realistic Painting*, p. 5.
99. Xia Hang, "Sichuan qingnian huajia tan chuangzuo", *Fine Art*, 1981, No. 1, p. 44.
100. Interview with Luo Zhongli, 1989, Chongqing.
101. Chen Yingde, *Haiwai kan dalu yishu*, p. 9.
102. Xi Lai, "Qingchunde xuanlü", *Fine Art*, 1981, No. 1, p. 5.
103. Xu Dixin, "Wei shixian weidade zhanlüe mubiao er nuli", *Red Flag*, 1982, No. 19, pp. 33–34.
104. A character from Liu Qing's "History of Creating Enterprises", on the collectivization of peasants after 1949.
105. Xi Lai, "Qingchunde xuanlü", *Fine Art*, 1981, No. 1, p. 5.
106. "Women buhui wei *Fuqin* gandao chiru", *Fine Art*, 1982, No. 1, p. 50.
107. Tao Yongbai, "Zan 'ying bangbangde' Sichuan xiaohuo", *On the History of Art (Meishu shilun)*, 1982, No. 1, p. 200.
108. "*Wode fuqin* de zuozhede laixin", *Fine Art*, 1981, No. 2, p. 4.
109. Xia Hang, "Sichuan qingnian huajia tan chuangzuo", *Fine Art*, 1981, No. 1, pp. 44–45.
110. Shao Yangde, "Chuangzuo xinshang pinglun — du *Fuqin* bing yu youguan pinglunzhe shangque", *Fine Art*, 1981, No. 9, p. 57.
111. Xia Hang, "Sichuan qingnian huajia tan chuangzuo", *Fine Art*, 1981, No. 1,

p. 45.

112. *Fine Art*, 1981, No. 1 for the Second Chinese Exhibition for Young Artists, 1980.

113. Shao Dazhen, "Ye tan *Fuqin* zhe fu huade pingjia", *Fine Art*, 1981, No. 11, p. 15.

114. Tao Yongbai, "Zan 'ying bangbangde' Sichuan xiaohuo", *On the History of Art*, 1982, No. 1, p. 199.

115. J. Chiari, *Art and Knowledge*, p. 76.

116. Ibid.

117. Zhang Shaoxia and Li Xiaoshan, *Zhongguo xiandai huihuashi*, pp. 328–329. He Duoling has commented, "I do indeed like this 'pained realist' very much and I try to model my work on his." See Chen Yingde, *Haiwai kan dalu yishu*, p. 40.

118. Lu Peng and Yi Dan, *Zhongguo xiandai yishushi*, p. 42.

119. Ibid., p. 41.

120. Chen Yingde, *Haiwai kan dalu yishu*, p. 41

121. Deng Pingxiang, "Chuyu liangzhong wenhua tiaodangzhongde qingnian huajia", *Contemporary Currents of Thought on the Arts*, March 1986, p. 103.

122. Ibid.

123. Chen Yingde, *Haiwai kan dalu yishu*, p. 16.

124. Chen Danqing, "Rang yishu shuohua", *Fine Art*, 1981, No. 1, p. 42.

125. Zhang Shaoxia and Li Xiaoshan, *Zhongguo xiandai huihuashi*, p. 333.

126. Xinhua News Agency (comp.), *Shinian gaige da shiji 1978–1987*.

127. D. C. Lau (trans.), *The Analects*, pp. 39–40.

128. A. Waley (trans.), *Analects of Confucius*, p. 69.

129. A. Waley (trans.), *Book of Songs*, p. 18.

130. B. Hook (ed.), *The Cambridge Encyclopaedia of China*, p. 318. Translated from the original *Analects* (Book XVII. 9), by I. McMorran.

131. D. C. Lau (trans.), *The Analects*, (Book XV. 11), p. 134.

132. Zhang Wei, "Chuantong wenhua zhiyuezhe Zhongguo dianying", *The Art of Film (Dianying yishu)*, 1987, No. 1, p. 14.

133. Ibid.

134. Deng Pingxiang, "Chuyu liangzhong wenhua tiaodangzhongde qingnian huajia", *Contemporary Currents of Thought on the Arts*, March 1986, p. 105.

135. Li Zehou, *Meide licheng*, p. 190.

136. Sullivan, *Art in the Twentieth Century*, pp. 52–53.

137. Ibid., pp. 51–52.

138. Sullivan, "Bliss Was It That Dawn To Be Alive", in Hui Ching-shuen (ed.), *Xingxing shinian*, p. 7.

139. J. Clark, "Problems of Modernity in Chinese Painting", *Oriental Art*, 1986, No. 3, Autumn, p. 280.

140. Ibid.

141. Hui Ching-shuen (ed.), *Xingxing shinian*, p. 57.

142. M. Sullivan, "Art and the Social Framework", *The Times Literary Supplement*, 24 June 1983, p. 654.

143. For more on the democracy movement see G. Benton (ed.), *Wild Lilies: Poisonous Weeds*.

144. Interview with Qu Leilei, 1986, London.

145. *Today*, No. 4 (i),(ii), 20 June 1979.

146. Interview with Qu Leilei, 1986, London.

147. Jiang Feng, *Jiang Feng meishu lunji*, pp. 126–127.

148. Interview with Wang Keping, 1989, Beijing.

149. Hui Ching-shuen (ed.), *Xingxing shinian*, p. 23.

150. Ibid.

151. Interview with Wang Keping, 1989, Beijing.

152. According to Yan Li (interview, 1985, Shanghai), not all the Stars were happy with this decision, particularly Huang Rui who feared the authorities might rescind their promise to allow the Stars' exhibition space. Wang Keping's view that they should proceed with the demonstration apparently won the day, and Huang finally agreed to participate in it.

153. Hui Ching-shuen (ed.), *Xingxing shinian*, p. 31.

154. Ibid.

155. Sullivan, "Bliss Was It That Dawn To Be Alive", in Hui Ching-shuen (ed.), *Xingxing shinian*, p. 6.

156. Li Xianting, "Guanyu 'Xingxing' meizhan", *Fine Art*, 1980, No. 3, p. 8.

157. Benton (ed.), *Wild Lilies: Poisonous Weeds*, p. 208.

158. Li Xianting, "Guanyu 'Xingxing' meizhan", *Fine Art*, 1980, No. 3, p. 9.

159. Interview with Yan Li, 1984, Beijing.

160. Gao Yan, "Bu shi duihua, shi tanxin — zhi Xingxing meizhan", *Fine Art*, 1980, No. 12, p. 35.

161. Ibid.

162. "Zhi Xingxing meizhan zuozhemende yi feng xin", *Fine Art*, 1981, No. 1, p. 41.

163. Quoted in Sullivan, "Bliss Was It That Dawn To Be Alive", in Hui Ching-shuen (ed.), *Xingxing shinian*, p. 6.

164. Wang Zhangling, *Bai Huade lu*, pp. 56–70.

165. Interviews with Yan Li, 1985, Shanghai; Hui Ching-shuen (ed.), *Xingxing shinian*, p. 34.

166. Hui Ching-shuen (ed.), *Xingxing shinian*, p. 10.

167. Quoted from Cohen, *The New Chinese Painting 1949–1986*, p. 62.

168. Interview with Yan Li, 1984, Beijing.

169. Personal attendance at the exhibition. This exhibition was financed and organized by Yan Li himself. By 1984 it was becoming increasingly common for artists to fund their own exhibitions, even those held at the prestigious

China Art Gallery, Beijing.

170. Mao Shi'an, "Xianshizhuyi he xiandaizhuyi — guanyu chuangzuo fangfa 'baihua qifang' de tantao", *Fine Art*, 1982, No. 1, p. 24.

171. Du Jian, "Jianchi 'Zai Yan'an wenyi zuotanhuishangde jianghua' de genben jingshen, cujin meishude fanrong fazhan", *Fine Art*, 1982, No. 5, p. 4.

172. *Reading (Dushu)*, 1980, No. 12, p. 138.

173. Wang Hongjian, "Qian tan yishude benzhi", *Fine Art*, 1981, No. 5, p. 10.

174. Lu Peng and Yi Dan, *Zhongguo xiandai yishushi*, p. 88.

175. Examples of Sartre's work translated in the 1980s include *Sate yanjiu*, Wang Keqian and Xia Jun, *Lun Sate*, Huang Songjie, *Sate qiren ji qi "renxue"*.

176. Cohen, *The New Chinese Painting 1949–1986*, p. 58.

177. Zhong Ming, "Cong hua Sate shuoqi — tan huihuazhongde ziwo biaoxian", *Fine Art*, 1981, No. 2, p. 7.

178. F. T. Kingston, *French Existentialism*, pp. 168–192; J. Chiari, *Twentieth Century French Thought*, pp. 94–116.

179. Ibid.

180. Cohen, *The New Chinese Painting 1949–1986*, p. 58.

181. Zhong Ming, "Cong hua Sate shuoqi — tan huihuazhongde ziwo biaoxian", *Fine Art*, 1981, No. 2, p. 8.

182. Ibid., p. 9.

183. Qi Ji, "Tan 'shehuizhuyi xianshizhuyi' zai meishu chuangzuozhongde yixie wenti", *Fine Art*, 1980, No. 7, p. 38.

184. Interest in the question of "self-expression" was apparently sparked off by a comment made by one of the Star artists, Qu Leilei, that "'self-expression' is expressing the joy and sadness one feels as a result of ones life experiences". See Gao Minglu, *Zhongguo dangdai meishushi*, p. 30.

185. Zhu Xuchu, "Meishude fei chun renshixing he zhiguanxing", *Fine Art*, 1982, No. 8, p. 15.

186. Wu Guanzhong, "Huihuade xingshi mei", *Fine Art*, 1979, No. 5, p. 34.

187. Zhu Xuchu, "Meishude fei chun renshixing he zhiguanxing", *Fine Art*, 1982, No. 8, p. 17.

188. Li Zhengtian, "Yishu xinlixue lungang", *Fine Art*, 1983, No. 1, p. 48.

189. Ibid., p. 47.

190. Cohen, *The New Chinese Painting 1949–1986*, p. 57; Li Xianting, "Xianshizhuyi bu shi weiyi zhengquede tujing", *Fine Art*, 1981, No. 2, p. 47.

191. Xia Hang, "Sichuan qingnian huajia tan chuangzuo", *Fine Art*, 1981, No. 1, p. 45.

192. J. L. Cohen, *Yunnan School — A Renaissance in Chinese Painting*, p. 21.

193. J. J. Spector, *The Aesthetics of Freud: A Study in Psychoanalysis and Art*, p. 95.

194. Zhang Qun and Meng Luding, "Xin shidaide qishi — *Zai xin shidai chuangzuo tan*", *Fine Art*, 1985, No. 7, pp. 47–48.

195. Lu Peng and Yi Dan, *Zhongguo xiandai yishushi*, p. 103.

196. Ibid., p. 102.
197. Wu Guanzhong, "Yinxiang zhuyi huihuade qianqian houhou", *Fine Art Research*, 1979, No. 4. p. 49.
198. Interview with Li Xianting, 1989, Beijing; see also Chen Yingde, *Haiwai kan dalu yishu*, p. 345.
199. Wu Guanzhong, "Huihuade xingshi mei", *Fine Art*, 1979, No. 5, p. 34.
200. Wu Guanzhong, "Guanyu chouxiang mei", *Fine Art*, 1980, No. 10, p. 37.
201. Ibid.
202. Ibid.
203. Zhang Shaoxia and Li Xiaoshan, *Zhongguo xiandai huihuashi*, p. 37.
204. Du Jian, "Xingxiangde jielü yu jielüde xingxiang — guanyu chouxiang mei wentide yixie yijian", *Fine Art*, 1983, No. 10, p. 16.
205. Ibid.
206. Zeng Jingchu, "'Ye tan chouxiang mei' zhe yi", *Fine Art*, 1983, No. 10, p. 21.
207. Ibid.
208. Ni Zhiyun, "Guanyu yuanshi shehui yishu xingshi fazhan jixiangde yijian", *Fine Art*, 1982, No. 3, p. 50.
209. Du Jian, "Xingxiangde jielü yu jielüde xingxiang — guanyu chouxiang mei wentide yixie yijian", *Fine Art*, 1983, No. 11, p. 10.
210. Yuan Ming, *Deng Xiaoping diguo*, pp. 128, 150.
211. Interview with Li Xianting, 1989, Beijing.
212. Interview with one of the Shanghai exhibitors, Li Shan, 1992, Shanghai.
213. Ibid.
214. Ibid.
215. "Qingchu jingshen wuran, gaohao diliujie quanguo meizhan", *Fine Art*, 1984, No. 1, p. 6.
216. *Fine Art* editorial, "Yingjie diliujie quanguo meizhan", *Fine Art*, 1984, No. 1.
217. Gao Minglu *et al.*, *Zhongguo dangdai meishushi*, pp. 56–57.
218. *Meishu sichao*, 1985, No. 1. p. 11.

Conclusion

I n this study, we have seen the extent to which artistic discourse has mirrored political and social discourse in modern China. The first three decades after 1949 were characterized generally by the suppression of individual subjectivity and the imposition of ideological uniformity, which diminished the crucial distance between politics and art. The years since the late 1970s, however, have witnessed the growing demand from artists for greater freedom of expression; they want to be allowed greater diversity in their creative work. In their search for modernity, many Chinese artists have focused on re-creating more clearly defined boundaries between politics and art by emphasizing the importance of "the self" or individual subjectivity in their work.

This has led to an explosion of new ideas and strong criticism of the established orthodoxy. New trends in art have developed concurrently with the blossoming of ideological and cultural debates. Artists have begun openly and seriously to re-examine, question and challenge the theoretical framework imposed upon them and their predecessors. Many of them stress, for example, that art should take the individual as the main focus of creation, but the particular individual with his or her own emotions, sense experience and physical and spiritual characteristics, rather than an individual who is a manifestation of the collective identity of a social group or the abstraction of an ideological concept in the form

of the "typical character" (*dianxing renwu*). This idea formed part of the general discussions in intellectual circles on humanism and alienation in the early 1980s.[1]

Artists now increasingly emphasize the aesthetic rather than the cognitive function of art, in reaction to the excessive use of art as political propaganda,[2] a phenomenon which constitutes an important attempt by Chinese artists to gain a measure of independence in their creative work. In the mid-1980s some artists even attempted to construct a metaphysical framework as the foundation of a "new wave in art" (*meishu xinchao*), comprising three main strands which took the individual self as the core of the new artistic values. The first strand advocated that art should capture some ultimate spirit beyond political reality and the mundane world; it should therefore be an expression of the ultimate meaning of human existence. The second, "Flow of Life" (*shengmingliu*) art, aimed to portray the emotive, intuitive, instinctive or subconscious dimension of the artist. This trend emphasized desire, stimulation and direct sense experience, and was influenced primarily by the ideas of Freud and Bergson.[3] The third was objective humanism, embodied in "performance art" (*xingwei yishu*) and "material art" (*shiwu yishu*). This trend stressed the interconnection between the individual and the objective world, reality and the self, and emphasized the, paradoxically, controlled yet incidental nature of artistic creation.[4]

These developments in art ran parallel with similar trends in other cultural fields, such as a new wave in film as represented by *Yellow Earth*, directed by Chan Kaige, the experimental creative writing of Bei Dao, Xu Xing and Liu Suola, and Gao Xingjian's dramas, *Bus Stop* and *Wild Man*. The "new wave in art" thus constituted an integral part of China's new cultural renaissance.[5]

However, the irony is that even though Chinese artists attempted to distance themselves from politics and create an autonomous realm for art, their efforts at experimentation in themselves carried political significance, because they helped to challenge and undermine the monopoly of the state in the cultural arena. The close relationship between art and politics, therefore, still existed, though in a much more subtle and complex form. As the authorities realized they could not maintain the old form of organizational and ideological control, so the conflict or tension between art and politics had to be mediated more through persuasion, rather than coercion.

The Tiananmen Incident and its aftermath has shown that the process of change will not be smooth.[6] However, although the situation appeared bleak immediately following the events of June 1989, it seems that the underlying trend towards liberalization is unstoppable, and there can be no going back on the achievements of recent years. Though the future is always uncertain, it would be extremely difficult for the old relationship between art and politics, as manifested during the first three decades after 1949, to be re-imposed effectively. Artists in China have struggled for too long to yield up their newly discovered "self".

Notes

1. Deng Pingxiang, "Yishu sikao jinru 'ren' de cengci", *Fine Art*, 1986, No. 12, pp. 41–43; M. Goldman, T. Cheek and C. L. Hamrin (eds.), *China's Intellectuals and the State: In Search of a New Relationship*, pp. 162–163, 166–71.

2. Zhu Xuchu, "Meishude fei chun renshixing he zhiguanxing", *Fine Art*, 1982, No. 8, pp. 15–17.

3. Liu Xilin, "Yipi shidaide nizi — qingnian meishu sichao yu shehui zhi jian", *Fine Art*, 1986, No. 6, pp. 10–13.

4. Wang Zhong, "Ping 'meishu xinchao'", *People's Daily*, 13 December 1990, p. 5.

5. Song Yaoliang (ed.), *Zhongguo yishiliu xiaoshuoxuan (1980–1987)*; Chen Jin, *Dangdai Zhongguode xiandaizhuyi*.

6. Following the Tiananmen Incident, there was strong criticism in the official media of the "new wave in art" as being in opposition to the Marxist theory of art. For details see Wang Zhong, "Ping 'meishu xinchao'", *People's Daily*, 13 December 1990, p. 5. For an excellent appraisal of the consequences for modern art of the June 1989 events, see J. Clark, "Official Reactions to Modern Art in China since the Beijing Massacre", *Pacific Affairs*, Vol. 65, No. 3, pp. 334–348.

Glossary

Terms given in the text in *pinyin*

ci	次	*renmin neibu*	人民內部
daticai	大題材	*shao, man, cha, fei*	少、慢、差、費
dianxing renwu	典型人物	*shenghuoliu*	生活流
duo, kuai, hao,	多、快、好、	*shengmingliu*	生命流
sheng	省	*shiwu yishu*	實物藝術
fanyinglun	反映論	*ticai jueding lun*	題材決定論
guohua	國畫	*tiyan shenghuo*	體驗生活
hong, guang, liang	紅、光、亮	*wenyi zaidao*	文以載道
huazhong you shi,	畫中有詩，	*xiaorenwu*	小人物
shizhong you hua	詩中有畫	*xiesheng*	寫生
kumingzhi	苦命痣	*xieyi*	寫意
Lu Xun Yishu	魯迅藝術	*xingshi zhuyi*	形式主義
Xueyuan	學院	*xingwei yishu*	行為藝術
meinü	美女	*xinhuapai*	新畫派
meishu xinchao	美術新潮	*yaomo guiguai*	妖魔鬼怪
nianhua	年畫	*yulun yilü*	輿論一律
niugui sheshen	牛鬼蛇神	*yuyong huajia*	御用畫家
qi yun	氣運	Zhongzitang	忠字堂
qingchun shidai	青春時代	*zhu*	主

| zhuguan zhandou jingshen | 主觀戰鬥精神 | ziwo biaoxian | 自我表現 |

Publications given in the text in *pinyin*

Dagong bao	《大公報》	*Qunzhong yishu*	《群眾藝術》
Dangdai wenyi sichao	《當代文藝思潮》	*Renmin meishu*	《人民美術》
		Renmin ribao	《人民日報》
Dazhong dianying	《大眾電影》	*Renmin wenxue*	《人民文學》
Dushu	《讀書》	*Renmin xiju*	《人民戲劇》
Guangming ribao	《光明日報》	*Wen Shi Zhe*	《文史哲》
Jiefang ribao	《解放日報》	*Wenyi bao*	《文藝報》
Jintian	《今天》	*Wenyi fukan*	《文藝副刊》
Lianhuanhua bao	《連環畫報》	*Wenyi yuebao*	《文藝月報》
Meishu	《美術》	*Wuxun huazhuan*	《武訓畫傳》
Meishu yanjiu	《美術研究》	*Xinxiqu*	《新戲曲》
Meishujia tongxun	《美術家通訊》	*Zhongguo meishu bao*	《中國美術報》

Selected list of artists' names given in the text in *pinyin*

Ai Weiwei	艾未未	Feng Zikai	豐子愷
Ai Xuan	艾軒	Fu Baoshi	傅抱石
Ai Zhongxin	艾中信	Gao Xiaohua	高小華
Cai Ruohong	蔡若虹	Ge Lu	葛路
Chen Banding	陳半丁	Gu Yuan	古元
Chen Danqing	陳丹青	Guan Liang	關良
Chen Dayu	陳大羽	Guan Shanyue	關山月
Chen Yansheng	陳延生	He Duoling	何多苓
Chen Yifei	陳逸飛	Hong Yiran	洪毅然
Chen Yiming	陳宜明	Hou Yimin	侯一民
Cheng Conglin	程叢林	Hu Yichuan	胡一川
Cheng Shifa	程十髮	Huang Binhong	黃賓虹
Cui Zifan	崔子範	Huang Rui	黃銳
Dong Xiwen	董希文	Huang Xinbo	黃新波
Feng Guodong	馮國東	Huang Yongyu	黃永玉

Huang Zhengyi	黃正誼	Qin Zhongwen	秦仲文
Huang Zhou	黃冑	Qu Leilei	曲磊磊
Jiang Feng	江豐	Shao Keping	邵克萍
Jiang Zhaohe	蔣兆和	Shao Yu	邵宇
Jin Shangyi	靳尚誼	Shi Lu	石魯
Lai Shaoqi	賴少其	Shi Meicheng	史美誠
Li Bing	李斌	Shi Tao	石濤
Li Fenglan	李鳳蘭	Situ Qiao	司徒喬
Li Hua	李樺	Song Wenzhi	宋文治
Li Keran	李可染	Tang Yun	唐雲
Li Kuchan	李苦禪	Wang Chaowen	王朝聞
Li Qun	力群	Wang Chuan	王川
Li Shan	李山	Wang Geyi	王個簃
Li Xiongcai	黎雄才	Wang Keping	王克平
Lin Fengmian	林風眠	Wang Qi	王琦
Lin Gang	林崗	Wang Shikuo	王式廓
Liu Chunhua	劉春華	Wo Zha	沃渣
Liu Haisu	劉海粟	Wu Changshuo	吳昌碩
Liu Kaiqu	劉開渠	Wu Guanzhong	吳冠中
Liu Yulian	劉宇廉	Wu Zuoren	吳作人
Liu Zhide	劉志德	Xiao Huixiang	肖惠祥
Luo Gongliu	羅工柳	Xing Shenghua	邢昇華
Luo Zhongli	羅中立	Xu Beihong	徐悲鴻
Ma Da	馬達	Ya Ming	亞明
Ma Desheng	馬德昇	Yan Han	彥涵
Ma Yali	馬亞利	Yan Li	嚴力
Meng Luding	孟祿丁	Ye Qianyu	葉淺予
Mi Gu	米谷	Yu Fei'an	于非闇
Mo Pu	莫樸	Yuan Yunsheng	袁運生
Ni Yide	倪貽德	Zhang Ding	張仃
Pan Tianshou	潘天壽	Zhang Leping	張樂平
Pang Xunqin	龐薰琹	Zhang Qun	張群
Peng Bin	彭彬	Zhang Wang	張望
Qi Baishi	齊白石	Zheng Yefu	鄭野夫
Qian Songyan	錢松	Zhong Ming	鍾鳴

Selected Bibliography

Books and articles

Academia Sinica. *Shinian laide xin Zhongguo wenxue* (New Chinese Literature of the Last Ten Years). Tokyo: Da'an, 1967.

Academia Sinica. *Shinian laide xin Zhongguo wenxue jishi* (Record of the Major Events in the New Chinese Literature of the Last Ten Years). Beijing: Zuojia chubanshe, 1960.

Ai Ke'en (ed.). *Yan'an wenyi yundong jisheng: 1937–1948* (Record of the Yan'an Arts Movement: 1937–1948). Beijing: Wenhua yishu chubanshe, 1987.

Ai Siqi. *Bianzheng weiwuzhuyi he lishi weiwuzhuyi* (Dialectical Materialism and Historical Materialism). Beijing: Renmin chubanshe, 1978.

Ai Zhongxin. "Chuangzuo gexing ji qita" (Individual Creation and Other Matters). *Fine Art*, 1961, No. 4.

Andrews, J. *Painters and Politics in the People's Republic of China, 1949–1979.* Berkeley: University of California Press, 1994.

Artist Magazine (comp.). *Zhongguo xiangtu yishu* (Chinese Native Art). Taibei: Yishujia chubanshe, 1982.

Artists' Association. "Jianyi ba Hu Feng cong wenyijie duiwuzhong qingxi chuqu" (We Recommend That Jiang Feng Is Purged from Literature and Art Circles). *Fine Art*, 1955, No. 6.

Artists' Association. "Zhongguo meishujia xiehui guanyu ying jie nongye hezuohua yundong gaochaode gongzuo buzhi qingkuang" (Report of the Chinese Artists' Association on the Work To Be Done and the Arrangements To Be Made to Greet the High Tide of Agricultural Collectivization). *Fine Art*, 1955, No. 11.

Artists' Association Nanjing Branch (comp.). *Meishu zhanxianshangde yike weixing — Jiangsu Pixian nongminhua wenji* (A Satellite on the Art Front — A Collection of Peasant Paintings from Pi County, Jiangsu Province). Shanghai: Shanghai renmin meishu chubanshe, 1958.

Asia Research Centre (comp. and ed.). *The Great Cultural Revolution in China.* Melbourne and Sydney: Paul Flesch and Co., 1968.

Auty, R. *An Introduction to Russian Art and Architecture.* Cambridge: Cambridge University Press, 1980.

Bai Chunxi. "Jue bu ying paichi richang suoshi" (We Certainly Should Not Exclude Mundane Matters). *Fine Art,* 1956, No. 11.

Barmé, G. "Using the Past to Save the Present: Dai Qing's Historiographical Dissent". *East Asian History,* Dec. 1991.

Barmé, G., and Lee, B. (trans.). *Fragrant Weeds — Chinese Stories Once Labelled As "Poisonous Weeds".* Edited by W. J. F. Jenner. Hong Kong: Joint Publishing Co., 1983.

Beijing Library (ed.). *Zhongguo guojia shumu* (National Bibliography of China). Beijing: Shumu wenxian chubanshe, 1987.

"Beijing meishu zhanlan jianshu" (A Brief Account of the Beijing Art Exhibition). *Fine Art,* 1956, No. 11, p. 12.

Beijing Traditional Chinese Painting Research Association. "Jianjue chedi fensui he suqing Hu Feng fangeming jituan" (We Must Resolutely and Thoroughly Smash and Eliminate Hu Feng's Counter-revolutionary Clique). *Fine Art,* 1955, No. 7.

Benton, G. (ed.). *Wild Lilies: Poisonous Weeds.* London: Pluto Press Ltd., 1982.

Bi Keguan. "Yilang geng bi yilang gao, manhua chuangzuode xin jieduan" (Each Wave Gets Higher, A New Stage in Cartoon Creativity). *Fine Art,* 1985, No. 4.

Binyon, L. *Painting in the Far East — An Introduction to the History of Pictorial Art in Asia, Especially China and Japan.* New York: Dover Publications Inc., 1959.

Bloodworth, D. *The Messiah and the Mandarins — Mao Tse-tung and the Ironies of Power.* New York: Atheneum, 1982.

Bo Songnian. "Shi hua hebi" (Poetry, Painting and the Brush). *Fine Art,* 1959, No. 2.

Bowlt, J. E. "The Virtues of Soviet Realism". *Art in America,* Vol. 60, Nov.–Dec. 1972.

Brumfitt, J. H. *The French Enlightenment.* London: Macmillan, 1972.

Bunt, C. *Russian Art from Scyths to Soviets.* London and New York: The Studio, 1946.

Burns, J. P. *Policy Conflicts in Post-Mao China.* Armonk: M. E. Sharpe Inc., 1986.

Bush, S. *The Chinese Literati on Painting: Su Shih (1037–1101) to Tung Ch'i ch'ang (1555–1636).* Cambridge: Harvard University Press, Harvard-Yenching Institute Studies 27, 1971.

Cahill, J. *Treasures of Asia: Chinese Painting*. New York: Rizzoli International Publications Inc., 1973.

Cai Danye. *Zhonggong wenyi pidou lunji* (Collected Essays on the Criticisms and Denunciations in the Field of Literature and Art in Communist China). Hong Kong: Zhongshan Co., 1972.

Cai Danye. *Zhonggong wenyi wenti lunji* (Collected Essays on the Problems in Literature and Art in Communist China). Taibei: Dalu guancha zazhi chubanshe, 1976.

Cai Ruohong. *Cai Ruohong meishu lunji* (Collected Essays of Cai Ruohong on Art). Chengdu: Sichuan meishu chubanshe, 1987.

Cai Ruohong. "Cong geren yu dangde guanxi lai kan Jiang Feng shifo fandang" (Looking at the Question of Whether or Not Jiang Feng is Anti-party from the Perspective of the Relationship between the Party and the Individual). *Fine Art*, 1957, No. 9.

Cai Ruohong. "Guanyu 'guohua' chuangzuode fazhan wenti" (The Problem of Developing Traditional Chinese Painting). *Fine Art*, 1955, No. 6.

Cai Ruohong. "Guanyu meishu jiaoxuezhong jiben xunlian kechengde gaijin wenti" (The Problem of Improving Basic Training Courses in Art). *Fine Art*, 1961, No. 5.

Cai Ruohong. "Guanyu xin nianhuade chuangzuo neirong" (The Creative Content of New New Year Pictures). *People's Art*, 1950, No. 2.

Cai Ruohong. "Lun 'zuo' you tongyuande Jiang Feng fandang wenyi sixiang" (On Jiang Feng's Anti-party Thinking on the Arts, Which Appears To Be "Left" but Is Really Right). *Fine Art*, 1957, No. 10.

Cai Ruohong. "Nianhua chuangzuo ying fayang minjian nianhuade youliang chuantong" (When Creating New Year Pictures, Artists Should Make Full Use of the Good Traditions of Popular New Year Pictures). *Fine Art*, 1954, No. 3.

Cai Ruohong. "Shandong nianhua you san hao" (Shandong New Year Pictures Have Three Good Aspects). *Fine Art*, 1965, No. 1.

Cai Ruohong. "Xiang gongnong qunzhong xuexi, cong sixiang yuejinzhong tigao chuangzuo shuiping" (Learn from the Workers and Peasants, and Raise Your Creative Level on the Basis of a Great Leap Forward in Thinking). *Fine Art*, 1958, No. 12.

Cai Ruohong. "Yinian lai de meishu chuangzuo he meixie gongzuo" (The Work Accomplished by the Artists' Association Over the Last Year, and the Artwork Produced). *Fine Art*, 1954, No. 2.

CCCPC Cultural Research Group (ed.). *Shiyijie sanzhong quanhui yilai zhongyao wenxian xuandu (shang)* (Selected Readings of Important Documents since the Third Plenum of the Eleventh Central Committee (Part 1)). Beijing: Renmin chubanshe, 1987.

Central Academy of Fine Art (comp.). *Zhongyang meishu xueyuan jianshi* (A Short

History of the Central Academy of Fine Art). Beijing: Zhongyang meiyuan, 1988.

Chang Wen-tsun. "Fu Pao-shih's Paintings". *Chinese Literature*, 1962, No. 7.

Chang, A. *Painting in the People's Republic of China: The Politics of Style*. Colorado: Westview Press, 1980.

Chao Hui. "An Art Programme Serving the Restoration of Capitalism". *Chinese Literature*, 1967, No. 4.

Chen Danqing. "Rang yishu shuohua" (Let Art Speak). *Fine Art*, 1981, No. 1.

Chen Fengzhi. "Xuexi he yunyong chuantong jifa zhi yilie" (An Example of the Study and Use of Traditional Techniques). *Fine Art*, 1957, No. 2.

Chen, J. "Picasso in Peking". *People's China*, 1 Jan. 1957.

Chen Jin. *Dangdai Zhongguode xiandaizhuyi* (Modernism in Contemporary China). Beijing: Zhongguo wenlian chuban gongsi, 1988.

Chen Liao. *Makesizhuyi wenyi sixiang shigao* (History of Marxist Thinking on Literature and Art). Chengdu: Sichuan wenyi chubanshe, 1986.

Chen Tiejian (ed.). *Qu Qiubai zhuan* (Biography of Qu Qiubai). Shanghai: Shanghai renmin chubanshe, 1986.

Chen Tiejian *et al.* (eds.). *Qu Qiubai yanjiu wenji* (Collected Research Essays on Qu Qiubai). Beijing: Zhonggong dangshi ziliao chubanshe, 1987.

Chen Yiming, Liu Yulian and Li Bing. "Guanyu chuangzuo lianhuanhua *Feng* de yixie xiangfa" (Some Thoughts on the Creation of the Picture-story Book *Maple*). *Fine Art*, 1980, No. 1.

Chen Yingde. *Haiwai kan dalu yishu* (Looking at the Art of Mainland China from Overseas). Taibei: Yishujia chubanshe, 1987.

Cheng Zhide. "Huaniaohua he meide jiejixing" (The Class Nature of Flower-and-bird Painting and Beauty). *Fine Art*, 1960, No. 6.

Cheng Zhiwei. "Duoduo chuangzuo geming xuanchuanhua" (Create Lots of Revolutionary Propaganda Posters). *Fine Art*, 1964, No. 2.

Chiang Ch'ing. *On the Revolution of Peking Opera*. Beijing: Foreign Languages Press, 1968.

Chiari, J. *Art and Knowledge*. London: Elek, 1977.

Chiari, J. *Twentieth Century French Thought*. London: Elek, 1975.

China Cultural History Publishing House editorial team (comp.). *Yishude zhaohuan — wenxue yishujiade zishu* (The Call of Art — Accounts by Writers and Artists). Beijing: Zhongguo wenshi chubanshe, 1986.

China Edition Library (comp.). *Quanguo zongshumu* (National Bibliography) 1986. Beijing: Zhonghua shuju, 1989.

China Literary and Art Federation (ed.). *Kaipi shehuizhuyi wenyi fanrongde xin shiqi* (Initiate a New Era of Blossoming in Socialist Literature and Art). Chengdu: Sichuan renmin chubanshe, 1980.

China Literary and Art Federation (ed.). *Zhongguo wenxue yishu gongzuozhe disici daibiao dahui wenji* (Collection of Essays on the Fourth Chinese Congress

of Literature and Art Workers). Chengdu: Sichuan renmin chubanshe, 1980.

China Reconstructs staff reporters. "Following Chairman Mao Means Victory". *China Reconstructs*, 1969, No. 8.

Chinese Literature editorial note. "Repudiation of the Black Line". *Chinese Literature*, 1967, No. 4.

Chinese Research Publishing Co. (comp.). *Zhishifenzi ping wannian Mao Zedong* (Intellectuals on Mao Zedong in His Later Years). Hong Kong: Zhongyan gongsi, 1989.

Chou Yang. "Mao Tse-tung's Teachings and Contemporary Art". *People's China*, 16 Sept. 1951.

Chou Yang. "The Path of Socialist Literature and Art in Our Country: Report Delivered to the Third Congress of Chinese Literary and Art Workers on 22 July, 1960". *Chinese Literature*, 1960, No. 10.

Chu Lan. "Jingju geming shinian" (Ten Years of Revolution in Peking Opera). *Red Flag*, 1974, No. 7.

Chu Lan. *Tan wenyi zuopinde shendu wenti (neibu ziliao)* (Discussion on the Question of Profundity in Works of Literature and Art (Restricted Circulation)). Nov. 1974.

Clark, J. "Official Reactions to Modern Art in China since the Beijing Massacre". *Pacific Affairs*, Vol. 65, No. 3.

Clark, J. "Problems of Modernity in Chinese Painting". *Oriental Art*, 1986, Autumn, No. 3.

Clark, J. "Realism in Revolutionary Chinese Painting". *The Journal of the Oriental Society of Australia*, Vols. 22 and 23, 1990–91.

Cohen, J. L. *The New Chinese Painting 1949–1986*. New York: Harry N. Abrams Inc. Publishers, 1987.

Cohen, J. L. *Yunnan School — A Renaissance in Chinese Painting*. Minneapolis, Minnesota: Fingerhut Group Publishers Inc., 1988.

Dai Qing. *Liang Shuming, Wang Shiwei he Chu Anping* (Liang Shuming, Wang Shiwei and Chu Anping). Nanjing: Jiangsu wenyi chubanshe, 1989.

Deng Pingxiang. "Chuyu liangzhong wenhua tiaodangzhongde qingnian huajia" (Young Artists Caught between Two Cultures). *Contemporary Currents of Thought on the Arts*, Mar. 1986.

Deng Pingxiang. "Yishu sikao jinru 'ren' de cengci" (Artistic Reflection Takes on a "Humanistic" Dimension). *Fine Art*, 1986, No. 12.

Ding Jingtang *et al.* (eds.). *Qu Qiubai yanjiu wenxuan* (Selected Research Essays on Qu Qiubai). Tianjin: Tianjin renmin chubanshe, 1984.

Ding Shouhe. *Qu Qiubai sixiang yanjiu* (Research on the Ideas of Qu Qiubai). Chengdu: Sichuan renmin chubanshe, 1985.

Ding Wang. *Wenhua Dageming pinglunji* (Collected Discussions on the Cultural Revolution). Hong Kong: Contemporary China Research Institute, 1967.

Ding Wang. *Zhonggong "Wenge" yundongzhongde zuzhi yu renshi wenti* (Organization and Personnel Issues in Communist China during the Cultural Revolution). Hong Kong: Contemporary China Research Institute, 1970.

Domes, J. *Peng Te-huai, The Man and the Image.* London: C. Hurst Co., 1985.

Dong Xiwen. "Youhuade secai wenti" (The Question of Colour in Oil Painting). *Fine Art,* 1962, No. 2.

Du Jian. "Jianchi 'Zai Yan'an wenyi zuotanhuishangde jianghua' de genben jingshen, cujin meishude fanrong fazhan" (Adhere to the Basic Spirit of Mao's Yan'an Talks, and Advance the Development and Blossoming of Art). *Fine Art,* 1982, No. 5.

Du Jian. "Xingxiangde jielü yu jielüde xingxiang — guanyu chouxiangmei wentide yixie yijian" (The Rhythm of Image and the Image of Rhythm — Some Opinions on the Question of Abstract Beauty). *Fine Art,* 1983, No. 10.

Esmein, J. *The Chinese Cultural Revolution.* Translated by W. J. F. Jenner. New York: Anchor Press/Doubleday, 1973.

Fan Yin. "Shi cuowude lishi haishi lishide cuowu?" (Is it Erroneous History or an Historical Error?). *Fine Art,* 1983, No. 7.

"Fazhan shehuizhuyide wenyi chuangzuo" (Develop Socialist Artwork). *People's Daily,* 16 December 1971, p. 1.

Fine Art editorial. "Cujin meishu da puji da fanrong" (Advance the Large-scale Popularization and Flourishing of Art). *Fine Art,* 1958, No. 9.

Fine Art editorial. "Fangchu qianbaike gongchanzhuyide yishu weixing" (Launch Thousands of Socialist Art Satellites). *Fine Art,* 1958, No. 10.

Fine Art editorial. "Gonggu fanyou chengguo, zai shehuizhuyi sixiang, yishushang dayuejin — zai jing meishujia zuotan 'wenyi zhanxianshangde yi chang da bianlun'" (Consolidate the Achievements of the Anti-Rightist Movement, and Make a Great Leap in Socialist Thinking and the Arts — Artists in Beijing Discuss "The Big Debate on the Literature and Arts Front"). *Fine Art,* 1958, No. 5.

Fine Art editorial. "Jiaqiang Mao Zedong wenyi sixiangde wuzhuang, jiji zhandou, fenyong qianjin" (Strengthen Our Armour in the Form of Mao Zedong's Thought on Literature and Art, Actively Engage in Battle, Advance Bravely). *Fine Art,* 1960, No. 3.

Fine Art editorial. "Yingjie diliujie quanguo meizhan" (Greet the Sixth National Art Exhibition). *Fine Art,* 1984, No. 1.

Fine Art editorial. "Yinian lai *Meishu* bianji gongzuode zhuyao quedian he cuowu" (The Main Failings and Mistakes in the Editorial Work of *Fine Art* Over the Last Year). *Fine Art,* 1954, No. 12.

Fine Art editorial. "Yinian zhi shi" (Matters Over the Last Year). *Fine Art,* 1957, No. 1.

Fine Art editorial. "Yu gongnong jiehe — geming meishujiade biyou zhi lu" (Unite With the Workers and Peasants — The Path That Revolutionary Artists Must Follow). *Fine Art,* 1958, No. 1.

Fine Art editorial. "Zhongguo meishujia dangqian zhongdade zhandou renwu" (Current Major Fighting Tasks for Chinese Artists). *Fine Art*, 1955, No. 1.

Fine Art journalist. "Beijing meishujia jihui piping wenhuabu ji meixie lingdao" (Beijing Artists Hold a Meeting to Criticize Leaders of the Ministry of Culture and the Artists' Association). *Fine Art*, 1957, No. 6.

Fine Art journalist. "Beijing meishujia zuotan jiyao" (Summary of the Informal Discussions Held by Beijing Artists). *Fine Art*, 1962, No. 4.

Fine Art journalist. "Beijing Zhongguohua huajiade yijian" (The Opinions of Beijing Traditional Chinese Painters). *Fine Art*, 1957, No. 6.

Fine Art journalist. "Changsuo yuyan hua 'zheng ming'" (Discuss Freely the "Hundred Flowers" Movement). *Fine Art*, 1956, No. 8.

Fine Art journalist. "Cujin xuanchuanhua chuangzuode geng da fazhan — shinian xuanchuanhua zhanlanhui zuotanhui" (Advance Even Further the Development of Propaganda Posters — Forum on Ten Years of Propaganda Poster Exhibitions). *Fine Art*, 1960, No. 2.

Fine Art journalist. "Daming dafang, dazheng dagai" (Speak Out Freely, Air Views Fully, Have Big Adjustments and Big Changes). *Fine Art*, 1957, No. 12.

Fine Art journalist. "Fanrong meishu shiye, wei shixian sihua er fendou" (Bring About a Flourishing Art Scene, Struggle to Achieve the Four Modernizations). *Fine Art*, 1979, No. 12.

Fine Art journalist. "Gedi meishu gongzuozhe bianhui 'sanshi' peihe shehuizhuyi jiaoyu yundong" (Art Workers All Over the Country are Compiling and Painting the "Three Histories" in Line with the Socialist Education Movement). *Fine Art*, 1963, No. 5.

Fine Art journalist. "Guanyu shanshui huaniaohua wentide taolun" (Discussion on the Problem of Chinese Landscape and Flower-and-bird Painting). *Fine Art*, 1961, No. 2.

Fine Art journalist. "Guanyu youhua jiaoxue, jifa he fengge deng wenti — quanguo youhua jiaoxue huiyide ruogan wenti taolun jiyao" (Problems Regarding Oil Painting and Teaching Methods, Technique, Style, etc. — Summary of Several Questions Discussed at the National Conference on the Teaching of Oil Painting). *Fine Art*, 1956, No. 12.

Fine Art journalist. "Jiang Feng shi meishujiede zonghuo toumu" (Jiang Feng is the Head Arsenist of the Art World). *Fine Art*, 1957, No. 8.

Fine Art journalist. "Meishu chuangzuo quanmian dayuejin dafengshou" (A Great Leap Forward and Great Achievements in All Aspects of Art Creativity). *Fine Art*, 1959, No. 1.

Fine Art journalist. "Meishu jiaoyu lai yige dayuejin" (Art Education Has a Great Leap Forward). *Fine Art*, 1958, No. 3.

Fine Art journalist. "Meishujie dayuejin" (A Great Leap Forward in the Art World). *Fine Art*, 1958, No. 3.

Fine Art journalist. "Quanguo gedi meishu gongzuozhe jixu canjia suqing Hu Feng

fangeming jituande douzheng" (Art Workers All Over China Continue to Participate in the Struggle to Eliminate Hu Feng's Counter-revolutionary Clique). *Fine Art*, 1955, No. 7.

Fine Art journalist. "Qunzhong xihuan shenmeyangde nianhua" (The Kind of New Year Pictures Appreciated by the Masses). *Fine Art*, 1958, No. 4.

Fine Art journalist. "Shengchan dayuejin, wenhua yishu jinjingen — ji quanguo nongcun qunzhong wenhua yishu gongzuo huiyi" (A Great Leap Forward in Production, Culture Follows Closely Behind — A Record of the National Working Conference on Rural Culture). *Fine Art*, 1958, No. 5.

Fine Art journalist. "Shenru shenghuo, jiaqiang fanying shehuizhuyi shidai" (Submerge Yourself in Real Life, Strengthen Your Portrayal of the Socialist Era). *Fine Art*, 1964, No. 1.

Fine Art journalist. "Shoudu meishujia jihui zuotan, jielu 'ming' he 'fang' de zhang'ai" (Artists in the Capital Meet for Informal Discussions to Expose the Obstacles to "Expressing Views" and "Airing Views Fully"). *Fine Art*, 1957, No. 5.

Fine Art journalist. "Tianjin meishujia ganjin da, liangtiao dajie jin shi hua" (Tianjin Artists Have Great Enthusiasm and Energy for Their Work — The Two Main Streets are Full of Paintings). *Fine Art*, 1958, No. 7.

Fine Art journalist. "Tuchu zhengzhi, yi Mao Zedong sixiang zhidao gongzuo" (Give Prominence to Politics, Use Mao Zedong Thought to Guide your Work). *Fine Art*, 1966, No. 2.

Fine Art journalist. "Wei zhengqu meishu chuangzuode geng da chengjiu er nuli — lai jing canguan di'erjie quanguo meizhande meishu gongzuozhe dui zhanchu zuopinde yijian" (Work Hard to Attain Even Greater Achievements in Art Creativity — Art Workers Who Have Come to Beijing to See the Second National Art Exhibition Give Their Opinions on the Exhibits). *Fine Art*, 1955, No. 5.

Fine Art journalist. "Wenhua yuejin da touchende nongcun yeyu meishu dajun" (The Amateur Peasant Art Force is in the Vanguard of the Cultural Great Leap). *Fine Art*, 1958, No. 6.

Fine Art journalist. "Xiang dang jiaoxin, shaojin zichanjieji sixiang" (Give Your Heart to the Party, Destroy Your Bourgeois Thoughts). *Fine Art*, 1958, No. 5.

Fine Art journalist. "Yuejin da xianli" (Great Contributions to the Great Leap Forward). *Fine Art*, 1958, No. 8.

Fine Art journalist. "Zai meishujie fanyoupai zhanxianshang" (At the Anti-Rightist Battlefront of the Art World). *Fine Art*, 1957, No. 10.

Fokkema, D. W. *Literary Doctrine in China and Soviet Influence 1956–1960*. The Hague: Mouton Co., 1965.

Fokkema, D. W. *Report from Peking: Observations of a Western Diplomat on the Cultural Revolution*. London: C. Hurst, 1971.

Foreign Languages Press. *Rent Collection Courtyard — Sculptures of Oppression and Revolt*. Beijing: Foreign Languages Press, 1968.

Fu Baoshi. *Zhongguode renwuhua he shanshuihua* (Chinese Portraiture and Landscape Painting). Hong Kong: Zhonghua shuju Xianggang fenju, 1973.

Gao Gang and He Kongde. "Yao yong lishi weiwuzhuyide taidu duidai geming lishihuade chuangzuo" (You Must Adopt an Historical Materialist Approach When Creating Revolutionary History Paintings). *Fine Art*, 1979, No. 1.

Gao Minglu. "Zhongguo dangdai meishu sichao" (Trends in Thinking in Contemporary Chinese Art). *Hsiung Shih Art Monthly*, Feb. 1989, No. 216.

Gao Minglu *et al*. *Zhongguo dangdai meishushi: 1985–1986* (The History of Contemporary Art in China: 1985–1986). Shanghai: Shanghai renmin chubanshe, 1991.

Gao Yan. "Bu shi duihua, shi tanxin — zhi Xingxing meizhan" (It's Not a Conversation, It's a Heart-to-Heart Talk — To the Stars Art Exhibition). *Fine Art*, 1980, No. 12.

Ge Lu. "Nianhuade minjian secai" (The Popular Flavour of New Year Pictures). *Fine Art*, 1959, No. 3.

Ge Lu. "Tan shijieguan yu chuangzuode guanxide jige wenti" (Discussion of Several Questions Relating to the Relationship between World Outlook and Creativity). *Fine Art*, 1958, No. 1.

Ge Lu. "Wo dui geming xianshizhuyi he geming langmanzhuyi jiehede lijie" (My Understanding of the Synthesis of Revolutionary Realism and Revolutionary Romanticism). *Fine Art*, 1959, No. 2.

"Gedi meishujia xiafang canjia laodong duanlian" (Artists from All Over China Transfer to the Countryside to Participate in Labour). *Fine Art*, 1958, No. 2, p. 46.

Goldblatt, H. (ed.). *Chinese Literature for the 1980s: The Fourth Congress of Writers and Artists*. Armonk: M. E. Sharpe Inc., 1982.

Goldman, M. *China's Intellectuals: Advise and Dissent*. Cambridge, Mass.: Harvard University Press, 1981.

Goldman, M. *Literary Dissent in Communist China*. Cambridge, Mass.: Harvard University Press, 1967.

Goldman, M., Cheek, T., and Hamrin, C. L. (eds.). *China's Intellectuals and the State: In Search of a New Relationship*. Cambridge, Mass.: Harvard University Press, 1987.

Goodman, D. S. G. *Beijing Street Voices*. London: Marion Boyars Publishers, 1981.

Gu Yuan (ed.). *Yan'an wenyi congshu (meishujuan)* (Yan'an Arts Series (Fine Art Volume)) (Changsha: Hunan renmin chubanshe, 1987).

Gu Yuan. "Dao 'Da Lu Yi' qu xuexi" (Go to the "Big Lu Xun Academy of Literature and Art" to Study). *Fine Art*, 1962, No. 3.

Gu Yuan. "Hui dao nongcun qu" (Return to the Countryside). *Fine Art*, 1958, No. 1.

Guo Licheng. *Zhongguo minsu shihua* (A History of Chinese Folk Customs). Taiwan: Hanguang wenhua shiye gongsi, 1984.

Guo Moruo. *Li Bai yu Du Fu* (Li Bai and Du Fu). Beijing: Renmin wenxue chubanshe, 1971.

Guo Sheng. "Chongqingde 'hualan'" (The "Flower Basket" of Chongqing). *Fine Art*, 1958, No. 7.

Hai Xiao. "Wei meishu gongzuozhe huyu" (An Appeal on Behalf of Art Workers). *Fine Art*, 1956, No. 11.

Hamrin, C. L., and Cheek, T (eds.). *China's Establishment Intellectuals*. Armonk: M. E. Sharpe Inc., 1986.

Han Suyin. "Painters in China Today". *Eastern Horizons*, 1977, No. 6.

Haraszti, M. *The Velvet Prison: Artists under State Socialism*. New York: Basic Books Inc., 1987.

He Chengying. "Tan Zhongguohua, sumiao" (Discussion on Traditional Chinese Painting and Sketching). *Fine Art*, 1958, No. 4.

He Huoren (ed.). *Dangqian wenxue zhutixing wenti lunzheng* (Debate on Current Questions Regarding Subjectivity in Literature). Fuzhou: Haixia wenyi chubanshe, 1986.

He Jinzhi. "Mantan shide geming langmanzhuyi" (An Informal Talk on the Revolutionary Romanticism in Poetry). *Literary and Art Gazette*, 1958, No. 9.

He Rong. "Jiang rensheng youjiazhide dongxi huimie gei ren kan — du lianhuan-hua *Feng* he xiangdaode yixie wenti" (Letting Everyone See the Destruction of the Most Important Things in Life — A Few Issues That Spring to Mind after Reading the Picture-story Book *Maple*). *Fine Art*, 1959, No. 7.

He Rong. "Mudan hao; dingxiang ye hao" (Peonies Are Good, Lilacs Are Also Good). *Fine Art*, 1959, No. 7.

He Rong. "Shanshui huaniao yu baihua qifang" (Landscape and Flower-and-bird Painting and Letting A Hundred Flowers Bloom). *Fine Art*, 1959, No. 2.

He Tianjian. "Zhongguo shanshuihuade meixue wenti" (The Aesthetic Problems of Chinese Landscape Painting). *Fine Art*, 1962, No. 1.

Holm, D. "Art and Ideology in Yan'an". PhD thesis, Oxford University, 1979.

Hong Yiran. "Guanyu guohua chuangzuozhongde liangge wenti" (Two Questions Relating to the Creation of Traditional Chinese Paintings). *Fine Art*, 1955, No. 3.

Hong Yiran. "Tan guohuade gaizao yu guohuajia" (Discussion on Traditional Chinese Painters and the Reform of Traditional Chinese Painting). *People's Art*, 1950, No. 1.

Hook, B. (ed.). *The Cambridge Encyclopaedia of China*. Cambridge: Cambridge University Press, 1982.

Hou Yimin. "*Liu Shaoqi tongzhi he Anyuan kuanggong de gousi*" (How the Painting *Comrade Liu Shaoqi and the Anyuan Miners* Was Conceived). *Fine Art*, 1961, No. 4.

Hou Yimin. "Youhuajia jian bihuajia" (Oil Painters and Mural Painters). *Fine Art*, 1983, No. 3.

Hsia, A. *The Chinese Cultural Revolution*. Translated by G. Onn. New York: McGraw-Hill, 1972.

Hu Dongfang. "Xifang xiandai huihuade zhexueguan" (The Philosophical Standpoint of Modern Western Painting). *Fine Art*, 1985, No. 9.

Hu Qiao. "Xiaomie wo sixiangshangde diren" (Destroy the Enemies in My Thoughts). *Literary and Art Gazette*, Jan. 1952, No. 54.

Hu Qiaomu. "Wenyi gongzuozhe weishenme yao gaizao sixiang?" (Why Do Art Workers Need to Reform Their Thinking?). *Literary and Art Gazette*, Dec. 1951, Vol. V, No. 52.

Hua Chun-wu [Hua Junwu]. "Some Thoughts on Cartooning". *Chinese Literature*, 1963, No. 10.

Hua Da (ed.). *Zhongguo minban kanwu huibian* (Collection of Chinese Underground Publications). Vol. II. Paris: Faguo she ke gaodeng yanjiuyuan; Hong Kong: Xianggang guanchajia chubanshe, 1984.

Hua Hsia. "The Paintings of Shih Lu". *Chinese Literature*, 1962, No. 7.

Hua Junwu. *Hua Junwu manhua 1945–1979* (The Cartoons of Hua Junwu 1945–1979). Chengdu: Sichuan meishu chubanshe, 1986.

Hua Junwu. "Jiang Feng fandangde fabao zhiyi 'zongpai daji'" ("Factional Attack", One of Jiang Feng's Anti-Party Weapons). *Fine Art*, 1957, No. 9.

Hua Junwu. "Meishujia bixu jiji canjia he fanying jieji douzheng" (Artists Must Actively Participate in and Reflect Class Struggle). *Fine Art*, 1955, No. 8.

Hua Junwu. "Qingchu meishu gongzuozhongde fei wuchanjieji sixiang" (Eliminate from Art Work Thinking Which Is Not Proletarian). *Literary and Art Gazette*, Dec. 1951, No. 52.

Hua Junwu. "Qinian laide huiwu gongzuo" (The Work of the Artists' Association Over the Last Seven Years). *Fine Art*, 1960, No. 8/9.

Hua Junwu. "Yidian ganxiang" (A Thought). *Fine Arts in China*, 1986, No. 8.

Hua Junwu. "Yongyuan shi yige gaizao he xuexide guocheng" (It Will Always Be a Process of Reform and Study). *Fine Art*, 1962, No. 3.

Hua Xia. "Guanyu 'zhuyao' yu 'ciyao' — ping 'Mudan hao, dingxiang ye hao'" ("Main" themes and "Secondary" Themes — Comments on "Peonies Are Good, Lilacs Are Also Good"). *Fine Art*, 1960, No. 1.

Huang Lisheng. "Dui 'chouxiang' zai meishuzhongde zuoyongde yixie renshi" (My Understanding of the Function of "Abstractism" in Art). *Fine Art*, 1982, No. 3.

Huang Songjie. *Sate qiren ji qi "renxue"* (Sartre and His Humanistic Philosophy). Shanghai: Fudan University, 1986.

Huang Wanzhang. "Meishu zuopin yao fanying jieji douzheng" (Works of Art Must Reflect Class Struggle). *Fine Art*, 1964, No. 6.

Huang Xinbo. "Renzhen guanche 'Shuangbai' fangzhen, jianjue shixing yishu

minzhu" (Earnestly Implement the "Double Hundred" Policy, Resolutely Practice Democracy in the Arts). *Fine Art*, 1979, No. 12.

Huang Xuanzhi. "1957 nian quanguo xin manhua zhanlan qingkuang he qunzhong yijian" (The 1957 National New Cartoon Exhibition and the Opinions of the Masses). *Fine Art*, 1958, No. 6.

Huang Yongyu. "Shao Yu he 'maotouying shijian' — xiaodan Shao Yu, Fan Zeng" (Shao Yu and the "Owl Incident" — A Small Criticism of Shao Yu and Fan Zeng). *The Nineties*, 1990, No. 8.

Huang Yuanlin and Bi Keguan (comps.). *Zhongguo manhuashi* (A History of Chinese Cartoons). Beijing: Wenhua yishu chubanshe, 1986.

Hui Ching-shuen (ed.). *Xingxing shinian* (Ten Years of the Stars). Hong Kong: Hanart Gallery, 1989.

Hunan Teachers' College (ed.). *Zhongguo lidai zuojia xiaozhuan* (*shang*) (Short Historical Biographies of Chinese Writers, Part 1). Changsha: Hunan renmin chubanshe, 1979.

Hung Yu. "Hua Chun-wu Is An Old Hand at Drawing Black Anti-Party Cartoons". *Chinese Literature*, 1967, No. 4.

Ioffe, M. *Tan nongye ticaide xuanchuanhua* (Discussion on Propaganda Posters with Rural Themes). Translated by Li Jiabi. Beijing: Renmin meishu chubanshe, 1956.

Ivanov, W. *Tan zhengzhi xuanchuanhua* (Discussion on Political Propaganda Posters). Translated by Wu Lanhan. Chaohua meishu chubanshe, 1954.

Ji Lan. "Shenme teng jie shenme gua" (You Sow What You Reap). *Fine Art*, 1958, No. 10.

Ji Xing (ed.). *Zhongguo minsu chuanshuo gushi* (Chinese Folklore). Beijing: Zhongguo minjian wenyi chubanshe, 1985.

Jiang Feng. "Burang youpai sixiang zuan kongzi" (Don't Let Rightist Thinking Take Advantage of Loopholes). *Fine Art*, 1957, No. 7.

Jiang Feng. *Jiang Feng meishu lunji* (Collection of Essays by Jiang Feng on Art). Beijing: Renmin meishu chubanshe, 1984.

Jiang Feng. "Jianjue jinxing sixiang gaizao, chedi suqing meishu jiaoyuzhongde zichanjieji yingxiang" (Resolutely Carry Out Thought Reform, and Thoroughly Eliminate Bourgeois Influence in Art Education). *Literary and Art Gazette*, Jan. 1952, No. 55.

Jiang Feng. "Kefu ziyouzhuyi caineng tigao zhengzhi jingti" (Only By Overcoming Liberalism Can You Strengthen Your Political Guard). *Fine Art*, 1955, No. 7.

Jiang Feng. "Meishu gongzuode zhongyao fazhan" (Important Developments in Art Work). *Fine Art*, 1954, No. 3.

Jiang Feng. "Sinian lai meishu gongzuode zhuangkuang he quanguo meixie jinhoude renwu" (The Situation in Art Work over the Last Four Years, and the Future Tasks of the National Artists' Association). *Fine Art*, 1954, No. 1.

Jiang Feng. "Weile manzu shiji yaoqiu, meishu jiaoyu bixu tigao yibu" (In Order to

Satisfy Practical Demands, the Level of Art Education Must Be Raised). *Literary and Art Gazette*, 1952, No. 10.

Jiang Feng. "Yidali Wenyifuxingde meishu" (The Art of Renaissance Italy). *People's Art*, 1950, No. 1.

Jiang Feng. "Yinxiang zhuyi bu shi xianshi zhuyi" (Impressionism Isn't Realism). *Fine Art Research*, 1957, No. 2.

Jiang Hong, Zhang Huanmin and Wang Youru. *Zhongguo xiandai meixue lunzhu, yi zhu tiyao* (Summary of Chinese Works and Translations on Modern Aesthetics). Shanghai: Fudan University, 1987.

Jiang Qing. *Jiang Qing guanyu Wenhua Dagemingde yanjiangji* (Collection of Speeches by Jiang Qing on the Cultural Revolution). Macau: Ao'men Tian-shan chubanshe, 1971.

Jiang Zhaohe. "Jiang Feng dui Zhongguohua xuwuzhuyide guandian" (Jiang Feng's Nihilistic Viewpoint towards Traditional Chinese Painting). *Fine Art*, 1957, No. 9.

Jiang Zi and Yuan Xiyu. "Jiaqiang nianhuade sixiang jiaoyu zuoyong" (Strengthen the Didactic and Ideological Functions of New Year Pictures). *Fine Art*, 1963, No. 2.

Jiangsu Literature and Art Publishing House (comp.). *Zhuanlun Pixian nongminhua* (Special Review of the Peasant Paintings of Pi County). Vol. I. Nanjiang: Jiangsu wenyi chubanshe, 1958.

Jin Chunming. *Wenge shiqide guaishi guaiyu* (The Strange Deeds and Words during the Cultural Revolution). Beijing: Qiushi chubanshe, 1989.

Jin Weinuo. "Huaniaohuade jiejixing" (The Class Nature of Flower-and-bird Painting). *Fine Art*, 1961, No. 3.

Jin Weinuo. "Xianxiang yu benzhi, xianshi yu xiangxiang" (Phenomenon and Essence, Reality and Phantasy). *Fine Art*, 1959, No. 2.

Jin Ye. "Tan chuangzuo jiaoxuezhongde jige wenti" (Discussion of Several Issues Relating to the Teaching of Art). *Fine Art*, 1954, No. 10.

Jin Ye. "Tan muqian meishu chuangzuozhong cunzaide wenti" (Discussion on the Problems Presently Existing in Artistic Creation). *Fine Art*, 1956, No. 11.

Kamenev, B. *Tigao zhengzhi xuanchuanhuade sixiang yishu shuiping* (Raise the Artistic and Ideological Levels of Political Propaganda Posters). Translated by Si He *et al.* Zhongyang wenjiao weiyuanhui chuban, 1952.

Kao, M. (ed.). *20th Century Chinese Painting*. Hong Kong: Oxford University Press, 1988.

Kingston, F. T. *French Existentialism*. Toronto: University of Toronto Press, 1961.

Kinkley, J. C. (ed.). *After Mao: Chinese Literature and Society 1978–1981*. Cambridge, Mass.: Harvard University Press, 1985.

Kong Lin. "'Sanjiehe' shi zuzhi chuangzuode hao banfa" ("The Three Combinations" is a Good Method of Organizing Artistic Creation). *Fine Art*, 1965, No. 2.

Ladany, L. *The Communist Party of China and Marxism 1921–1985*. London: Hurst, 1988.

Laing, E. J. *The Winking Owl — Art in the People's Republic of China*. Berkeley: University of California Press, 1988.

Lamb, M. *Directory of Officials and Organisations in China 1968–1983* (Contemporary China Papers 17). Canberra: Contemporary China Centre, Australian National University, 1983.

Lao Guo. "Buyao ba shenghuo guli qilai" (Don't Isolate the Reality of Life from Everything Else). *Fine Art*, 1956, No. 2.

Lau, D. C. (trans.). *The Analects*. New York: Penguin Books, 1979.

Lei Meng. "Duchuang, yishu fazhande zhenghou" (Original Creativity, a Sign of Progress in the Arts). *Fine Art*, 1961, No. 1.

Li, C. T., and Watt, J. C. Y. (eds.). *The Chinese Scholar's Studio: Artistic Life in the Late Ming Period*. London: Thames and Hudson, 1987.

Li Cangchan (ed.). *Zhongguo jixiang tu'an* (Chinese Propitious Patterns). Taibei: Nantian shuju, 1988.

Li Hua. "Gaizao Zhongguohuade jiben wenti" (Reform the Basic Problems of Traditional Chinese Painting). *People's Art*, 1950, No. 1.

Li Hua. "Zenyang tigao nianhuade jiaoyu gongneng" (How to Improve the Didactic Function of New Year Pictures). *People's Art*, 1950, No. 2.

Li Jinwei. *Hong weibing shilu* (A Factual Record of the Red Guards). Hong Kong: The Hong Kong World Overseas Chinese Society, 1967.

Li Keran. "Jiang Feng weifan dang dui minzu chuantongde zhengce" (Jiang Feng Has Violated the Party's Policies on Our National Heritage). *Fine Art*, 1957, No. 9.

Li Keran. "Tan Zhongguohuade gaizao" (Discussion on the Reform of Traditional Chinese Painting). *People's Art*, 1950, No. 1.

Li Lang. *Dalu meishu pingji* (Collection of Reviews on Art in Mainland China). Taibei: Xiongshi tushu, 1989.

Li Lang. *Dalu ming huajia tan fang lu* (Record of Interviews with Famous Painters in Mainland China). Taibei: Yishujia chubanshe, 1992.

Li Ping and Lin Feng. "Yishude 'xin' yu 'jiu'" ("New" and "Old" in the Arts). *Fine Art*, 1963, No. 6.

Li Qianyan. *Chinese Propitious Patterns*. Taibei: Nantian shuju, 1988.

Li Qun. "Lun manhuade xingshi wenti" (On the Problem of Form in Cartoons). *Fine Art*, 1956, No. 3.

Li Qun. "Lun xin nianhuade chuangzuo wenti" (On the Creative Problems of New New Year Pictures). *People's Art*, 1950, No. 5.

Li Qun. "Lun yishu jiagong" (On the Creative Process of Art). *Fine Art Research*, 1979, No. 4.

Li Qun. "Ruhe kandai gongnongbing meishu chuangzuo" (What Approach to Adopt towards the Artwork of Workers, Peasants and Soldiers). *Fine Art*, 1958, No. 11.

Li Qun. "Tan jifu youxiude xin nianhua" (Discussion of Several Good New Year Pictures). *Fine Art*, 1954, No. 2.

Li Qun. "Xin bihuade chuxian shi yijian dashi" (The Appearance of New Murals is a Great Event). *Fine Art*, 1958, No. 8.

Li Rui. *Lushan huiyi shilu* (Factual Record of the Lushan Conference). Beijing: Chunqiu chubanshe, 1988.

Li Shaoyan. "Xiang diaosu gongzuozhe xuexi" (Learn from the Sculpting Workers). *Fine Art*, 1965, No. 6.

Li Shengping and Zhang Mingshu (eds.). *1976–1986 shinian zhengzhi dashiji* (Record of Important Political Events over the Last Ten Years). Beijing: Guangming ribao chubanshe, 1988.

Li Shulei. "Man lun 'yangbanxi' de wenhua hanyi" (Views on the Cultural Implications of the Model Operas). *Towards the Future*, Dec. 1988.

Li Song. "Yougong youwei zhi shi, youzhi youxin zhi ren — fang *Lianhuanhua bao* bianjibu" (A Successful Achievement, Conscientious People — A Visit to the Editorial Offices of *The Picture-story Book*). *Fine Art*, 1981, No. 4.

Li Weiming. "Ye tan youhua *Fuqin*" (Another Discussion on the Oil Painting, *Father*). *Fine Art*, 1982, No. 1.

Li Xianting. "Guanyu 'Xingxing' meizhan" (The "Stars" Art Exhibition). *Fine Art* , 1980, No. 3.

Li Xianting. "Xiandai mixinde chentong jiaoxun — tan lianhuanhua *Feng* dui dianxing huanjingde kehua" (A Bitter Lesson in Modern Superstition — A Discussion of the Picture-story Book *Maple* and Its Portrayal of the Typical Environment). *Fine Art*, 1979, No. 8.

Li Xianting. "Xianshizhuyi bushi weiyi zhengquede tujing" (Realism Isn't the Only Correct Way). *Fine Art*, 1981, No. 2.

Li Xiaoshan. "Zhongguohua yi daole qiongtu moride shihou" (Traditional Chinese Painting is Already at a Dead-end). *Fine Arts in China*, 1985, No. 14.

Li Zehou. *Meide licheng* (The Path of Beauty). Beijing: Renmin chubanshe, 1982.

Li Zhengtian. "Yishu xinlixue lungang" (An Outline of the Psychology of the Arts). *Fine Art*, 1983, No. 1.

Li Zongjin. "'Zai Yan'an wenyi zuotanhui shangde jianghua' yu 'baihua qifang'" ("Mao's Yan'an Talks" and the "Hundred Flowers"). *Fine Art*, 1957, No. 6.

Liao Jingwen. *Xu Beihong — Life of a Master Painter*. Beijing: Foreign Languages Press, 1987.

Liaoning University (ed.). *Wenyi sixiang zhanxian sanshinian* (Thirty Years of the Arts and Ideology Front). Liaoning: Liaoning University, 1975.

Lin Haoji. *Caisede shengming: Yishu dashi Qi Baishi zhuan* (A Colourful Life: A Biography of the Great Art Master, Qi Baishi). Beijing: Zhongguo qingnian chubanshe, 1987.

Lin Qun. *Zhongguo minjian zhushen* (The Gods and Goddesses of the Chinese Folk Tradition). Shijiazhuang: Hebei renmin chubanshe, 1986.

Lin Zhihao. *Lu Xun zhuan* (A Biography of Lu Xun). Beijing: Beijing chubanshe, 1981.

Link, P. (ed.). *Roses and Thorns: The Second Blooming of the Hundred Flowers in Chinese Fiction 1979–1980*. Berkeley: University of California Press, 1984.

Literary and Art Gazette Editorial. "Shanghai wenyijie ying jiuzheng sixiang hunluan xianxiang" (Shanghai Art Circles Should Correct Their Confused Thinking). *Literary and Art Gazette*, 1952, No. 3.

Liu Chun-hua. "Painting Pictures of Chairman Mao is Our Greatest Happiness". *China Reconstructs*, 1968, No. 11.

Liu Gangji. "Makesizhuyi meixue yu zichanjieji xingshizhuyi meixuede genben duili — ping Wang Qi dui Makesizhuyi meixuede kanfa" (The Fundamental Antagonisms between Marxist Aesthetics and Bourgeois Formalist Aesthetics — Comments on Wang Qi's Views of Marxist Aesthetics). *Fine Art*, 1964, No. 5.

Liu Jian'an. "Ji Zhongyang gongyi meishu xueyuan fanyoupai douzhengzhongde da bianlun" (A Record of the Big Debate on the Anti-Rightist Struggle at the Central Academy of Arts and Crafts). *Fine Art*, 1957, No. 12.

Liu Mingjiu (ed.). *Sate yanjiu* (Research on Sartre). Beijing: Zhongguo shehui kexue chubanshe, 1981.

Liu Shaoqi. *Liu Shaoqi xuanji* (The Selected Works of Liu Shaoqi). Beijing: Renmin chubanshe, 1985.

Liu Xianbiao. *Zhongguo xiandai wenxue shouce* (A Handbook of Modern Chinese Literature). Beijing: Zhongguo wenlian chubanshe, 1989.

Liu Xilin. "Yipi shidaide nizi — qingnian meishu sichao yu shehui zhi jian" (Non-Conformists of Their Time — Between the Artistic Currents of Thought of Young Artists and Society). *Fine Art*, 1986, No. 6.

Liu Xinwu et al. *Shanghen* (The Wounded). Hong Kong: Sanlian shudian, 1978.

Liu, B. *Cultural Policy in the People's Republic of China: Letting a Hundred Flowers Bloom*. Paris: Unesco, 1983.

Lu Di. *Zhongguo xiandai banhuashi* (A History of Modern Chinese Prints). Beijing: Renmin meishu chubanshe, 1987.

"Lu Dingyi, Zhou Yang zai zuoxie dangzu kuoda huiyishang zuo zhongyao jianghua" (Lu Dingyi and Zhou Yang Make Important Speeches at an Enlarged Meeting of the Leading Party Group of the Writers' Association). *Literary and Art Gazette*, 1957, No. 25, pp. 1–3.

Lu Peng and Yi Dan. *Zhongguo xiandai yishushi* (A History of Chinese Modern Arts). Changsha: Hunan meishu chubanshe, 1992.

Lu Ping. "Lüe tan shanshui huaniaohua" (A Brief Discussion on Landscape and Flower-and-bird Paintings). *Fine Art*, 1960, No. 4.

Lu Shengzhong (ed.). *Zhongguo minjian jianzhi* (Chinese Popular Paper-cuts). Changsha: Hunan meishu chubanshe, 1987.

Lu Xinhua, Liu Xinwu et al. *The Wounded: New Stories of the Cultural Revolution,*

1977–78. Translated by G. Barmé and B. Lee. Hong Kong: Joint Publishing Co.; London: Guangwa Co., 1979.

Lu Yuan. "Wo dui Hu Feng de cuowu sixiangde jidian renshi" (My Understanding of Hu Feng's Erroneous Thinking). *Literary and Art Gazette*, 1955, No. 4.

Luo Gongliu. "Guanyu youhuade jige wenti" (Several Problems Concerning Oil Painting). *Fine Art*, 1961, No. 1.

Luo Qirong and Ou Renxuan. *Zhongguo nianjie* (Chinese Festivals). Beijing: Kexue puji chubanshe, 1983.

Luo Zhongli. *"Wode fuqin* de zuozhe Luo Zhongli lai xin" (A Letter from the Creator of *My Father,* Luo Zhongli). *Fine Art*, 1981, No. 2.

Ma Keh. "The Weifang New-Year Pictures". *Chinese Literature*, 1960, No. 8.

MacFarquhar, R. *The Origins of the Cultural Revolution.* London: Oxford University Press, 1974.

Mao Jiaqi (ed.). *Taiwan sanshinian 1949–1979* (Taiwan: Thirty Years 1949–1979). Zhengzhou: Henan renmin chubanshe, 1988.

Mao Shi'an. "Xianshizhuyi he xiandaizhuyi — guanyu chuangzuo fangfa 'baihua qifang' de tantao" (Realism and Modernism — Exploring "Pluralism" in Creative Methods). *Fine Art*, 1982, No. 1.

Mao Tse-tung. *Unselected Works of Mao Tse-tung 1957.* Hong Kong: Union Research Institute, 1976.

Mao Zedong. *Mao Zedong lun wenhua yishu* (Mao Zedong on Culture and the Arts). Beijing: Wenhuabu zhengce yanjiushi, 1978.

Mao Zedong. *Mao Zedong lun wenxue he yishu* (Mao Zedong on Literature and Art). Beijing: Renmin chubanshe, 1965.

Mao Zedong. *Mao Zedong lun wenyi* (Mao Zedong on Literature and Art). Beijing: Renmin wenxue chubanshe, 1966.

Mao Zedong. *Mao Zedong sixiang wansui* (Long Live Mao Zedong Thought). Tokyo: Xiandai pinglunshe, 1974.

Mao Zedong. *Mao Zedong xuanji* (The Selected Works of Mao Zedong). Taibei: Taibei shudian, 1948.

Mao Zedong. *Mao Zedong xuanji* (The Selected Works of Mao Zedong). Vol. V. Bejing: Renmin chubanshe, 1977.

Mao Zedong. *Mao Zedong xuanji buyi* (Addendum to the Selected Works of Mao Zedong). Vol. III: 1949–1959. Hong Kong: Ming Pao Monthly, 1971.

Mao Zedong. *Mao Zedong ziliao xuanbian (neibu ziliao)* (Selected Materials on Mao Zedong (Restricted Circulation)). Collected by University of Leeds, 1966.

Martin, H. *Cult and Cannon: The Origins and Development of State Maoism.* Armonk: M. E. Sharpe Inc., 1982.

Marx, K. *Maliezhuyi meixue lilun* (Marxist Aesthetic Theories). Beijing: Sanlian shudian, 1986.

McDougall, B. *Mao Zedong's "Talks at the Yan'an Conference on Literature and Art": A Translation of the 1943 Text with Commentary* (Michigan Papers in Chinese

Studies No. 39). Ann Arbor: Centre for Chinese Studies, University of Michigan, 1980.

"Meishu chubande zhuliu wenti" (The Main Problems in Art Publishing). *Fine Art*, 1958, No. 5, p. 18.

Meisner, M. *Mao's China : A History of the People's Republic.* New York: Free Press, 1977.

"Meixie xiang fenhui he meishujia tichu changyi" (The Artists' Association Puts Forward Proposals to Its Branches and Artists in General). *Fine Art*, 1958, No. 4, p. 5.

Meng Luding and Zhang Qun. "Cong Yidianyuan zou chulai" (Coming Out of the Garden of Eden). *Fine Arts in China*, 1985, No. 2.

Mi Gu. "Zhangwo manhua yishu texing, chuangzuo chu duozhong fenggede manhua lai — canguan quanguo manhuazhan yougan" (Grasp the Particular Qualities of Cartoons as an Art Form, and Create Cartoons with a Variety of Styles — Thoughts after Seeing the National Exhibition of Cartoons). *Fine Art*, 1957, No. 2.

Mi Ku. "Lin Feng-mien's Paintings". *Chinese Literature*, 1963, No. 1.

Ming Hao. "Yinggai shedang zengjia youmo manhuade chuangzuo" (We Should Increase to an Appropriate Level the Number of Humorous Cartoons Produced). *Fine Art*, 1956, No. 3.

Ministry of Culture. *Quanguo zongshumu* (National Bibliography) (for late 1950s, early 1960s). Beijing: Zhonghua shuju.

Mo Pu. "Tan xuexi Zhongguo huihua chuantongde wenti" (Discussion on the Problem of Studying Chinese Painting Traditions). *Fine Art*, 1954, No. 7.

Mo Yidian. "Shenzhen dushuji" (Reading in Shenzhen). *Ming Pao Monthly*, Oct. 1977.

Mu Xun. "Wo dui nianhua tedian wentide yidian lijie" (My Understanding of the Problems Concerning the Characteristics of New Year Pictures). *Fine Art*, 1957, No. 5.

"Nanjingde gongren meizhan" (Nanjing Workers' Exhibition). *Fine Art*, 1958, No. 6, p. 20.

Ni Yi-teh. "Pan Tien-shou's Paintings". *Chinese Literature*, 1961, No. 10.

Ni Yide. "Chedi jielu Hu Feng ji qi fangeming jituande yinmou" (Thoroughly Expose the Plot of Hu Feng and his Counter-revolutionary Clique). *Fine Art*, 1955, No. 6.

Ni Zhiyun. "Guanyu yuanshi shehui yishu xingshi fazhan jixiangde yijian" (Views on the Development of Art Forms in Primitive Societies). *Fine Art*, 1982, No. 3.

"Nongcun zibande meishu xuexiao" (Art Schools Set Up by Rural People). *Fine Art*, 1958, No. 8, p. 26.

"Nongmin re'ai xin bihua" (The Peasants Love the New Murals). *Fine Art*, 1958, No. 8, p. 21.

Pan Yaochang. "Bijiao, xuanze, sisuo" (Comparing, Selecting, Pondering). *Fine Art*, 1986, No. 6.

Pang Xianzhi. "Mao Zhuxi he tade mishu Tian Jiaying" (Chairman Mao and His Secretary, Tian Jiaying). *New China Digest*, 1990, No. 3.

Peng De. "Shenmei zuoyong shi meishude weiyi gongneng" (The Aesthetic Effect is the Only Function of Art). *Fine Art*, 1982, No. 5.

People's Art editorial. "Wei biaoxian xin Zhongguo er nuli" (Strive to Portray the New China). *People's Art*, 1950, No. 1.

Pickowicz, P. G. *Marxist Literary Thought in China — Influence of Ch'ü Ch'iu-pai*. Berkeley: University of California Press, 1981.

"Pixiande qunzhong meishu huodong" (The Artistic Activities of the Masses in Pi County). *Fine Art*, 1958, No. 9, p. 3.

Primary Sources Editorial Team. *Zhonggong zenyang duidai zhishifenzi* (How the Chinese Communist Party Treats Intellectuals). Taibei: Liming wenhua chubanshe, 1983.

Publishing Administrative Bureau (comp.). *Quanguo zongshumu* (National Bibliography) (for early 1970s). Beijing: Zhonghua shuju, 1976.

Qi Ji. "Tan 'shehuizhuyi xianshizhuyi' zai meishu chuangzuozhongde yixie wenti" (Discussion on Some Problems of "Socialist Realism" in Art). *Fine Art*, 1980, No. 7.

Qi Yuan. "Zenyang yonghu baijia zhengming" (How to Support "Letting a Hundred Schools of Thought Contend"). *Fine Art*, 1956, No. 8.

Qian He. "Huihua benzhi yu ziwo biaoxian" (The Essence of Painting and Self-expression), *Fine Art*, 1981, No. 6.

Qin Lingyun. *Minjian huagong shiliao* (Historical Materials on Popular Artisans). Beijing: Zhongguo gudian yishu chubanshe, 1958.

Qin Zhaoyang. "Lun Hu Feng de 'yige jiben wenti'" (On Hu Feng's "A Fundamental Problem"). *Literary and Art Gazette*, 1955, No. 4.

"Qingzhu jianguo sanshizhounian meizhan huojiang zuopin tulu" (Pictures of the Winning Exhibits from the Exhibition to Celebrate the Thirtieth Anniversary of the Founding of the People's Republic). *Fine Art*, 1980, No. 5, p. 3.

"Qingchu jingshen wuran, gaohao diliujie quanguo meizhan" (Eliminate Spiritual Pollution, Make a Success of the Sixth National Art Exhibition). *Fine Art*, 1984, No. 1, p. 6.

Qiu Wen. "Ye tan shanshui huaniaohua" (Another Discussion on Landscape and Flower-and-bird Painting). *Fine Art*, 1960, No. 5.

Red Guard publication. *Meishu zhanxianshang liangtiao luxian douzheng dashiji* (A Record of Big Events in the Two-line Struggle on the Art Front). Beijing: Hongweibing chubanwu, 1967.

Red Guard publication. *Revolution in the Arts*. Beijing: Hongweibing chubanwu, 1967.

Red Guard publication. *The Proletarian*. Beijing: Hongweibing chubanwu, 1967.

Rice, T. T. A Concise History of Russian Art. London: Thames and Hudson, 1963.

Ritter, C. The Essence of Plato's Philosophy. Trans. by A. Alles. London: Allen and Unwin, 1933.

Shaanxi Masses Arts Centre. "Pubian fadong, zhongdian fudao" (General Mass Mobilization, Emphasis on Selective Training). Fine Art, 1959, No. 1.

Shaanxi People's Publishing House (ed.). Huxian nongminhua xuanji (Selection of Hu County Peasant Paintings). Xi'an: Shaanxi renmin chubanshe, 1974.

Shaanxi Worker-Peasant-Soldier Art Centre (ed.). Huxian nongminhua lunwenji (Collection of Essays on Hu County Peasant Paintings). Beijing: Renmin meishu chubanshe, 1975.

Shanghai Art Office. "Pujiang liang'an, manhua rechao" (On Both Sides of the Pu river is a High Tide in Cartoons). Fine Art, 1997, No. 1.

"Shanghai meishujie che qi shangshan xiaxiang rechao" (The Shanghai Art World Initiates a High Tide of "Going Down to the Countryside"). Fine Art, 1957, No. 12, p. 10.

Shanghai People's Fine Art Publishing House (comp.). Shandong nianhua xuanji (Selected Shandong New Year Pictures). Shanghai: Shanghai renmin meishu chubanshe, 1965.

Shanghai People's Fine Art Publishing House (ed.). Shandong nianhua chuangzuo jingyantan (Discussion on the Experiences Gleaned from Creating the Shandong New Year Pictures). Shanghai: Shanghai renmin meishu chubanshe, 1965.

Shanghai People's Publishing House (ed.). Meishu pinglunji (Collection of Critical Essays on Art). Shanghai: Shanghai renmin chubanshe, 1975.

"Shanghai Zhongguo huayuan guohuajia xiachang xiaxiang" (Traditional Chinese Painters from the Shanghai Academy of Traditional Chinese Painting Go Into Factories and Down to the Countryside). Fine Art, 1958, No. 4, p. 30.

Shao Dazhen. Chuantong meishu yu xiandaipai (Traditional Art and the Modernists). Chengdu: Sichuan renmin chubanshe, 1983.

Shao Dazhen. "Xianshizhuyi jingshen yu xiandaipai yishu" (Modern Art Embodying the Spirit of Realism). Fine Art, 1980, No. 11.

Shao Dazhen. "Ye tan Fuqin zhe fu huade pingjia" (Another Discussion on the Appraisal of the Painting, Father). Fine Art, 1981, No. 11.

Shao Yangde. "Chuangzuo xinshang pinglun — du Fuqin bing yu youguan pinglunzhe shangque" (Creation, Appreciation, Discussion — A Discussion with the Relevant Debators, After Viewing Father). Fine Art, 1981, No. 9.

Shao Yangde. "Zai tan Fuqin zhe fu huade pingjia" (Another Discussion on the Appraisal of the Painting, Father). Fine Art, 1982, No. 4.

Shao Yu. "Cong xiaxiang shangshan xiangqi de" (Thoughts That Arise from the "Going Down to the Countryside" Movement). Fine Art, 1958, No. 1.

Shao Zenghu. "Lishide zeren — chuangzuo Nongji zhuanjia zhisi de ganxiang" (The Responsibility of History — Thoughts on the Creation of The Death of An Agricultural Machinery Specialist). Fine Art, 1980, No. 6.

Shen Taihui *et al.* (eds.). *Wenyi lunzhengji* (Collected Debates on Literature and Art). Zhengzhou: Huanghe wenyi chubanshe, 1985.

Shi Lu. "Gaoju Mao Zedong wenyi sixiangde qizhi pandeng wuchanjieji yishude gaofeng" (Hold High the Banner of Mao Zedong Thought on Literature and Art, and Scale the Heights of Proletarian Art). *Fine Art*, 1960, No. 4.

Shi Lu. "Nianhua chuangzuo jiantao" (Appraising New Year Picture Work). *People's Art*, 1950, No. 2.

Shi Qiang. "Shi Lu tan Zhongguohua wenti" (Shi Lu Discusses Problems Relating to Traditional Chinese Painting). *Fine Art*, 1980, No. 11.

"Shida huajia yishu chengjiude tantao" (Exploring the Artistic Achievements of Ten Great Artists). *Fine Art*, 1961, No. 3, pp. 4–6.

"*Shouzuyuan* nisu chuangzuode gousi sheji" (The Conception and Design of the Sculpture *The Rent Collection Courtyard*). *Fine Art*, 1965, No. 6, pp. 4–8.

Shu Liang. "Cong Yan'ande xin nianhua yundong tanqi" (Discussion Which Takes as Its Starting Point the New New Year Picture Movement in Yan'an). *Fine Art*, 1957, No. 3.

Siren, O. *Chinese Painting: Leading Masters and Principles*. Vol. I. New York: Hacker Art Books Inc., 1973.

Song Yaoliang (ed.). *Zhongguo yishiliu xiaoshuoxuan (1980–1987)* (Selection of Chinese Stream-of-Thought Short Stories (1980–1987)). Shanghai: Shanghai shekeyuan chubanshe, 1988.

Song Zongyuan *et al.* (eds.). *Yishu yaolan* (Cradle of the Arts). Hangzhou: Zhejiang meishu xueyuan chubanshe, 1988.

Spector, J. J. *The Aesthetics of Freud: A Study in Psychoanalysis and Art*. New York: Praeger, 1972.

State Council Cultural Group (comp.). "Jinian Mao Zhuxi 'Zai Yan'an wenyi zuotanhuishangde jianghua' fabiao sanshizhounian meishu zuopinxuan" (Selection of Published Art Works to Commemorate the Thirtieth Anniversary of Chairman Mao's "Yan'an Talks"). Beijing: Renmin meishu chubanshe, 1972.

State Council Cultural Group (comp.). *Shanghai, Yangquan, Lü Da gongrenhua zhanlan zuopin xuanji* (Selected Works from the Shanghai, Yangquan, Lü Da Workers Art Exhibition). Beijing: Renmin meishu chubanshe, 1974.

Sullivan, M. *Chinese Art in the Twentieth Century*. London: Faber, 1959.

Sullivan, M. *The Arts of China*. 3rd edition. Berkeley: University of California Press, 1984.

Sullivan, M. *The Meeting of Eastern and Western Art from 16th Century to the Present Day*. Berkeley: University of California Press, 1989.

Sun Wuxia. *Gongchan guoji he Zhongguo geming guanxi shigang* (A Brief History of the Relationship between the Comintern and the Chinese Communist Revolution). Zhengzhou: Henan renmin chubanshe, 1988.

"Suzao wuchanjieji yingxiang dianxing shi shehuizhuyi wenyide genben renwu"

(The Basic Task of Socialist Art is to Create Models That Exert a Proletarian Influence). *People's Daily*, 12 July 1974, p. 5.

Tan Zongji *et al.* (eds.). *Shinianhoude pingshuo — "Wenhua Dageming" shi lunji* (A Review Ten Years On — Collected Essays on the History of the "Cultural Revolution"). Beijing: Zhonggong dangshi ziliao chubanshe, 1987.

Tao Yongbai. "Zan 'ying bangbangde' Sichuan xiaohuo" (In Praise of Those "Honest and Resolute" Sichuan Fellows). *On the History of Art*, 1982, No. 1.

Tao Yongbai. "Zhongguo youhua erbaibashinian" (Two Hundred and Eighty Years of Chinese Oil Painting). *On the History of Art*, 1988, Nos. 2, 3.

Taylor, C. *Hegel*. Cambridge: Cambridge University Press, 1975.

Teiwes, F. C. "The Origins of Rectification: Inner-Party Purges and Education before Liberation". *China Quarterly*, 1976, No. 65.

Tertiary Education Research Group. *Dangdai wenyixue tansuo yu sikao* (The Experimentation in and the Ideas behind Contemporary Literature and Art). Beijing: Gaodeng jiaoyu chubanshe, 1987.

The Seventies journalist. "Zhongguo huatan chunyi nong — Han Suyin nüshi tan Zhongguo meishujie jinkuang" (A Strong Feeling of Spring in Chinese Painting Circles — Han Suyin Discusses the Recent Situation in the Chinese Art World). *The Seventies*, 1977, No. 4.

Tian Lihe. "Nongmin xinchun ping xinhua" (Peasants Comment on the New Paintings of the New Spring). *Fine Art*, 1964, No. 2.

"Tianjin guo mianchang hua changshi" (The Tianjin Textile Factory Produces Paintings on the Factory's History). *Fine Art*, 1958, No. 6, p. 35.

Tsui Tzu-fan. "Two Flower-and-Bird Painting Exhibitions." *Peking Review*, 11 Aug. 1961.

Valkenier, E. *Russian Realist Art. The State and Society: The Peredvizhniki and Their Tradition*. Michigan: Ann Arbor, 1977.

Vaughan J. C. *Soviet Socialist Realism: Origins and Theory*. New York and London: Macmillan Press, 1973.

Waley, A. (trans.). *Book of Songs*. London: George Allen and Unwin Ltd., 1937.

Waley, A. (trans.). *The Analects of Confucius*. London: George Allen and Unwin, Ltd., 1971.

Walicki, A. *A History of Russian Thought from the Enlightenment to Marxism*. Oxford: Clarendon Press, 1980.

Wang Chaowen. "Bixu jianchi zhengzhi biaozhun diyi — bo Zhang Wang tongzhi" (We Must Continue to Put the Political Criterion First — Refuting Comrade Zhang Wang). *Fine Art*, 1960, No. 3.

Wang Chaowen. "Gen minge bimei" (As Good As Folk Songs). *Fine Art*, 1958, No. 8.

Wang Chaowen. "Gongnongbing meishu hao!" (The Art of the Workers, Peasants and Soldiers is Good!). *Fine Art*, 1958, No. 12.

Wang Chaowen. "Guanyu xuexi jiu nianhua xingshi" (Studying the Forms of Old New Year Pictures). *People's Art*, 1950, No. 2.

Wang Chaowen. "Tansuo zai tansuo" (Explore Again and Again). *Fine Art*, 1963, No. 6.

Wang Chi. "Modern Chinese Woodcuts". *China Reconstructs*, 1 May 1953.

Wang Hongjian. "Qian tan yishude benzhi" (A Brief Discussion on the Essence of the Arts). *Fine Art*, 1981, No. 5.

Wang Jicong. *Zhonggong wenyi xilun* (Discussion and Analysis of the Literature and Art of Communist China). Taibei: Liming wenhua shiye gongsi, 1979.

Wang Jing. "Ba guohua yishu tuixiang xinde fanrong" (Push the Art of Chinese Painting towards New Heights). *Fine Art*, 1956, No. 8.

Wang Keqian and Xia Jun. *Lun Sate* (On Sartre). Fuzhou: Fujian renmin chubanshe, 1985.

Wang Lin *et al.* (comps.). *New Realistic Painting*. Guangxi: Lijiang chubanshe, 1988.

Wang Nianyi. *1949–1989 niande Zhongguo — dadongluande niandai* (China, 1949–1989 — Years of Great Turbulence). Zhengzhou: Henan renmin chubanshe, 1988.

Wang Qi. "Zouxiang fuxiu siwangde zichanjieji huihua yishu" (Towards Decadent and Doomed Bourgeois Art). *People's Art*, 1950, No. 6.

Wang Rong. "Bixu suqing meishu pipingzhongde zichanjieji guandian" (We Must Eliminate Bourgeois Viewpoints from Art Criticism). *Fine Art*, 1954, No. 12.

Wang Xueqi *et al. Zhongguo shehuizhuyi shiqi shigao* (History of Chinese Socialism). Hangzhou: Zhejiang renmin chubanshe, 1983.

Wang Xun. "Dui muqian guohua chuangzuode jidian yijian" (Some Opinions on Recent Traditional Chinese Paintings). *Fine Art*, 1954, No. 8.

Wang Xun. "Tan minjian nianhua" (Discussion on Popular New Year Pictures). *Fine Art*, 1956, No. 3.

Wang Yangcun. "Maibudao, maibudiao" (Can't Buy It, Can't Sell It). *Fine Art*, 1957, No. 3.

Wang Zhangling. *Bai Huade lu* (The Path of Bai Hua). Taibei: Liming wenhua shiye gongsi, 1982.

Wang Zhangling. *Zhonggongde wenyi zhengfeng* (Rectification in Literature and Art in Communist China). Taibei: Guoji guanxi yanjiusuo, 1967.

Wang Zhong, "Ping 'meishu xinchao'" (Assessing the "New Wave in Art"), *People's Daily*, 13 December 1990, p. 5.

"Weile shehuizhuyi wenyi jianshede bainian daji" (A Hundred-year Plan for the Construction of Socialist Arts). *Literary and Art Gazette*, 1957, No. 26, p. 1.

Wen Hua. "Tan nianhuade chuangzuo ji chuban wenti" (Discussion on Problems Regarding the Creation and Publication of New Year Pictures). *Fine Art*, 1956, No. 12.

Wen Tianxing (ed.). *Guotongqu kangzhan wenyi yundong dashiji* (Record of Major

Events in the KMT-held Areas during the War-of-Resistance-Against-Japan Movement). Chengdu: Sichuan sheke chubanshe, 1985.

Wen Zhaotong (ed.). *Meishu lilun shumu 1949–1979* (Catalogue of Publications of Art Theories 1949–1979). Shanghai: Shanghai renmin meishu chubanshe, 1983.

Wenyijie boluan fanzhengde yici shenghui — Zhongguo wenxue yishujie lianhehui disanjie quanguo weiyuanhui disanci kuoda huiyi wenjian, fayanji (A Successful Meeting of the Art World to Right the Wrongs of the Cultural Revolution — Documents and Speeches from the Enlarged Third Plenum of the Third National Executive Committee of the China Federation of Writers and Artisits). Beijing: Renmin wenxue chubanshe, 1979.

"*Wode fuqin* de zuozhede laixin" (A Letter from the Creator of *Father*). *Fine Art*, 1981, No. 2.

"Women buhui wei *Fuqin* gandao chiru" (We Won't Feel Ashamed About *Father*). *Fine Art*, 1982, No. 1.

"Women dui lianhuanhua *Feng* de yijian" (Our Opinions on the Picture-story Book *Maple*). *Fine Art*, 1979, No. 8, p. 33.

Wu Dazhi. "Shijiu shiji Faguode langmanzhuyi yishu" (Nineteenth Century French Romantic Art). *Fine Art*, 1958, No. 10.

Wu Fan. "Yao shenke fanying jieji douzheng" (We Need to Profoundly Reflect Class Struggle). *Fine Art*, 1965, No. 4.

Wu Guanzhong. "Guanyu chouxiang mei" (Abstract Beauty). *Fine Art*, 1980, No. 10.

Wu Guanzhong. "Huihuade xingshi mei" (The Beauty of Form in Painting). *Fine Art*, 1979, No. 5.

Wu Guanzhong. "Yinxiang zhuyi huihuade qianqian houhou" (The Story of Impressionist Painting). *Fine Art Research*, 1979, No. 4.

Wu Guanzhong. "Zaoxing yishu libukai dui renti meide yanjiu" (The Plastic Arts Are Inseparable from Research into the Beauty of the Human Form). *Fine Art*, 1980, No. 4.

Wu Tso-jen. "A Reflection on Landscape Painting". *Chinese Literature*, 1962, No. 7.

Wu Yanqing. "Zhengzhi yu shiyede guanxi" (The Relationship between Politics and One's Work). *Fine Art*, 1966, No. 2.

Wu Zuoren. "Dui youhua 'minzuhua' de renshi" (My Understanding of the "Sinicization" of Oil Painting). *Fine Art*, 1959, No. 7.

Wu Zuoren. "Wu Zuoren da benbao jizhe wen" (Wu Zuoren Replies to Questions Raised by Our Reporters). *Fine Arts in China*, 1985, No. 11.

Xi Lai. "Qingchunde xuanlü" (Melody of Youth). *Fine Art*, 1981, No. 1.

Xia Hang. "Sichuan qingnian huajia tan chuangzuo" (Young Sichuan Painters Discuss Creating Works of Art). *Fine Art*, 1981, No. 1.

Xia Jun. "Zhongguo meishujia xiehui disanci huiyuan daibiao dahui zai Jing

zhaokai" (The Third Congress of the Chinese Artists' Association Opens in Beijing). *Fine Art*, 1979, No. 11.

Xia Nong. "Haishi yinggai you zhu ci zhi fen" (We Should Still Differentiate Between "Main" and "Secondary" Themes). *Fine Art*, 1960, No. 1.

Xiao Caizhou. "Meishu gongzuozhe ruhe tiyan shenghuo" (How Art Workers Observe and Learn from Real Life). *Fine Art*, 1957, No. 1.

Xiao Feng. "Wei xin shiqide xin renwu chuangzao xinde tuhua" (Create New Paintings for The New Tasks of a New Era). *Fine Art*, 1979, No. 1.

Xiao Yanzhong (ed.). *Wannian Mao Zedong* (Mao Zedong in His Later Years). Beijing: Chunqiu chubanshe, 1989.

"Xiaxiang xiaoxi" (News on "Going Down to the Countryside"). *Fine Art*, 1958, No. 3, p. 35.

Xie Changyi. "Xiang minjian nianhua xuexi — Shandong sheng xiang jianguo shizhounian xianlide muban nianhua chuangzuo jingguo he tihui" (Learn from Popular New Year Pictures — The Process and Experiences of Shandong Province in Creating Woodblock Print New Year Pictures as Contributions to the Tenth Anniversary of the Founding of the People's Republic). *Fine Art*, 1960, No. 2.

Xing Guohua (ed.). *Zhongguo gemingshi xuexi shouce* (Study Handbook on the History of the Chinese Revolution). Nanchang: Jiangxi renmin chubanshe, 1987.

Xinhua News Agency (comp.). *Shinian gaige da shiji 1978–1987* (Record of the Major Events over Ten Years of Reform, 1978–1987). Beijing: Xinhua chubanshe, 1988.

Xinhua News Agency (ed.). *Zhonghua quanguo wenxue yishu gongzuozhe daibiao dahui jinian wenji* (Commemorative Collection of Essays on the Chinese National Congress of Writers and Artists). Beijing: Xinhua shudian, 1950.

Xiong Weishi. "Lun 'wenrenhua'" (On "Literati Painting"). *Fine Art*, 1959, No. 3.

Xu Dixin. "Wei shixian weidade zhanlüe mubiao er nuli" (Strive to Carry Out Our Great Strategic Aims). *Red Flag*, 1982, No. 19.

Xu Ling. "Nianhua gongzuozhong cunzaide zhuyao wenti" (The Main Problems Existing in Our New Year Picture Work). *Fine Art*, 1958, No. 4.

Xu Yanxun. "Dui taolun guohua chuangzuo jieshou yichan wentide wo jian" (My View on the Discussions of the Problems of Incorporating Our Cultural Heritage into Traditional Chinese Painting). *Fine Art*, 1955, No. 2.

Yan Han. "Zai meishu chuangzuozhong genchu xingshizhuyide yingxiang" (Eliminate the Influence of Formalism in Art Creation). *Literary and Art Gazette*, Jan. 1952, No. 55.

Yan Jiaqi and Gao Gao. *Wenhua Dageming shinianshi* (History of the Ten Years of the Cultural Revolution). 2 vols. Taibei: Yuanliu chuban gongsi, 1990.

"Yangfan gulang, lizheng shangyou" (Hoist the Sails and the Waves Will Beat on the Side of the Boat, Do Your Utmost To Be the Best). *Literary and Art Gazette*, 1958, No. 6, p. 20.

Ye Qianyu. "Cong jiu nianhua kan xin nianhua" (Looking at New New Year Pictures from the Perspective of Old New Year Pictures). *People's Art*, 1950, No. 2.

Ye Qianyu. "Liujie quanguo meizhande qishi" (Inspiration Gained from the Sixth National Art Exhibition). *Fine Art*, 1985, No. 2.

Ye Qianyu. "Tan renwuhua chuangzuode jige wenti" (Discussion of Several Problems Regarding the Creation of Portraits). *Fine Art*, 1980, No. 5.

Yi Xiaowu. "Dangqian chuangzuozhongde xiangzhengzhuyi qingxiang" (The Present Trend towards Symbolism in Artistic Creation). *Fine Art*, 1985, No. 10.

Yu Feng. "Kan 'Shanhe xin mao' huazhan suiji" (Informal Comments after Seeing the Exhibition "New Face of the Land"). *Fine Art*, 1961, No. 4.

Yu Feng. "New Things in an Old Art". *Peking Review*, 22 Mar. 1963.

Yu Feng. "New Year Pictures", *China Reconstructs*. 1 Mar. 1953.

Yu Hui-jung. "Let Our Theatre Propagate Mao Tse-tung's Thought Forever". *Chinese Literature*, 1968, No. 7/8.

Yu Jianhua. "Yi xing xie shen" (Using Form to Convey Spirit). *Fine Art*, 1962, No. 2.

Yu Shifang. "Wenhua Dageming — yichang xiandai zaoshen yundong" (The Cultural Revolution — A Modern Movement to Create Gods). *The Chinese Intellectual*, Spring, 1986.

Yuan Ming. *Deng Xiaoping diguo* (The Empire of Deng Xiaoping). Taibei: Shibao wenhua chuban qiye youxian gongsi, 1992.

Zeng Jingchu. "'Ye tan chouxiang mei' zhe yi" (Questions Arising from "Another Discussion on Abstract Beauty"). *Fine Art*, 1983, No. 10.

Zeng Zhushao. "Gu wei jin yong, wai wei zhong yong" (Use the Past to Serve the Present, Use Foreign Things to Serve China's Purposes). *Fine Art*, 1965, No. 6.

Zhan Jianjun. "Zai chuantong yu xiandai zhi jian sikao — guanyu xifang huihua" (Thinking That Is between Tradition and Modernity — On Western Art). *Fine Art*, 1985, No. 6.

Zhang Baoqi. "Mianlin xifeng — xuanze jieshou yu minzuxing" (Facing the West Wind — Choice, Acceptance and National Traditions). *Fine Art*, 1985, No. 10.

Zhang Baoqi. "Xin yidaide yishuguan" (The Artistic Outlook of the New Generation). *Fine Art*, 1985, No. 7.

Zhang Ding. "Gongyi meishu shiye burong zichanjieji sixiang fushi — ping Chen Shuliang tongzhide liang pian wenzhang" (Those Working in the Arts and Crafts Field Shouldn't Allow Themselves To Be Corrupted by Bourgeois Thinking — Comments on Two Articles by Comrade Chen Shuliang). *Fine Art*, 1960, No. 3.

Zhang Ding. "Guanyu guohua chuangzuo jicheng youliang chuantong wenti" (The

Problem of Inheriting the Good Aspects of Tradition When Creating Traditional Chinese Paintings). *Fine Art*, 1955, No. 6.

Zhang Leping. *The Adventures of San Mao the Orphan*. Translated by W. J. F. Jenner and C. M. Chan. Hong Kong: Joint Publishing Co., 1981.

Zhang Qicheng. "Pingjia gudai meishu ying you pipan jingshen" (In Evaluating Classical Art, One Should Adopt a Critical Approach). *Fine Art*, 1964, No. 3.

Zhang Qun and Meng Luding. "Xin shidai qishi — *Zai xin shidai* chuangzuo tan" (The Enlightenment of a New Era — Discussing the Creation of *In the New Era*). *Fine Art*, 1985, No. 7.

Zhang Shaoxia and Li Xiaoshan. *Zhongguo xiandai huihuashi* (A History of Modern Chinese Painting). Nanjing: Jiangsu meishu chubanshe, 1986.

Zhang Wang. "Cong 1958 nianhua shuoqi" (Beginning with the 1958 New Year Pictures). *Fine Art*, 1958, No. 2.

Zhang Wei. "Chuantong wenhua zhiyuezhe Zhongguo dianying" (Traditional Culture Restricts Chinese Film). *The Art of Film*, 1987, No. 1.

Zhao Yongmao. *Mao Zedong zhexue sixiang fazhan shigao* (History of the Development of Mao Zedong's Philosophical Ideas). Changchun: Jilin University, 1988.

Zheng Derong *et al.* (eds.). *Zhongguo shehuizhuyi jianshi* (Brief History of Chinese Socialism). Harbin: Heilongjiang jiaoyu chubanshe, 1987.

Zheng Derong *et al.* (eds.). *Xin Zhongguo jishi 1949–1984* (Record of Major Events in the New China 1949–1984). Shanghai: Huadong shifan daxue chubanshe, 1986.

"Zhi Xingxing meizhan zuozhemende yi feng xin" (A Letter to the Participants in the Stars Exhibition). *Fine Art*, 1981, No. 1, p. 41.

"Zhiyou zhongyu shishi caineng zhongyu zhenli" (Only by Being Faithful to Reality Can You Be Faithful to the Truth). *Historical Research*, 1979, No. 7, p. 1.

Zhong Chengxiang (ed.). *Xin Zhongguo wenxue jishi he zhongyao zhuzuo nianbiao (1949–1966)* (Record of Major Events in Literature in New China and Chronicles of Important Works 1949–1966). Chengdu: Sichuan shekeyuan chubanshe, 1984.

Zhong Jingwen. *Yan'an Lu Yi — wo dang suo chuangbande yisuo yishu xueyuan* (Yan'an Lu Xun Academy of Literature and Art — An Academy of Literature and Art Set Up and Run by the Party). Beijing: Wenwu chubanshe, 1981.

Zhong Jinzhi and Jin Ziguang (eds.). *Yan'an wenyi congshu (wenyi shiliaojuan)* (Yan'an Arts Series (Volume on the History of the Arts)). Changsha: Hunan wenyi chubanshe, 1987.

Zhong Ming. "Cong hua Sate shuoqi — tan huihuazhongde ziwo biaoxian" (Taking My Painting of Sartre As a Starting Point — A Discussion of Self-expression in Painting). *Fine Art*, 1981, No. 2.

"Zhongguo meishujia xiehui disanci huiyuan daibiao dahui xin xuanchu zhuxi, fu

zhuxi, changwu lishi, lishi" (The Third Congress of The Artists' Association Elects a New Chairman, Vice-Chairmen, and Standing Members and Members of the Executive Committee). *Fine Art*, 1979, No. 12, p. 6.

"Zhongguo meishujia xiehui zhangcheng" (The Constitution of the Chinese Artists' Association). *Fine Art*, 1979, No.12, p. 5.

"Zhongguo zuojia xiehui yanjiu zhixing 'baihua qifang, baijia zhengming' de fangzhen" (The Chinese Writers' Association Discusses How to Implement the "Hundred Flowers" Policy). *Literary and Art Gazette*, 1956, No. 14, pp. 20–21.

Zhou Enlai. *Zhou Enlai xuanji (xia)* (Selected Works of Zhou Enlai (Part 2)). Beijing: Renmin chubanshe, 1984.

Zhou Shaohua and Liu Gangji. "Lüe lun Zhongguohuade bimo yu tuichen chuxin" (A Brief Discussion on the Brush and Ink Used in Traditional Chinese Painting, and Weeding Out the Old to Bring Forth the New). *Fine Art*, 1963, No. 2.

Zhou Ya. "Nianhuade chuangzuo zuzhi yu chuban" (The Organization and Publication of New Year Picture Work). *People's Art*, 1950, No. 2.

Zhou Yang (ed.). *Makesizhuyi yu wenyi* (Marxism and Literature and Art). Beijing: Zuojia chubanshe, 1984.

Zhou Yang. "Fan renmin, fan lishide sixiang he fan xianshizhuyide yishu" (Ideas Which Oppose the People and History, and Art That Opposes Realism). *Literary and Art Gazette*, Sept. 1951, Vol. IV, No. 45.

Zhou Yang. "Guanyu meishu gongzuode yixie yijian" (Some Opinions on Art Work). *Fine Art*, 1955, No. 7.

Zhou Yang. *Jianjue guanche Mao Zedong wenyi luxian* (Resolutely Implement Mao Zedong's Line on Literature and Art). Beijing: Renmin wenxue chubanshe, 1952.

Zhou Yang. "The Path of Socialist Literature and Art in Our Country: Report Delivered to the Third Congress of Chinese Literature and Art Workers on 22 July 1960". *Chinese Literature*, 1960, No. 10.

Zhou Yang. "Wo guo shehuizhuyi wenxue yishude daolu" (The Socialist Path of Literature and Art in China). *Fine Art*, 1960, No. 7.

Zhou Yang. "Zhengdun wenyi sixiang, gaijin lingdao gongzuo" (Rectify Thinking on Literature and Art, Improve Leadership Work). *Literary and Art Gazette*, Dec. 1951, Vol. V, No. 52.

Zhou Yang. *Zhou Yang wenji* (Collected Works of Zhou Yang). Beijing: Renmin wenxue chubanshe, 1984.

Zhu Shan. "Zhutide duchuangxing yu duoyanghua" (The Originality and Variety in [Painting] Themes). *Fine Art*, 1961, No. 4.

Zhu Shiji. "Tan nongmin dui nianhuade yaoqiu" (Discussion on What Peasants Want in New Year Pictures). *Fine Art*, 1963, No. 2.

Zhu Xuchu. "Meishude fei chun renshixing he zhiguanxing" (The Aspects of Art

That Are Not Pure Mirror-reflection or Cognitive Perception). *Fine Art*, 1982, No. 8.

Zhu Yang *et al.* (eds.). *Zhonghua renmin gongheguo sishinian* (Forty Years of the People's Republic of China). Changchun: Jilin renmin chubanshe, 1989.

Zhu Zhangchao. "Cong chuban gongzuo tan nianhua chuangzuode wenti" (Discussion of the Problems in New Year Pictures As Seen from the Perspective of Publishing Work). *Fine Art*, 1956, No. 1.

Zhu Zongyu and Yang Yuanhua (eds.). *Zhonghua renmin gongheguo zhuyao shijian renwu* (Main Events and Individuals in the PRC). Fuzhou: Fujian renmin chubanshe, 1989.

Zong Ze. "Zhongguo meishujia xiehui zhangcheng" (The Constitution of the National Artists' Association). *Fine Art*, 1954, No. 2.

"Zongjie jingyan, fanrong chuangzuo — Zhongguo meishujia xiehui zhaokai changwu lishi kuoda huiyi" (Summarize Experiences, Cause Creativity to Flourish — The Chinese Artists' Association Calls an Enlarged Meeting of the Standing Members of Its Executive Committee). *Fine Art*, 1979, No. 12, p. 9.

Newspapers and periodicals

Art of Film, The (Dianying yishu) 《電影藝術》
China Quarterly
China Reconstructs
Chinese Intellectual, The (Zhongguo zhishifenzi) 《中國知識分子》
Chinese Literature
Contemporary Currents of Thought on the Arts (Dangdai wenyi sichao)
　　《當代文藝思潮》
East Asian History
Fine Art (Meishu) 《美術》
Fine Art Research (Meishu yanjiu) 《美術研究》
Fine Arts in China (Zhongguo meishu bao) 《中國美術報》
Guangming Daily (Guangming ribao) 《光明日報》
Hsiung Shih Art Monthly (Xiongshi meishu) 《雄獅美術》
Ideological Trends in Art (Meishu sichao) 《美術思潮》
Journal of Oriental Studies of Australia
Literary and Art Gazette (Wenyi bao) 《文藝報》
Ming Pao Monthly (Mingbao yuekan) 《明報月刊》
New China Digest (Xinhua wenzhai) 《新華文摘》
Nineties, The (Jiushi niandai) 《九十年代》
On the History of Art (Meishu shilun) 《美術史論》
Oriental Art

Pacific Affairs
Peking Review
People's Art (Renmin meishu) 《人民美術》
People's Daily (Renmin ribao) 《人民日報》
Reading (Dushu) 《讀書》
Red Flag (Hongqi) 《紅旗》
SCMP (Survey of China Mainland Press)
Seventies, The (Qishi niandai) 《七十年代》
Towards the Future (Zouxiang weilai) 《走向未來》

Index